HAGIA SOPHIA IN THE LONG
NINETEENTH CENTURY

Edinburgh Studies on the Ottoman Empire
Series Editor: Kent F. Schull

Published and forthcoming titles

The Ottoman Canon and the Construction of Arabic and Turkish Literatures
C. Ceyhun Arslan

Migrating Texts: Circulating Translations around the Ottoman Mediterranean
Edited by Marilyn Booth

Death and Life in the Ottoman Palace: Revelations of the Sultan Abdülhamid I Tomb
Douglas Brookes

Ottoman Sunnism: New Perspectives
Edited by Vefa Erginbaş

Jews and Palestinians in the Late Ottoman Era, 1908–1914: Claiming the Homeland
Louis A. Fishman

Spiritual Vernacular of the Early Ottoman Frontier: The Yazıcıoğlu Family
Carlos Grenier

The Politics of Armenian Migration to North America, 1885–1915: Sojourners, Smugglers and Dubious Citizens
David Gutman

The Kizilbash-Alevis in Ottoman Anatolia: Sufism, Politics and Community
Ayfer Karakaya-Stump

Çemberlitaş Hamamı in Istanbul: The Biographical Memoir of a Turkish Bath
Nina Macaraig

Hagia Sophia in the Long Nineteenth Century
Edited by Emily Neumeier and Benjamin Anderson

The Kurdish Nobility in the Ottoman Empire: Loyalty, Autonomy and Privilege
Nilay Özok-Gündoğan

Nineteenth-century Local Governance in Ottoman Bulgaria: Politics in Provincial Councils
M. Safa Saraçoğlu

Prisons in the Late Ottoman Empire: Microcosms of Modernity
Kent F. Schull

Ruler Visibility and Popular Belonging in the Ottoman Empire, 1808–1908
Darin N. Stephanov

The North Caucasus Borderland: Between Muscovy and the Ottoman Empire, 1555–1605
Murat Yaşar

Children and Childhood in the Ottoman Empire: From the 15th to the 20th Century
Edited by Gülay Yılmaz and Fruma Zachs

euppublishing.com/series/esoe

HAGIA SOPHIA IN THE LONG NINETEENTH CENTURY

Edited by Emily Neumeier and Benjamin Anderson

Edinburgh University Press is one of the leading university presses in the UK.
We publish academic books and journals in our selected subject areas across the
humanities and social sciences, combining cutting-edge scholarship with high editorial
and production values to produce academic works of lasting importance. For more
information visit our website: edinburghuniversitypress.com

© editorial matter and organisation Emily Neumeier and Benjamin Anderson, 2024
© the chapters their several authors, 2024

Edinburgh University Press Ltd
13 Infirmary Street
Edinburgh EH1 1LT

Typeset in 11/13 Jaghbuni by
Cheshire Typesetting Ltd, Cuddington, Cheshire
and printed and bound in Turkey

A CIP record for this book is available from the British Library

ISBN 978 1 4744 6100 9 (hardback)
ISBN 978 1 4744 6102 3 (webready PDF)
ISBN 978 1 4744 6103 0 (epub)

The right of Emily Neumeier and Benjamin Anderson to be identified as editors of this
work has been asserted in accordance with the Copyright, Designs and Patents Act 1988
and the Copyright and Related Rights Regulations 2003 (SI No. 2498).

Contents

List of Figures	vii
Notes on Contributors	xii
Note on Translation and Transliteration	xv
Acknowledgements	xvi

Introduction: Writing the Modern Biography of an Ancient Monument 1
Emily Neumeier and Benjamin Anderson

1. Hagia Sophia's Second Conversion: The Building Campaign of Mahmud I and the Transformation from Mosque to Complex (1739–43) 27
Ünver Rüstem

2. The Paradoxes of Hagia Sophia's Ablution Fountain: The *Qasida al-Burda* in Cosmopolitan Istanbul, 1740 66
Tülay Artan

3. The Calligraphic Arts in the Age of Ottoman Architectural Renovation 98
Emily Neumeier

4. From the Mouth of Angels: Folkloric Hagia Sophia 125
Benjamin Anderson

5. The Other Ayasofya: The Restoration of Thessaloniki's Ayasofya Mosque, 1890–1911 148
Sotirios Dimitriadis

6. 'That Domed Feeling': A Byzantine Synagogue in Cleveland 169
Robert S. Nelson

Contents

7. The Monument of the Present: The Fossati Restoration of Hagia Sophia (1847–9) 197
 Asli Menevse

8. From Ceremony to Spectacle: Changing Perceptions of Hagia Sophia through the Night of Power (*Laylat al-Qadr*) Prayer Ceremonies 240
 Ayşe Hilâl Uğurlu

9. Temple of the World's Desire: Hagia Sophia in the American Press, c. 1910–27 265
 Robert Ousterhout

Index 281

Figures

I.1 View of the public square in front of Hagia Sophia, 2022 4
I.2 A view of Hagia Sophia, 'the exterior of the mosque, before its restoration' 4
I.3 Hagia Sophia, mosaic of the south-west vestibule 8
I.4 Wilhelm Salzenberg, *Alt-christliche Baudenkmale von Constantinopel vom V. bis XII. Jahrhundert* 11
I.5 Narthex of Hagia Sophia, June 2022 18
1.1 Hagia Sophia Library, 1739–40, exterior 28
1.2 Hagia Sophia Library, entrance façade in the basilica's right aisle 29
1.3 Hagia Sophia Library, interior of the reading and recitation room 29
1.4 Hagia Sophia Library, interior of the kiosk 30
1.5 Hagia Sophia Primary School, 1740–1 31
1.6 Hagia Sophia ablution fountain, 1740–1 32
1.7 View to the north-west taken from the north-east minaret of Hagia Sophia, with the ʿimāret extending diagonally from the bottom right corner 32
1.8 Hagia Sophia ʿİmāret, 1742–3, interior of the dining hall looking towards the service windows of the adjacent kitchen 34
1.9 Hagia Sophia ʿİmāret, exterior of the main building looking towards the principal entrance of the dining hall 35
1.10 Hagia Sophia ʿİmāret, principal gate 36
1.11 Hagia Sophia Library, ornamental plasterwork on the ceiling of the kiosk reading area 40
1.12 Hagia Sophia Library, inner face of the kiosk entrance 42
1.13 Hagia Sophia ablution fountain, detail of the marble tank and bronze grillwork 43

Figures

1.14	Hagia Sophia ʿİmāret, upper part of the main gate	44
1.15	Comparison of column capitals from the interior of Hagia Sophia, the main gate of Hagia Sophia ʿİmāret and the façade of the Church of Santi Celso e Giuliano, Rome	51
2.1	Historical view of the ablution fountain of Hagia Sophia	67
2.2	Public fountain commissioned by Ahmed III at the entrance to the Topkapı Palace	68
2.3	Ablution fountain of Hagia Sophia	69
2.4	The central fount and the brass gratings topping it have sixteen sides	70
2.5	Finial topping the brass gratings of the ablution fountain at Hagia Sophia	70
2.6	Finial topping the outer dome of the ablution fountain at Hagia Sophia	72
2.7	Inscription frieze of couplets from a *qasida* attributed to Emin Mehmed, found on the interior of the octagonal colonnade at the ablution fountain of Hagia Sophia	73
2.8	Inscription frieze of the *Qasida al-Burda*, found on the exterior of the octagonal colonnade at the ablution fountain of Hagia Sophia	73
2.9	Fourteenth-century manuscript copy of the *Qasida al-Burda*	76
2.10	Frontispiece of fourteenth-century manuscript copy of the *Qasida al-Burda*	77
2.11	Colophon of seventeenth-century manuscript copy of the *Qasida al-Burda*	79
2.12	Colophon of fourteenth-century manuscript copy of the *Qasida al-Burda*	80
2.13	Flyleaf of fifteenth-century manuscript copy of the *Qasida al-Burda*	81
3.1	View of the interior of Hagia Sophia	98
3.2	Diagram indicating the location of the calligraphic roundels placed in the interior of Hagia Sophia in the nineteenth century	101
3.3	The roundel bearing the name of Huseyin, with the artist's signature and date located at the bottom	102
3.4	Interior of the Hırka-i Şerif Mosque, Istanbul	103
3.5	Front and rear view of the calligraphic roundels in Hagia Sophia, showing the wooden frame	103
3.6	Cornelius Loos, Drawing of the Interior of Hagia Sophia, 1711	105
3.7	Interior of the Kılıç Ali Pasha Mosque in Tophane, Istanbul	107

Figures

3.8 Interior view of the Great Mosque of Adana — 108
3.9 Interior of the Mosque of Sultan Murad III in Manisa, Turkey — 110
3.10 Interior of the Nuruosmaniye Mosque, Istanbul — 111
3.11 Interior view of the Başçavuş Mosque in Yozgat, Turkey — 112
3.12 Detail of a roundel painted on the wall of the upper gallery at the Başçavuş Mosque in Yozgat, Turkey — 113
3.13 Interior of the Süleymaniye Mosque, showing the black-and-gold medallions added in the nineteenth century in the semi-dome of the mihrab area and on the main piers supporting the central dome — 116
3.14 View of Hagia Sophia after the Fossati restorations — 118
4.1 Comparison of the dimensions of Hagia Sophia with those of other monuments of world architecture — 131
4.2 The angel Jibrîl delivers a message from God to Muhammad, ordering him to leave Mecca and go to Medina — 137
4.3 Austen Henry Layard, *Nineveh and its Remains* — 138
5.1 Transverse section of the Ayasofya Mosque — 149
5.2 The mihrab area of the Ayasofya Mosque — 152
5.3 Ayasofya and its courtyard after the 1890 fire — 156
5.4 The mosque's portico (*son cemaat mahalli*) following the 1890 fire — 157
5.5 The catacombs superimposed on a street plan for the reconstruction of the area — 159
5.6 Thessaloniki, Catacombs of St John the Baptist — 160
5.7 Sultan Mehmed V disembarks as his carriage draws to a halt in front of the mosque's entrance — 162
5.8 The interior of the building, shortly after its reconversion to a church — 164
6.1 Temple Tifereth Israel, Cleveland, main façade, 1924 — 172
6.2 Temple Tifereth Israel, plan — 172
6.3 Temple Tifereth Israel, older aerial view — 173
6.4 Temple Tifereth Israel, vestibule — 173
6.5 Temple Tifereth Israel, interior view to bimah — 174
6.6 Temple Tifereth Israel, interior view to entrance — 175
6.7 Temple Tifereth Israel, 1894, currently Friendship Baptist Church, Cleveland — 176
6.8 Hagia Sophia, Istanbul, dome — 177
6.9 Domes of the Tifaret Yisrael and Hurva synagogues, Jerusalem, c. 1900 — 178
6.10 Temple Tifereth Israel, façade capital — 179

Figures

6.11	Hagia Sophia, Istanbul, nave capital	180
6.12	Hagia Sophia, Istanbul, view to apse	183
6.13	Newark, former B'nai Jeshuran, 1915	183
7.1	First page of the *Journal de Constantinople. Écho de l'Orient* (29 July 1849)	200
7.2	Frontispiece from Gaspare Fossati's lithography album, *Aya Sofia, Constantinople, as Recently Restored by Order of H.M. the Sultan Abdul-Medjid* (1852)	206
7.3	'View from the Main Entrance', Plate 1 from the Fossati album	208
7.4	Plate 1 from the Fossati album	209
7.5	W. H. Bartlett, 'View from the West Gallery'. Julia Pardoe, *The Beauties of the Bosphorus by Miss Pardoe* (London, 1838)	211
7.6	'View of the Upper Gallery', Plate 11 from the Fossati album	212
7.7	Detail from Plate 11 of the Fossati album	213
7.8	'Entrance of the Upper Gallery', Plate 10 from the Fossati album	214
7.9	'The New Imperial Loge' (Hünkâr Mahfili), Plate 9 from the Fossati album	216
7.10	'The View from the North Aisle', Plate 5 from the Fossati album	218
7.11	'The View of the Grand Vizier's Place', Plate 7 from the Fossati album	220
7.12	Detail from Plate 7 of the Fossati album	221
7.13	Wilhelm Salzenberg, *Alt-christliche Baudenkmale von Constantinopel vom V. bis XII. Jahrhundert*	223
7.14	'The View of the Central Nave from the North Aisle', Plate 6 from the Fossati album	224
8.1	A plate from the Fossati album showing the interior view of the Hagia Sophia Mosque, drawn from the lower north gallery	242
8.2	A plate from the Fossati album showing the upper galleries of Hagia Sophia from the north-west	243
8.3	A nineteenth-century map of Istanbul, showing major imperial mosques that were visited by sultans during Night of Power ceremonies	246
8.4	A detail from the same map showing the route of the European group from Büyükdere to Hagia Sophia	249
8.5	Newspaper clips about the Night of Power ceremony held in Hagia Sophia on 4 February 1932	253

Figures

8.6 A scene from the 3D Mapping Show held in 2020 for the 567th anniversary of the conquest of Istanbul	255
9.1 Hagia Sophia, seen from the south-west in a popular postcard view	265
9.2 Hagia Sophia, interior looking east	266
9.3 Hagia Sophia, as illustrated in a newspaper article of 1912	271
9.4 Popular newspaper feature from 1927 concerning the conversion of Hagia Sophia into a dancehall	275

Notes on Contributors

Benjamin Anderson is Associate Professor of History of Art and Classics at Cornell University. His research focuses on late Roman and Byzantine art and architecture, the urban history of Constantinople and the history of archaeology. He is author of *Cosmos and Community in Early Medieval Art* (2017) and co-editor of *Antiquarianisms* (2017), *The Byzantine Neighbourhood* (2022), *Otros Pasados* (2022) and *Is Byzantine Studies a Colonialist Discipline?* (2023).

Tülay Artan is a Professor in the History Program, Sabancı University, İstanbul. She works on prosopographical networks of the Ottoman elite and their households; antiquarianism, collecting and material culture; consumption history and standards of living; and seventeenth-to-eighteenth-century Ottoman arts, architecture and literature in comparative perspective. She is the director of a three-year TUBITAK (Scientific and Technological Research Council of Turkey) project on the manuscript collection of an early eighteenth-century grand vizier, Şehid Ali Paşa. Recent publications include 'Patrons, Painters, Women in Distress: The Changing Fortunes of Nev'izade Atayi and Üskübi Mehmed Efendi in Early Eighteenth-Century Istanbul', *Muqarnas* 39 (2022): 109–52.

Sotirios Dimitriadis is a historian currently teaching at Temple University. His research focuses on the late Ottoman Empire and the modern Middle East, and he has worked on themes of urban and social transformations, the emergence of modern education and the perception of the Ottoman past in contemporary Greece.

Asli Menevse is currently an Assistant Professor in the Civilizations, Cultures and Ideas programme of Bilkent University (Ankara, Turkey).

Notes on Contributors

Her primary area of research is the intersection of politics and art in public space, focusing especially on two contradictory aesthetic interventions into everyday life: official monuments and political ephemera. Asli received her Ph.D. degree from the Department of the History of Art and Visual Studies at Cornell University in 2021.

Robert S. Nelson, an Emeritus Professor at Yale University, has long been interested in what the Byzantines called the 'Great Church', the subject of this volume. He is the author of *Hagia Sophia, 1850–1950: Holy Wisdom Modern Monument* (2004), which asks the question, how did a building so disparaged by Europeans in the eighteenth century come to be regarded as great again? During his research he happened upon an early twentieth-century synagogue in San Francisco that resembled the mosque in Istanbul. Since then, others have been noted, including the building in Cleveland studied here.

Emily Neumeier is Assistant Professor of Art History in the Tyler School of Art and Architecture at Temple University. Her work examines the visual and spatial cultures of the eastern Mediterranean, with a focus on the Ottoman Empire. She has published in the *Journal of the Ottoman and Turkish Studies Association*, *History and Anthropology* and the *International Journal of Islamic Architecture*. This research has been supported by the Getty Foundation, the American Council of Learned Societies, the American Research Institute in Turkey and the Fulbright Program.

Robert Ousterhout (1950–2023) was Professor Emeritus of the History of Art at the University of Pennsylvania. He published widely on Byzantine architecture, monumental art and urbanism. His many books include *Master Builders of Byzantium* (1999), *Visualizing Community: Art, Material Culture, and Settlement in Byzantine Cappadocia* (2017) and *Eastern Medieval Architecture: The Building Traditions of Byzantium and Neighboring Lands* (2019), for which he was awarded the 2021 Haskins Medal by the Medieval Academy of America.

Ünver Rüstem is the Second Decade Society Associate Professor of Islamic Art and Architecture at Johns Hopkins University. His research centres on the Ottoman Empire in its later centuries and on questions of cross-cultural exchange and interaction. He is the author of *Ottoman Baroque: The Architectural Refashioning of Eighteenth-Century Istanbul* (Princeton University Press, 2019) and has published articles and chapters

on subjects including the reception of illustrated Islamic manuscripts, the tombstones of Ottoman Cyprus, the art of medieval Qur'ans with interlinear translations, and Ottoman costume books in the age of modernity.

Ayşe Hilâl Uğurlu is Associate Professor of Architectural History at MEF University, Istanbul. Her research interests include Ottoman social, political and architectural history, especially of the eighteenth and nineteenth centuries. She co-edited a book with Professor Hatice Aynur in 2016 entitled *Osmanlı Mimarlık Kültürü* (*Ottoman Architectural Culture*), and two books with Dr Suzan Yalman: *Sacred Spaces and Urban Networks* (2019) and *The Friday Mosque in the City: Liminality, Ritual, Politics* (2020). Her academic work has been supported by a Major Award from Barakat Trust, ANAMED of Koç University, Salt Research and Istanbul Research Institute.

Note on Translation and Transliteration

Unless otherwise noted, all translations into English are by the chapter authors.

Names, texts and terms in Arabic and Persian are transliterated following IJMES guidelines. Archival and epigraphic texts in Ottoman Turkish are transliterated according either to IJMES guidelines or to modern Turkish orthography, at the discretion of the chapter author. Previously published editions of Ottoman source texts retain the system of the original publication. Primary sources in Greek are not transliterated.

Acknowledgements

The papers collected within this volume began as presentations at a symposium held at the Ohio State University in September 2018. Our sincere thanks to OSU's Department of Classics for sponsoring the event, and especially to Department chair Anthony Kaldellis for his support. We also owe our gratitude to the Department manager, Khalid Jama, who expertly handled all the logistical aspects of the gathering. Additional financial support was provided with a generous grant from the OSU College of Arts and Sciences and the Discovery Theme Initiative.

We have both profited from learning about Hagia Sophia with students at our respective institutions. In the spring of 2014, Ben led a seminar on 'Problems in Byzantine Art: Hagia Sophia' at Cornell University. He thanks all participants – Billy Breitweiser, Liana Brent, Asa Cameron, Betty Hensellek, Nichita Kulkarni, Nick Lashway, Asli Menevse, Margaret Moline, Avinash Murugan, Chinelo Onyilofor and Weihong Rong – for open-minded and exploratory engagement with Hagia Sophia's many histories. In the fall of 2020, Emily organised a graduate seminar titled 'The Biography of a Monument: Hagia Sophia' at Temple University. She would like to extend her thanks to the participants in that seminar – Nonna Batrakova, Molly Bernhard, Michael Ernst, Michael Lally, Ari Lipkis, Nicole Emser Marcel, Sara Potts, Kendra Schmit, Alexa Smith and Özlem Yıldız – for joining her to think through the many layers (both physical and metaphorical) that Hagia Sophia has accrued over time.

We are grateful to Sam Barber and Max Meyer for assistance with copy-editing, and to Michael Ernst and Özlem Yıldız for assistance with securing images and permissions. Thank you especially to Ayla Çevik, who prepared the index.

This book could not have been realised without the attentive staff of Edinburgh University Press. We would like to acknowledge our editors

Acknowledgements

Nicola Ramsey, Louise Hutton and Isobel Birks for their steadfast patience and continuous encouragement, as well as series editor Kent F. Schull for his willingness to include this volume in the Edinburgh Studies on the Ottoman Empire and managing desk editor Eddie Clark for shepherding the book into print. We wish additionally to thank the anonymous peer reviewers who evaluated our proposal and finalised manuscript. Most importantly, we are grateful for having the opportunity to work with all the incredible contributors to this volume, whose collective voices offer many new perspectives on a building that continues to capture the imagination and command the attention of the world.

As we readied the final manuscript for submission to the press, we received the sad news that Bob Ousterhout, the author of the concluding chapter, had passed. We were fortunate to know Bob as a teacher, a mentor, and a true friend of Hagia Sophia. This book is dedicated to his memory.

Introduction: Writing the Modern Biography of an Ancient Monument

Emily Neumeier and Benjamin Anderson

Hagia Sophia, the colossal structure whose domes have defined Istanbul's skyline for a millennium and a half, has led – and continues to lead – multiple lives. The present volume tracks its constantly fluctuating status and meaning to a wide variety of stakeholders during the long nineteenth century, a crucial yet understudied period in the building's history, c. 1739–1934. We hope that it might serve simultaneously as a detailed examination of a fascinating moment in the biography of a building, and as a resource for considering its enduring significance in the present.

In the summer of 2020, while the chapters in this book were still under preparation, a Turkish high court ruled that the transformation of Hagia Sophia into a museum in the early twentieth century was unlawful. The effects of this ruling were immediate, paving the way for the site's re-conversion into a mosque in a matter of weeks. As responses to these events erupted across news networks, social media and countless op-eds, the urgency for an account of Hagia Sophia during the late Ottoman period became even more apparent. For, we contend, it was during the long nineteenth century that Hagia Sophia's contested status, its use as a sign for something else, first began to determine the fate of its physical fabric.

This volume begins with Hagia Sophia's transformation from a free-standing mosque to a multi-functional complex under Sultan Mahmud I (r. 1739–43). Contributors continue the story by examining the large-scale restorations of Hagia Sophia ordered by Sultan Abdülmecid (r. 1839–61) and carried out by the Swiss-Italian architect Gaspare Fossati. The book concludes with the abolition of the sultanate (1922) and the debates about the building during the first decade of the Turkish Republic, which culminated in the decision (1934) to turn Hagia Sophia into a museum. The nine chapters, by scholars of both Byzantine and Ottoman history, adopt a variety of methodological approaches, including archival research, literary

analysis and art history. Despite the diversity of these different accounts, the volume taken as a whole offers a coherent narrative of the process by which Hagia Sophia became an image. This process was not a linear progression, but involved a variety of interactions between different and sometimes competing conceptions of heritage, architectural patronage and restoration practices. The plurality of claims mapped onto Hagia Sophia that emerge during the nineteenth century establishes this period as a largely unacknowledged precursor for the debates and dynamics that we have seen unfold in public discourse since 2020.

Monument Biography

This volume adapts the concept of object biography, an approach that developed from the fields of anthropology and archaeology, and extends it to an entire built environment – to the realm of the monumental. Some maintain that the practice of writing life histories of the inanimate dates back at least to the European Enlightenment, along with the emergence of biography itself as a modern literary genre.[1] Yet it is Igor Kopytoff's 1986 essay that launched the contemporary scholarly conversation about how objects can be 'culturally redefined and put to use' over time.[2]

As the mobility of objects often plays a key role in these narratives, it may seem incongruous to apply object biography to architecture.[3] After all, most objects are portable, and, by moving around, can be exchanged and have encounters with a number of people in different geographies. By contrast, buildings usually remain in one place over the course of their lives. Even if a structure is fixed in one place, however, it inevitably experiences physical changes to its fabric over time, of which some are dramatic and intentional, and others present as natural ('decay') or routine ('maintenance').[4] Both types of change find analogies in biography, just as the human body transforms and may require outside medical intervention with age. Moreover, if an object is able to meet many individuals on its peregrinations, a building conversely can receive those who make their way to the site, with a potentially wide range of patrons, architects, builders, caretakers, residents, congregants, visitors and tourists all developing their own unique relationship with the structure. As we are reminded by Asli Menevse and Robert Ousterhout's chapters in this volume, it is also perfectly possible in the modern era for armchair travellers to 'visit' a monument remotely through the consumption of mass media.

In short, every building has a biography. As it happens, the first example Kopytoff uses to introduce the concept of object biography is architectural: the houses constructed by the Suku in Central Africa, whose physical state

Introduction

'at each given age corresponds to a particular use'.[5] The authors of this volume explore the extent to which the same can be said of Hagia Sophia.

There are many ways to write a biography. In her study of the Çemberlitaş Hamam in Istanbul, the architectural historian Nina Macaraig takes methodological inspiration from the specific genre of biographical memoir (*tezkere*) in Ottoman literature.[6] She observes that, while Western biographies tend to follow a sequential order in terms of time, *tezkere* are typically organised according to more thematic categories like birth, physical appearance, professional activities, etc. In a similar fashion, the present chapters, while arranged in a loosely chronological structure, examine how Hagia Sophia became a cultural symbol endowed with different meanings for various individuals and groups of people during the same era.

Over the course of the long nineteenth century, Hagia Sophia served multiple functions even while its 'status' as a mosque remained firmly fixed. For example, the site was an imperial monument that had received the special attention of the Ottoman sultans for hundreds of years, from its privileged position adjacent to the Topkapı Palace to the construction of several royal tombs within the confines of the mosque precinct in the sixteenth and seventeenth centuries. In this capacity, Hagia Sophia attracted a large number of pilgrims from all corners of the Ottoman Empire and beyond, as explored by Tülay Artan in this volume. At the same time, the complex also played a specific role within Istanbul's urban geography as the Friday mosque that served the people who lived and worked in the immediately surrounding area.

Today, there is a park between Hagia Sophia and the Mosque of Sultan Ahmet, which affords tourists and the city's residents unencumbered views of both monuments (Figure I.1). This expansive space, however, was only realised about a hundred years ago in the early twentieth century (1913), when an entire residential quarter of wooden houses was cleared out and levelled to the ground.[7] Archival documents and contemporary images are now all that remain of this *mahalle* (neighbourhood) of 'Ayasofya-yı Kebir', which contained around a hundred and fifty houses.[8] A plate from the 1852 album commemorating the Fossati restorations shows a bustling warren of narrow streets, with buildings of various sizes and states of repair reflecting the mixed nature of the residents in terms of their income and social status (Figure I.2). Archival records also offer a glimpse of an overwhelmingly Muslim neighbourhood that housed a cross-section of society, from the impoverished (like Ayşe Hanım, a mother raising four daughters on her own) to the political elite (like Zübeyde Hanım, wife of the Edirne governor Abdurrahman Pasha).[9]

Figure I.1 View of the public square in front of Hagia Sophia, 2022. Photo: Emily Neumeier.

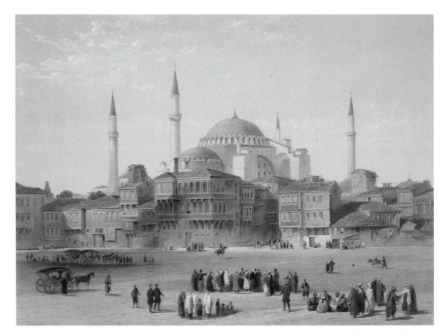

Figure I.2 A view of Hagia Sophia, 'the exterior of the mosque, before its restoration': Gaspare Fossati, *Aya Sofia, Constantinople: As Recently Restored by Order of H.M. the Sultan Abdul-Medjid* (London: R. & C. Colnagni & Co., 1852), plate 25. Library of Congress, Washington, DC.

Introduction

In Ottoman Istanbul, the *mahalle* served not only as an administrative unit but also as a durable source of local identity, and the neighbourhood's mosque usually functioned as the public meeting space for the surrounding community.[10] Thus, even as Hagia Sophia became an internationally famous building, it also continued to define the everyday experiences of those who lived just beyond its walls. Indicatively, the residents of the Ayasofya *mahalle* rallied to fight against the municipality's 1913 plan for a park between the two mosques, arguing in petitions that the process of eminent domain (*istimlak*) would deprive Hagia Sophia of its local congregation and only a 'large desert' would remain.[11]

Perhaps the Fossati album features the screen of wooden houses in front of Hagia Sophia to stress the need for their ultimate destruction – as they impede a clear view of the monument. Nevertheless, the image simultaneously illustrates the integration of the mosque into the urban fabric, hovering protectively over the residents of its *mahalle*.[12] All of the contributors to the present volume are likewise attuned to the importance of tracing both top-down and state-sanctioned narratives about Hagia Sophia, which determine the bulk of our source material, and the local or non-traditional perspectives that are less visible today.

If we define a monument as an example of architectural excess – an opportunity, in other words, for a patron to showcase their wealth and power by spending lavishly on the construction of a building of exceptional scale and expert design – then Hagia Sophia has been a monument since its foundation under Justinian.[13] Yet the case study of the 1913 park acts as a stark reminder that, especially during the long nineteenth century, there were shifting and increasingly incompatible approaches to what constitutes a monument.[14] Within the Ottoman context, the demolition of the Ayasofya neighbourhood signals the potential tensions between understanding Hagia Sophia as an *imaret* (mosque complex) and understanding it as an *eser* (historical building) or *abide* (memorial). All these terms could legitimately be translated as 'monument', but there are significant semantic differences behind each.

İmaret was often used in Ottoman Turkish to describe a collection of charitable works that provide essential services to the public, like education or food for the poor, usually anchored by a Friday mosque.[15] As Ünver Rüstem and Tülay Artan show in this volume, Hagia Sophia did not become an *imaret* in the full sense of an imperial mosque complex until the mid-eighteenth century.

Meanwhile, the word *eser* distinguishes what would otherwise be an ordinary object or building as a work of fine art or architecture; while *abide* conveys the idea of a structure that is perpetual or eternal.[16] These terms

come closer to the conceptions of the historical monument that took form in Europe over the course of the long nineteenth century, even if neither follows quite the same trajectory as the French and English 'monument' or the German 'Denkmal'.[17] For example, the definition of the historical monument (*Denkmal*) offered in 1903 by the Habsburg art historian Alois Riegl emphasises its value as a permanent document of a certain period of artistic production, thus as an element in a linear history of style.[18]

Accordingly, the biography of Hagia Sophia in the long nineteenth century cannot rest on a stable understanding of what constitutes a monument. Rather, the building itself became a testing ground for multiple general concepts of the monument. The architect Aldo Rossi writes eloquently of the fashion in which buildings can shed one function in favour of another many times over the course of their lives, even if they maintain almost exactly the same form.[19] To this we would add that Hagia Sophia in the long nineteenth century served many functions at the same time, and sometimes even for the same person. The contributors to this book thus follow not only Hagia Sophia's physical transformations but also, and perhaps even more crucially, its discursive transformations. This book joins a wider movement in scholarship that considers monuments as generators of plural histories, and we hope that it may inspire a biographical approach for other major architectural landmarks around the globe.[20]

Hagia Sophia: A Very Short History

The Great Church of Constantinople was consecrated under Constantius II, son of the city's founder, on 15 February 360, beneath the acropolis of old Byzantium. Its dedication to Hagia Sophia (Greek for 'Holy Wisdom') parallels that of the proximate Hagia Eirene ('Holy Peace'), built already under Constantine.[21] We know nothing, archaeologically or textually, of these buildings, but they were probably basilicas, like Constantine's foundations in Rome: St Peter's in the Vatican, St John's in the Lateran. Unlike the Roman churches, the Constantinopolitan were dedicated, not to saints, but to 'glorious powers' (in the words of a sixth-century poet).[22]

The first Hagia Sophia burned in a riot, 404;[23] its successor, whose atrium and narthex were excavated in the twentieth century, burned in another, 532.[24] The construction of the third Hagia Sophia under Justinian was the stuff of legend from the start. Justinian's court historian, Procopius, supposed

> that if anyone had enquired of the Christians before the burning if it would be their wish that the church should be destroyed and one like this should

take its place, showing them some sort of model of the building we now see, it seems to me that they would have prayed that they might see their church destroyed forthwith, in order that the building might be converted into its present form.[25]

For Romanos the Melode, great poet of the age, the riot was divinely ordained, after which:

> The very structure of the church
> Was erected with such excellence
> That it imitated Heaven, the divine throne,
> Which indeed offers
> Eternal life.[26]

Both historian and poet link the wonder of the building directly to its form (even as Procopius imagines its form as existing prior to the building). The third Hagia Sophia is still, in essence, a basilica, but one (as Procopius writes) both 'exceedingly long and at the same time unusually broad'.[27] That is to say, it is both bigger and closer in plan to square than most basilicas. Justinian's Hagia Sophia was additionally distinguished by (quoting the same historian) 'the huge spherical dome which makes the structure exceptionally beautiful. Yet it seems not to rest upon solid masonry, but to cover the space with its golden dome suspended from heaven.'[28]

'Hazardous in its statics',[29] that dome collapsed in an earthquake two decades later, 557. A contemporary historian, Agathias, reported that its replacement was more secure but less impressive: 'it has become narrower, its lines have hardened, and it has lost something of its old power to inspire awe and wonder in the beholder'.[30] Otherwise, Justinian's basilica is in essence the same structure that we visit today. The primary changes have been to its decoration.

The vast naos, spanned by the dome, was rich in mosaics. Those original to Justinian's church displayed a rich variety of motifs, including vegetal scrolls, trees, rosettes, palmettes, ropes, jewel strands, stars and crosses; but figures (be they animal, human or divine) were wholly absent.[31] The earliest figural mosaics of the naos date to some three centuries later, after the end of the Iconoclast controversy. Thus the mosaic of the Virgin and Child in the apse was installed in the ninth century, and surrounded by an inscription, fragments of which remain: 'The images that the heretics took down from here our pious sovereigns replaced.'[32] This is false – there were no images in the apse before Iconoclasm. However, there is evidence for iconoclast-era removal of bust-length portraits of saints from a space adjacent to the naos (the 'Room Over the Ramp'), which may have served the patriarchs as an office.[33]

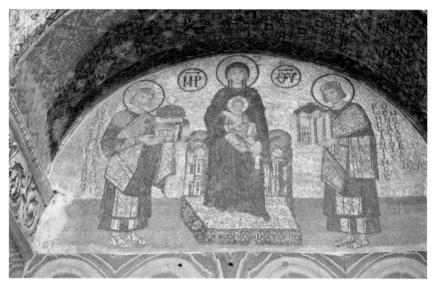

Figure I.3 Hagia Sophia, mosaic of the south-west vestibule. Photo: Emily Neumeier.

Images subsequently executed include portraits of reigning emperors and venerated saints.[34] More difficult to classify is the mosaic of the South-west Vestibule, opposite the 'beautiful door', in which the Virgin and Child receive the city from Constantine, the church from Justinian. The mosaic retrospectively makes both emperors into saints,[35] even as it presents the earliest preserved picture of Hagia Sophia itself, magnifying its already massive dome out of all proportion to its supports (Figure I.3). The mosaic is an amalgam of fiction and truth, religion and politics, tensions that would remain in all subsequent representations of the building.

The image of Hagia Sophia in Byzantine literature remained closely entwined with its matter. 'The Story [*Diegesis*] of Hagia Sophia' is a text of the ninth century, thus contemporary with the mosaic of the apse. Like that inscription, the *Diegesis* mythologises the building's origins, but it also exhibits a minute interest in its structure and fabric. Thus, when an angel appears to the architect's son, swearing 'that he would protect the church on behalf of God', this happens 'on the right side of the pier for the upper arch that reaches up to the dome'.[36]

The dome remained subject to gravity, and fell once more in an earthquake, 989. A contemporary historian records that

> there were many attempts by ingenious Greek architects to restore it again. But the leading architect of the Armenians, Trdat the stoneworker, happened

to be there; he offered a plan of the building and through clever invention, he prepared models of the apparatus and started the rebuilding; it was constructed more beautifully, more brilliant than before.[37]

The third – thus far final – collapse occurred in 1346; the reconstruction is attributed to two Italians, Fazzolati and Giovanni de Peralta, and a Greek, Astras.[38]

These successive repairs represent one aspect of the building's internationalisation: namely, the consistent role of foreigners (non-Byzantines) in the maintenance of its fabric. Another aspect is its growing fame abroad, often among those who had never seen it, as a symbol of earthly power and divine favour. A chronicle composed in Kyiv in the eleventh century granted Hagia Sophia a role in the conversion of Rus to Orthodoxy: for when its ambassadors entered the Great Church, 'we knew not whether we were in heaven or on earth'.[39] Arab visitors, if Muslim, seem not to have been granted entrance, but still traded accounts of '"the Great Church, where it is said that an angel resides" and where lies "a colossal high altar with huge doors and columns"'.[40]

Yet another side of the internationalisation of Hagia Sophia was military. This begins already with the Varangian mercenary who carved his name (Halvdan) on a gallery balustrade in the eleventh century.[41] A more direct military appropriation was enacted by the Frankish Crusaders, who in 1204 robed, anointed and enthroned their new emperor, Baldwin, in the Great Church.[42] They also rearranged the furniture; so that when the Greek emperor Michael re-took Constantinople, 1261, he 'restored to its previous condition the entire church which had been altered by the Italians in many respects. And placing in charge the monk Rouchas . . . he rearranged the bema and ambo and solea.'[43]

Two centuries later, immediately after taking Constantinople, Sultan Mehmed II visited the Great Church, which the new rulers swiftly adopted as the city's principal congregational mosque.[44] An anonymous Greek poet writing in the aftermath of the conquest thought back to the story from the *Diegesis*, wondering:

> Was the angel watching, as he had been ordered to do,
> the one who, once upon a time, made a promise to the young man
> saying: 'I will not leave until you come back?'[45]

The new rulers, too, were interested in the *Diegesis*, as attested by a Greek manuscript of the text, copied in 1474, and still preserved in the library of the Topkapı Palace;[46] and its stories found their way into the new accounts of the building's wonders composed in Persian and Turkish.[47]

Adaptation of the interior to Muslim worship required little more than mihrab and minbar. Many of the figural mosaics remained visible for centuries after the conquest. The Virgin and Child in the apse, for example, appear in views as late as the early eighteenth century. The seraphim in the pendentives were never entirely concealed. These Byzantine mosaics were gradually joined by a variety of inscriptions in Arabic, of which the most prominent are the calligraphic panels studied in this volume by Emily Neumeier. Other inscriptions established a dialogue with the earlier decorations. The Qur'anic text of Mehmed's mihrab (3:37), for example, refers to Mary, whose image appears in the apse directly above.[48] Others are more agonistic, such as that executed in 1698 and displayed outside the South-west Vestibule – thus near to the mosaic of Constantine and Justinian – on which appears the hadith foretelling the capture of Constantinople by a Muslim army.[49]

While the sultans exercised a light touch on the interior, they substantially altered the external image of Hagia Sophia. The minarets arose successively: at the south-east under Mehmed, at the north-east under his successor Bayezid, and the two at the west under Selim II and Murad III in the following century. The mausolea that cluster along the building's southern flank are likewise products of the sixteenth and seventeenth centuries, built to house the mortal remains of the same Selim and Murad, and of Mehmed III. The final substantial addition to the exterior was the construction of library, school, fountain and soup kitchen under Mahmud I, either side of 1740, analysed in this volume by Ünver Rüstem and Tülay Artan.

Subsequent campaigns have focused primarily on conservation and documentation of the historical fabric: the work undertaken by the Fossatis at the behest of Abdülmecid I in the 1840s;[50] the work of the Byzantine Institute in the mid-twentieth century;[51] and the more recent work of the Turkish Ministry of Tourism and Culture.[52] At the same time, the image of Hagia Sophia continued to change, sometimes in response to its physical structure, sometimes in a nearly independent fashion.

Ottoman officials played a decisive role in this changing image: both through the literal production of images, and through staged events open to visitors both foreign and domestic, such as the *Laylat al-Qadr* celebrations studied by Ayşe Hilâl Uğurlu in this volume. But they could not hinder the production of a great variety of alternative images. These too engaged a mix of local and foreign audiences: on the one hand, the 'folkloric' accounts exchanged by residents of Constantinople and studied by Benjamin Anderson in this volume; on the other, the (often manifestly false) accounts published in American newspapers and here treated by Robert Ousterhout.

Introduction

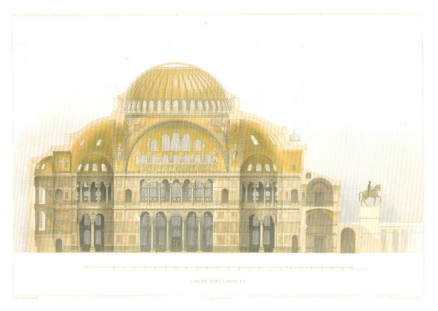

Figure I.4 Wilhelm Salzenberg, *Alt-christliche Baudenkmale von Constantinopel vom V. bis XII. Jahrhundert* (Berlin: Ernst & Korn, 1854), Bl. IX. Universitätsbibliothek Heidelberg.

The emergence of a scholarly image of Hagia Sophia was subject to the same tensions. The Ottoman state advanced its own view, as in the folio of images prepared by the Fossatis and published by the Porte in 1852, and analysed by Asli Menevse in this volume. Eugène Antoniades's three-volume *Description of Hagia Sophia* (1907–9), to date the most comprehensive monographic treatment of the building, was likewise published with imperial support. Both publications emphasise the palimpsestic, multiple temporalities of the building. They thus participate in an emerging Ottoman discourse on the meaning of historical monuments, whose impact was felt also in the provinces: for example, in the conservation of another Hagia Sophia, this one in Thessaloniki, studied in this volume by Sotirios Dimitriadis.

A very different kind of image appears in Wilhelm Salzenberg's 1854 *Early Christian Monuments of Constantinople* (Figure I.4). Here the Ottoman additions are stripped away, while the (in truth also palimpsestic and temporally multiple) Byzantine elements are treated as if part of a coherent, 'original' structure. These were the images that enjoyed the greatest circulation in Western Europe and North America, entering university libraries and serving as the basis for 'Byzantine revival' structures such as Tifereth Israel in Cleveland, here studied by Robert Nelson.

The image *of* Hagia Sophia was (and remains) inextricably tied to the images *in* Hagia Sophia. In the 1930s, the government of the newly declared Turkish Republic commissioned the Byzantine Institute to uncover and conserve the medieval mosaics, many of which had been first uncovered then re-covered by the Fossatis the century before. The success of their work convinced the Turkish Council of Ministers to transfer custody of the building, still at that time a mosque, to the Ministry of Education, and to open it as a museum.

This manoeuvre was naturally interpreted within the context of early Republican secularisation: touted by some as a sign of Turkey's modernity, condemned by others as an illegal abrogation of the *vakıf*. Perhaps it also eased UNESCO's 1985 inclusion of Hagia Sophia on the World Heritage List – although the official inscription (of the 'Historic Areas of Istanbul') includes monuments still in religious use, not least Süleymaniye.[53]

The 1934 declaration fixed, for a time, custody over the physical fabric of the building. Extensive subsequent campaigns of restoration and consolidation sought above all to protect the dome against the threat of future earthquakes. Let us call this the Hagia Sophia of the engineers. Its story reaches back to the construction of the building in the sixth century, and runs throughout the centuries, through Trdat and the Fossatis to today, in a contest between human ingenuity and the implacable natural forces of gravity and seismics.

Thus the Hagia Sophia of the engineers has always been a single building. The Hagia Sophia of the historians, by contrast, is usually split into three – church, mosque and museum. Its defining struggle was more about the building's image than its fabric. Some interventions were intentionally polarising. The American 'Free Agia Sophia Council' published photographs of the building with its minarets erased; while conservative Turkish newspapers published drawings of the building in chains.[54] Scholarly and touristic publications rarely acknowledge such polemics, but reinforce the fundamental division every time they repeat the potted history: 'Justinian's church was completed in 537 and reigned as the greatest church in Christendom until the conquest of Constantinople in 1453. Aya Sofya remained a mosque until 1935 [*sic*], when Atatürk proclaimed it a museum.'[55]

An alternative history would track the gradual divergence of the building's image from its physical structure; the process by which 'the building has accrued meanings that have nothing to do with its physical form and quite possibly very little to do with its history'.[56] Such a history would begin already with the mythologising texts of the ninth century, if not indeed those of the sixth, as we have sought to indicate above. However,

Introduction

the period that we define here as the 'long nineteenth century' witnessed something different in kind, an all-encompassing acceleration and intensification of this process. It is, namely, the period in which Hagia Sophia definitively became an image. On the one hand, the nature of physical interventions shifted, from monumental additions (annexes and outbuildings) to restoration of the existing structure. On the other, representations of the building proliferated both within and beyond the Ottoman Empire. Thus, while the present volume encompasses a period during which Hagia Sophia was 'simply' a mosque, it nevertheless describes a series of changes arguably more consequential (if far more gradual) than those of 1453 and 1934 – or indeed of 2020.

A Very Long Nineteenth Century

The restoration and internationalisation of Hagia Sophia were closely interrelated processes. As Robert Nelson explores in his monograph on the building's reception, the seeds of Hagia Sophia's canonical status in Western art history took root in the 1840s, propelled by efforts to document the renovations that were ordered by Sultan Abdülmecid and led by Gaspare Fossati.[57] This was the moment when both Europeans and Americans 'discovered' the significance of Byzantium's contributions to the history of design and gradually came to be involved with both the physical restoration and widespread media representation of Justinian's most ambitious architectural gambit.

While armchair travellers and foreign visitors to the Ottoman capital alike advocated for their own conceptions of Hagia Sophia, local actors remained intimately involved in the evolution of the building and its representation. As Gülru Necipoğlu has shown, Hagia Sophia in the nineteenth century became a repository of signifiers proclaiming the Ottoman sultans as the rightful caliphs of Sunni Islam, from the installation of large calligraphic roundels in the central prayer area to the decision to cover all figural mosaics from the Byzantine period.[58] Necipoğlu's account emphasises the continuity of the monument as a vehicle for political power, even as one reign gave way to another. The chapters included in the present volume likewise seek the audiences of Hagia Sophia beyond strictly Western observers, including not only Ottoman government officials but also the non-Muslim communities living throughout the empire. The result is an expansion in the geographic, demographic and social range of the interpreters whose voices are heard in scholarship.[59]

While the nineteenth century has long been an important subject for historians of the Ottoman Empire, largely because it serves in wider

narratives as the lead-up to the First World War and the formation of the modern Middle East, it has been less prominent in studies of Ottoman art and architecture. Studies of the built environment, in particular, have traditionally focused on the 'classical' age of Ottoman rule in the sixteenth century, especially the work of the chief architect Mimar Sinan, whose tenure spanned the reigns of three sultans. Sinan's mammoth edifices are, by design, difficult to ignore: the dome and minarets of the Selimiye Mosque in Edirne (c. 1575), for example, give the impression of a massive ship sailing through the plains of Thrace. However, in the last decade, the remarkably wide range of architectural innovation and spatial transformations in the late Ottoman Empire – including urban palaces and mosque complexes built in eclectic styles, the personal mansions of district governors giving way to civic buildings as nodes of authority in the provinces, and large-scale infrastructure projects such as fortifications and railroads – have enjoyed increased scholarly attention.[60]

This new attention to late Ottoman art and architecture benefits from a wealth of increasingly accessible documentary sources. For Hagia Sophia specifically, we now have an encyclopaedic volume prepared by Ahmed Akgündüz, Said Öztürk and Yaşar Baş that exhaustively traces the material interventions in the building during the Byzantine and Ottoman periods and almost until the present day, largely by means of the presentation of archival documents.[61] The Fossati restorations were particularly well documented, due to the state's direct investment in and stewardship of the project.[62] While several of the chapters in this volume make use of sources from the state Ottoman archives, authors also present a wider variety of under-studied materials, including contemporary academic publications in both Greek and Ottoman Turkish, mass media (newspaper articles and photographs), and the material evidence – especially inscriptions and other architectural decorations. This material has much to contribute to the growing field of nineteenth-century studies.

For the purposes of our investigation, the long nineteenth century indicated in the title of the present volume is a very long century indeed. The volume begins in 1739, with the building campaigns of Sultan Mahmud I, and concludes in 1934 with the decree establishing Hagia Sophia as a museum – an era that in fact spans almost two hundred years. We thus take on the broader historical concept of the long nineteenth century and use key moments of engagement with Hagia Sophia to push this framework to its furthest limits. The story of how one brick-and-mortar building became a present-day architectural icon thus may in turn serve as a useful barometer for how we discuss and track broader paradigms of modernity within the eastern Mediterranean.

Introduction

The notion of the century that simply could not remain confined to the span of one hundred years was popularised by the historian Eric Hobsbawm.[63] His trilogy of books covering the history of modern Europe begins with the French Revolution in 1789 and concludes with the eruption of the First World War in 1914.[64] Hobsbawm admitted he did not intend to write a history of 'the long nineteenth century' until he reached the third volume.[65] Nevertheless, a phrase originally coined for a specific study on the triumph and impacts of capitalism in north-western Europe has, since the 1990s, become a byword for the beginning of modernity itself, and applied to a much broader, even global expanse.[66]

Just as scholars have questioned the precedence afforded to the Western programme of modernity, proposing instead a constellation of 'multiple modernities', it is time to discuss the possibility of multiple long nineteenth centuries.[67] In the case of the Ottoman Empire, which officially followed the Hijri and not the Gregorian calendar, it may be appropriate to talk about a long thirteenth century (1200–1300 H/1785–1882 CE) instead. This volume thus presents an opportunity to revisit normative periodisations.

For its part, Hagia Sophia already has its own commonly accepted chronologies. To many, the modern history of the building begins with the Fossati restorations in the 1840s. As discussed above, 'foreign' architects have contributed to the upkeep of Hagia Sophia since the tenth century, if not before. Yet, in the context of the nineteenth century, the Ottoman state's decision to hire an Italian architect is understood as an act of westernisation,[68] particularly as the restorations coincided with the Tanzimat reforms, traditionally held by Ottoman historians to be the watershed moment that ushered in a new, modern socio-political project for the region.[69] Despite attempts to nuance this strict periodisation, the notion that the Ottomans had a rather delayed start to their nineteenth century – and, thus, modernity – has been difficult to shake.[70]

On this point, the field of art history has much to offer. Recent scholarship questions a definitive split between the pre-modern and modern eras in the Ottoman Empire. For example, Shirine Hamadeh suggests that the reforms under sultans Mahmud II and Abdülmecid I in the mid-1800s were anticipated by cultural developments in the eighteenth century. This was a time, Hamadeh argues, in which Ottoman commentators placed a good deal of emphasis on notions of novelty and innovation, which could be seen on the ground in the form of new public spaces staged around large monumental fountains and garden complexes along the Bosphorus.[71] In a recent volume on the art and architecture of the nineteenth-century Islamic Mediterranean, editors Margaret Graves and Alexandra Seggerman reject the binary model of rupture versus continuity in this era: 'In reality there

are no moments of true and total rupture in material practices, just as there are no traditions that continue without modification from past to present.'[72]

In addition to challenging the long-standing narratives of periodisation during the late Ottoman Empire, studies on the art and architectural production also have had to confront the related characterisation of westernisation (Tr. *Batılılaşma*) as an act of blind copying of European fashions. Both Hamadeh and, more recently, Ünver Rüstem have worked to decouple the engagement with foreign trends or audiences from the decline model inherently embedded in the concept of westernisation.[73]

Similarly, the study of Hagia Sophia exemplifies the need for a more expansive framing of modernity in the late Ottoman Empire, both chronologically and geographically. The first three chapters in this volume demonstrate that the restoration of the building under the Fossatis was not a clean break from the past, but a continuation of processes that began in the mid-eighteenth century. Ünver Rüstem shows that Mahmud I's 'Baroque' remake of Hagia Sophia anticipated the 'Neoclassical' restoration of the Fossatis. Moreover, Mahmud's interventions drew their aesthetic inspiration as much from the sixth-century sculpture of Hagia Sophia itself as they did from contemporary sculpture in Rome. Tülay Artan demonstrates that the epigraphy of Mahmud's ablution fountain already addressed an international audience, but not a European one. Rather these inscriptions spoke to Muslim 'merchants, diplomats and pilgrims' from 'Cairo, Damascus, Isfahan, Bukhara, and even Mughal India'. Finally, Emily Neumeier traces the eighteenth-century precedents of the calligraphic roundels that have become metonyms for the Fossati restorations. She finds them not only in Istanbul but also in such provincial Anatolian cities as Yozgat and Manisa. In brief, if the restoration and internationalisation of Hagia Sophia jointly constitute its entry into modernity, both processes had been under way for 100 years when Abdülmecid commissioned the work of the Fossatis.

So too was the decision taken in 1934 to 'secularise' Hagia Sophia and open it as a museum the result of a much longer development. In this volume, Asli Menevse and Ayşe Hilâl Uğurlu explore the complex balancing act that the Ottoman state and, subsequently, the Turkish Republic undertook in the aftermath of the Fossati restorations, as they sought to instrumentalise the building on both the domestic and the international stages. Robert Ousterhout examines the other side of the coin: the rampant circulation in the US press of bizarre rumours about the fate of the building as the Ottoman state collapsed and the Turkish Republic was founded. Both arenas witnessed trial secularisations in advance of 1934, ranging from the ridiculous (the 1926 rumour in the international press that Hagia

Introduction

Sophia would become a dance hall) to the profound (the introduction of Turkish-language prayer in 1932).

Coda: Hagia Sophia's Many Conversions

We offer this study of changing attitudes towards Hagia Sophia in the long nineteenth century during a similarly dynamic period in the early twenty-first century. Here too, the changes have taken place gradually, even if the summer of 2020 marked a watershed: both in terms of the conversion of Hagia Sophia, and in terms of a broader reassessment of the legacies of politically fraught monuments around the world.[74] It has become increasingly clear that 'monuments no longer signify the universal, idealized, and permanent'.[75] Ongoing debates about the status and proper stewardship of Hagia Sophia challenge the notion of monument-making as a neutral act and force us to ask whose past is monumentalised.

On 10 July 2020, the highest administrative court in Turkey annulled the 1934 transformation of Hagia Sophia into a museum, arguing that the Council of Ministers did not have the authority to abrogate a pious foundation (*vakıf*).[76] Within the hour, President Recep Tayyıp Erdoğan issued his own decree that, after almost a century of serving as a museum, Hagia Sophia would once again become a mosque.[77] The cultural and legal groundwork for these events had been laid in the previous decades, notably in the re-conversions of two buildings likewise named Hagia Sophia in İznik and Trabzon in 2011 and 2013, respectively.[78] In anticipation of the official ruling in the summer of 2020, we joined several colleagues to publish an 'Open Letter About the Status of Hagia Sophia', which garnered almost four hundred signatures from scholars of Byzantine and Ottoman studies.[79] We argued that the discussion about the status of the building – should it be a museum or a mosque? – was a distraction from the more pressing issue of its conservation and management, asking 'How can we best care for Hagia Sophia?' Only two weeks after Erdoğan's decree, the building was outfitted for Friday prayers, an event that marked its official conversion into a mosque.[80] For this ceremony, the majority of the visible Byzantine mosaics were shielded from view with sail-like fabric and the marble floors were covered with green carpeting.[81]

The material transformations of Hagia Sophia are ongoing, and this is not the place to document them. However, we do want to draw attention to one display in which the nineteenth-century history of the building is mobilised to legitimate Erdoğan's decree. During a visit in June 2022, we observed a new installation in the narthex, greeting visitors just as they enter

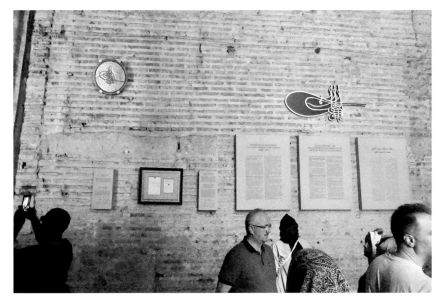

Figure I.5 Narthex of Hagia Sophia, June 2022. Photo: Emily Neumeier.

the building from the west (Figure I.5). A new set of texts and emblems hang alongside a sultanic monogram (*tuğra*) of Sultan Abdülmecid in gold mosaic, which was created to commemorate the Fossati restorations in the mid-nineteenth century and has been on view in that location for quite some time. The recent additions comprise: a gilded *tuğra* of Sultan Mehmed II (r. 1451–81); the legal text (*vakfiye*) endowing Hagia Sophia as a mosque after Mehmed II's conquest of Istanbul in 1453; and the decrees ordering the re-conversion in 2020.

These quasi-documentary displays include text panels in Turkish, English and Arabic, indicating the multiple (domestic and international) audiences that this exhibition is intended to address. The panel that describes the *tuğra* of Abdülmecid emphasises the sultan's role in commissioning Fossati to 'complete one of the restorations (*tamirler*) taking place in Hagia Sophia', placing this particular restoration effort within a wider constellation of interventions during the life of the building. To that point, situated below Abdülmecid's mosaic *tuğra* is a frame containing two documents signed by Erdoğan on 10 July 2020, which represent the Presidential decree that officially opened the building to Muslim worshipers. The format of the document on the left, on certified letterhead emblazoned with the Turkish flag and embellished with Erdoğan's arching signature, visually echoes the famous decree signed by President Mustafa Kemal Atatürk and the Turkish Council of Ministers on 24 November

Introduction

1934 proclaiming the secularisation of Hagia Sophia: a text that had been frequently reproduced in Turkish news media in the lead-up to the 2020 court decision, but is notably absent here.[82]

The new display thus constructs a genealogy for Erdoğan's decree. By recovering the 'lost mosque',[83] Erdoğan's order restores the original intent of Mehmed II's pious endowment. Abdülmecid, not Atatürk, stands as the steward who ushered Hagia Sophia into the modern era. This exhibit reveals that the nineteenth-century history of Hagia Sophia remains ideologically relevant in the current moment. Multiple interpretations of its significance are anticipated and countered on the walls of the monument itself.

The 2020 court rulings have largely established the parameters of recent public discourse, in particular the underlying assumption that Hagia Sophia can only serve one function – church, mosque or museum – at any given time. Yet this assumption belies the reality on the ground. Over the previous three decades, the function of the museum had expanded to include increasingly visible (and audible) expressions of Muslim piety. Since 1991, there was a small area dedicated to Muslim prayer in the Hünkar Kasrı accessible on the south-east side of the complex.[84] Meanwhile, the call to prayer has sounded from the minarets since 2012, and the site was served by a full-time imam since 2016.[85] Thus, in a certain sense, Hagia Sophia for some time had been functioning as both a museum *and* a mosque.

Understanding the fluidity and possible overlap between different functional categories for a monument at a given time leads us to the further observation that any one individual function is also in and of itself unstable, a phenomenon that one of us has described elsewhere as the 'mutability' of a monument.[86] During the Ottoman period, the stewardship of the site repeatedly defied common expectations of a mosque – for example, through the continuing visibility of Byzantine-era mosaics. As noted above, the mosaic of the Virgin and Child in the apse was still visible in the eighteenth century. What is more, the faces of the seraphim under the central dome of Hagia Sophia were visible for a full four centuries after 1453, and only covered during the Fossati restorations in the mid-nineteenth century. It was also during the Fossati restorations that, for the first time, architects uncovered and documented the Byzantine mosaics, then concealed them again, all by order of Sultan Abdülmecid. It is reported that, after he had seen the mosaics, Abdülmecid said 'They are beautiful, yet hide them because our religion forbids them; hide them well, but do not destroy them, for who knows what can happen [in the future]?'[87] This statement reveals the nineteenth century as a moment

when the Ottoman elites began to consider Hagia Sophia as a potentially shared sacred space – simultaneously a site of active religious worship, and a monument that documents a layered and multiple history.

The first Friday prayers in nearly a century were held in Hagia Sophia in July 2020. Ali Erbaş, as president of the national Directorate of Religious Affairs, delivered the sermon from the minbar, in which he positioned Hagia Sophia's newest conversion as the fulfilment of ideals first established by Sultan Mehmed II: 'The re-opening of Hagia Sophia for worship is the attainment of the fundamental character (*aslı vasıf*) of a holy place that welcomed the faithful for five centuries.'[88] In this statement, Erbaş calls for a return of the monument to its past as a symbol of Ottoman conquest. And yet, the 'fundamental character' of what defined a mosque space did not remain stable throughout the Ottoman period, but shifted gradually over time. By charting how Hagia Sophia presented multiple alternative images to different stakeholders simultaneously in the long nineteenth century, we hope to destabilise such a rigid, functional categorisation and reconfigure the terms of the ongoing conversations about the building.

In response to the decision to change Hagia Sophia's status in 2020, Robert Ousterhout noted that 'A church is never just a church'.[89] Looking at the full range of approaches to Hagia Sophia during the long nineteenth century that are presented in this volume, we can likewise observe that a mosque is never just a mosque.

Notes

1. Ann-Sophie Lehmann, 'Object Biography: The Life of a Concept', lecture at the Bard Graduate Center, 2 November 2021.
2. Igor Kopytoff, 'The Cultural Biography of Things: Commoditization as Process', in Arjun Appadurai (ed.), *The Social Life of Things: Commodities in Cultural Perspective* (Cambridge: Cambridge University Press, 1986), 67.
3. Lieselotte E. Saurma-Jeltsch, 'About the Agency of Things, of Objects and Artefacts', in Lieselotte E. Saurma-Jeltsch and Anja Eisenbeiß (eds), *The Power of Things and the Flow of Cultural Transformations: Art and Culture between Europe and Asia* (Berlin: Deutscher Kunstverlag, 2010), 17.
4. See Tim Edensor, 'Entangled Agencies, Material Networks, and Repair in a Building Assemblage: The Mutable Stone of St. Ann's Church, Manchester', *Transactions of the Institute of British Geographers* 36 (2011): 238–52.
5. Kopytoff, 'The Cultural Biography of Things', 67.
6. Nina Macaraig, *Çemberlitaş Hamamı in Istanbul: The Biographical Memoir of a Turkish Bath* (Edinburgh: Edinburgh University Press, 2019), 12–16.

Introduction

7. As early as 1868, a row of houses was demolished to the immediate southwest of the building to create what was commonly referred to as 'Hagia Sophia Square': Zeynep Çelik, *The Remaking of Istanbul: Portrait of an Ottoman City in the Nineteenth Century* (Berkeley: University of California Press, 1993), 114. For the 1913 demolition, see: Presidential State Ottoman Archives (T.C. Cumhurbaşbakanlığı Devlet Osmanlı Arşivleri, hereafter BOA), Istanbul, DH.UMVM 103.4 (30 Receb 1331 H/5 July 1913 CE), cited in Ahmed Akgündüz, Said Öztürk and Yaşar Baş, *Üç Devirde bir Mabed: Ayasofya* (Istanbul: Osmanlı Araştırmaları Vakfı Yayınları, 2005), 650–1; Çelik, *The Remaking of Istanbul*, 114; and Robert S. Nelson, *Hagia Sophia, 1850–1950: Holy Wisdom Modern Monument* (Chicago: University of Chicago Press, 2004), 104.
8. Akgündüz et al., *Üç Devirde bir Mabed: Ayasofya*, 651.
9. Respectively: BOA, Istanbul, TS.MA.e 279/14 (22 Muharrem 1292 H/28 February 1875 CE); and İ.EV. 6/37 (9 Zilkade 1311 H/14 May 1894 CE).
10. Cem Behar, *A Neighborhood in Ottoman Istanbul: Fruit Vendors and Civil Servants in the Kasap İlyas Mahalle* (Albany: State University of New York Press, 2003), 4–6.
11. Akgündüz et al., *Üç Devirde bir Mabed: Ayasofya*, 651.
12. Gaspare Fossati, *Aya Sofia, Constantinople: As Recently Restored by Order of H.M. the Sultan Abdul-Medjid* (London: R. & C. Colnagni & Co., 1852), 6.
13. Bruce Trigger, 'Monumental Architecture: A Thermodynamic Explanation of Symbolic Behaviour', *World Archaeology* 22 (1990): 121.
14. As Edhem Eldem argues, these distinctions in Hagia Sophia's function become even sharper during political crises, like the lead-up to the First World War: 'Ayasofya: Kilise, Cami, Abide, Müze, Simge', *Toplumsal Tarih* 254 (February 2015), 85.
15. Turkish literature on Ottoman architecture also commonly uses the word *külliye* to describe a mosque complex, but, as Gülru Necipoğlu points out, this term was coined in the early twentieth century: *The Age of Sinan: Architectural Culture in the Ottoman Empire* (Princeton: Princeton University Press, 2005), 71. Also see Zeynep Tarım Ertuğ, 'İmaret', in *Türkiye Diyanet Vakfı İslâm Ansiklopedisi*, vol. 22 (Istanbul: Türkiye Diyanet Vakfı, 2000), 219; and Osman Ergin, *Türk Şehirlerinde İmaret Sistemi* (Istanbul: Cumhuriyet Matbaası, 1939).
16. Both terms were deployed in early twentieth-century Istanbul for initial efforts in historical preservation, such as the 1912 law for the preservation of monuments (Muhafaza-i Abidat Hakkında Nizamname) and the 1915 Council for the Preservation of Monuments (Asar-i Atika Encümeni): Nur Altınyıldız, 'The Architectural Heritage of Istanbul and the Ideology of Preservation', *Muqarnas* 24 (2007): 286.
17. See Françoise Choay, *L'allégoire du patrimoine* (Paris: Éditions du Seuil, 1992); English translation by Lauren M. O'Connell, *The Invention of the Historic Monument* (Cambridge: Cambridge University Press, 2001).

18. Alois Riegl, trans. Kurt W. Forster and Diane Ghirardo, 'The Modern Cult of Monuments: Its Character and its Origin', *Oppositions* 25 (1982, originally pub. 1903): 34–5.
19. Aldo Rossi, trans. Diane Ghirardo and Joan Ockman, *The Architecture of the City* (Cambridge, MA: MIT Press, 1982), 29.
20. Mrinalini Rajagopalan, *Building Histories: The Archival and Affective Lives of Five Monuments in Modern Delhi* (Chicago: University of Chicago Press, 2016); and Macaraig, *Çemberlitaş Hamamı in Istanbul*.
21. For translations of the key primary sources, see: *Chronicon Paschale, 284–628 AD*, trans. Michael and Mary Whitby (Liverpool: Liverpool University Press, 1989), 34–5; Socrates, *Histoire Ecclésiastique, Livres II–III*, trans. Pierre Périchon and Pierre Maraval (Paris: Les Éditions du Cerf, 2005), 65.
22. *Kontakia of Romanos, Byzantine Melode*, trans. Marjorie Carpenter (Columbia: University of Missouri Press, 1973), II.246.
23. *Chronicon Paschale*, 59; Palladius, *Dialogue on the Life of St. John Chrysostom*, trans. Robert T. Meyer (New York: Newman Press, 1985), 67–9.
24. For the excavations, see Alfons Maria Schneider, *Die Grabung im Westhof der Sophienkirche zu Istanbul* (Berlin: Deutsches Archäologisches Institut, 1941). For a synthetic treatment of this (second) Hagia Sophia, see Thomas F. Mathews, *The Early Churches of Constantinople: Architecture and Liturgy* (University Park: Pennsylvania State University Press, 1971), 11–19.
25. Procopius, *Buildings*, trans. H. B. Dewing (Cambridge, MA: Harvard University Press, 1954), 11.
26. *Kontakia of Romanos*, 247.
27. Procopius, *Buildings*, 13. For synthetic treatments in English of Justinian's Hagia Sophia, see: Robert G. Ousterhout, *Eastern Medieval Architecture: The Building Traditions of Byzantium and Neighboring Lands* (Oxford: Oxford University Press, 2019), 199–216; Rowland J. Mainstone, *Hagia Sophia: Architecture, Structure and Liturgy of Justinian's Great Church* (New York: Thames & Hudson, 1988).
28. Procopius, *Buildings*, 21.
29. Richard Krautheimer, *Early Christian and Byzantine Architecture* (New Haven: Yale University Press, 1986), 210.
30. Agathias, *The Histories*, trans. Joseph D. Frendo (Berlin: de Gruyter, 1975), 144.
31. Natalia B. Teteriatnikov, *Justinianic Mosaics of Hagia Sophia and Their Aftermath* (Washington, DC: Dumbarton Oaks Research Library and Collection, 2017).
32. The text of this verse epigram is preserved in its entirety as the first poem in the 'Palatine Anthology': see *The Greek Anthology*, trans. W. R. Paton (London: William Heinemann, 1927), I.3. For the remaining fragments, see Cyril Mango, *Materials for the Study of the Mosaics of St. Sophia at Istanbul* (Washington, DC: Dumbarton Oaks Research Library and Collection, 1962), 82.

Introduction

33. Robin Cormack and Ernest J. W. Hawkins, 'The Mosaics of St. Sophia at Istanbul: The Rooms above the Southwest Vestibule and Ramp', *Dumbarton Oaks Papers* 31 (1977): 175–251, here at 202–12.
34. The surest guide to these later mosaics remains Mango, *Materials*.
35. Kateryna Kovalchuk, 'The Founder as a Saint: The Image of Justinian I in the Great Church of St. Sophia', *Byzantion* 77 (2007): 205–38.
36. *Accounts of Medieval Constantinople: The* Patria, trans. Albrecht Berger (Cambridge, MA: Harvard University Press, 2013), 247.
37. *The* Universal History *of Step'anos Tarōnec'i*, trans. Tim Greenwood (Oxford: Oxford University Press, 2017), 289.
38. Timothy S. Miller, 'The History of John Cantacuzenus (Book IV): Text, Translation, and Commentary' (Ph.D. diss., The Catholic University of America, 1975), 167.
39. *The Russian Primary Chronicle: Laurentian Text*, trans. Samuel Hazzard Cross and Olgerd P. Scherbowitz-Wetzor (Cambridge, MA: Medieval Academy of America, 1953), 111.
40. Shams al-Din al-Dimashqi, as quoted by Nadia Maria El Cheikh, *Byzantium Viewed by the Arabs* (Cambridge, MA: Harvard University Press, 2004), 208.
41. Elisabeth Svärdström, 'Runorna I Hagia Sofia', *Fornvännen* 65 (1970): 247–9.
42. Robert of Clari, *The Conquest of Constantinople*, trans. Edgar Holmes McNeal (New York: Norton, 1969), 115–17.
43. George Pachymeres, *Relations Historiques*, trans. Vitalien Laurent (Paris: Belles Lettres, 1984), I.232; here as translated by Alice-Mary Talbot, 'The Restoration of Constantinople under Michael VIII', *Dumbarton Oaks Papers* 47 (1993): 243–61, at 247.
44. Doukas, *Decline and Fall of Byzantium to the Ottoman Turks*, trans. Harry J. Magoulias (Detroit: Wayne State University, 1975), 231–2; Tursun Beg, *The History of Mehmed the Conqueror*, trans. Halil Inalcik and Rhoads Murphey (Minneapolis: Bibliotheca Islamica, 1978), 37; Nestor-Iskander, *The Tale of Constantinople*, trans. Walter K. Hanak and Marios Philippides (New Rochelle: Aristide D. Caratzas, 1998), 93.
45. The 'Lament for Constantinople', trans. Eleni Kefala, *The Conquered: Byzantium and America on the Cusp of Modernity* (Washington, DC: Dumbarton Oaks Library and Collection, 2020), 37.
46. Topkapı Palace, Istanbul, MS GI 6; Julian Raby, 'Mehmed the Conqueror's Greek Scriptorium', *Dumbarton Oaks Papers* 37 (1983): 15–34, here at 19.
47. Stephane Yerasimos, *La fondation de Constantinople et de Sainte-Sophie dans les traditions turques* (Paris: Institut Français d'Études Anatoliennes d'Istanbul, 1990).
48. Gülru Necipoğlu, 'The Life of an Imperial Monument: Hagia Sophia after Byzantium', in Robert S. Mark and Ahmet Ş. Çakmak, *Hagia Sophia: From the Age of Justinian to the Present* (Cambridge: Cambridge University Press, 1992), 195–225, here at 219.

49. Akgündüz et al., *Üç Devirde bir Mabed: Ayasofya*, 235.
50. Sabine Schlüter, *Gaspare Fossatis Restaurierung der Hagia Sophia in Istanbul 1847–49* (Bern: Peter Lang, 1999).
51. Nelson, *Hagia Sophia*, 155–86.
52. Hasan Fırat Diker, Mine Esmer and Mesut Dural (eds), *Proceedings of the International Hagia Sophia Symposium, 24–25 September 2020* (Istanbul: Fatih Sultan Mehmet Vakıf University Press, 2020).
53. 'Historic Areas of Istanbul', *UNESCO*, https://whc.unesco.org/en/list/356/ (accessed 14 June 2022).
54. Robert G. Ousterhout, 'From Hagia Sophia to Ayasofya: Architecture and the Persistence of Memory', *İstanbul Araştırmaları Yıllığı* 2 (2013): 1–8; Akgündüz et al., *Üç Devirde bir Mabed: Ayasofya*, 768.
55. Tom Brosnahan, Pat Yale and Richard Plunkett, *Turkey* (Hawthorn: Lonely Planet, 2001), 135.
56. Ousterhout, 'From Hagia Sophia to Ayasofya', 7.
57. Nelson, *Hagia Sophia, 1850–1950*, xviii.
58. Necipoğlu, 'The Life of an Imperial Monument', 220–5.
59. This effort is inspired by and contributes to a renewed project of decolonising art history. For a broad range of approaches to this question, see Catherine Grant and Dorothy Price, 'Decolonizing Art History', *Art History* 43.1 (2020): 8–66.
60. An important touchstone for these works is Çelik, *The Remaking of Istanbul* (1993). More recent scholarship includes Ahmet Ersoy, *Architecture and the Late Ottoman Historical Imaginary: Reconfiguring the Architectural Past in a Modernizing Empire* (Burlington, VT: Ashgate, 2015); Deniz Türker, 'Ottoman Victoriana: Nineteenth-Century Sultans and the Making of a Palace, 1795–1909' (Ph.D. diss., Harvard University, 2016); Emily Neumeier, 'The Architectural Transformation of the Ottoman Provinces under Tepedelenli Ali Pasha, 1788–1822' (Ph.D. diss., University of Pennsylvania, 2016); and Peter Christensen, *Germany and the Ottoman Railways: Art, Empire, and Infrastructure* (New Haven: Yale University Press, 2017).
61. Akgündüz et al., *Üç Devirde bir Mabed: Ayasofya*. Also see Hasan Fırat Diker, *Ayasofya ve Onarımları* (Istanbul: Fatih Sultan Mehmet Vakıf Üniversitesi Yayınları, 2016).
62. Erdem Yücel, 'Ayasofya Onarımları ve Vakıf Arşivinde Bulunan Bazı Belgeler', *Vakıflar Dergisi* 10 (1973): 219–28; and Sema Doğan, 'Sultan Abdülmecid Döneminde İstanbul-Ayasofya Camii'ndeki Onarımlar ve Çalışmaları Aktaran Belgeler', *Bilig* 49 (2009): 1–34.
63. Though the concept of a 'long' century had already been suggested by Fernand Braudel in his influential study on the sixteenth-century Mediterranean: *The Mediterranean and the Mediterranean World in the Age of Philip II*, trans. Siân Reynolds, vol. 1 (New York: Harper & Row, 1972, originally published in French in 1949), 326.

64. Eric Hobsbawm, *The Age of Revolution: Europe, 1789–1848* (London: Phoenix, 1962); *The Age of Capital: 1848–1875* (New York: Scribner, 1975); and *The Age of Empire, 1875–1914* (New York: Pantheon, 1987).
65. Hobsbawm, *The Age of Empire*, 8.
66. Peter Stearns et al., *World Civilizations: The Global Experience* (Longman, NJ: Pearson, 2011, 6th edn), 630.
67. S. N. Eisenstadt, 'Multiple Modernities', *Daedalus* 129.1 (2000): 2–3.
68. Nelson, *Hagia Sophia, 1850–1950*, 29–33; Necipoğlu, 'The Life of an Imperial Monument', 221; Hasan Fırat Diker, 'Belgeler Işığında Ayasofya'nın Geçirdiği Onarımlar' (Ph.D. diss., Mimar Sinan Güzel Sanatlar Üniversitesi, 2010), 82.
69. Şükrü Hanioğlu, *A Brief History of the Late Ottoman Empire* (Princeton: Princeton University, 2008), 72–5; Carter Vaughn Findley, 'The Tanzimat', in Reşat Kasaba (ed.), *The Cambridge History of Turkey, Volume 4: Turkey in the Modern World* (Cambridge: Cambridge University, 2008), 13–14.
70. Butrus Abu-Manneh, 'The Islamic Roots of the Gülhane Rescript', *Die Welt des Islams* 34.2 (1994): 174–5; Donald Quataert, *The Ottoman Empire, 1700–1922* (Cambridge: Cambridge University Press, 2000), 66.
71. Shirine Hamadeh, *The City's Pleasures: Istanbul in the Eighteenth Century* (Seattle: University of Washington Press, 2008), 239.
72. Margaret Graves and Alex Seggerman, 'Introduction: Making Modernity in the Islamic Mediterranean', in Margaret Graves and Alex Seggerman (eds), *Making Modernity in the Islamic Mediterranean* (Bloomington, IN: Indiana University Press, 2022), 7.
73. Ünver Rüstem, *Ottoman Baroque: The Architectural Refashioning of Eighteenth-Century Istanbul* (Princeton: Princeton University Press, 2019), 274–5.
74. Nicole Emser Marcel, 'Temporary Iconoclasms', *Monument Biography* podcast, 9 December 2021, https://www.stellaonline.art/monument-bio/epis ode-4 (accessed 27 July 2023); Laurel Wamsley, 'Judge Orders Richmond's Robert E. Lee Statue Can Be Removed', *NPR*, 27 October 2020, https://www .npr.org/sections/live-updates-protests-for-racialjustice/2020/10/27/925407 770/judge-orders-richmonds-robert-e-lee-statue can-be-removed (accessed 27 July 2023).
75. Paul M. Farber, 'How to Build a Monument', in Paul M. Farber and Ken Lum (eds), *Monument Lab: Creative Speculations for Philadelphia* (Philadelphia: Temple University Press, 2016), 6.
76. For the text of the decision, accompanied by an English translation, see Council of State (Turkey), 'Court Decision Annulling Cabinet Decision of 1934 Converting Hagia Sophia into a Mosque', 28 July 2020, http://beta.sha riasource.com/documents/3778 (accessed 27 July 2023).
77. Carlotta Gall, 'Erdogan Signs Decree Allowing Hagia Sophia to Be Used as a Mosque Again', *The New York Times*, 10 July 2020, https://www.nytimes

.com/2020/07/10/world/europe/hagia-sophia-erdogan.html (accessed 27 July 2023).
78. Tuğba Tanyeri-Erdemir, 'Remains of the Day: Converted Anatolian Churches', in Ivana Jevtic and Suzan Yalman (eds), Spolia *Reincarnated: Afterlives of Objects, Materials, and Spaces in Anatolia* (Istanbul: ANAMED, 2018), 89–90.
79. 'An Open Letter About the Status of Hagia Sophia', *Medium*, 30 June 2020, https://medium.com/@hagiasophia/an-enletter-about-the-status-of-hagia-sophia-bea9afd1a62f (accessed 27 July 2023).
80. Kaan Bozdoğan and Murat Paksoy, 'Ayasofya-i Kebir Cami-i Şerifi'nde 86 Yıl Sonra İlk Hutbe Okundu', *Anadolu Ajansi*, 24 July 2020, https://www.aa.com.tr/tr/ayasofya-camii/ayasofya-i-kebir-cami-i-serifinde-86-yil-sonra-ilk-hutbe-okundu/1921074 (accessed 27 July 2023).
81. For preliminary remarks on the architectural interventions since July 2020, see Berin F. Gür, 'Political Misuse of Hagia Sophia as the Lost Object of the Istanbul Conquest', *Space and Culture* 26 (2023): 11–16.
82. Ceren Katıpoğlu and Çağla Caner-Yüksel, 'Hagia Sophia "Museum": A Humanist Project of the Turkish Republic', in Cana Bilsel et al. (eds), *Constructing Cultural Identity, Representing Social Power* (Pisa: Plus-Pisa University Press, 2010), 214–15.
83. Gür, 'Political Misuse of Hagia Sophia', 8.
84. Pinar Tremblay, 'Is New Imam Answered Prayer or Impending Doom for Hagia Sophia?', *Al-Monitor*, 27 October 2016, https://www.al-monitor.com/originals/2016/10/turkey-greece-hagia-sophia-gets-its-own-imam.html (accessed 27 July 2023).
85. Kübra Sönmezışık, 'Ayasofya'da Ezan Sesleri Yükseliyor', *Yeni Şafak*, 18 November 2012, https://www.yenisafak.com/yenisafakpazar/ayasofyada-ezan-sesleri-yukseliyor-424447 (accessed 27 July 2023).
86. Emily Neumeier and Shannon Steiner, '"A Church Is Never Just a Church": Hagia Sophia and the Mutability of Monuments', *Journal of the Ottoman and Turkish Studies Association* 8.1 (2021): 216.
87. Mango, *Materials for the Study of the Mosaics of St. Sophia at Istanbul*, 140.
88. Bozdoğan and Paksoy, 'Ayasofya-i Kebir Cami-i Şerifi'nde 86 Yıl Sonra İlk Hutbe Okundu'.
89. Anthony Kaldellis, Interview with Robert Ousterhout, 'The Many Identities of Hagia Sophia, Past and Present', *Byzantium & Friends* podcast, 30 July 2020, https://byzantiumandfriends.podbean.com/e/29-the-many-identities-of-hagia-sophia-past-and-present-with-bob-ousterhout/ (accessed 27 July 2023).

Chapter 1

Hagia Sophia's Second Conversion: The Building Campaign of Mahmud I and the Transformation from Mosque to Complex (1739–43)

Ünver Rüstem

From cathedral to mosque to museum – and recently to mosque again – Hagia Sophia is as famous for its conversions as it is for its extraordinary architecture. But one key stage in the monument's alteration history has tended to escape notice, overshadowed – understandably enough – by the more dramatic changes that preceded and followed it. Between 1739 and 1743, more than a hundred years before the Fossati brothers came along, Sultan Mahmud I (r. 1730–54) ordered a thoroughgoing renovation of Hagia Sophia that provided it with a library, primary school, ablution fountain and public soup kitchen. These additions turned what was already the Ottoman Empire's principal mosque into a true *külliye*, or religious complex, thereby bringing the monument more fully into the Ottoman fold. Besides their importance to Hagia Sophia itself, the buildings that Mahmud commissioned document a remarkable shift in Ottoman visual culture, capturing the very moment when a new architectural style – the Ottoman Baroque – came into being and forever changed the look of Istanbul. This chapter, which expands on my earlier work on the Ottoman Baroque, explores the political timing and purpose of Mahmud's Hagia Sophia campaign and its relationship to broader artistic developments of the eighteenth century. In particular, I shall discuss why the erstwhile church provided such a meaningful context for the new Baroque manner, whose locational and aesthetic association with the site gave it a crucial foothold during its emergence as a favoured state style.

The Making of a Complex

Mahmud's expansion of Hagia Sophia has left us an ambitious and varied group of works spread across the site.[1] The earliest in the sequence, constructed between 1739 and 1740, is the library, a substantial stone

Ünver Rüstem

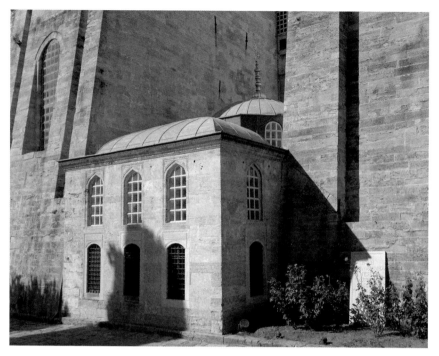

Figure 1.1 Hagia Sophia Library, 1739–40, exterior. Photo: author.

building in its own right that is squeezed between two massive buttresses – themselves sixteenth-century Ottoman additions – on Hagia Sophia's south-west side (Figure 1.1).[2] Entered from within the right aisle of the former church, the library is the only one of the works to stand partially inside the monument, where it appears as an irregular single-storey structure clad in marble and pierced by arches containing ornate scrollwork bronze grilles (Figure 1.2). Five of the arches front a rectangular room that was originally used for reading, recitation and teaching, its flat roof crowned by a parapet of geometric interlace (Figure 1.3). To the right of this arcade and set back from it, the remaining arches form a three-bay vestibule that is covered with an ogival vault and contains the library's main entrance. From here, one can access the adjacent reading room as well as a corridor that connects to the rest of the library, which lies beyond Hagia Sophia's original footprint on the other side of a small courtyard. This, the library proper, forms a kiosk that is divided by an arcade into a domed square space housing wooden bookcases and a vaulted rectangular reading area whose raised floor would once have been furnished with low sofas (Figure 1.4).[3] Their contents now removed, the cases originally held some 4,400 choice works donated by Mahmud and members of his elite.[4]

Figure 1.2 Hagia Sophia Library, entrance façade in the basilica's right aisle. Photo: author.

Figure 1.3 Hagia Sophia Library, interior of the reading and recitation room looking towards the sultan's *tuğra*. Photo: author.

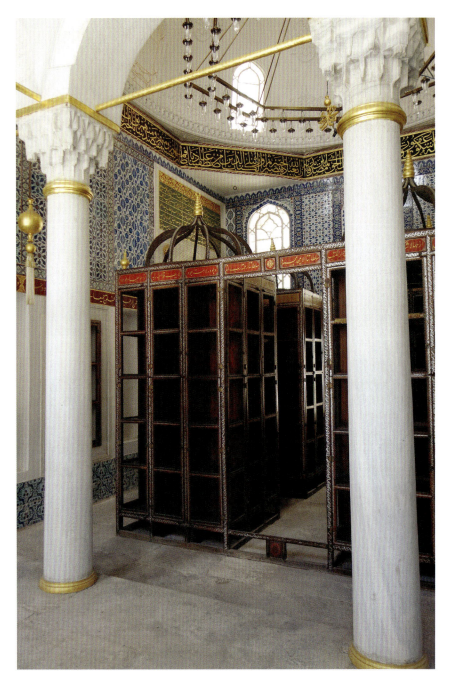

Figure 1.4 Hagia Sophia Library, interior of the kiosk looking from the vaulted reading area towards the bookcases of the domed main space, with the over-door inscription panel visible in the background. Photo: author.

Hagia Sophia's Second Conversion

Figure 1.5 Hagia Sophia Primary School, 1740–1, with the ablution fountain partially visible on the left. Photo: author.

All of the library's sections remain richly decorated, with polychrome tilework being the main ornamental feature. Most of the tiles are re-used İznik and (to a much lesser extent) Kütahya wares of the sixteenth and seventeenth centuries, though the scheme also includes a good amount of revivalist eighteenth-century Tekfur Sarayı production and even, in the corridor, some European (probably Italian) faience of the same period.[5]

After the library came the primary school and ablution fountain, both of which are dated 1740–1 (AH 1153) and situated in the western corner of Hagia Sophia's precinct, not far from its main entrance. The first of these is a sizable but simple rectangular building topped by a large dome and constructed of alternating courses of brick and stone (Figure 1.5). Arranged on two levels, its multiple rooms – whose original users included forty poor boys provided with daily stipends – have been much changed over the years and contain no trace of their original decoration.[6] The ablution fountain is an altogether more splendid affair, with a richly carved marble tank that is surmounted by elaborate bronze grillwork and surrounded by an octagonal marble arcade that carries a domical roof with wide eaves (Figure 1.6).[7]

Last to be built was the *ʿimāret*, or public soup kitchen, a long multi-domed edifice along the north-east edge of the precinct that is preceded by a gateway bordering the square in front of the entrance into the Topkapı Palace (Figure 1.7).[8] This final addition is not mentioned in the 1740

31

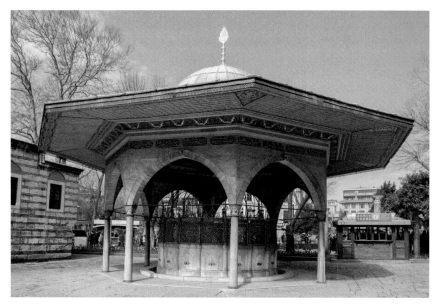

Figure 1.6 Hagia Sophia ablution fountain, 1740–1. Photo courtesy of Samuel Magal.

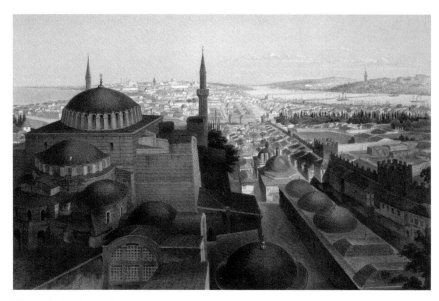

Figure 1.7 View to the north-west taken from the north-east minaret of Hagia Sophia, with the ⁽ᶜ⁾*imāret* extending diagonally from the bottom right corner. Gaspare Fossati, *Aya Sofia, Constantinople: As Recently Restored by Order of H.M. the Sultan Abdul-Medjid* (London: R. & C. Colnagni & Co., 1852), plate 21. Lithograph. Library of Congress, Washington, DC.

waqfiyya (endowment deed) pertaining to the other works and may have been conceived after them, which would mean that Mahmud's plans for the complex grew in scale as the campaign progressed.[9] At any rate, construction of the ʿ*imāret* began in the summer of 1742 and was completed by early 1743. Used until recently as a carpet museum, the main building is of brick and stone and comprises three contiguous sections arranged in a line running in a north-westerly direction; the first, covered by three successive domes, was once a dining hall, while the second and third, each with a single large dome, served as the kitchen and bakery respectively (Figure 1.8). Marking the entrance to the dining hall – and providing the ʿ*imāret* with its principal façade – is a vaulted vestibule with a marble door and a portico resting on four marble columns (Figure 1.9). Parallel with the main building and separated from it by a narrow courtyard are a series of storerooms and other functional annexes that incorporate pre-existing Byzantine structures, including Hagia Sophia's original circular treasury. This adapted treasury and the ʿ*imāret*'s portico overlook a small forecourt that is accessed by the aforementioned gate, which rises high from the eastern tip of Hagia Sophia's perimeter (Figure 1.10). With its sumptuously carved marble surfaces and vaulted wide-eaved vaulted roof, this gate constitutes arguably the most eye-catching – and certainly the most distinctive – element of Mahmud's entire scheme, as will be discussed below. A smaller and plainer secondary gate pierces the perimeter at the other end of the ʿ*imāret* near the kitchen.

Although largely passed over in the historiography, the period in which these structures were created was one of far-reaching domestic and international consequence for the Ottoman Empire. Mahmud had come to the throne in 1730 with the toppling of his better-known predecessor and uncle, Ahmed III (r. 1703–30, d. 1736), who was brought down against the backdrop of an unpopular war with Iran. Having executed the rebels to whom he owed his rise, Mahmud soon proved himself an able and, for the most part, popular sultan.[10] His greatest test came when the empire was plunged into war with not one but two mighty foes, the Russians, who initiated the conflict in 1736 with the aim of conquering the Crimea, and the Habsburgs, who joined the Russian side a year later. Outnumbered though they initially were, the Ottoman troops managed by 1739 to bring the war to a favourable conclusion, even taking back Belgrade and other Balkan territories that had been lost to the Habsburgs two decades earlier.[11] These events reflected well on Mahmud, who, as ruler, could claim credit for his army's successes despite having never fought in battle himself.

It is, I would argue, no coincidence that Mahmud began his Hagia Sophia renovation around the time that this conflict was drawing to a

Figure 1.8 Hagia Sophia ʿ*İmāret*, 1742–3, interior of the dining hall looking towards the service windows of the adjacent kitchen. Photo: author.

positive end for the Ottomans. The first of his commissions, the library, was opened on 21 April 1740, about half a year after the signing of the Treaties of Belgrade and Niš with Austria and Russia respectively (18 September 1739 and 3 October 1739). The documentary record shows that the building was already in the works before peace was declared,[12] but

Figure 1.9 Hagia Sophia ʿİmāret, exterior of the main building looking towards the principal entrance of the dining hall, with the domed kitchen and its separate entrance visible in the background. © Saiko3p/Dreamstime.com.

it had been apparent for some time that the Ottomans had the upper hand against the Habsburgs, so that the atmosphere in which the project was conceived was surely one of optimism and anticipated triumph. Indeed, the accompanying *waqfiyya*, which is dated 15 Shawwal 1152 (14 January 1740), refers to Mahmud as 'father of conquests and holy wars',[13] while a long versified over-door inscription in the library kiosk itself is still more explicit in tying the project to the recent victory (Figures 1.4, 1.12):

> God give strength to the possessor of kingship and lord of Muslims [Sultan Mahmud],
> Who loves knowledge and nurtures all who have intellect and cognisance.
>
> In battle, his victorious army is like the [irresistible] Flood of ʿArim,
> His drawn sword is sharp and sparkles like the stars.
>
> He fought and trounced the infidels until they cried for mercy,
> Imploring peace while wrapped in shame.
>
> He raised good works in sincere thanks for divine grace
> After God's help in destroying the idolators . . .[14]

Evidently composed and carved subsequent to the 1739 treaties, the inscription frames the building as a direct consequence of – and thus

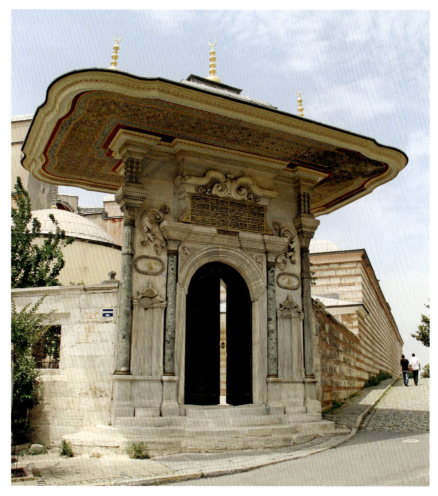

Figure 1.10 Hagia Sophia ʿImāret, principal gate, with the main building visible to its right and the re-purposed Byzantine treasury to its left. Photo: author.

monument to – the Ottoman triumph, a simplified explanation that fudges the chronology yet aptly reflects the project's circumstances. Only educated users of the library would have had access to this text, which, in a further indication of the erudite audience for which it was intended, is written in Arabic rather than the far more typical Ottoman Turkish.[15] Nevertheless, the poem's key message – that Mahmud had earned the right to celebrate his victory in holy war – would have been popularly disseminated through sermons delivered in the empire's mosques, including, of course, Hagia Sophia itself, where the preachers who praised the sultan could point to his renovations as physical proofs of his merits.[16] No site was better suited

to marking this positive juncture than Hagia Sophia, a monument long and inextricably associated with Ottoman conquest. As the late Yavuz Sezer noted in his magisterial study of eighteenth-century Ottoman libraries, the official court chronicler Subhi's (d. 1769) description of the project tells us that, after some initial indecision on the matter, the sultan himself chose the location of the library 'in accordance with divine inspiration', a highly unusual detail that bespeaks 'Hagia Sophia's sanctity and its symbolic weight in Ottoman consciousness'.[17]

For Mahmud, moreover, the renovation presented an opportunity to intensify his already considerable sponsorship of the arts. While little remembered in modern art-historical narratives, Mahmud was in his own time a renowned patron, noted in the contemporary sources for his love of jewelled objects and architecture.[18] His first major undertaking, completed in 1732, had been as a leading figure in the installation of some forty new drinking fountains – each commissioned by a different member of the ruling and bureaucratic classes – throughout the Istanbul suburbs of Galata and Pera. Designed as a monumental domed cubic structure with elaborately carved marble façades, the sultan's own fountain at Tophane made a fitting centrepiece to this comprehensive new water network, which gave its name to the district of Taksim (*taksīm*, '[water] distribution').[19] Such extensive building activity continued a trend that had started in 1703 with the reign of Ahmed III, who, having himself ascended the throne through revolution, moved the Ottoman seat of power back to Istanbul following a fifty-year period in which the court had been based in Edirne, the empire's second city. Its fortunes thus restored, Istanbul flourished with new architectural works that made ample use of rich surface decoration, in contrast to the more restrained aesthetic of the Ottoman classical period (roughly the sixteenth century).[20] This ornamental approach, which, like other aspects of Ahmed's reign, is often discussed under the problematic rubric of the 'Tulip Era',[21] put a novel spin on a mostly traditional stock of Ottoman geometric, vegetal and floral motifs, not only employing them with a new plenitude, but also infusing them with a number of borrowings from the European, Iranian and even Mughal repertoires.[22] This 'Tulip Era' manner continued into the first decade of Mahmud's reign, as can be seen from its presence on the various fountains of the Taksim waterworks project, which had itself been initiated by Ahmed towards the end of his sultanate.[23]

At Hagia Sophia, Mahmud was able to assert his patronage in more independent terms, signalling his firm hold on power after ten years of rule and a successfully fought war. His predecessor, Ahmed, had shown relatively little interest in religious architecture, a matter he left mainly

to his mother and grandees while he lavished his attention on secular and palatial buildings.[24] Mahmud's Hagia Sophia campaign thus saw a deliberate reassertion of the sultan's own primacy in the sponsorship of pious works. He had already made changes to the mosque in 1733–4, when he remodelled the royal prayer loge and added a pavilion on its outside, but this earlier foray followed safely in the footsteps of several other sultans – Ahmed among them – who had augmented the loge since its construction in the late sixteenth century.[25] Mahmud's later interventions, by contrast, represented an altogether more individual and assertive approach, one that significantly added to Hagia Sophia's existing makeup rather than just altering it. Indeed, in transforming the mosque into a complex, Mahmud was casting himself as a preeminent sultan entitled to create a great religious foundation, a point to which I shall return. Hagia Sophia made a savvy choice for such self-aggrandisement, its physical and symbolic centrality in the Ottoman capital ensuring that Mahmud's works would be noticed and appreciated by their diverse beneficiaries, who ran the gamut from learned members of the ulema to the urban poor. As the most 'public-facing' of Mahmud's additions and the only one accessed directly by its own entrance, the ʿimāret announced the sultan's magnanimity with particular vigour, all the more so because its construction entailed the purchase and clearing of a number of houses encroaching on Hagia Sophia's precinct.[26]

Earlier sultans had, to be sure, already done much to claim the monument for themselves and the Ottoman dynasty, whether by adding minarets to it or, as we have just seen, renovating its royal loge.[27] One of the most conspicuous signs of the church's conversion was the progressive obscuring of its figural mosaics, and it is significant in light of the library inscription's reference to idolaters that the last visible patches of imagery seem to have been covered up during Mahmud's reign.[28] The idea of expanding Hagia Sophia into a complex was likewise not without precedent. Just to the north, Mehmed the Conqueror (r. 1444–6, 1451–81) – under whom the church became a mosque – had established a dependent madrasa, which was rebuilt in the nineteenth century and destroyed in the 1930s.[29] And beginning with the mausoleum of Selim II (r. 1566–74) – another sultan who made the site a focus of his patronage – a series of dynastic tombs had sprung up in the precinct's southern corner.[30] Even with these existing layers of Ottomanisation, however, the monument had lacked the multi-functional character and charitable attributes of a sultanic mosque complex proper until Mahmud made good this shortcoming. His additions endowed Hagia Sophia with valuable facilities pertaining not only to worship and study, but also to his subjects' very sustenance in the form of

the ʿimāret, where staff of the complex, madrasa students and the poor and hungry could eat gratis every day.[31]

The ʿimāret's versified overdoor inscriptions, composed by the poet Niʿmetullah Efendi (d. 1773), sum up the collective feat represented by these new dependencies. The text above the secondary gate lists all four of Mahmud's additions and treats the ʿimāret as their culmination,[32] an idea echoed by the inscription over the door into the dining hall, which identifies Mahmud as having 'completed the Conqueror's work' and concludes by declaring that 'Ayasofya has become truly flourishing with this ʿimāret'.[33] The most conspicuous of the inscriptions – that surmounting the ʿimāret's main gate – is also the most fulsome, stating of Mahmud that 'none of his predecessors since the Conqueror has accomplished such glorious beneficence' (Figure 1.14).[34] Exaggerated as this claim may seem, it is arguably accurate as far as Hagia Sophia is concerned.

Novelty and the Aesthetics of Conversion

The impact of Mahmud's Hagia Sophia additions was not limited to the services they offered. Except for the primary school, which is a fittingly workaday building, these good works were intended also to be beautiful ones, their magnificence giving impressive visual and material expression to the sultan's achievement in converting the mosque into a complex.[35] Novelty would emerge as a key tool in the endeavour to win admiration for Mahmud's munificence.

The library, with its crisply carved marble arches and fine grillwork, makes an attractive and discreet appearance in Hagia Sophia's right aisle, preparing the user-viewer for the impressive faience filling its interior (Figures 1.2–1.4). These spoliated and revivalist tiles harmonise well with the structure's *muqarnas* (stalactite) column capitals and geometric openwork balustrade, which follow longstanding Ottoman tradition, but the end result is no mere rehashing of earlier models. Libraries as a self-sufficient building type were a fairly recent introduction to the Ottoman architectural canon, the earliest established in about 1678, and only from the 1730s onward were library structures incorporated into mosque complexes.[36] Mahmud played a prominent role in this regard: besides the Hagia Sophia Library, which was the first to be added to a sultanic mosque, he also appended a library to the mosque of Mehmed the Conqueror in 1742 and created another as part of his own foundation, the Nuruosmaniye, discussed below.[37] The Hagia Sophia Library was, then, a cutting-edge addition, and its recentness is evident also from certain novel touches in its design. The arches of its marble entrance façade, for example, are round

Figure 1.11 Hagia Sophia Library, ornamental plasterwork on the ceiling of the kiosk reading area. Photo: author.

rather than the conventional pointed shape, and between them, over the columns, are pilaster-like protrusions that recall the treatment of arcades in Western architecture (Figure 1.2). Within the reading room, surrounded by green tiles, is a rectangular polychrome marble-effect panel inscribed with a gold *tuğra*, the imperial monogram (Figure 1.3), and though this calligraphic device had a very long history in the Ottoman chancery, its use as a decorative heraldic emblem was not common before the reign of Ahmed III, as Bora Keskiner has demonstrated.[38] The panel in the library is made all the more striking by its indeterminate material, which resembles marbled paper and appears to be fashioned from a composite substance akin to *scagliola*.[39]

It is in the main kiosk space that the library's most innovative elements are to be found. The ceilings of the dome and vault display intricate plasterwork reliefs of vegetal and floral scrolls that are distinguished by their relative naturalism, their stems incorporating Classicising acanthus leaves that appear also in the foliate mouldings around the ceilings' base (Figure 1.11). Such naturalism, together with the scrolls' arrangement into medallion-like compositions whose borders combine straight and C-shaped lines, reveals a clear engagement with Western Baroque and Rococo models, even as the resultant designs remain consonant with the Ottomans' own arabesque tradition. Though somewhat less obvious, the

same cosmopolitan sensibility is at play in the minute carved scrollwork ornamenting the kiosk's marble inscription panels and also, outside this space, in the bronze grilles of the library's entrance façade.[40] To return to the kiosk, the pointed arch of its doorframe springs from jambs with engaged columns bearing plaster (or plaster-coated) capitals sculpted in a simplified approximation of the Corinthian order, with scrolling volutes and leafy embellishments.[41] The lunette above and behind these unusual capitals is carved with an imposing *tuğra*, once more demonstrating the monogram's growing decorative prominence (Figure 1.12).

No less notable for its artistic verve is the ablution fountain, which is among the grandest ever created by the Ottomans, its eaves far exceeding in diameter the dome of the nearby primary school. Like the library, the fountain juxtaposes traditional forms such as the *muqarnas* capitals and pointed arches of its octagonal arcade with less accustomed features that show knowledge of foreign sources (Figure 1.6). The marble tank that constitutes the core of the fountain is thus carved with fictive round arches around which grow fleshy foliate scrolls that recall those of the library (Figure 1.13). The effect of these reliefs is both complemented and contrasted by the surmounting grillwork, whose own scrolls – formed of thin serrated leaves – are more geometricised and less naturalistic in appearance.

As the foregoing descriptions suggest, even with their more novel aspects, both the library and the fountain remain largely true to an established Ottoman aesthetic, and in this they are consistent with the 'Tulip Era' architecture of preceding decades. The round arches of the library's façade do not overwhelm the *muqarnas* capitals from which they spring, just as the Europeanate carvings of the fountain's tank are not more conspicuous than the eminently Islamic arcade that looms over them. What freshness these structures achieve is, in other words, couched in a largely traditional language that has been tweaked rather than substantially reformed. All this changes, however, with the ʿ*imāret*, whose gate in particular presents us with a very different picture (Figures 1.10, 1.14).[42] Here, not a single pointed arch, *muqarnas*, or geometric interlace is to be seen: in their stead are a deeply moulded round-arched door with a swan-neck pediment, four Corinthianising columns carrying dentil-studded architraves and entablatures, a pair of niches crowned by scrolling pediments and set with scallop shells, and two massive leafy scrolls in high relief that descend from the architrave running above the door. This design is Baroque (encompassing Rococo[43]) through and through, comparable in its ingredients and tripartite arrangement to Italian church façades of the same period,[44] and it goes well beyond the circumscribed and scattered intimations of the style seen in the slightly earlier library and fountain.

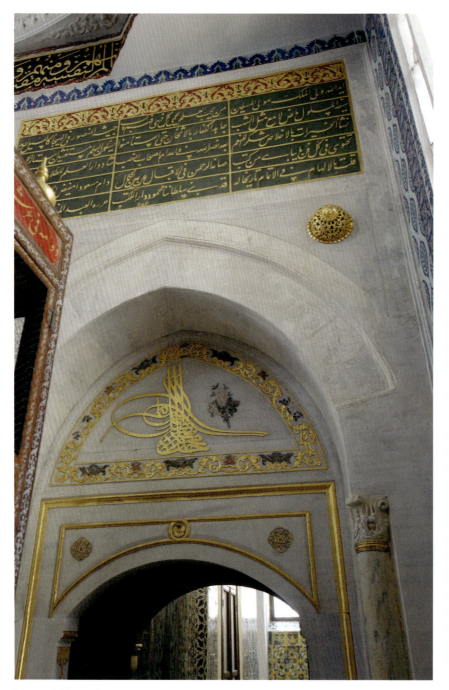

Figure 1.12 Hagia Sophia Library, inner face of the kiosk entrance, surmounted by the sultan's *tuğra* and a versified inscription. Photo: author.

Hagia Sophia's Second Conversion

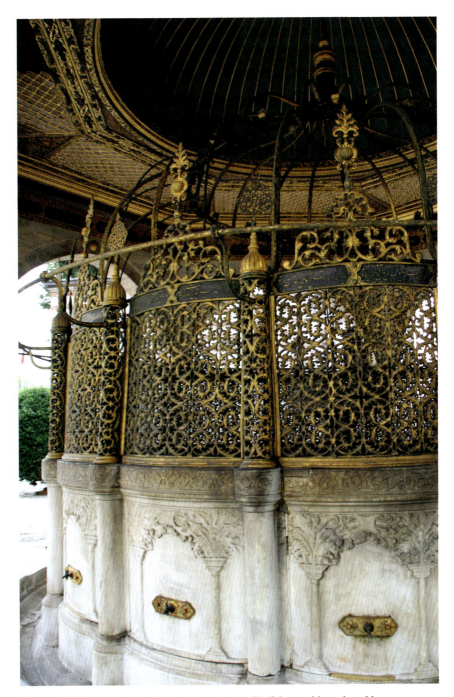

Figure 1.13 Hagia Sophia ablution fountain, detail of the marble tank and bronze grillwork. Photo: author.

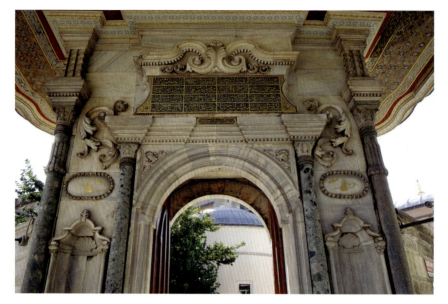

Figure 1.14 Hagia Sophia ʿİmāret, upper part of the main gate. Photo: author.

Markedly untraditional as it is, however, the overall effect of the portal is far from alien. For one thing, the design gives generous space to calligraphy, which appears not only in the expected overdoor panel, but also in two wreath-framed oval cartouches that are carved above the niches and inscribed in gold with mirrored *tuğra*s (in their current form nineteenth-century modifications).[45] And while the Baroque ornament surrounding these inscriptions represents a new departure in Istanbul's cityscape, its curvilinearity and vegetal character are attributes shared, albeit in different guise, with earlier varieties of Ottoman scrollwork, a rapport already signalled by the ceilings of the library kiosk.[46] Moreover, all of the gate's foreign-inspired elements have been creatively assimilated rather than unthinkingly borrowed, as exemplified by the treatment of the two outermost columns, which, defying European norms, feature partially gadrooned shafts and support entablature blocks carved with peculiar dentil-like squares of alternating sizes. Such idiosyncrasies serve to differentiate – and so localise – the gate's use of the Baroque, and that the whole structure is surmounted by a vaulted roof with wide eaves and flanking cupolas confirms its Ottomanness. We are dealing, in sum, with a stylistic fusion whose character and originality are aptly expressed by the label 'Ottoman Baroque', for it is simultaneously both of these things even as it is novel by the standards of each.[47] This dual originality imbues the style with considerable transformative power, so that even the

ʿimāret's main building – a largely nondescript and utilitarian affair – is rendered eye-catching by the relatively few Baroque touches that enliven its entrance side (Figure 1.9). Carved of white marble and shining bright against the building's brick-and-limestone walls, these flourishes include Corinthianising columns and an elaborate doorframe featuring a mixtilinear architrave, shells, a scrollwork pediment, baluster finials, and – sounding an unmistakably Ottoman note – a finely calligraphed inscription panel.

The impression that this inventive synthesis would have made on contemporary viewers can be gauged from Subhi's account of the ʿimāret's opening ceremony on 19 January 1743, during which Sultan Mahmud

> moved with light and dignified gait to observe and enjoy the various subtle arts that, with utmost care and consideration, had been produced and brought about in the plan, form and style of that graceful edifice by the artists of the workshop of architecture and the skilled masters of invention and construction . . . He looked attentively from top to bottom, scrutinising one by one each of the exalted doors and walls and matchless vaults and arches present in its various parts. Not only did the aforementioned building shame the construction of [the legendary king] Shaddad by the strength and solidity of its piers and columns, but it also matched the art of Bihzad in the elegance and gracefulness of its form and design, and every one of its artistically novel elements [*her fıkra-ı bedīʿüʾl-āsārı*] was of such consummate beauty and splendour that each resembled a work of calligraphy by Imad, all of which meant that the whole appeared most comely and pleasing in [Mahmud's] well-informed eyes.[48]

Almost ekphrastic in its denseness, this description succeeds in verbalising the rich and variegated effect of the carved stonework in terms that conform to Ottoman literary tradition. Even the comparisons to the miniature painter Bihzad (d. 1535–6) and calligrapher Mir ʿImad al-Hasani (d. 1615) – Persian artists far removed from the Baroque tradition – are appropriately evocative of the stonework's intricacy, the latter analogy, as noted by Yavuz Sezer, alluding to 'the similarity between rococo forms and the cursive scripts of the Arabic alphabet'.[49]

It is telling that Subhi's account of the opening of the library only a few years earlier includes nothing about its appearance beyond some generalised praise.[50] To be sure, the library's beauty did not go unnoticed by historical audiences, as we know from an eighteenth-century ballad sung by Istanbul's night watchmen in honour of the building. Besides extolling the grillwork, tiles and *tuğra* panel visible from inside Hagia Sophia, the ballad also notes the artistic skill exhibited in the kiosk's bookshelves, which shows that even the less readily accessible areas of the library had entered popular consciousness.[51] The song appears in an anonymous

manuscript that also records a similar ballad about the ʿimāret, as well as in a printed compilation that includes a song in praise of the ablution fountain.[52] But even if all three works earned widespread admiration, it was surely the ʿimāret that most surprised the mid-eighteenth-century viewer. Its thoroughly Baroque gate announced a startling change from the dynamic yet tradition-based manner of the immediately preceding years, no doubt prompting many who saw it to experience the sort of deeply engaged fascination that Subhi's account ascribes to the sultan himself. We might be tempted to view this stylistic shift as the creative upshot of a building campaign already marked by a search for novelty, but a watershed of such magnitude bespeaks a less spontaneous process whose explanation cannot be sought in artistic daring alone.

Style, Symbolism and Site

What had happened, then, to bring about this visual sea change even as Mahmud's Hagia Sophia additions were being planned and created? Once again, I believe that the answer lies in the political climate that followed the peace treaties of 1739. From surviving dated works of architecture, it seems that the Ottoman Baroque's breakout year was AH 1154 (March 1741–March 1742), which postdates all of our structures other than the ʿimāret. The works in question are scattered across Istanbul and its suburbs and include a *sebīl* (fountain kiosk) built by the cavalry commander (*sipāhī aġası*) Mehmed Emin Agha (d. 1743–4) in Dolmabahçe; another erected in Karacaahmet by Saʿdeddin Efendi (d. 1759–60), son of a chief military judge (*każʿasker*); a gate with an adjacent wall fountain installed by the grand vizier Nişancı Ahmed Pasha (d. 1753) at the Fatih Mosque complex; and the interior stonework of a new double bathhouse in Cağaloğlu that – in a further demonstration of his concern for the monument – Mahmud himself established to generate revenue for Hagia Sophia.[53] There is nothing to link these projects' circumstances other than their elite patronage, and this, combined with the suddenness with which the style made its public appearance, has convinced me that the Ottoman Baroque came about as a deliberate, state-sponsored strategy, as I have discussed at length elsewhere.[54] Introduced soon after the retaking of Belgrade, the style provided a new aesthetic vehicle by which to mark the empire's recent successes, and its undisguised engagement with European models was both an acknowledgement of the Baroque's international cachet as an aesthetic of power and a self-assured move by which the Ottomans brought themselves into closer – and thus more competitive – visual dialogue with their Christian rivals and neighbours.[55]

Later narratives of Ottoman decline, which paint the eighteenth century as a period of unrelenting losses for the empire, have treated the style as yet another symptom of decadence and westernisation, ignoring the confident background against which it arose.[56] The Hagia Sophia campaign – itself a product of this more buoyant mood – conclusively challenges such declinist understandings of the Ottoman Baroque and affords us a vivid record of the transition to the style and the milieu in which it occurred. As we have seen, the campaign as a whole seems to have been prompted, or at least propelled, by the Ottomans' success in the 1736–9 war, and the switch to the Baroque was clearly not needed for the point to be made. The new manner could, however, highlight and amplify this celebratory message, whether through its geopolitical symbolism (which not every viewer would have been equipped to understand) or simply by virtue of its vigorous inventiveness. That the library and ablution fountain already flirt with the Baroque suggests an existing desire to mark this politically charged moment through heightened novelty. By the time the *ᶜimāret* was built, the style was primed for full deployment.

Quite how and by whom the turn to the Baroque was orchestrated is unclear, though Mahmud himself must have played a major role in the process, supported by other leading members of the court who, like the sultan, were well versed in foreign styles through their collections of imported books, prints and luxury objects.[57] We have less information concerning the architects and craftsmen whose handiwork spanned this transitional period, including with regard to Mahmud's Hagia Sophia additions.[58] Subhi's history relates that the chief imperial architect, whose name is not given, received a robe of honour from the grand vizier shortly after the inauguration of the *ᶜimāret*,[59] but his had become a largely regulatory and ministerial job by the eighteenth century, and we cannot know what creative input, if any, he had in the design and decoration of this building or the other structures of the complex.[60] Only the works' calligraphies, which would have been executed on paper before being translated into stone relief, can be definitively attributed to particular individuals: those of the *ᶜimāret* bear the signature of the talented calligrapher Moralı Beşir Agha (d. 1752), a black eunuch who was at the time palace treasurer and would in 1746 become the chief harem eunuch (Figure 1.14).[61] Both of these posts traditionally necessitated a high degree of involvement in the art and architecture of the court, with the eunuchs acting as agents of the sultan and the women of the harem. Contemporary sources confirm Beşir and his fellow eunuchs as influential tastemakers during this time, a point borne out by his artistic presence at the Hagia Sophia *ᶜİmāret*.[62]

But this still leaves us to consider the identities of those responsible for conceiving and executing the buildings' architectural and ornamental features. The presence (even if limited) of Baroque motifs in the library and ablution fountain show that we are dealing with essentially the same group of artists both before and after the change in style, which further indicates a top-down impetus for the shift dictated more by political circumstances than by artistic inclination. Documents pertaining to other projects of the period, together with a variety of descriptive sources, reveal that Istanbul's building trade was dominated throughout the eighteenth century by semi-autonomous Greek and Armenian masters who worked for the court under the nominal oversight of the chief architect; we may safely assume that it is their craftsmanship we are seeing at Hagia Sophia.[63] Their non-Muslim status left them especially well placed to assimilate Baroque motifs, for Ottoman Greeks and Armenians had long since developed close mercantile and cultural ties with Western Europe, and Italy in particular, where many of them sojourned. Whether any of our artists travelled west is unknown, but their exposure to European models would in any case have been considerable owing to the wealth of foreign goods and printed materials circulating among their communities.[64] Indeed, such was their familiarity with European art that Istanbul's Armenians – and probably Greeks, too – were employing Ottoman Baroque forms in their own (mostly non-public) visual culture already by the 1730s, seemingly as an expression of their Christian identity. Shortly thereafter, the rich semantic potential of this cosmopolitan style, with its acknowledged associations with Christendom, came to the attention of the artists' elite Muslim patrons, who utilised these resonances for very different ideological ends in the creation of a new architectural language appropriate to the political mood.[65]

Regardless of the precise actors involved in this development, the switch was decisive, and by the mid-1740s, the Ottoman Baroque had become the accepted standard in the architecture of Istanbul before taking hold in other parts of the empire and in other artforms.[66] Its most significant manifestation – and the first Ottoman Baroque work to be executed on a truly grand scale – came in the shape of a new imperial mosque situated in the heart of the capital. Begun by Mahmud in 1748, the mosque was as yet unfinished at the time of his death in 1754, and so it was his brother and successor, Osman III (r. 1754–7), who brought the monument to completion a year later and named it Nuruosmaniye in oblique reference to himself.[67] This was the first imperial mosque to be erected in Istanbul by a sultan for well over a century, ending an interruption whose main cause appears to have been the high bar set by Ottoman codes of decorum, which discouraged sultans from building mosques in the capital without having

first prevailed over 'infidel' enemies.[68] Deference to this standard may in part explain why Ahmed III, whose reign had seen territorial losses, refrained from constructing such a monument despite his larger efforts to reanimate Istanbul.[69] Mahmud, however, considered the reconquest of Belgrade reason enough to pick up where his glorious ancestors had left off, and it was on the basis of this victory – which had already fuelled so much of his architectural ambition – that he decided to build a mosque that would follow in the footsteps of past royal foundations.[70]

Nevertheless, the Nuruosmaniye took a markedly different route from these earlier mosques, which had been typified by their pyramidal dome arrangements, quadrangular courtyards and sober geometric stonework. Its architect, a Greek master known as Simeon Kalfa, instead designed the building in the latest Baroque manner, with a high single dome, a rounded courtyard (the only example of its kind in Ottoman mosque architecture) and magnificent carved stonework replete with scrolls, shells and acanthus leaves.[71] Echoing Mahmud's Hagia Sophia additions, the mosque was constructed as part of a larger complex that includes, among other elements, a madrasa, an ʿimāret and a library, all of which share in the same vibrant aesthetic as the main building.[72] The result proved deeply impressive to foreign as well as Ottoman observers of the time, their admiring assessments of the Nuruosmaniye attesting to the reach and force of the Ottoman Baroque's triumphal address.[73]

The Hagia Sophia campaign, which preceded the Nuruosmaniye by about a decade, can be considered a sort of anticipatory turning point, when circumstances allowed Mahmud to embark on a bolder course of self-representation that would culminate in a mosque of his own. As well as announcing his commitment to religious architecture, the campaign coincided with, and itself contributed to, the emergence of a new architectural manner that more compellingly expressed Mahmud's message. Only a year old, the fledgling style acquired high visibility and instant prestige through its display in so venerable a location. Hagia Sophia served, then, to anchor and legitimate the Ottoman Baroque even as it was being launched, and what better venue for such a manoeuvre than one so intrinsically emblematic of the Ottomans' purposeful use of styles adapted from other cultures? After all, the new Baroque style creatively recast forms associated with the Ottomans' defeated rivals in much the same way that earlier Ottoman architecture had assertively borrowed from the Byzantine tradition, and in particular from Hagia Sophia, which became a model both to emulate and to outdo.[74]

The Ottoman Baroque itself facilitated the process of its establishment, for it would never have taken root had it not been suited to its surroundings.

As we have seen, the style was keyed to its Ottoman context in various ways, localised without losing its cross-cultural qualities. Better-informed viewers would have recognised and understood the connotations of this pluralistic approach, but even they, like most ordinary observers, would have regarded the overall effect as an innovation rather than an importation. Moreover, as the *ʿimāret*'s main building demonstrates, the style had little typological impact on the architecture itself, which continued to perpetuate older plans and spatial arrangements even as its constituent forms and decoration underwent sweeping changes.[75] The very fact that one of the earliest instances of this Ottoman Baroque amalgam was an *ʿimāret* – an eminently traditional building type symbolising the sultan's divinely ordained guardianship – is proof enough of how quickly, fully and effectively the Ottomans had made the style their own.[76] It remained Istanbul's preferred artistic mode into the early 1800s and was succeeded thereafter by an Ottoman version of the equally international manner of Neoclassisicism, whose practitioners in Istanbul included the Fossatis.[77] Having proven the power of synthesis, the Ottoman Baroque thus opened the cosmopolitan path along which the empire's visual culture would continue during and indeed beyond the time of Hagia Sophia's final Ottoman makeover, more than a century after Mahmud's campaign.[78]

Conclusion: Back to Byzantium

It was not only through dialogue with the *Ottoman* past, however, that Hagia Sophia's rendition of the Baroque implanted itself so deeply and fruitfully in its local setting. Let us zoom in for a moment on the *ʿimāret*'s Corinthianising column capitals, which have bead-studded foliate volutes at their corners and oval medallions on their main faces.[79] Despite their patent relationship to seventeenth- and eighteenth-century Western models, particularly the elaborated Corinthian and Composite variants common in the Italian Baroque,[80] a closer look invites a more nearby comparison: the late antique capitals within Hagia Sophia itself (Figure 1.15). These so-called basket capitals are likewise derived from the Composite order, and the way that their leafy carving clings to their surface rather than protruding in high relief finds its parallel in the similarly close-fitting embellishments of their Ottoman counterparts. More tellingly, the Byzantine capitals bear little roundels that resemble the oval medallions of the Ottoman ones, and immediately below their bases are beaded bronze collars of a type unknown in the European Baroque but replicated at the *ʿimāret*.

Hagia Sophia's Second Conversion

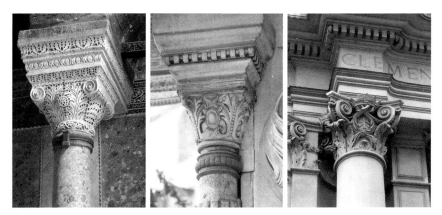

Figure 1.15 Comparison of column capitals from the interior of Hagia Sophia, 532–7 (left), the main gate of Hagia Sophia *ʿİmāret* (centre) and the façade of the Church of Santi Celso e Giuliano, Rome, 1733–5 (right). Photos: author.

Once alerted to this Byzantine connection, we soon find it in other eighteenth-century Ottoman buildings, including the pre-Baroque Hagia Sophia Library, whose designers evidently took inspiration from the converted church around them. The round arches of the library's entrance façade thus reflect in miniature the towering arcades of the basilica's aisles – even the porphyry disks inlaid into the Byzantine spandrels are echoed by circles incised into the otherwise Europeanising pilasters topping the *muqarnas* capitals (Figure 1.2).[81] The marble-effect *tuğra* panel inside the reading room, meanwhile, pays unmistakable homage to Hagia Sophia's famous polychrome wall revetments, which are interspersed with intarsia scrollwork that in turn offers a further analogue to the library's bronze grilles and plaster ceilings (Figures 1.3, 1.11, 1.15). Already visible before 1740, such Byzantine references proliferated and came into clearer focus with the Ottoman Baroque, and this is hardly surprising. The Baroque and Byzantine traditions were linked, after all, by a shared Classical pedigree, drawing many of their forms and motifs from the same Greco-Roman repertoire. Exemplified by such commonalities as round arches, acanthus scrolls, dentils and egg-and-dart mouldings, this affinity must have been apparent to more astute Ottoman patrons and artists (Figure 1.15). The Ottoman Baroque's advent therefore prompted an intensified re-engagement with Istanbul's Byzantine monuments, from which certain elements were borrowed and blended into the new style as if to further secure its place in the city's fabric.[82] Among the stonework of the Nuruosmaniye's prayer hall, for example, is a distinctive kind of dentil moulding whose squares zigzag in alternating directions, contrary

51

to Western Baroque practice but entirely in keeping with the decoration of Hagia Sophia, where larger and more protuberant versions of such dentils occur in abundance.[83] Another Ottoman Baroque royal mosque, the Laleli, built by Mustafa III (r. 1757–74) between 1760 and 1764, has striated brick-and-stone outer walls and an interior clad in polychrome stone, features that are rare for Ottoman sultanic mosque architecture and look instead to Istanbul's converted Byzantine churches.[84]

The invocation of Constantinopolitan precedent that we see in buildings like the Hagia Sophia *ʿİmāret* appears too pointed to have been a display of stylistic acuity alone. As I have argued elsewhere, such referentiality may also have had an intellectual and even a competitive motivation, driven by a consciousness among certain Ottomans of the lofty and monopolistic claims that Western discourse made to the legacy of Greco-Roman art. By citing Istanbul's copious Byzantine heritage, Ottoman stakeholders were able to flaunt their own, arguably more direct, share in the Classical tradition, and thereby to signal their entitlement to the Baroque as a culture already conversant with *all'antica* aesthetics.[85] It was not only members of the Muslim ruling class that might have held this attitude, but also those of the city's Greek community, which, as Çiğdem Kafescioğlu has discussed, was engaging in its own Byzantine revival in these years.[86] Little survives of the latter endeavour, but a round-arched marble gate with a neo-Byzantine inscription that was added in 1733 to the Kantakouzenos Mansion in the Greek neighbourhood of Fener (Phanar) offers a precious glimpse into the cultural (self-)awareness of the eponymous Phanariot elite, whose extensive connections with the Ottoman court help to explain the development of broadly overlapping (albeit differently inflected) antiquarian sensibilities across demographic lines.[87] Moreover, this communal interest in Byzantium lends further significance to the role of Greek masters in Istanbul's eighteenth-century architecture, reminding us that practitioners as well as patrons had reason to reaffirm their Constantinopolitan heritage in this moment.

From the perspective of the court, such reaffirmation would have built on the much older claim – going back to Mehmed II's conquest of Constantinople – that the Ottoman state was the rightful successor to the Roman Empire, with all its standing in the European arena.[88] The enduring relevance of this idea well into the eighteenth century is substantiated by a fascinating report written for Sultan Mahmud in 1741 by Claude Alexandre, Comte de Bonneval (d. 1747), a French nobleman and convert to Islam who entered into Ottoman service as a military adviser and took the name Humbaracı Ahmed Pasha. Consisting mainly of political analysis, Bonneval's report includes historical overviews of Europe in which

he posits two legitimate heirs to the Romans: France, the successor of Western Rome through its kings' descent from Charlemagne; and the Ottoman Empire, the successor of Eastern Rome – that is, Byzantium – by right of conquest.[89]

As the very embodiment of the passing of the Byzantine mantle, Hagia Sophia provided a matchless setting in which to explore and advance such notions of the Ottomans' cultural credentials and political legitimacy. Capitalising on its illustrious past and rich symbolism, and continuing its history as a site of Ottoman aesthetic rebranding, Mahmud chose the monument as the ideal springboard for his augmented patronal image. His campaign not only converted the mosque into a complex, but also – and relatedly – helped to bring about a transformative new direction in Istanbul's architectural development. With its inventive Baroque design and allusive Byzantine touches, the *ᶜimāret* gateway stands as both the fulfilment and the encapsulation of this far-reaching scheme, invoking Hagia Sophia's antiquity in service of a thoroughly modern enterprise.

Notes

1. *Author's note*. I am grateful to Benjamin Anderson and Emily Neumeier for inviting me to take part in the symposium from which this chapter stems and for their comments on earlier drafts; to Doris Behrens-Abouseif, Çiğdem Kafescioğlu, Julia Landweber, Kimia Maleki and Tim Stanley for their generous and helpful responses to my enquiries; and to Hayrullah Cengiz, the then director of the Ayasofya Museum, and his assistant Begüm Yanık for granting me rare and full access to Mahmud's additions when I showed up unannounced in August 2019. Little did I know at the time that this would be my last visit to Hagia Sophia while it was still a museum, and before the world itself changed in ways I could never have predicted. For a detailed overview of Mahmud's patronage of the site, which extended beyond the additions discussed here, see Ahmed Akgündüz, Said Öztürk and Yaşar Baş, *Üç Devirde Bir Mabed: Ayasofya* (Istanbul: Osmanlı Araştırmaları Vakfı, 2005), 424–65.
2. For the library, see ibid., 424–44, 445; İsmail E. Erünsal, 'I. Mahmûd Devri Kütüphaneleri', in Hatice Aynur (ed.), *Gölgelenen Sultan, Unutulan Yıllar: I. Mahmûd ve Dönemi (1730–1754)*, 2 vols (Istanbul: Dergâh Yayınları, 2020), vol. 1, 291–3; İsmail E. Erünsal and Semavi Eyice, 'Ayasofya Kütüphanesi', in *Türkiye Diyanet Vakfı İslâm Ansiklopedisi*, vol. 4 (Istanbul: Türkiye Diyanet Vakfı, 1991), 212–14; and Yavuz Sezer, 'The Architecture of Bibliophilia: Eighteenth-Century Ottoman Libraries' (Ph.D. diss., Massachusetts Institute of Technology, 2016), 63–8. For its recent restoration, see Selman Can, 'Ayasofya I. Mahmud Kütüphanesi ve Geçirdiği Onarımlar', *Atatürk Üniversitesi Güzel Sanatlar Enstitüsü Dergisi* 35 (2015), 181–222.

3. I borrow the kiosk characterisation from Sezer, 'The Architecture of Bibliophilia', 67.
4. Ibid., 64; and Yoichi Takamatsu, 'I. Mahmûd Döneminde Ayasofya Kütüphanesi ve Koleksiyonu', in Hatice Aynur (ed.), *Gölgelenen Sultan, Unutulan Yıllar: I. Mahmûd ve Dönemi (1730–1754)*, 2 vols (Istanbul: Dergâh Yayınları, 2020), vol. 1, 308–57. For the subsequent growth of the library's collection, which was relocated to the Süleymaniye Library in 1968, see Akgündüz et al., *Ayasofya*, 426–8.
5. Akgündüz et al., *Ayasofya*, 430–1, 445; Erünsal and Eyice, 'Ayasofya Kütüphanesi', 213–14; and Filiz Yenişehirlioğlu, 'Geleneğin Devamı: Ayasofya I. Mahmûd Kütüphanesi Çini Süsleme Programı', in Hatice Aynur (ed.), *Gölgelenen Sultan, Unutulan Yıllar: I. Mahmûd ve Dönemi (1730–1754)*, 2 vols (Istanbul: Dergâh Yayınları, 2020), vol. 1, 358–71, where it is suggested that some of the tile panels in the corridor were added as part of a later repair. On the use of European tiles in eighteenth-century Ottoman architecture more generally, see Hans Theunissen, 'Dutch Tiles in 18th-Century Ottoman Baroque-Rococo Interiors: *Hünkâr Sofası* and *Hünkâr Hamamı*', *Sanat Tarihi Dergisi* 18:2 (October 2009): 71–135.
6. For the school, which was being used as a coffee house by 1907 and in 2019 served as an office and meeting space, see Akgündüz et al., *Ayasofya*, 445, 446–7; and Semavi Eyice, 'Ayasofya Sıbyan Mektebi', in *Türkiye Diyanet Vakfı İslâm Ansiklopedisi*, vol. 4 (Istanbul: Türkiye Diyanet Vakfı, 1991), 216–17. The forty boys, who received other charitable provisions besides, are mentioned in the *waqfiyya* (see Akgündüz et al., *Ayasofya*, 445), which does not specify how many pupils in total the school was meant to accommodate.
7. For the fountain, see Akgündüz et al., *Ayasofya*, 445, 453–60; and Semavi Eyice, 'Ayasoyfa Şadırvanı', in *Türkiye Diyanet Vakfı İslâm Ansiklopedisi*, vol. 4 (Istanbul: Türkiye Diyanet Vakfı, 1991), 217.
8. For the ʿ*imāret*, see Akgündüz et al., *Ayasofya*, 447–52; Ayşe Budak, 'Kutsal Mabedin Gölgesinde Doymak: Ayasofya İmareti', *Türk Tarih Kurumu Höyük Dergisi* 7 (2014): 67–96; and Semavi Eyice, 'Ayasoyfa İmareti', in *Türkiye Diyanet Vakfı İslâm Ansiklopedisi*, vol. 4 (Istanbul: Türkiye Diyanet Vakfı, 1991), 212.
9. The ʿ*imāret* is included in a later *waqfiyya* of 1743–4: see Budak, 'Ayasofya İmareti', 68.
10. For overviews of Ahmed's fall and Mahmud's reign, see Caroline Finkel, *Osman's Dream: The Story of the Ottoman Empire, 1300–1923* (London: John Murray, 2005), 352–71. For a recent collection of Turkish and English essays aimed at redressing the scholarly neglect of this period, see Hatice Aynur (ed.), *Gölgelenen Sultan, Unutulan Yıllar: I. Mahmûd ve Dönemi (1730–1754)*, 2 vols (Istanbul: Dergâh Yayınları, 2020). Several essays from this collection (which includes a contribution by me in Turkish on Mahmud's architectural and artistic patronage) are cited in the present chapter.

11. Virginia H. Aksan, *Ottoman Wars, 1700–1870: An Empire Besieged* (Harlow: Pearson/Longman, 2007), 102–18, 130.
12. The earliest known document in connection with the project – a record of sums spent on various building materials – is dated 2 September 1739. See Diker, 'Ayasofya'nın Geçirdiği Onarımlar', 61, 555, no. 3.
13. 'Ebü'l-fütūḥāt ve'l-maġāzī'. See Akgündüz et al., *Ayasofya*, 445. This characterisation deliberately harks back to Mehmed II's nickname of *Ebü'l-Fetḥ*, 'Father of Conquest'.
14. 'Ayyada llāhu waliyya l-mulki mawla l-Muslimīn / Man yuḥibbu l-ʿilma yaḥmī kulla dhī fahmin wa lubb // Jayshuhu l-manṣūru fī l-hayjāʾi ka-l-sayli l-ʿarim [sic: should read *ka-sayli l-ʿarim*] / Sayfuhu l-maslūlu mādin lāmiʿun mithlu l-shuhub // Jāhada l-kuffāra bi-l-ithkhāni ḥatta staʾmanū / Yasʾalūna [written with the Qur'anic spelling] l-silma mustaghshīna astāra l-ḥujub // Nashshaʾa l-khayrāti bi-l-ikhlāṣi shukran li-l-niʿam / Baʿda naṣri llāhi fī iʿdāmi aṣḥābi l-nuṣub'. For (imperfect) Arabic transcriptions and modern Turkish renderings of the entire poem, see Akgündüz et al., *Ayasofya*, 435–7 (the translation is taken from Ahmet Küçükkalfa, 'Ayasofya Kütüphanesi', *İlgi* 17:37 (September 1983): 17; and the *Database for Ottoman Inscriptions* at http://www.ottomaninscriptions.com/verse.aspx?ref=list&bid=2915&hid=5106 (accessed 7 November 2019), which also includes detailed photographs of the inscription panel. The latter translation is by Mehmet Boynukalın and taken from Hatice Aynur's study of the poetic encomia composed in honour of Mahmud I's libraries, in which she also analyses the buildings' inscription programmes: see Hatice Aynur, 'I. Mahmûd'un (ö. 1754) Kütüphaneleri ve Tarih Manzumeleri', in Hatice Aynur, Bilgin Aydın and Mustafa Birol Ülker (eds), *Kitaplara Vakfedilen bir Ömre Tuhfe: İsmail E. Erünsal'a Armağan*, 2 vols (Ülke Armağan: Istanbul, 2014), vol. 2, 681–734 (686–97 and 708–17 for the Hagia Sophia Library, and 692–3 for the Arabic over-door inscription specifically). These Turkish translations proved helpful for my own English rendering, particularly when it came to the difficult phrase *astāra l-ḥujub* (lit. 'veils of veils', though the second word in the construction is here being used in *ḥijāb*'s extended sense of 'shame').
15. While the poem's author is unknown, the inscription – elegantly written in the sweeping *taʿlīk* script – is signed by the calligrapher İsmaʿil Refik Efendi. See Aynur, 'I. Mahmûd'un (ö. 1754) Kütüphaneleri', 692; and İrvin Cemil Schick, 'I. Mahmûd Döneminde Hat Sanatı', in Hatice Aynur (ed.), *Gölgelenen Sultan, Unutulan Yıllar: I. Mahmûd ve Dönemi (1730–1754)*, 2 vols (Istanbul: Dergâh Yayınları, 2020), vol. 1, 436.
16. Relatedly, the *waqfiyya* stipulates that the Qur'an be recited in the library's reading room 'in supplication for the continuance of the sultanic state and for imperial conquest and victory' (*devām-ı devlet-i pādişāhī ve fetḥ u nuṣret-i cihānbānī deʿavātıyla*). See Akgündüz et al., *Ayasofya*, 445.
17. Sezer, 'The Architecture of Bibliophilia', 64–5, from which my translation of Subhi is adapted. Dr Sezer's death from COVID-19 in 2021 has deprived

the field of Ottoman architectural history of one of its leading new voices. For a transliteration of Subhi's original text, part of a longer description of the library project, see Subhi Mehmed Efendi, with Mustafa Sami Efendi and Hüseyin Şakir Efendi, *Subhî Tarihi, Sâmî ve Şâkir Tarihleri ile Birlikte (İnceleme ve Karşılaştırmalı Metin)*, ed. Mesut Aydıner (Istanbul: Kitabevi, 2007), 619–20.

18. Bora Keskiner, Ünver Rüstem and Tim Stanley, 'Armed and Splendorous: The Jeweled Gun of Sultan Mahmud I', in Amy Landau (ed.), *Pearls on a String: Artists, Patrons, and Poets at the Great Islamic Courts* (Baltimore: Walters Art Museum, 2015), 205–35; and Ünver Rüstem, *Ottoman Baroque: The Architectural Refashioning of Eighteenth-Century Istanbul* (Princeton and Oxford: Princeton University Press, 2019), 97–103.

19. Shirine Hamadeh, *The City's Pleasures: Istanbul in the Eighteenth Century* (Seattle and London: University of Washington Press, 2008), 76–109; Rüstem, *Ottoman Baroque*, 60–3; and Alexander Wielemaker, 'The Taksim Water Network: Renegotiation of Authority and Dynastic Legitimacy', in Hatice Aynur (ed.), *Gölgelenen Sultan, Unutulan Yıllar: I. Mahmûd ve Dönemi (1730–1754)*, 2 vols (Istanbul: Dergâh Yayınları, 2020), vol. 2, 556–603. I disagree with Wielemaker's assertion that the Tophane Fountain was built as a belated addendum to the rest of the project, an assertion based on what I consider to be a misinterpretation of some of the primary sources. In particular, the January 1733 document that Wielemaker treats as a commission is, by my reading, a record of work already completed. See Wielemaker, 'The Taksim Water Network', 583–4; and, for the document in question, Zarif Ongun, 'Tophane Çeşmesi', *Tarih Köşesi* (no date), 230, available at https://www.yumpu.com/tr/document/read/28268159/ia-9-a-3 (accessed 4 July 2022).

20. Tülay Artan, 'Istanbul in the 18th Century: Days of Reconciliation and Consolidation', in *From Byzantion to Istanbul: 8000 Years of a Capital* (Istanbul: Sakıp Sabancı Museum, 2010), 300–12; Hamadeh, *The City's Pleasures*; and Rüstem, *Ottoman Baroque*, 21–55.

21. For discussion of this term, which was coined (as *Lāle Devri*) by Turkish historians in the early twentieth century, see Can Erimtan, *Ottomans Looking West? The Origins of the Tulip Age and Its Development in Modern Turkey* (London and New York: Tauris Academic Studies, 2008); Rüstem, *Ottoman Baroque*, 22–6; and Ariel Salzmann, 'The Age of Tulips: Confluence and Conflict in Early Modern Consumer Culture (1550–1730)', in Donald Quataert (ed.), *Consumption Studies and the History of the Ottoman Empire, 1550–1922* (Albany: State University of New York Press, 2000), 83–106.

22. On this style, see Hamadeh, *City's Pleasures*, 85–7, 199–200, 226–37; Rüstem, *Ottoman Baroque*, 26–45; and Turgut Saner, 'Lale Devri Mimarlığında Hint Esinleri: "Çinihane"', *Sanat Tarihi Defterleri* 3 (1999): 35–54.

23. Rüstem, *Ottoman Baroque*, 60–3, 281–2, n. 21.
24. Ibid., 54–5, 119, 120.
25. Akgündüz et al., *Ayasofya*, 373–4, 394–6, 419–20, 460–3.
26. Diker, 'Ayasofya'nın Geçirdiği Onarımlar', 62–3, 555, no. 5. This act followed in the footsteps of late sixteenth-century efforts to clear Hagia Sophia's perimeter of unwanted urban encroachments: see Gülru Necipoğlu, 'The Life of an Imperial Monument: Hagia Sophia after Byzantium', in Robert Mark and Ahmet Ş. Çakmak (eds), *Hagia Sophia: From the Age of Justinian to the Present* (London: Cambridge University Press, 1992), 205–7.
27. For Hagia Sophia's Ottoman history, see Akgündüz et al., *Ayasofya*, 221–685; and Necipoğlu, 'Life of an Imperial Monument', 195–225.
28. Akgündüz et al., *Ayasofya*, 424; and Necipoğlu, 'Life of an Imperial Monument', 211–21.
29. Semavi Eyice, 'Ayasoyfa Medresesi', in *Türkiye Diyanet Vakfı İslâm Ansiklopedisi*, vol. 4 (Istanbul: Türkiye Diyanet Vakfı, 1991), 214–15. As part of his far-reaching renovation campaign, Selim II had unrealised plans to provide the mosque with two new madrasas: see Necipoğlu, 'Life of an Imperial Monument', 207, 208.
30. Akgündüz et al., *Ayasofya*, 361–8, 376–7, 383–7, 396–400, 406–7; and Necipoğlu, 'Life of an Imperial Monument', 205–11.
31. According to a *waqfiyya* dated 1743–4, the ʿ*imāret*'s daily offerings were bread and soup after the morning prayer and an additional serving of soup after the evening prayer. The menu was supplemented with rice (*dāne*) on Thursdays and with ʿ*aşūre* (a kind of pudding) during the month of Muharram. See Budak, 'Ayasofya İmareti', 68, n. 14. A ballad celebrating the ʿ*imāret* (see the citation in n. 52 below) corroborates these details, telling us that the kitchen served soup, *fodla* (a type of flatbread) and, on Thursdays, rice together with saffron-flavoured rice pudding (*zerde*). Interestingly, the *waqfiyya* indicates that the indigent were the last to be fed: most of the food was to go to staff and students of the complex, with the poor receiving whatever was left over. Such a hierarchy of distribution was typical for Ottoman ʿ*imāret*s: see Amy Singer, 'Imarets', in Christine Woodhead (ed.), *The Ottoman World* (London and New York: Routledge, 2012), 72–85.
32. Akgündüz et al., *Ayasofya*, 452.
33. 'Ebü'l-Fetḥ'iñ edüp āsārını itmām'; 'Ayaṣofiyye ābād oldu el-ḥaḳḳ bu ʿimāretle'. For the entire inscription, see ibid., 451.
34. 'Ḫuṣūṣen ʿahd-i Fātiḥ'den beri bu ḫayr-ı vālāya / Muvaffaḳ olmamış eslāfı şāhāndan biri ammā'. For the entire inscription, see ibid., 451–2.
35. I am paraphrasing a similar argument I have made for a later Ottoman Baroque charitable foundation, the primary school of Recaʾi Mehmed Efendi (1775): see Ünver Rüstem, 'Ottoman Baroque', in John D. Lyons (ed.), *The Oxford Handbook of the Baroque* (Oxford: Oxford University Press, 2019), 350–1.

36. Doğan Kuban, *Ottoman Architecture*, trans. Adair Mill (Woodbridge: Antique Collectors' Club, 2010), 558–62; and Sezer, 'The Architecture of Bibliophilia', esp. 38–74, 152–210.
37. Aynur, 'I. Mahmûd'un (ö. 1754) Kütüphaneleri'; Erünsal, 'I. Mahmûd Devri Kütüphaneleri', 284–307; Rüstem, *Ottoman Baroque*, 216; and Sezer, 'The Architecture of Bibliophilia', 152–67, 171–80. See also n. 79 below.
38. Philippe Bora Keskiner, 'Sultan Ahmed III's *Hadith-Tughra*: Uniting the Word of the Prophet and the Imperial Monogram', *İstanbul Araştırmaları Enstitüsü Yıllığı=Annual of İstanbul Studies* 2 (2013): 111–25.
39. While the panel is simplistically identified as marble inlay in much of the scholarship (see e.g. Akgündüz et al., *Ayasofya*, 430), this was not my impression when I observed it at close range in 2019. In a 2020 essay, Filiz Yenişehirlioğlu ('Geleneğin Devamı', 368–7), acknowledging the input of Baha Tanman, characterises the material as hardened coloured paste and the technique as Italian, which would seem to correspond to my suggestion that the panel is a kind of *scagliola*.
40. For the library's inscriptions, see Aynur, 'I. Mahmûd'un (ö. 1754) Kütüphaneleri', 688–93.
41. These capitals, together with the columns they surmount, are not as well-crafted as the rest of the library kiosk's elements and appear to have been rather crudely repaired or remodelled in recent times. Whether they are made of, or simply coated in, plaster was not clear to me when I examined them. They are, in any case, ornamental rather than true supports for the arch above them. For the library's restoration history (albeit without reference to these particular capitals), see Can, 'Ayasofya I. Mahmud Kütüphanesi'.
42. The following discussion of the *ʿimāret* draws on Rüstem, *Ottoman Baroque*, 70–6.
43. Like other historians of both Western and Ottoman art, I use 'Baroque' as an umbrella term that, in its eighteenth-century application, includes the Rococo (which is itself sometimes referred to as 'Late Baroque'). While I would disagree with his claim that I underplay the Rococo component of the Ottoman Baroque, Gauvin Bailey's review of my book rightly notes that I missed the likely relationship between the two large leafy scrolls of the *ʿimāret*'s gate and the Rococo prints of Alexis Peyrotte (d. 1769). See Gauvin Alexander Bailey, review of *Ottoman Baroque: The Architectural Refashioning of Eighteenth-Century Istanbul*, by Ünver Rüstem, *The Burlington Magazine* 161 (September 2019): 787–8.
44. Rüstem, *Ottoman Baroque*, 89–92.
45. Previous scholarship (my own included) has failed to notice that these *tuğras* refer not to Mahmud I, but to Mahmud II (r. 1808–39), who restored the *ʿimāret* in 1824 (see Akgündüz et al., *Ayasofya*, 477). I learned of this anomaly from the relevant entries in the *Database for Ottoman Inscriptions*: see http://www.ottomaninscriptions.com/verse.aspx?ref=list&bid=1169&hid=4836

and http://www.ottomaninscriptions.com/verse.aspx?ref=list&bid=1169&hid=4837 (accessed 7 November 2019). The *tuğra*s' shape, however, is not characteristic of Mahmud II's period and preserves a distinctly eighteenth-century flavour, which, together with the implausibility of the cartouches' being empty beforehand, means that these monograms are almost certainly replacements for (abraded) originals rather than additions per se. The result punningly capitalises on the fact that Mahmud II was the namesake of the building's founder.

46. On this rapport in the context of Ottoman printmaking, see Ünver Rüstem, 'Mapping Cosmopolitanism: An Eighteenth-Century Printed Ottoman Atlas and the Turn to Baroque', in Holly Shaffer (ed.), 'The Graphic Arts: Replication and the Force of Forms', special issue, *Ars Orientalis* 51 (2021): 188–248, esp. 194–204.

47. On this contentious term, see Shirine Hamadeh, 'Westernization, Decadence, and the Turkish Baroque: Modern Constructions of the Eighteenth Century', *Muqarnas* 24 (2007): 185–97; and Rüstem, *Ottoman Baroque*, 4–9, 15–17.

48. 'Celse-i ḥafīfeden şoñra ol buḳʿa-ı laṭīfeniñ ṭarḥ u ṭarz u üslūbünde ressāmān-ı kārgāh-ı ṣanʿat-ı binā ve çīre-destān-ı esātize-i ibdāʿ u inşā nīrū-yı ihtimām-ı naẓar u ümenā ile iẓhār u icrā eyledükleri envāʿ-ı ṣanāyiʿ-i daḳīḳayı seyr ü temāşā içün biʾz-zāt mihter-i nesīm-i ḥareket ü ḫirām ve muḳaddemā mütevellī-i vaḳf-ı mezbūr ṭarafından esnāf-ı şekerleme ve ezhār ve envāʿ-ı bākūre-i ābdār ile tezyīn olunan mastaba ve ṣofalara nigāh-endāz-ı iʿtibār olaraḳ zīr ü bālā ve zevāyā-yı şettāsında vāḳiʿ der ü dīvār-ı muʿallā ve ṭāḳ u kemer-i bī-hemtāsından her birine yegān yegān diḳḳat ü imʿān buyurduḳlarında ebniye-i merḳūme metānet ü raṣānet-i erkān u iʿmād ile ṭaʿn-endāz-ı binā-yı Şeddād iken leṭāfet ü nezāket-i resm ü heyʾetde hem naḳş-ı ṣūret-i Behzād ve her fıḳra-ı bedīʿüʾl-āsārı kemāl-i ḥüsn ü nümāyiş ile gūyiyā bir ḳıṭʿa-i ʿİmād olmaġla cümlesi cilve-nümā-yı naẓargāh-ı ibtihāc u istiḥsān-ı ṭabʿ-ı daḳīḳa-dānları olup'. Transliteration adapted from Subhi, *Subhî Tarihi*, 763.

49. Rüstem, *Ottoman Baroque*, 75; and Sezer, 'The Architecture of Bibliophilia', 165. I am very grateful to Dr Sezer for having corrected my earlier misreading of Subhi's mention of Mir ʿImad. For other references to Bihzad (and the Persian painter-prophet Mani) in relation to eighteenth-century Ottoman architecture, see Hamadeh, *The City's Pleasures*, 206, 216, 220, 235; and Sezer, 'The Architecture of Bibliophilia', 162.

50. Subhi, *Subhî Tarihi*, 619–23.

51. Such ballads were sung before dawn during Ramadan. For two variants of the library ballad, see Âmil Çelebioğlu (ed.), *Ramazan-nâme* (Istanbul: Milli Eğitim Bakanlığı, 1995), 135–8, quoted in Akgündüz et al., *Ayasofya*, 440; and Muhtar Yahya Dağlı (ed.), *İstanbul Mahalle Bekçilerinin Destan ve Mâni Katarları* (Istanbul: Türk Neşriyat Yurdu, 1948), 58–61, quoted in Erünsal, 'I. Mahmûd Devri Kütüphaneleri', 292. I owe my knowledge of

this song to the discussion of it in Sezer, 'The Architecture of Bibliophilia', 157–8.

52. Çelebioğlu, *Ramazan-nâme*, 135–8, 183–5, quoted in Akgündüz et al., *Ayasofya*, 440, 449; and Dağlı, *Destan ve Mâni Katarları*, 32–4. The fountain ballad also mentions the neighbouring primary school.

53. For these works, see Rüstem, *Ottoman Baroque*, 63–9. For the Cağaloğlu Baths' connection to Hagia Sophia, see Akgündüz et al., *Ayasofya*, 444, 446. See also n. 79 below.

54. Rüstem, *Ottoman Baroque*, esp. 70–82, 96–109, 154–96. For a summary of the arguments advanced by my book, see Rüstem, 'Ottoman Baroque', 334–69. For an alternative perspective on eighteenth-century Ottoman architecture, see Hamadeh, *The City's Pleasures*; and Hamadeh, 'Westernization, Decadence, and the Turkish Baroque'.

55. For the Baroque as an international aesthetic of power, see Rüstem, *Ottoman Baroque*, 157–64; and Michael Snodin and Nigel Llewellyn (eds), *Baroque, 1620–1800: Style in the Age of Magnificence* (London: V&A, 2009). Despite the view that the Ottomans turned to the style even as it was becoming outmoded elsewhere (see e.g. Kuban, *Ottoman Architecture*, 505–6, 508), the Baroque, together with the Rococo, continued to flourish in Central, Eastern and Southern Europe throughout the second half of the eighteenth century. For some examples, see Anthony Blunt, *Neapolitan Baroque & Rococo Architecture* (London: A. Zwemmer, 1975); Manlio Brusatin and Gilberto Pizzamiglio (eds), *The Baroque in Central Europe: Places, Architecture and Art* (New York: Marsilio, 1992); Eberhard Hempel, *Baroque Art and Architecture in Central Europe*, trans. Elisabeth Hempel and Marguerite Kay (Baltimore: Penguin, 1965); and Christian Norberg-Schulz, *Late Baroque and Rococo Architecture*, English trans. (New York: H. N. Abrams, 1974).

56. On these negative assessments, see Hamadeh, 'Westernization, Decadence, and the Turkish Baroque'; and Rüstem, *Ottoman Baroque*, 2, 4–7.

57. Gül İrepoğlu, 'Topkapı Sarayı Müzesi Hazinesi Kütüphanesindeki Batılı Kaynakar Üzerine Düşünceler', *Topkapı Sarayı Müzesi Yıllığı* 1 (1986): 56–72; Feryal İrez, 'Topkapı Sarayı Harem Bölümü'ndeki Rokoko Süsleminin Batılı Kaynakları', *Topkapı Sarayı Müzesi Yıllığı* 4 (1990): 21–54; and Rüstem, *Ottoman Baroque*, 82–3, 96–109.

58. Despite my best efforts, I discovered no documents in the Prime Ministry Ottoman Archives listing the names of those employed on these projects. For a helpful overview of some of the known documents relating to Mahmud's patronage of the site, see Hasan Fırat Diker, 'Belgeler Işığında Ayasofya'nın Geçirdiği Onarımlar' (Ph.D. diss., Mimar Sinan Güzel Sanatlar Üniversitesi, 2010), 59–63.

59. Subhi, *Subhî Tarihi*, 764. The imperial architect at this time was Hacı Mustafa Agha, who took up the post in 1741, replacing Kayserili Mehmed Agha. See Budak, 'Ayasofya İmareti', 68. Another individual mentioned by Subhi in

relation to the ʿimāret is Mehterzade Ali Efendi (d. 1752), who was trustee of its endowment and thus responsible for organising its opening ceremony. As Yavuz Sezer has discussed, Mehterzade played a prominent supervisory role in court-sponsored architectural projects of the 1730s and 1740s, and in some cases may have contributed to the buildings' designs. I am less convinced than Sezer, however, that Mehterzade – one of numerous state officials charged with overseeing the court's building activities – should be considered an architect or artistic practitioner per se, and there is no evidence that he served the Hagia Sophia campaign in such a capacity. See Sezer, 'The Architecture of Bibliophilia', 161–7, 254; and Rüstem, *Ottoman Baroque*, 82–3.

60. On this shift in the chief architect's responsibilities, see Rüstem, *Ottoman Baroque*, 46–8, 82–3.
61. For the identities of the calligraphers involved in Mahmud's Hagia Sophia additions, see Akgündüz et al., *Ayasofya*, 435, 451, 456: Aynur, 'I. Mahmûd'un (ö. 1754) Kütüphaneleri', 690–1, 692; and Schick, 'I. Mahmûd Döneminde Hat Sanatı', 436, 447–8. See also n. 15 above. For Moralı Beşir Agha, see Jane Hathaway, *The Chief Eunuch of the Ottoman Harem: From African Slave to Power-Broker* (Cambridge: Cambridge University Press, 2018), 151–4.
62. Jean-Claude Flachat, *Observations sur le commerce et sur les arts d'une partie de l'Europe, de l'Asie, de l'Afrique, et même des Indes Orientales*, 2 vols (Lyon: Chez Jacquenod père & Rusand, 1766), vol. 1, 402, vol. 2, 206; Hathaway, *Chief Eunuch*, 145–7, 151–2, 193–220; Jane Hathaway, 'Jean-Claude Flachat and the Chief Black Eunuch: Observations of a French Merchant at the Sultan's Court', in Sabra J. Webber and Margaret R. Lynd (eds), *Fantasy or Ethnography? Irony and Collusion in Subaltern Representation* (Columbus: Ohio State University, 1996), 45–50; and Rüstem, *Ottoman Baroque*, 105–7.
63. Rüstem, *Ottoman Baroque*, 46–54, 82–96. For an alternative view of the period's architectural actors, see Sezer, 'The Architecture of Bibliophilia', 161–7. John Hobhouse, later Baron Broughton (d. 1869), who travelled in the Ottoman Empire between 1809 and 1810, writes that the fountain was 'erected by a Persian architect, after the fashion of his own country': see John Cam Hobhouse, *A Journey through Albania, and Other Provinces of Turkey in Europe and Asia, to Constantinople, during the Years 1809 and 1810*, 2nd edn, 2 vols (London: James Cawthorn, 1813), vol. 2, 973–4. I have not been able to determine the source of this curious assertion.
64. Mathieu Grenet, 'A Business *alla Turca*? Levant Trade and the Representation of Ottoman Merchants in Eighteenth-Century European Commercial Literature', in Michael Rotenberg-Schwartz (ed.), with Tara Czechowski, *Global Economies, Cultural Currencies of the Eighteenth Century* (Brooklyn: AMS Press, 2012), 47–50; and Rüstem, *Ottoman Baroque*, 84–92. See also the discussion of printed models in n. 43 above.

65. Rüstem, 'Mapping Cosmopolitanism', esp. 216–27; and Rüstem, *Ottoman Baroque*, 94–6, 108–9.
66. It is interesting to note that one of the earliest examples of a building outside Istanbul with Ottoman Baroque features – the Tombul (Şerif Halil Pasha) Mosque (1744) in Shumen, Bulgaria – includes capitals that are almost identical to those of the gate of the Hagia Sophia *ʿİmāret*. Flanking the principal mihrab (prayer niche), these capitals are among several variants of the Corinthian that can be found at the mosque and that have close analogues in the immediately preceding architecture of Istanbul (see n. 79 below). Yavuz Sezer, who was the first to bring these connections to light, argues that some of the Shumen capitals were produced by (and presumably imported from, though he does not say so) the same workshop as their Istanbul counterparts, a view I share on the basis of the photographs I have seen. See Sezer, 'The Architecture of Bibliophilia', 51–3 (incl. n. 48); and the images at https://grandmufti.bg/en/za-nas-3/news/9203-za-arhitekturnata-perla-sherif-halil-pasha-dzhamiya-i-nekolkogodishnata-restavratziya-3.html (accessed 14 July 2022). While a close link to Istanbul is evident in the case of the Tombul Mosque, Baha Tanman, in an essay exploring the architectural relationship between the capital and provinces during the reign of Mahmud I, rightly emphasises that the Ottoman Baroque took on highly localised expressions that, even if inspired by shifts in Istanbul, often followed their own rhythm and had their own sources of influence. See M. Baha Tanman, 'I. Mahmûd Dönemi Mimarîsinde Payitaht-Eyalet İlişkileri', in Hatice Aynur (ed.), *Gölgelenen Sultan, Unutulan Yıllar: I. Mahmûd ve Dönemi (1730–1754)*, 2 vols (Istanbul: Dergâh Yayınları, 2020), vol. 2, 516–55, esp. 548–9. For further examples of Ottoman Baroque architecture outside Istanbul, see Doris Behrens-Abouseif, 'The Complex of Sultan Mahmud I in Cairo', *Muqarnas* 28 (2011): 195–219; Maximilian Hartmuth, 'Eighteenth-Century Ottoman Architecture and the Problem of Scope: A Critical View from the Balkan "Periphery"', in Géza Dávid and Ibolya Gerelyes (eds), *Thirteenth International Congress of Turkish Art: Proceedings* (Budapest: Hungarian National Museum, 2009), 295–307; and Rüstem, *Ottoman Baroque*, 180–1. For the style's proliferation in non-architectural contexts, see Şule Aksoy, 'Kitap Süslemelerinde Türk-Barok-Rokoko Üslûbu', *Sanat* 3:6 (June 1977): 126–36; and Zeren Tanındı, 'Kitap Sanatında Gelenek ve Yenilik: I. Mahmûd Dönemi', in Hatice Aynur (ed.), *Gölgelenen Sultan, Unutulan Yıllar: I. Mahmûd ve Dönemi (1730–1754)*, 2 vols (Istanbul: Dergâh Yayınları, 2020), vol. 1, 372–99.
67. In a clearly intentional semantic overlap, the name might can be construed as 'Light of Osman' or 'Light of the Ottomans'. For this monument, see Kuban, *Ottoman Architecture*, 526–36; Ali Uzay Peker, 'Return of the Sultan: Nuruosmânîye Mosque and the Istanbul Bedestan', in Cânâ Bilsel et al. (eds), *Constructing Cultural Identity, Representing Social Power* (Pisa: Plus-Pisa University Press, 2010), 139–57; Rüstem, *Ottoman Baroque*, 111–69 (and for

discussion of its name specifically, 111); and Selva Suman, 'Questioning an "Icon of Change": The Nuruosmaniye Complex and the Writing of Ottoman Architectural History', *METU Journal of the Faculty of Architecture* 28:2 (2011): 145–66.

68. On the codes typically followed in the construction of earlier sultanic sultans, see Samet Budak, '"The Temple of the Incredulous": Ottoman Sultanic Mosques and the Principle of Legality', *Muqarnas* 36 (2019): 179–207; Gülru Necipoğlu, *The Age of Sinan: Architectural Culture in the Ottoman Empire*, 2nd edn (London: Reaktion, 2011), 55–66, 514–17; Ünver Rüstem, 'Piety and Presence in the Post-Classical Sultanic Mosque', in Tijana Krstić and Derin Terzioğlu (eds), *Historicizing Sunni Islam in the Ottoman Empire, c. 1450–c. 1750* (Leiden and Boston: Brill, 2020), 376–420, esp. 376–93; and Ünver Rüstem, 'The Spectacle of Legitimacy: The Dome-Closing Ceremony of the Sultan Ahmed Mosque', *Muqarnas* 33 (2016): 253–344.

69. Rüstem, *Ottoman Baroque*, 54–5; and Rüstem, 'Piety and Presence', 391–3. For Ottoman military fortunes under Ahmed, see Aksan, *Ottoman Wars*, 83–102.

70. Rüstem, *Ottoman Baroque*, 115–19; and Rüstem, 'Piety and Presence', 393–400.

71. Rüstem, *Ottoman Baroque*, 137–54 (and 120, 147–8, 152, 194, 255 for Simeon Kalfa).

72. Ibid., 112–15, 145–6.

73. Ibid., 154–7.

74. On the Ottomans' competitive response to Hagia Sophia, see Gülru Necipoğlu, 'Challenging the Past: Sinan and the Competitive Discourse of Early Modern Islamic Architecture', *Muqarnas* 10 (1993): 169–80. It is notable in this regard that Belgrade returned to Ottoman hands with a number of Baroque buildings that had been added by the Habsburgs during their brief rule of the city. See Rüstem, *Ottoman Baroque*, 92; and Nikola Samardžić, 'The Emergence of the Baroque in Belgrade', in Charles Ingrao, Nikola Samardžić and Jovan Pešalj (eds), *The Peace of Passarowitz, 1718* (West Lafayette, IN: Purdue University Press, 2011), 255–66.

75. On the Ottoman Baroque's surface quality, see Rüstem, *Ottoman Baroque*, 6–7, 75–6, 138, 225–6, 276. See also the following note.

76. To be sure, Ottoman soup kitchens were not as standard in their arrangement as certain other building types, but the Hagia Sophia *ᶜİmāret* nonetheless conforms to wider patterns within the genre, particularly in its use of multiple contiguous domed spaces. See Cengiz Gürbıyık, 'Osmanlı İmaretlerinin (Aşevleri) Tipolojisi Üzerine Bir Deneme', *Sanat Tarihi Dergisi* 24:1 (April 2015): 23–51, esp. 34. On the institutional and social significance of Ottoman soup kitchens, see Singer, 'Imarets'.

77. Göksun Akyürek, 'Political Ideals and Their Architectural Visibility: Gaspare Fossati's Projects for Tanzimat Istanbul (1845–1865)', in Paolo Girardelli and

Ezio Godoli (eds), *Italian Architects and Builders in the Ottoman Empire and Modern Turkey: Design across Borders* (Newcastle upon Tyne: Cambridge Scholars Publishing, 2017), 45–61; Zeynep Çelik, *The Remaking of Istanbul: Portrait of an Ottoman City in the Nineteenth Century* (Seattle and London: University of Washington Press, 1986), esp. 126–43; Beatrice Daskas, 'Aya Sofia Kibir Giamy Scheriffy: The Fossati Brothers, the Ottoman Capital and the "Superb Imperial Mosque of Hagia Sophia"', in Brigitte Pitarakis (ed.), *From Istanbul to Byzantium: Paths to Rediscovery, 1800–1955* (Istanbul: Pera Museum, 2021), 21–39; and Alyson Wharton[-Durgaryan], *The Architects of Ottoman Constantinople: The Balyan Family and the History of Ottoman Architecture* (London and New York: I. B. Tauris, 2015).
78. A variety of internationally inflected styles flourished after and alongside Neoclassicism in the late Ottoman Empire, including Eclecticism (with elements of Gothic and Moorish Revival) and Art Nouveau. See Çelik, *The Remaking of Istanbul*, esp. 143–54; Ahmet A. Ersoy, *Architecture and the Late Ottoman Historical Imaginary: Reconfiguring the Architectural Past in a Modernizing Empire* (Farnham, UK and Burlington, VT: Ashgate, 2015); and Kuban, *Ottoman Architecture*, 605–78.
79. Capitals almost identical to these are present in the Tombul Mosque in Shumen, Bulgaria: see n. 66 above. In Istanbul at least, this design seems to have been limited to (or principally associated with) sultanic contexts: versions of it appear in two other buildings that Mahmud commissioned in the earliest years of the Ottoman Baroque – the Cağaloğlu Baths and the library of the Fatih Mosque, both mentioned above in the main text – as well as much later in a seemingly conscious revival under Abdülhamid I (r. 1774–89). See Rüstem, *Ottoman Baroque*, 69, 216, 238.
80. Rüstem, *Ottoman Baroque*, 90–2.
81. The resemblance between the library's arches and those of the basilica itself is independently noted in Sezer, 'The Architecture of Bibliophilia', 66–7.
82. On the little-noted Byzantinising aspects of eighteenth-century Ottoman architecture, see Maurice Cerasi, 'Historicism and Inventive Innovation in Ottoman Architecture, 1720–1820', in Nur Akın, Afife Batur and Selçuk Batur (eds), *7 Centuries of Ottoman Architecture: 'A Supra-National Heritage'* (Istanbul: YEM Yayın, 2001), 34–42; Rüstem, *Ottoman Baroque*, 195–6, 198–207; Ünver Rüstem, '*Spolia* and the Invocation of History in Eighteenth-Century Istanbul', in Ivana Jevtić and Suzan Yalman (eds), *Spolia Reincarnated: Afterlives of Objects, Materials, and Spaces in Anatolia from Antiquity to the Ottoman Era* (Istanbul: ANAMED, 2018), 289–307; and Sezer, 'Architecture of Bibliophilia', 153–61.
83. Rüstem, *Ottoman Baroque*, 145, 198–9.
84. Ibid., 195–6 (and 182–98 for the mosque more generally).
85. Ibid., 200–7; and Rüstem, '*Spolia* and the Invocation of History'. A similar argument is made in relation to the mid-nineteenth context in Daskas, 'Aya Sofia Kibir Giamy Scheriffy', 29. For another example of late Ottoman

appropriation of the ancient past, see Emily Neumeier, 'Spoils for the New Pyrrhus: Alternative Claims to Antiquity in Ottoman Greece', *International Journal of Islamic Architecture* 6:2 (2017): 311–37.

86. Çiğdem Kafescioğlu, 'Byzantium in Early Modern Istanbul', in Sarah Bassett (ed.), *The Cambridge Companion to Constantinople* (Cambridge and New York: Cambridge University Press, 2022), 354–5; and Çiğdem Kafescioğlu, 'Rethinking Byzantium in Early Modern Istanbul', paper presented at the conference *Shifting the Paradigm: New Studies in Islamic Art and Architecture in Honor of Prof. Gülru Necipoğlu*, Boston and Cambridge, MA, 8–9 November 2022. I am grateful to Dr Kafescioğlu for sharing her work and thoughts on this topic with me.

87. I learned of this gate and its Byzantinising design from the conference paper by Çiğdem Kafescioğlu cited in the preceding note. For images of the gate, which was later incorporated into the precinct wall of the Ioakeimeion High School for Girls (founded 1879), see the Panorama Cultural Society's online archive at https://archive.apan.gr/en/data/Accompanying-List/253 (accessed 28 February 2023). On the role of the Phanariots in the architectural culture of eighteenth-century Istanbul, see Rüstem, *Ottoman Baroque*, 84–6, 88–9.

88. Gülru Necipoğlu, 'Visual Cosmopolitanism and Creative Translation: Artistic Conversations with Renaissance Italy in Mehmed II's Constantinople', *Muqarnas* 29 (2012): 1–81. On the architectural dimensions of this continuity, see Çiğdem Kafescioğlu, *Constantinopolis/Istanbul: Cultural Encounter, Imperial Vision, and the Construction of the Ottoman Capital* (University Park: Pennsylvania State University Press, 2009).

89. See 'Mémoire du Comte de Bonneval donné a la Sublime Porte par ordre du Grand Seigneur Le 4. fevrier 1741', Centre des Archives diplomatiques de La Courneuve, 133CP (Turquie)/108, fols. 67a–89a, discussed in Rüstem, *Ottoman Baroque*, 204–5. For Bonneval's life and career, see Julia Landweber, 'Fashioning Nationality and Identity in the Eighteenth Century: The Comte de Bonneval in the Ottoman Empire', *The International History Review* 30:1 (March 2008): 1–31.

Chapter 2

The Paradoxes of Hagia Sophia's Ablution Fountain: *The Qasida al-Burda* in Cosmopolitan Istanbul, 1740

Tülay Artan

In the atrium of Justinian's Hagia Sophia, there stood a lead-covered canopy over a great stone vessel. 'Wash your sins, not just your face', the inscription admonished.[1] The message was straightforward. This study, however, dwells on another, more oblique architectural inscription: the *Qasida al-Burda* ('Poem of the Mantle'), composed by the eminent Sufi poet and mystic Imam Sharafaddin al-Būṣīrī (d. 1294), whose verses adorn the ablution fountain added to the atrium of Hagia Sophia in 1740.[2]

Just like Byzantine holy wells, ablution fountains (*şadırvan*) allow congregants to perform the cleansing rituals required in the practice of worship – both were monuments erected in honour of the sanctity of water. The decorative sensibilities of the fountains placed in the courtyards of Ottoman mosques underlined this theme, proclaiming the virtues attributed to water in Islamic mysticism. The *qasida* decorating the entablature of Hagia Sophia's ablution fountain is not about water *per se*, however, but rather love for the Prophet Muhammad (Figure 2.1).[3]

Eighteenth-century Istanbul was a hub for diplomats, dervishes and dealers – all drawn to the cosmopolitan Ottoman capital from across the Empire and beyond: Cairo, Damascus, Tabriz, Isfahan, Bukhara, and even India. Some of those were pilgrims who, striving to fulfil one of the five pillars of Islam, chose to travel to the Ottoman capital with the intention of visiting the Tomb of al-Ayyub and Hagia Sophia before continuing to the Hijaz, visiting other 'Second Meccas' and 'Sufi Ka'bas' along the way.[4] For both Istanbullus and those Muslims visiting the Ottoman capital, the public display of the *Qasida al-Burda* must have been understood as a deliberate choice. The motivations and stimuli that lay behind the choice of al-Būṣīrī's *qasida* for this prominent location have, however, not yet been adequately explained. This chapter will argue that the political and cultural climates of the first half of the eighteenth century triggered

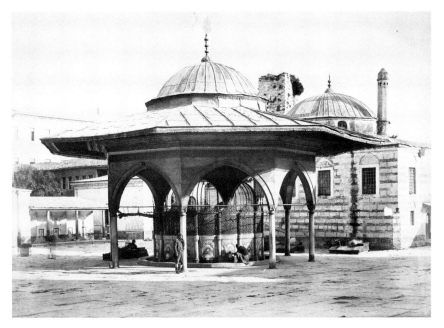

Figure 2.1 Historical view of the ablution fountain of Hagia Sophia. Undated, photographer unknown. Getty Research Institute, Los Angeles, Pierre de Gigord Collection, 96.R.14 (C11.10).

the widespread circulation of this particular *qasida* in manuscripts and other media, which were transmitted by Eastern merchants, diplomats and pilgrims to Istanbul. By taking the reception of the *Qasida al-Burda* in Istanbul and its selection for Hagia Sophia's *şadırvan* as our point of departure, we obtain a new perspective on the interconnectedness of the Ottoman Empire in the long nineteenth century.

Ablution in the Courtyard of the Cathedral-Mosque: The şadırvan *of Hagia Sophia*

There has been considerable interest in the waterworks and waterways of Istanbul. As Sezer Tansuğ complained in 1965, however, studies of Ottoman ablution fountains have generally not adopted a critical approach to their plastic and decorative values.[5] Since then, at least some of the eighteenth-century fountains of Istanbul have been studied for their characteristic architectural monumentality. Outstanding in this regard were the epoch-making public fountains commissioned between 1726 and 1730 by Ahmed III, at the entrance to the Topkapı Palace and the Üsküdar landing place, and in the 1740s by his nephew Mahmud I and

Tülay Artan

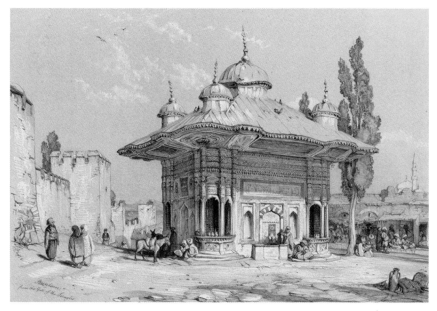

Figure 2.2 Public fountain commissioned by Ahmed III at the entrance to the Topkapı Palace. John F. Lewis, Lewis's *Illustrations of Constantinople made during a Residence in that City &c. in the Years 1835–5. Arranged and drawn on Stone from the original Sketches of Coke Smyth* (London, 1838), pl. V. University of Houston Libraries Special Collections; Rare Books and Maps Collection.

other members of the sultan's family at, for example, Kabataş, Azabkapu and Tophane (Figure 2.2). These fountains' public placement, elegantly painted eaves and ornate surface decoration have made them special focuses for scholarly attention.

The *şadırvan* placed in the courtyard of Hagia Sophia by Mahmud I in 1740, however, is distinct in every respect. Its form is not typical of the predominant architectural style of the time – the so-called 'Ottoman Baroque', which was exemplified by the Nuruosmaniye Mosque complex, another significant project commissioned by Mahmud in 1748.[6] As Tansuğ has put it, the *şadırvan* of Hagia Sophia is closer to classical Ottoman styles than the 'pretentious' and 'exaggerated' mosque of Nuruosmaniye.[7] It also differs in significant ways from earlier and contemporary public fountains.

In principle, an ablution fountain consists of a ring of faucets facing outwards from a central fount into a circular chamber.[8] Generally, the central fountain is surrounded by a colonnade that supports a dome. In some *şadırvans* the columns spring directly from the inner rim of the circular chamber, so that these two basic elements, the chamber and the colonnade,

Hagia Sophia's Ablution Fountain

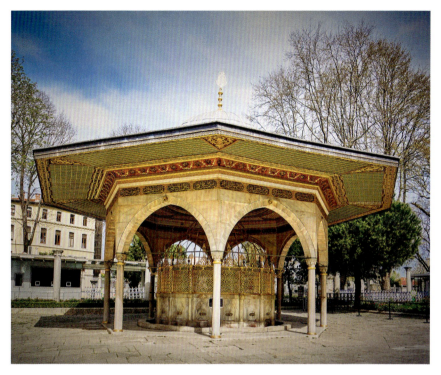

Figure 2.3 Ablution fountain of Hagia Sophia. Image courtesy of Serdar Tanyeli.

come to be united. In such cases, brass gratings are used to close the spaces directly between the columns, denying access to the top of the central fountain. At Hagia Sophia, however, there are eight marble columns with *muqarnas* capitals carrying eight pointed arches that together make up a whole building (Figure 2.3). Inside this outer colonnade, the central fount and the brass gratings topping it have sixteen sides (i.e., two sides per each side of the outer octagon) (Figure 2.4). The brass grill is composed of a repeated conventional acanthus scroll motifs and geometric interlace. Along the top edge of each grating panel are two gilt frames with *ta'lik* inscriptions that form a continuous upper band. The dark blue background of these thirty-two narrow frames carries a sixteen-couplet chronogram by a certain Emin Mehmed in gilded letters and the date 1740 (AH 1153).[9] Above this calligraphic border, each of the sixteen grates is further surmounted by triangular pediments completed with finials. From the joints of the sixteen grating panels there also rise brass ribs that converge in a perforated cupola over the central fount. It peaks in a tulip-shaped finial of its own carrying a Qur'anic verse: 'We have made from water every living thing' (*Sura al-Anbiya*, 21/30) (Figure 2.5). Similar finials, each with an

Tülay Artan

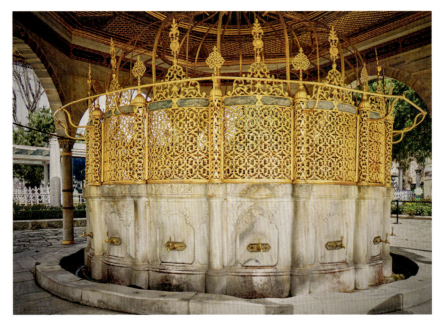

Figure 2.4 The central fount and the brass gratings topping it have sixteen sides. Image courtesy of Serdar Tanyeli.

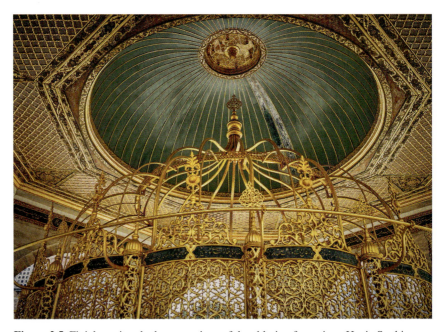

Figure 2.5 Finial topping the brass gratings of the ablution fountain at Hagia Sophia. Image courtesy of Serdar Tanyeli.

abridged version of the same *sura*, are located above the pseudo-columns at the junction of each grating panel.

A low octagonal roof with deep projecting eaves rests on the fountain's marble base, its entire surface richly decorated with ornamental friezes and gilt grooves. The entablature, which forms a wide frieze uniting the roof to the marble structure, is ornamented with flower bouquets and leaves. From the centre of the roof there rises an outer dome, with its peak crowned by yet another finial. Nineteenth-century photographs show it to have been crescent-shaped. It must therefore have been during a recent restoration that this was replaced by a drop-shaped or tulip-shaped finial with 'Allah' on top and a double 'Muhammad' inscribed below it in mirror-image (Figure 2.6).[10] On the interior of the octagonal colonnade is a further frieze, handsomely inscribed in *ta'lik* with sixteen couplets taken from a *qasida* also attributed to the poet Emin Mehmed (Figure 2.7).[11]

Clearly visible on the exterior, executed in gilded relief, are the first sixteen couplets of *al-Kawākib al-Durriyyah fī Madḥ Khayr al-Bariyyah* ('Celestial Lights in Praise of the Best of Creation'), better known as the *Qasida al-Burda* or *Poem of the Mantle*, an ode in praise of the Prophet Muhammad (Figure 2.8). We give them here in the translation of Suzanne Pinkney Stetkevych:

> Was it the memory of those you loved at Dhū Salam
> That made you weep so hard your tears were mixed with blood?
>
> Or was it the wind that stirred from the direction of Kāzimah
> And the lightning that flashed in the darkness of Idam?
>
> What ails your eyes? If you say, 'Cease!' they flow with tears;
> What ails your heart? If you say 'Be still!' its passion flares once more.
>
> Does the lover think that his passion can be concealed
> When his tears are flowing with it and his heart inflamed?
>
> But for passion you would not shed tears over a ruined abode,
> Nor spend nights sleepless from remembering the ben-tree's fragrance and the supple banner spear.
>
> How can you deny your love when two upstanding witnesses,
> Tears and lovesickness, have testified to it?
>
> And passion has borne witness to it
> With two streaks of tears upon your cheeks, as red as 'anam-boughs, and a sickly face, as yellow as the blossoms of bahār?
>
> Oh yes, the phantom of the one I love did come by night
> And leave me sleepless; love does indeed impede delight with pain.

Figure 2.6 Finial topping the outer dome of the ablution fountain at Hagia Sophia. Image courtesy of Serdar Tanyeli.

Hagia Sophia's Ablution Fountain

Figure 2.7 Inscription frieze of couplets from a *qasida* attributed to Emin Mehmed, found on the interior of the octagonal colonnade at the ablution fountain of Hagia Sophia. Image courtesy of Serdar Tanyeli.

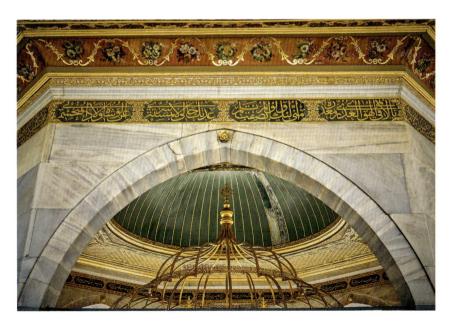

Figure 2.8 Inscription frieze of the *Qasida al-Burda*, found on the exterior of the octagonal colonnade at the ablution fountain of Hagia Sophia. Image courtesy of Serdar Tanyeli.

Tülay Artan

Oh you who fault me for chaste 'Udhrī passion, forgive me!
For were you fair, you would not censure me.

May you be stricken with the same affliction!
My secret is not hidden from my enemies; my sickness never ends!

You gave me sound counsel, but I didn't listen,
For lovers are deaf to those that reproach them.

Even the advice of grey hair I held suspect,
Though grey hair is the least suspect of all reproachers.

My willful wicked soul in its folly refused all warnings
From the harbingers of grey hair and old age.

It did not prepare a repast of good deeds to welcome
The guest [grey hair] that, unabashed, alighted on my head.

Had I known that I could not honor this guest,
I would have concealed his arrival with katam-dye.

Who will restrain my defiant soul from error
The way that bolting steeds are curbed by yanking back the reins?[12]

Written between 1260 and 1268 in Mamluk Egypt by the Moroccan Sufi Imam Sharafaddin al-Būṣīrī, the *Qasida al-Burda* is among the masterpieces of classical Arabic poetry and one of the most exquisite poems exalting the Prophet.[13]

The choice of al-Būṣīrī's *qasida* for as prominent a location as Mahmud I's distinctive new *şadırvan* for Hagia Sophia was far from accidental. We can be in no doubt that it reflected the intellectual climate of the Ottoman court: the calligrapher was Baltacızâde Mustafa Paşa (d. 1763), son of the grand vizier Baltacı Mehmed Paşa, Mahmud's sword-bearer.[14] It also had a wider significance, however: it connects cosmopolitan Istanbul with intellectual and religious networks that extended outwards from the Ottoman capital to the south and to the east – to Egypt, the Hijaz, and further afield to Central Asia and India. Its symbolic resonances were activated for an audience of merchants, pilgrims, scholars and diplomats in the context of widespread interest in al-Būṣīrī's *qasida* in the early eighteenth century.

Elite Libraries and the Manuscript Transmission of al-Būṣīrī's Qasida al-Burda

Al-Būṣīrī claimed that he composed his poem after the Prophet's mantle had cured him of a paralytic stroke.[15] In his account, having been afflicted with incurable hemiplegia, he offered a tribute of devotion to the Prophet

in order to invoke his help and intercession.[16] Fervently praying with tears of repentance and sincerity of purpose, he recited the poem continuously. When he fell asleep, he saw the Prophet Muhammad in his dream, who asked al-Būṣīrī to again read the ode he had written. As a reward, the Prophet took off his mantle and covered him; when he woke up, he found himself cured. In addition to a reputation for possessing talismanic or curative powers, the poem's focus on the plight of a man repenting before God for not dedicating his life and work to a higher goal epitomises the concept of *jihad al-nafs*, or one's greater struggle with oneself.

It is no wonder that the *Qasida al-Burda* became arguably the most frequently memorised, recited and performed poem throughout the Muslim world. It was part of the curriculum of madrasa education from North Africa to western China, being translated into Persian, Urdu, Pashto, Uzbek and Khorezmian Turkic and many other languages; it was copied into luxury manuscripts and adorned the interiors of stately homes.[17] Complementing the ubiquitous main text, there was also a large, mobile pool of *al-Burda* resources that circulated widely. In addition to recitation, copying and translation, it also received numerous commentaries, glosses, expansions and parallels that emulated it in the same rhyme and meter – Turkish *nazire*, Arabic *muʿaradah*, Persian *mucaradah*. The eminent Ottoman bibliophile Katib Çelebi (d. 1657) alone cited more than a dozen commentaries written in Arabic, Persian and Turkish, and many more were written by his contemporaries.[18]

The poem's popularity can be seen in its circulation in sumptuous manuscripts produced for elite audiences. Indeed, there was a continuous flow of luxury manuscripts and works of calligraphy between Islamic courts as gifts, including many fine examples of the *Qasida al-Burda*.[19] Already during the Mongol siege of Damascus in 1400, the renowned scholar Ibn Khaldun (d. 1406) gifted 'a copy of the famous poem, *Qasidah al-Burda* by al-Busiri in praise of the Prophet' to the conqueror Timur.[20] In the Ottoman world, many lavishly-gilded manuscripts produced in Mamluk Egypt, Syria and Iran were appropriated by both the sultans and the elite for their libraries.[21] Some of these bore the traces of Ottoman literati, who seem to have hoarded these luxury manuscripts and occasionally added personal notes.[22]

One such manuscript – one of the earliest that survived in the Ottoman capital – highlights the *Qasida al-Burda*'s significance at the intersection of courtly, intellectual and religious circles under Mahmud I. A fourteenth-century manuscript of the *qasida* now in the Süleymaniye Library is a fine example of Mamluk calligraphy and ornamentation (Figure 2.9).[23] Brought by Selim I (r. 1512–20) from Egypt, it was copied in 1372 by Ahmad b.

Tülay Artan

Figure 2.9 Fourteenth-century manuscript copy of the *Qasida al-Burda*. Süleymaniye Kütüphanesi, Istanbul, Ayasofya 4170, 1r-2v and 3r-4v.

Hagia Sophia's Ablution Fountain

Figure 2.10 Frontispiece of fourteenth-century manuscript copy of the *Qasida al-Burda*. Süleymaniye Kütüphanesi, Istanbul, Ayasofya 4170, 1v.

Tagay al-Mui'zzî on burnished Eastern paper with black, red and blue ink; it is splendidly decorated in decoupage.[24] The frontispiece, however, bears two seals: Selim's and that of Mahmud I (Figure 2.10). Its ornamented brown leather cover is also a later addition. The likely occasion for this eighteenth-century restoration of a fourteenth-century manuscript was the transferral of a number of manuscripts from the Topkapı Palace to the new library established by Mahmud I at Hagia Sophia in 1740.[25]

Already in 1733, Mahmud had created a library for the attendants of the Privy Chamber (*Has Oda*) of the Topkapı Palace by collecting some artistically illustrated and illuminated manuscripts of the imperial treasury within the wooden cabinets of the monumental Revan Kiosk.[26] Among the multiple public libraries he later established, that at Hagia Sophia housed the principal collection of rare and valuable manuscripts. Though this was followed in 1742 by the establishment of a library at the Fatih Mosque and, in 1754, at Galatasaray, Mahmud continued to add to Hagia Sophia's riches by endowing new funds in seven separate instalments.[27] Many copies of the *Qasida al-Burda* are extant from these collections, some marked by the seal of the sultan who acquired them (in one case, like that in the Süleymaniye Library, accompanied by Mahmud I's).[28]

Courtly interest in deluxe copies of the *Qasida al-Burda* was continuous through the eighteenth century and beyond. This can be seen in a seventeenth-century codex now in the Walters Art Museum, Baltimore.[29] The script suggests a Central or West Asian calligrapher, named in the colophon as Habib Allah ibn Dust Muhammad al-Khwarizmi (Figure 2.11).[30] It is, to be sure, a magnificent manuscript. The first page alone features an illuminated rectangular headpiece with five inner panels of text executed in three different scripts differentiated by colour: *muhaqqaq* (gold), *naskh* (black) and *thuluth* (blue).[31] The following pages have borders decorated with illuminated floral and geometric motifs in various colours – typical features of Central Asian aesthetics. The two partially erased seals prove that the codex was in the Ottoman capital by the first half of the eighteenth century.[32] The larger of the two is that of Osman III (r. 1754–7), indicating that the *qasida* was once in the collection of the Nuruosmaniye Library; the other is that of the inspector of the Imperial Endowments, Bende-i Latîf İbrahim Hanîf, who played a major role in Osman III's appropriation of books Mahmud I had intended for the library he commissioned.[33]

Interest in the *al-Burda* was far from limited to the Sultan's court, however. Notes in the manuscripts, *ex libris* plates and seals, as well as the bindings of these beautifully crafted manuscripts, showcase competition among Ottoman collectors from the mid-fifteenth century onwards. For example, a luxury *al-Burda* manuscript also in the Walters Museum contains not only the text of the poem but also an amplification (*takhmis*) by the thirteenth-century Egyptian poet Nasir al-Din Muhammad al-Fayyumi (d. 1294).[34] Both texts were copied by Rıdwan ibn Muhammad al-Tabrizi in 1366, possibly for the library of the Mawlawîhane in Konya (Figure 2.12).[35] Fourteenth-century Anatolia was in turmoil at the time, with (Damad) Alaaddin Ali of the Karamanid dynasty (r. 1361–98), a son-in-law and a rival of the rising Ottomans, ruling from the erstwhile capital of the Seljuk Sultanate of Rum.[36] The sixteenth-century Ottoman binding suggests that the manuscript circulated in Anatolia before being incorporated into the manuscript cabinet of an Ottoman collector. The Walters manuscript reveals not just the continuity of demand for *al-Burda* manuscripts in the Ottoman world, but also the literary networks that lay behind them: a manuscript produced in Cairo, bringing together a poet from Fayyum and a calligrapher from Tabriz for a patron in Konya, eventually coming into the possession of an Ottoman collector.[37]

This same mobility can be seen in another manuscript now in the Bibliothèque nationale in Paris.[38] This magnificent Mamluk copy, noteworthy for its emulation of Timurid ornament as well as its deviation from the by-then standard *mise-en-page* for the *al-Burda*, was produced for

Figure 2.11 Colophon of seventeenth-century manuscript copy of the *Qasida al-Burda*. Walters Art Museum, Baltimore, W.582.

Figure 2.12 Colophon of fourteenth-century manuscript copy of the *Qasida al-Burda*. Walters Art Museum, Baltimore, W.581.

Figure 2.13 Flyleaf of fifteenth-century manuscript copy of the *Qasida al-Burda*. Bibliothèque nationale de France, Paris, Arabe 6072.

Aboul-Baka Mohammad ibn Hadjar al-Saʿïdi al-Shafiʿi, the army inspector at Damascus in 1431 or 1432.[39] Paired with the text of the *al-Burda* is a *takhmis* by another high-ranking officer, Taki al-Din Abou Bakr ibn Hadjdjat al-Hanafi al-Hamawi, secretary in the Office of Protocol in Cairo. The binding, however, is a later addition, and a manuscript note in Arabic names a certain Hüseyin, an Ottoman scribe involved in the administration

of the tax on silk (*katib-i harir*). His *ex libris* is written over his small rectangular seal (Figure 2.13). In the left margin at the bottom of the page, we find another *ex libris* (also in Arabic) with the name of a later Ottoman owner: Şeyh Ahmed Hilmi, known as Muslihiddin-zade. This is followed by an inscription in Persian: 'The book is the beloved of the wise; the wise should not give away his books'.[40] It is impossible to know for certain, but it is not unlikely that Charles Schefer – the French orientalist and bibliophile from whose collection the manuscript was donated to the Bibliothèque nationale in 1899 – acquired the manuscript during his tenure as a translator in the French embassy in Istanbul between 1846 and 1857.

Ottoman demand was not solely for imported manuscripts. A late fifteenth- or sixteenth-century *al-Burda* has been decisively identified as an Ottoman product.[41] With six lines per page written in fine *naskh* script, it has been identified as the sole known manuscript by the master calligrapher Muhyiddin al-Amâsî (d. after 1520), a member of a family of distinguished calligraphers from Amasya on Anatolia's Black Sea coast.[42] Muhyiddin al-Amâsî's father, Celâl(leddin) Amâsî, and uncle, Mehmed Cemâl(leddin) Amâsî, were both well-known in Isfahan and Herat; Muyhiddin al-Amâsî's exceptional talent was so highly revered that his aunt's son, Şeyh Hamdullah (d. 1520), is said to have recommended him to the sultan, who wanted to have him produce a Qur'an, a job that he himself refused because of his old age according to Ekrem Hakkı Ayverdi, the manuscript's erstwhile owner.[43] Decorations in the margins, including an interlace of large split-palmettes outlined in gold against contrasting grounds, differ from earlier Mamluk examplars.[44] It was certainly presented to Süleyman I (1520–66). The family's reputation is confirmed by another sixteenth-century *al-Burda* manuscript recently sold at auction in London, which includes a poem in Turkish from Gelibolu 'Ali's *Epic Deeds of Artists* (*Menâkıb-ı Hünerveran*), which praises the calligrapher Muhyiddin al-Amâsî and his relatives, listing the 'seven masters' including Muhyiddin and Hamdullah.[45] Later Ottoman manuscripts too are easily identified, thanks to the polychrome and gold headpieces and their floral-patterned marginal fills, even if colophons and *ex libris* notes are missing.[46]

While the preceding discussion has focused on a small selection of examples, it should nonetheless be clear that there was significant demand for deluxe copies of the *Qasida al-Burda* in both courtly and elite circles in the Ottoman capital. These examples provide only a limited snapshot of much broader intellectual networks, however. As we saw in the case of Muhyiddin al-Amâsî's *Qasida al-Burda*, for example, even famed copyists working in Anatolia had long-established links to Central Asia, and the large number of extant *al-Burda* manuscripts produced in Iran and

Central Asia in the fifteenth and sixteenth centuries certainly attests to the vitality of the culture of commentary on the poem in those regions. Manuscripts were a ubiquitous feature of the gift economies of Islamic courts – and diplomatic contact between the Ottomans and, for example, the courts of the Uzbek Khans, Safavid shahs and Mughal emperors only intensified the circulation of the *al-Burda* across this geography.[47]

The Qasida al-Burda's *appeal for the Ottoman Court*

Despite the widespread evidence for its circulation in manuscripts, however, there is every indication that the Ottomans were not initially taken with al-Būṣīrī's *qasida* – or at least, not its public display. As a rule, al-Būṣīrī's verses were not publicly displayed in Ottoman mosques, with the lone exception of the Masjid an-Nabawi in Medina, popularly known as the Prophet's Mosque, renovated and redecorated in the eighteenth century.[48] Only towards the end of the sixteenth century did al-Būṣīrī's poem make an imperial entry into the Ottoman world, when it was chosen to decorate Süleyman I's Privy Chamber in the Topkapı Palace.[49] Even then, however, the choice of the *Qasida al-Burda* for the space was not that of Süleyman himself, but his grandson, to coincide with the space's conversion into a treasury for relics of the Prophet. The tiled inscriptions bearing verses of the *al-Burda* were added under the patronage of Murad III in the context of the chamber's new function housing the holy standard, the sacred seal, and the tooth, footprint, hairs of the beard and holy mantle of the Prophet Muhammad. It came to be known as the Chamber of the Holy Mantle (*Hırka-i Saadet*), and al-Būṣīrī's poem was thus a fitting accompaniment.

There is no record of the *Qasida al-Burda* being displayed elsewhere in the Topkapı Palace – or in any other location in Istanbul – for another century, until two major fires in the Harem quarters in 1662 and 1665 led Mehmed IV to undertake major rebuilding and renovation.[50] Thereafter, however, it proliferated, with the poem being conspicuously displayed in several locations. For example, after the 1665 fire, Mehmed had his Privy Chamber and the adjoining pavilion decorated with the first fifteen couplets of the *al-Burda* written on blue and white tiles forming a band around the entire chamber and between the two tiers of windows on one side.[51] The reconstruction between 1666 and 1668 set the tone for the redecoration of other sections of the Harem, with inscriptions of verses from the *Qasida al-Burda* being added to a variety of spaces, including the courtyard of the Black Eunuchs.[52] Mehmed IV's second son, Ahmed III, followed his father's lead and in 1705 also had the *Qasida*'s third chapter written in gold on a calligraphic band that ran around his Privy Chamber.[53] Further

examples could be adduced. Throughout the decorative programme of the Chamber of the Holy Mantle, and the Harem generally following the 1665 fire, there is a marked stress on the Prophet's person and the salutary power of meditating on his virtues.

The intensification of the veneration of the Prophet during the reigns of Mehmed IV and his sons is striking given the influence of the Kadızadeli reformers at the court. After all, the Kadızadelis were given to condemning many Ottoman religious practices as *bid'ah* – non-Islamic. This led to the much-discussed violent quarrels between the puritan Kadızadelis, who dominated the court, and their rivals, the Sufis. Būṣīrī's *qasida*, too, had long been suspect in the eyes of orthodox scholars, who argued that its adoration – and elevation – of the Prophet bordered on 'blatant *shirk*': that is to say, it went against the central tenet of Islam, the belief in God's singular unity (*tawhid*).[54] Nonetheless, the notion of the 'Path of Muhammad' (*al-Tariqah al-Muhammadiyyah*), relating either to a return to the model of the Prophet or to his age, found a voice in Ottoman scholarly circles, among both Sufis and non-Sufis. It is difficult to avoid the conclusion that, starting with the reign of Mehmed IV, there was a shift in attitude towards the *Qasida al-Burda* at the Ottoman court.[55] It seems that, despite arguments that its verses contained blasphemy (*kufr*) and heresy, the *Qasida al-Burda* came to be accepted by mainstream Islamic scholarship as a pure expression of deep and passionate love for the Messenger of God – love for whom is a condition of the Faith. In other words, the 'non-Islamic' aspects that conservative scholars had long pointed to, such as swearing an oath by the name of anyone other than Allah or claiming that believers should call out to the Prophet in times of distress, came to be tolerated. Put simply, opposition to the *al-Burda* gradually faded at the late seventeenth- and early eighteenth-century Ottoman court.

The display of the *Qasida al-Burda* on Mahmud I's new *şadırvan* for Hagia Sophia represented the next stage in this process. Mahmud I, Mehmed IV's grandson and Mustafa II's heir, had also been born into the puritanical Kadızadeli court in Edirne in 1696, and after his father's deposition and death in 1703, he grew up under his uncle Ahmed III's tutelage, succeeding him in 1730 following the bloody Patrona revolt. That the ablution fountain at Hagia Sophia – the first structure built as part of his renovation project – should have so prominently displayed the *Qasida al-Burda* on its entablature thus reflects the climate at the Ottoman court and in the capital at the time.

Pilgrims and Popular Reception: The Poetics of Nostalgia and Devotion

The growing acceptance of the *Qasida al-Burda* at the Ottoman court reflects developments in the Muslim world more generally. In the early eighteenth century, there was a new emphasis on the figure of the Prophet and the centrality of the Prophetic tradition (*hadith*) and example (*sunna*). In this climate, al-Būṣīrī's poem seems to have also found new appeal. The *şadırvan* inscription invites its audiences to engage in nostalgic recollection and celebratory praise. Crowds gathering in the courtyard of Hagia Sophia are invited to reproduce a cultural memory of the Prophet by way of the poem – notwithstanding the illegibility of the text's classical Arabic for many of its reciters. Although it is impossible to quantify the *Qasida al-Burda*'s popularity in the Ottoman capital, the sheer volume of Turkish translations and commentaries attest to its widespread reception among Islamic scholars, Sufis and the general public. It also resonated with meaning for the city's many visitors. In particular, for Asians in the retinues of Eastern envoys, or passing through as pilgrims en route to Mecca and Medina, the verses of al-Būṣīrī's *qasida* inscribed on the fountain's entablature resonated with meaning, evoking Sufi practices of devotion to the Prophet.

It is true that, all things being equal, the shortest route from Central Asia to Mecca was via Khorasan, then Basra, and finally on to Mecca either overland or by ship. Frequent political disputes between Iran and the Khanates, however, as well as the enduring attraction of Istanbul for those in pursuit of knowledge or commercial goods, made the more indirect route attractive for many travellers.[56] Many of these travellers stayed in 'Afghan', 'Uzbek', 'Kashgari' or 'Bukharan' lodges, many of them founded in the late seventeenth and eighteenth centuries, that were part Sufi confraternity and part urban *caravanserai*.[57] The majority of these lodges in Eyüb were also in close proximity to an important secondary pilgrimage site, the Tomb of al-Ayyub, Muhammad's companion and standard bearer. Despite being predominantly Naqshbandi lodges, these institutions also welcomed devotees of other Sufi orders arriving in the city.[58]

These lodges were a primary locus of interaction between the Ottoman elite and Central Asian visitors. Their local patrons and supporters, who were influential Ottoman statemen and Islamic scholars, presented a uniform character to the locals because of their Mujaddidî and Malâmî affiliations.[59] They mixed and mingled with the *şeyhs*, exchanging ideas, favours and gifts. As a result, among those travelling dervishes who chose

to stay even longer, some found positions in the Ottoman administration. The lodges were also a gathering place for skilled calligraphers, poets, painters and craftspeople to ply their trades, including copying manuscripts.

The *Qasida al-Burda* held a special place in Sufi worship. Like Jazuli's *Dalāʾil al-khayrāt*, al-Būṣīrī's *al-Burda* was recited out loud during Shadhiliya Sufi gatherings, for example.[60] One couplet was performed for seven days for healing the paralysed and in the hope of curing the mentally disturbed. The verses of the *Qasida* were also recited as a devotional song for the enjoyment and edification of listeners as religious music (*şuğul*). Communal recitations as a means of *dhikr* or collective supplication, public celebrations and observation of holy days and nights – particularly the Prophet's birthday (*mawlid al-nabî*) – were widespread.[61] Pilgrims visiting the city, therefore, would pass through environments that were suffused with the *Qasida al-Burda* and its commentaries – in books, in music and in solemn recitation, as well as other media.[62]

For their part, the Ottoman sultans – conscious of their role as Caliphs and Protectors of the Holy Cities – not only placed the Prophet at the centre of religious life, but also involved themselves in the provision and protection of the pilgrimage routes.[63] They periodically restored the Kaʿba in Mecca and the Prophet's Tomb in Medina, located in the southeastern corner of the Masjid an-Nabawi (the Mosque of the Prophet). In 1630, for example, Murad IV ordered the reconstruction of the Kaʿba after it partly collapsed following torrential rain. Mustafa II and Ahmed III, too, refurbished the Masjid an-Nabawi, with verses from the first part of the *Qasida al-Burda* inscribed in the newly-built domes covering the prayer hall – verses that would later adorn the ablution fountain of Hagia Sophia.[64] The Prophet's Tomb, known as the Sacred Chamber, was adorned with the poems of K'ab ibn Zuhayr and al-Būṣīrī, both called *al-Burda*, and a line from al-Būṣīrī's *qasida* is also inscribed on a lock of the house of the Prophet's daughter, Fatima, which is adjacent to the Masjid an-Nabawi.[65] For Muslims on the pilgrimage, therefore, the *Qasida al-Burda* symbolically connected Istanbul to the geography of the Prophet's life.

Simultaneously, however, Hagia Sophia was promoted as a site of secondary pilgrimage in its own right and was perceived, at least by some, as an integral component of the Hajj. As Gülru Necipoğlu has shown, Hagia Sophia became the focus of a number of legends following its consecration as a mosque by Mehmed II, including that it had been consecrated by the Prophet himself and that any who prayed there would go to Paradise.[66] Sixteenth-century Ottoman authors went so far as to compare Hagia

Sophia's sanctity both to that of the al-Aqsa Mosque in Jerusalem, the site of the Prophet's ascension to heaven on his Night Journey, and to that of the Ka'ba in Mecca.[67] Central Asians held Hagia Sophia in particularly high esteem, and propagated its significance as an integral part of their onerous pilgrimage to Mecca in a number of pilgrimage manuals. By the nineteenth century the name Hagia Sophia/Ayasofya itself – erroneously read as 'Ayoz Sofi' or 'Ayaz Sufi' – was being explained as deriving from a mythical Sufi founder.[68] The account of an early twentieth-century pilgrim from Tashkent, Mirim Khan, whose manual was composed in vernacular Turki (Chagatay), describes the all-encompassing experience of visiting Hagia Sophia in Ramadan:

> the heart helped to make sense of the material world . . . its eyes see the sights of the unseen, its ears hear God's speech, its nose smells the perfumes of the heavenly realm, its tongue tastes divine love and interior knowledge, and the sense of touch, which spread all over its exterior, gives a comprehensive experience of the unseen world.[69]

For this pilgrim, Hagia Sophia was as transformative a destination as the holy sites of the Hijaz.

Conclusion: A Source of Longing and Meaning

Throughout the eighteenth century, the popularity of visiting Eyüb and Hagia Sophia did not wane among the pilgrims who departed from Asian countries on their journey to Mecca and Medina. Some chose to stay in the Ottoman capital, others continued to wander with no fixed destination, others still returned after the successful completion of the Hajj. All, however, were in search of meaning about themselves or a higher good.

For these individuals, then, the prominent display of the *Qasida al-Burda* on the new ablution fountain commissioned for Hagia Sophia had a dual significance: simultaneously a signpost of the Hajj and recognition of a shared religious idiom. The inscribed couplets reference the sacred geography of the Hijaz – the valley of Dhu Salam between Basra and Mecca, the settlement of Kazimah on the Kuwaiti coast, the Wādī al-Ḥamḍ (Idam) in the region of Medina – but the named places do not correspond to any pilgrimage route that al-Būṣīrī, or anyone else, would have taken to Mecca from Egypt. In Stetkevych's words, they 'form a poetic and spiritual genealogy rather than a geographical itinerary'.[70] At the same time, however, they also neatly reference a view of the Hijaz from the north, as if approaching via Khorasan and Basra. Though this direct route was frequently closed to travellers, the verses inscribed on Hagia Sophia's

ablution fountain functioned as symbolic waystations on a spiritual Hajj, reminding the pilgrim of both origin and destination.

At the same time, the poem's sensuous language of longing – the poet's love-sick passion, the beloved's anguished tears – remind the reader of their place in a broader landscape of shared religious experience, especially in its Sufi idiom.[71] A rich corpus recalling a feeling, memory, or image of the Prophet Muhammad to mind and a devotional poetic pilgrimage, in verse, tune and image, grew around the Hajj ritual and circulated in the form of praise poetry, *qasida*s, manuscript paintings, tile panels or calligraphic compositions, as well as pilgrim diaries in several languages. Those verses, therefore, memorised by heart by Muslims across the Islamic world would have been easily recognisable in this crowded meeting place where foreigners mixed and mingled with locals. The fountain's shared architectural grammar with other contemporary fountains founded with elite and courtly patronage at the Bukhara and Kashgari lodges only underscores its status as a meeting place of the local and the international.

As much as the inscription of Hagia Sophia's ablution fountain transported the reader to the spiritual geography of the Hajj, it also firmly located them in Istanbul. It is likely that in 1740, during the construction of Mahmud I's fountain, fragments of the Justinianic atrium and the original fountain that stood before Hagia Sophia's entrance, the Holy Well or *Phiale*, were still extant.[72] Archaeological evidence from this period indicates a complex and thorough re-design and repair of the subterranean waterways in the area.[73] Although no remnants from the Holy Well are visible today, the possibility that the Ottomans knew its location in the eighteenth century makes Mahmud I's commission of a new ablution fountain all the more striking. Hagia Sophia's 'popular' conceptualisation as not just a symbol of Ottoman imperial glory, but also a site of devotion to the Prophet in its own right, indicates that the inscription of the *Qasida al-Burda* resonated on multiple planes of significance.

The *şadırvan* of Hagia Sophia is located at the intersection of local and international, traditional and novel, ancient and modern. Its audience was more than just the faithful seeking entry, but a multicultural crowd of painters and pilgrims, artists and ambassadors, musicians and mystics who flocked to the cosmopolitan Ottoman capital. By locating ourselves before the fountain, taking in the gilded lettering of al-Būṣīrī's *qasida*, we thus stand at the intersection of multiple religious and intellectual networks whose extent stretched far from eighteenth-century Istanbul. It is precisely the mobility of the people and objects through these networks, however, that led to the paradoxes of Hagia Sophia's ablution fountain – the meeting place of all, the local and the foreign, locals and foreigners.

Notes

1. Jelena Bogdanovic, *The Framing of Sacred Space: The Canopy and the Byzantine Church* (Oxford: Oxford University Press, 2017), 165–8: *ΝΙΨΟΝ ΑΝΟΜΗΜΑΤΑ ΜΗ ΜΟΝΑΝ ΟΨΙΝ*. The phrase is variously attributed to Gregory of Nazianzus, the fourth-century bishop of Constantinople, or to the emperor Leo the Philosopher (886–911). See: Federico Broilo, 'A Dome for the Water: Canopied Fountains and Cypress Trees in Byzantine and Early Ottoman Constantinople', in B. Shilling and P. Stephenson (eds), *Fountains and Water Culture in Byzantium* (Cambridge: Cambridge University Press, 2016), 314–23.
2. On al-Būṣīrī and the *Qasida al-Burda*, see: René Basset, *La Bordah du cheikh El-Bousîrî, poème en l'honneur de Mohamed, traduite et commentée* (Paris: Ernest Leroux, 1894); T. Emil Homerin, 'al-Būṣīrī', *EI³* 2010/1, http://dx.doi.org/10.1163/1573-3912_ei3_COM_23124 (accessed 27 July 2023); Annemarie Schimmel, *And Muhammad Is His Messenger: The Veneration of the Prophet in Islamic Piety*, Studies in Religion (Chapel Hill, NC: University of North Carolina Press, 1985), 181–7. For a list of commentaries, see: Carl Brockelmann, *Geschichte der arabischen Litteratur*, vol. 1 (Weimar: Emil Felber, 1898), 264–7.
3. Suzanne Stetkevych, *The Mantle Odes: Arabic Praise Poems to the Prophet Muḥammad* (Indianapolis, IN: Indiana University Press, 2010), 92–3, 95.
4. Secondary pilgrimages (i.e., visits to shrines and tombs of the pious and saintly) were extremely popular, either as a substitute for *hajj* or as an addition to it: Thierry Zarcone, 'Pilgrimage to the "Second Meccas" and "Ka'bas" of Central Asia', in Alexandre Papas et al. (eds), *Central Asian Pilgrims: Hajj Routes and Pious Visits between Central Asia and the Hijaz* (Berlin: Klaus Schwarz Verlag, 2011), 251–77; Yusuf Sarınay, 'Türkistanlı Hacıların Ziyaret Merkezi olarak İstanbul', *Bilig Türk Dünyası Sosyal Bilimler Dergisi* 88 (2019): 1–18; Güllü Yıldız, 'Iranlı Hacıların Gözüyle İstanbul'u Temâşâ', *Marmara Üniversitesi İlâhiyat Fakültesi Dergisi* 51 (2016): 135–60.
5. Sezer Tansuğ, '18. Yüzyılda İstanbul Çeşmeleri ve Ayasofya Şadırvanı', *Vakıflar Dergisi* 6 (1965): 93–101; idem, 'The Fountains of Istanbul in the 18th Century and the Shadirvan of Saint Sofia', *Vakıflar Dergisi* 6 (1965): 102–10.
6. See especially: Doğan Kuban, *Türk Barok Mimarisi Hakkında Bir Deneme* (İstanbul: İTÜ Mimarlık Fakültesi, 1954); Ünver Rüstem, *Ottoman Baroque: The Architectural Refashioning of Eighteenth-Century Istanbul* (Princeton: Princeton University Press, 2019).
7. Tansuğ, '18. Yüzyılda İstanbul Çeşmeleri'.
8. On ablution fountains generally, see: Ali Kılcı, 'Şadırvan', *TDV İslâm Ansiklopedisi* 38 (2010), 219–21; Affan Egemen, *İstanbul'un Çeşme ve Sebilleri* (İstanbul: Arıtan Yayınevi, 1993), 154–7.

9. While there are a few contemporary poets of the same name, the most plausible candidate is Mehmed Emin (d. 1743/44 [AH 1156]), a member of the Hâdîzâde faily of Bursa, who died in Mecca and was buried in the Şahabeddin Mosque. For the text and images of the inscription, see: *Database for Ottoman Inscriptions/Osmanlı Kitabeleri Projesi*, K965, http://www.ottomaninscriptions.com/verse.aspx?ref=list&bid=873&hid=965 (accessed 27 July 2023).
10. The drawings made for the mirror-image finial made by Hüsrev Tayla, over a photograph noted 'Bursa Uluâbâd Issız Han' (Bayezid I, 1396) during the 1963 restoration of the Ayasofya Şadırvanı, suggest that this was a twentieth-century addition.
11. *Database for Ottoman Inscriptions/Osmanlı Kitabeleri Projesi*, K964, http://www.ottomaninscriptions.com/verse.aspx?ref=list&bid=873&hid=964 (accessed 27 July 2023).
12. Stetkevych, *Mantle Odes*, 92–5.
13. On the *Qasida al-Burda*, see above all: Stetkevych, *Mantle Odes*; eadem, 'From Sīrah to Qaṣīdah: Poetics and Polemics in al-Buṣīrī's Qaṣīdat al-Burdah (Mantle Ode)', *Journal of Arabic Literature* 38/1 (2007): 1–52; eadem, 'From Text to Talisman: Al-Būṣīrī's Qaṣīdat al-Burdah (Mantle Ode) and the Poetics of Supplication', *Journal of Arabic Literature* 37/2 (2006): 145–89.
14. Baltacızâde Mustafa (then Ağa) was commissioned to work in other parts of Mahmud's renovation of Hagia Sophia, including the calligraphic band of verses from the *Sura Fatr* that decorates the domed chamber in the new library at Hagia Sophia (see below), as well as a Qur'anic inscription panel, composed by Şeyhülislâm Pirî Sâlih Efendi, which, we are told, was placed on a monumental gate into the complex. See: 'Mustafa Paşa bin Mehmed Paşa [Baltacı-zâde Silâh-dâr Mustafa Paşa]', *Müstakîmzâde Süleyman Sa'deddîn Efendi, Tuhfe-i Hattâtîn*, ed. Mustafa Koç (İstanbul: Klasik Yayınlar, 2014), 482–3. Unfortunately, the panel is lost and it is no longer possible to identify the gate it once decorated. Other calligraphic panels from the complex were distributed to other museums and mosques on Hagia Sophia's conversion into a museum, including one by Yesarîzade now in the Turkish and Islamic Arts Museum (TIEM) and two others by Hulusi Efendi and Abdürrauf Efendi, which were transferred to Sultanahmed Mosque, yet there is no record of others: Azade Akar, 'Ayasofya'ya Bulunan Türk Eserleri ve Süslemelerine Dair Bir Araştırma', *Vakıflar Dergisi* 9 (2006): 277–90.
15. On al-Būṣīrī's biography see: Stetkevych, *Mantle Odes*, 82.
16. It has also been claimed that the poem makes no mention of a physical illness, but rather refers to a spiritual crisis or malady: Stefan Sperl, 'Al-Busuri's Burdah', in Stefan Sperl and Christopher Shackle (eds), *Qasida Poetry in Islamic Asia and Africa, Vol. 2: Eulogy's Bounty, Meaning's Abundance: An Anthology* (Leiden: Brill, 1996), 470–1.
17. See e.g. Scott Cameron Levi and Ron Sela, *Islamic Central Asia: An Anthology of Historical Source*s (Bloomington, IN: Indiana University Press, 2010),

206; Guantian Ha, 'Hui Muslims and Han Converts: Islam and the Paradox of Recognition', in Stephan Feuchtwang (ed.), *Handbook on Religion in China* (Cheltenham: Edward Elgar, 2020), 316.
18. Kâtib Çelebi, *Keşfü'z-zunûn* (Istanbul: Tarih Vakfı, 2007). For further information on translations and commentaries in Turkish, see especially: Sadık Yazar, *Anadolu Sahası Klâsik Türk Edebiyatında Tercüme ve Şerh Geleneği* (Ph.D. diss., İstanbul Üniversitesi, 2011).
19. Zeren Tanındı, 'Additions to Illustrated Manuscripts in Ottoman Workshops', *Muqarnas* 17 (2000): 147–61.
20. Stetkevych, *Mantle Odes*, xii. Ibn Khaldun's account of his encounter with Timur outside Damascus is included in the autobiographical section of his monumental historical chronicle, the *Kitāb al-'Ibar*: Walter J. Fischel, *Ibn Khaldun and Tamerlane (*Berkeley: University of California Press, 1952), 29–47.
21. For the Mamluk manuscripts see: Esin Atıl, *Renaissance of Islam. Art of the Mamluks* (Washington, DC: Smithsonian Institution Press, 1981), 46–8. Some fifty luxury copies of al-Burda are held in manuscript libraries in the United Kingdom and Ireland: nine (including one commissioned by the Mamluk ruler Qaitbay [r. 1468–95]) in the Chester Beatty Library, Dublin and a further forty in the British Library, London: Arthur Arberry, *A Handlist of the Arabic Manuscripts in the Chester Beatty Library, vol. 5* (Dublin: Walker, 1962), 55; Peter Stocks and Colin Baker, *Subject-Guide to the Arabic Manuscripts in the British Library (*London: British Library, 2001), 304–5; Elaine Wright, *Islam: Faith, Art, Culture. Manuscripts of the Chester Beatty Library* (London: Scala, 2009), 44–5.
22. For a pioneering study of Ottoman manuscript notes in the library of a single collector: Berat Açıl (ed.), *Osmanlı Kitap Kültürü, Cârullah Efendi Kütüphanesi ve Derkenar Notları* (Ankara: İlem Kitaplığı, 2020).
23. Istanbul, Süleymaniye Kütüphanesi, Ayasofya 4170. Gülbin Mesara, *Türk Sanatında Ince Kağıt Oymacılığı* (Istanbul: İş Bankası, 1991), figs 42–3; *Mürekkebin İzi: Yazma Eserler Seçkisi* (Istanbul: Türkiye Yazma Eserler Kurumu Başkanlığı, 2020), 184, no. 75.
24. For other examples of *al-Burda* decorated in decoupage from the Istanbul collections: Istanbul, Bâyezîd Devlet Kütüphanesi 3462 and 9279. See also: Zeynep Atbaş, 'Artistic Aspects of Sultan Bayezid II's Book Treasury Collection: Extant Volumes Preserved at the Topkapı Palace Museum Library', *Treasures of Knowledge: An Inventory of the Ottoman Palace Library (1502/3–1503/4)*, vol. 1, *Essays*, Muqarnas Supplements 14 (Leiden: Brill, 2019), 161–211.
25. Balcızade Tahir Harimi, *Tarih Medeniyette Kütüphaneler* (Balıkesir: Vilayet Matbaası, 1931), 473.
26. It was expanded by manuscripts bequested by Osman III and Mustafa III: İsmail Baykal, 'Topkapı Müzesi Kitaplıkları', *Güzel Sanatlar Dergisi* 6 (1949): 75–84.

27. Takamatsu located seven catalogues of the Hagia Sophia library: Yoichi Takamatsu, 'I. Mahmûd Döneminde Ayasofya Kütüphanesi ve Koleksiyonu', in Hatice Aynur (ed.), *Gölgelenen Sultan, Unutulan Yıllar. I. Mahmûd ve Dönemi (1730–1754)* (Istanbul: Dergâh, 2020), 309–57. See also: Günay Kut, 'Sultan I. Mahmud Kütüphanesi (Ayasofya Kütüphanesi)', in Özlem Bayram et al. (eds), *Osmanlı Devleti'nde Bilim ve Kültür ve Kütüphaneler* (Istanbul: Türk Kütüphaneciler Derneği, 1999), 99–128; Said Öztürk, 'Bir Yazma Eser Kütüphanesi: Sultan I. Mahmud'un Ayasofya Kütüphanesi ve Kütüphane Vakfı', in *I. Ulusal Islam Elyazmaları Sempozyumu* (Istanbul: Türçek, 2009), 156–68.
28. For example: Istanbul, Süleymaniye Kütüphanesi, Ayasofya 516, fol. 68a–95a (a miscellany without an *ex libris*; five pieces have Mamluk headpieces; the sixth, which does not, has Bayezid II's and Mahmud I's seals); 2768, fol. 34a–40b; 3393, fol. 31a–40b; 4168, 1b–29a; 4863, 1b–5b (with Selim I's seal, an erased *ex libris*, and another partially legible *ex libris* that reads '. . . Efendi'); 2002, 40b–46a; 3405, 68b–83b; 3124, 74a–85a.
29. Baltimore, The Walters Art Museum, MS W.582; 'Poem in Honor of the Prophet Muhammad', The Walters Ex Libris, The Walters Art Museum, http://manuscripts.thewalters.org/viewer.php?id=W.582 (accessed 27 July 2023).
30. Walters, MS W.582, fol. 23a. While his name indicates he was from Khwarazm, it does not follow, of course, that the manuscript was copied there.
31. Ibid., fol. 1b.
32. Ibid., fol. 1a.
33. Ibrahim Hanîf's seal appears on several manuscripts now at the Nuruosmaniye Library: Müjgan Cumhur, 'Münif Paşa ve Kütüphanelerin Yönetimiyle İlgili İlk Resmi Talimatname', *Türk Kütüphaneciliği* 13/1–2 (1964): 28–35; for İbrahim Hanîf's role in Osman III's appropriation of Mahmud I's books: Esad Serezli, 'Nur-u Osmaniye Kütüphanesi (Bibliothèque de la mosquée de Nour-ou-Osmaniye)', *TTOK Belleteni* 76 (1948): 19–20.
34. Baltimore, The Walters Art Museum, MS W.581; 'Amplified Poem in Honor of the Prophet Muhammad', Walters Ex Libris, The Walters Art Museum, https://manuscripts.thewalters.org/viewer.php?id=W.581(accessed 27 July 2023).
35. Walters Art Museum W.581, fol. 27a.
36. For his marriage to the daughter of Murad I: Hasan Taşkıran, 'Karamanlı Sarayında Bir Osmanlı: Melek Hatun', *Türk & İslam Dünyası Sosyal Araştırmalar Dergisi* 3/6 (2016): 329–38.
37. Zeren Tanındı, 'Seçkin Bir Mevlevi'nin Tezhipli Kitapları', in C. Irvin Schick (ed.), *M. Uğur Derman. 65. Yaş Armağanı* (Istanbul: SU Publications, 2000), 513–36.
38. Paris, BnF, MS Arabe 6072. See: E. Blochet, *Catalogue de la collection de manuscrits orientaux, arabes, persans et turcs formée par M. Charles Schefer*

(Paris: Ernest Leroux, 1900), 58; M. G. Guesdon and A. Vernay-Nouri (eds), *L'Art du livre arabe: du manuscrit au livre d'artiste* (Paris: Bibliothèque nationale de France, 2001), no. 74, 105.

39. Adam Gacek, *Arabic Manuscripts: A Vademecum for Readers* (Leiden: Brill, 2009), 15.
40. *maʿshūqa-yi ʿārifān kitāb ast/ʿārif na-dahad kitāb az dast*. Wadād al-Qāḍī (Kadi), 'Scholars and Their Books: A Peculiar Islamic View from the Fifth/Eleventh Century', *Journal of the American Oriental Society* 124/4 (2004), 627–40.
41. Sotheby's London, 'Arts of the Islamic World', 3 October 2012, lot 56.
42. Ekrem Hakkı Ayverdi, *Fatih Devri Hattatları ve Hat Sanatı* (Istanbul: Fetih Derneği Yayınları, 1953), 46–7.
43. Ibid., 48.
44. For sixteenth-century Ottoman manuscript ornament, see especially: Yanni Petsopoulos (ed.), *Tulips, Arabesques and Turbans: Decorative Arts from the Ottoman Empire* (London: Alexandria Press, 1982), 186–204.
45. Christie's, 'Art of the Islamic and Indian Worlds', 5 October 2010, lot 303. For the poem: Gelibolu 'Ali, *Muṣṭafá Alī's Epic Deeds of Artists: A Critical Edition of the Earliest Ottoman Text about the Calligraphers and Painters of the Islamic World*, ed. and trans. Esra Akın-Kıvanc, Islamic History and Civilization 87 (Leiden: Brill, 2011), 326–7.
46. E.g. an Ottoman Turkish expansion of the *Qasida al-Burda* copied by 'Abd Allāh al-Wahbī, probably in the seventeenth century: New York City, Columbia University, Rare Book and Manuscript Library, MS Or 424.
47. For example, the Naqshabandi Zawiya, one of the many Sufi lodges in the Old City of Jerusalem, was also known as Uzbek Zawiya or Bukhari Zawiya. Its manuscript collection was begun by Mohammad Baha al-Din al-Bukhari, who settled in Jerusalem in 1616. For its collection, which contains 167 single-text manuscripts and ten miscellanies, see: *Bashīr 'Abd al-Ghanī Barakāt, Catalogue of Manuscripts of the Uzbek Zawiya in Jerusalem* (Jerusalem: Al-Shafi'i, 2003). For exchange between the Ottoman and Mughal courts, see: Ankita Choudhary, 'Books as Objects of Exchange: A Study of Cross-Cultural Interaction and Connected Systems between the Mughals and Ottomans', *Madison Historical Review* 17 (2020): 65–93.
48. Later, the Çinili Cami, commissioned in 1640 by the *valide sultan* Kösem Sultan, the mother of Murad IV and Ibrahim, has rectangular panels on the window and cabinet shutters inscribed with the *Qasida al-Burda*: İbrahim Hakkı Konyalı, *İstanbul Âbideleri* (Istanbul: Yedigün Neşriyatı, 1940), 27; idem, *Abideleri ve Kitabeleriyle Üsküdar Tarihi* (İstanbul: Yeşilay Cemiyeti Yayınları, 1976), 130–6.
49. Gülru Necipoğlu, *Architecture, Ceremonial, and Power: The Topkapı Palace in the Fifteenth and Sixteenth Centuries* (Cambridge, MA: MIT Press, 1991), 150.

50. There has been to date no comprehensive examination of the architectural inscriptions of the Harem. Previous studies have been partial and at times somewhat misleading: Ahmet Şimşirgil, *Taşa Yazılan Tarih. Topkapı Sarayı* (Istanbul: Tarih Düşünce Kitapları, 2005); Necdet Sakaoğlu, *Tarihi, Mekânları, Kitabeleri ve Anıları ile Saray-ı Hümayun Topkapı Sarayı* (Istanbul: Denizbank Yayınları, 2002). More reliably: Abdurrahman Şeref, 'Topkapı Saray-ı Hümâyunu', *Tarih-i Osmanî Encümeni Mecmuası*, fasc. 5–12 (1910–11). For a study of calligraphic tile panels: F. Zehra Dumlupınar, *Topkapı Sarayı Harem Dairesi 17. Yüzyıl Çini Pano Tasarımları* (Ph.D. diss., Marmara Üniversitesi, 2015), 11–55.
51. Tülay Artan, 'Art and Architecture', in Suraya Faroqhi (ed.), *The Later Ottoman Empire, 1603–1839*, vol. 3 of *The Cambridge History of Turkey* (Cambridge: Cambridge University Press, 2006), 460.
52. Ahmet Nezihi Turan, 'Mahremiyetin Muhafızları Darüssaade Ağaları', *The Journal of Ottoman Studies* 19 (1999): 123–48; Murat Kocaaslan, *IV. Mehmed Saltanatında Topkapı Sarayı Haremi. İktidar, Sınırlar ve Mimari* (Istanbul: Kitap Yayınevi, 2014). Şeref 1329: 8. Cüz, 473.
53. Tülay Artan, 'A Solemn Poem in the Midst of Temptation: The Privy Chamber of Ahmed III and the Qasida al-Burda', forthcoming.
54. Stetkevych, *Mantle Odes*, 102–4. *Shirk* may be translated as 'idolatry' or 'polytheism', i.e., the deification or worship of anyone or anything other than the singular God. Those advocating a return to the 'unadulterated' or 'pure' form of Islam practised by the first three generations of Muslims considered *al-Burda* to be *shirk* because some of the verses (such as couplets 33, 109, 152 and 154) praise the Prophet with attributes of Allah. Generally, see: Elizabeth Sirriyeh, 'Modern Muslim Interpretations of Shirk', *Religion* 20/2 (1990): 139–59.
55. For example, Rızâ'î, Seyyid Hasan b. Abdurrahman Aksarayî (d. 1669), praises Mehmed IV in his commentary of *al-Burda*, entitled *Miftâhû's Sa'âde* (completed 1652–3). He was a member of the Celvetiye order: Yazar, *Anadolu Sahası Klâsik Türk Edebiyatında Tercüme ve Şerh Geleneği*, 595–6.
56. Thierry Zarcone, 'Histoire et croyances des derviches turkestanais et indiens à Istanbul', *Anatolia moderna. Yeni Anadolu* 2 (1991): 137–200; Mustafa Kara, 'Bukhara–Bombay–Bursa Hattında Dervişlerin Seyr ü Seferi', *Divan: Disiplinlerarası Çalışmalar Dergisi* 20/1 (2006): 45–73; Scott Levi, *The Bukharan Crisis: A Connected History of Eighteenth-century Central Asia*, Central Asia in Context (Pittsburgh: University of Pittsburgh Press, 2020). For Central Asian trade, see: Audrey Burton, *Bukharan Trade, 1558–1718* (Bloomington, IN: Indiana University Press, 1993); eadem, *The Bukharans: A Dynastic, Diplomatic and Commercial History 1550–1702* (New York: St Martin's Press, 1997); Magnus Marsden, 'Beyond Bukhara: Trade, Identity and Interregional Exchange Across Asia', *History and Anthropology* 29 (2018): 84–100.

57. There is not space here for a comprehensive list of these foundations. To cite a few examples, the 'Afghan' lodge in Üsküdar was built in in 1792/3: M. Baha Tanman, 'Afganîler Tekkesi', *TDV İslâm Ansiklopedisi* 1 (1988), 400. Three lodges in Istanbul were known as *Özbek Tekkesi*. One, located in Kadırga/Küçükayasofya, and also known as 'Bukharan' (*Buhârî Tekkesi*), was built in 1692 by İsmail Efendi, the Head of the Financial Department in İstanbul. From the late eighteenth century onwards, the *şeyhs* also served as the ambassador between the two states: M. Baha Tanman, 'Özbekler Tekkesi', *TDV İslâm Ansiklopedisi* 34 (2007), 121–3. The others, at Eyüb and Sultantepe/Üsküdar, were founded in 1740 and 1753 respectively. See: Martin Smith, 'The Özbek Tekkes of İstanbul', *Der Islam* 57/1 (1980): 130–9; Cengiz Bektaş, 'Üsküdar'ın Sultantepe'sindeki Özbekler Tekkesi', *Tarih ve Toplum Dergisi* 8 (1984): 40–5. Generally, see: Hamit Algar, 'Tarîqat and Tarîq: Central Asian Naqshbandîs on the Roads to Haramayn', in *Central Asian Pilgrims*, 21–135; Lale Can, *Spiritual Subjects: Central Asian Pilgrims and the Ottoman Hajj at the End of Empire* (Stanford: Stanford University Press, 2020, 65–93.
58. Baxtiyor Babadzanov, 'On the History of the Nashbandiya Mugaddidiya in Central Mawara'annahr in the Late 18th and Early 19th Centuries', in Anke von Kügelgen et al. (eds), *Muslim Culture in Russia and Central Asia from the 18th to the Early 19th Centuries* (Berlin: Klaus Schwarz, 1996), 385–413.
59. Mehmet Akif Köseoğlu, 'İstanbul'da Nakşî-Ahrârî ve Nakşî-Mücedidî Şeyhlerin Post-Nişîn Olduğu Tekkeler ve Günümüzdeki Durumları', in Rıdvan Yıldırım (ed.), *Uluslararası Melâmîlik ve Seyyid Muhammed Nûru'l-Arabî Sempozyumu Bildirileri* (Ankara: T.C. Başbakanlık, 2016), 65–86.
60. Ö. Tuğrul İnançer, 'Rituals and Main Principles of Sufism during the Ottoman Empire', in Ahmet Yaşar Ocak (ed.), *Sufism and Sufis in Ottoman Society: Sources, Doctrine, Rituals, Turuq, Architecture, Literature, Fine Arts, and Modernism* (Ankara: TTK, 2005), 144.
61. Mahmut Kaya, 'Kasîdetü'l-Bürde', *TDV İslâm Ansiklopedisi* 24 (2001), 568–9.
62. The ubiquity of the *Qasida al-Burda* is also reflected in the portable objects that circulated in the Islamic world. For example, a late eighteenth- or nineteenth-century Ottoman sword, comprising an Iranian blade, North African rhinoceros-horn hilt and a pommel carved with a design inspired by Mughal hardstones, signed by the master swordsmith Acemoğlu, is inscribed with the opening lines of the *Qasida al-Burda* to invoke the Prophet's protection for the bearer: David G. Alexander, *Islamic Arms and Armor in The Metropolitan Museum of Art* (New Haven, CT: Yale University Press, 2015), nos 60 and 63, 161–3, 168–9.
63. See generally: Suraiya Faroqhi, *Pilgrims and Sultans: The Hajj Under the Ottomans, 1517–1683* (London: I. B. Tauris: 1996), 139–42; Nir Shafir, 'In an Ottoman Holy Land: The Hajj and the Road from Damascus, 1500–1800', *History of Religions* 60/1 (2020): 1–36.

64. With the advent of the puritan Wahhābi movement in Saudi Arabia, which calls the *Qasida al-Burda* 'an ode to shirk', some portions of the poem were painted over in 1925, leaving only two lines visible. Eyüp Sabri Paşa recorded in the nineteenth century that the inscription was from the *qasida*'s first part, the Prophetic *nasīb* (verses 1 to 12). He himself penned a commentary on *al-Burda*: Stetkevych, *Mantle Odes*, 92–5.
65. Robert Hillenbrand, *Islamic Architecture: Form Function and Meaning* (Edinburgh: Edinburgh University Press, 1994), 72–3; Salma Samar Damluji (ed.), *The Architecture of the Prophet's Holy Mosque, al Madīnah* (London: Hazar, 1998); Syed Ahmad Iskandar Syed Ariffin, *Architectural Conservation in Islam: Case Study of the Prophet's Mosque* (Johor Darul Ta'zim: Penerbit UTM, 2005), 88–9, 109. The lock is a symbolic recollection of a confrontation which took place at the home of Fatima, shortly after the Prophet's death in 632. For commentary, see: Stetkevych, *Mantle Odes*, 97.
66. Gülru Necipoğlu, 'Life of an Imperial Monument: Hagia Sophia after Byzantium', in Robert Mark and Ahmet Ş. Çakmak (eds), *Hagia Sophia from the Age of Justinian to the Present* (Cambridge: Cambridge University Press, 1992), 195–225, esp. 198–202. See also: Stéphane Yerasimos, *La fondation de Constantinople et de Sainte-Sophie dans les traditions turques. Légendes d'Empire* (Paris: Institut français d'études anatoliennes et Jean Maisonneuve, 1990); Ferhat Aslan, *Ayasofya Efsaneleri* (İstanbul: İstanbul 2010 Avrupa Kültür Başkenti, 2010).
67. Necipoğlu, 'Hagia Sophia after Byzantium', 201. It was even described as a substitute for the Ka'ba for the poor who could not afford to undertake the Hajj. See e.g. Ali Emre Özyıldırım, *Mâşî-zâde Fikrî Çelebi ve Ebkâr-ı Efkâr'ı. On Altıncı Yüzyıldan Sıradışı Bir Aşk Hikâyesi* (Istanbul: Dergâh, 2017), 240: *Ka'beye varıbilmeyen fukara/Varmış olur ana gelürse sana*.
68. Can, *Spiritual Subjects*, 41, 201, n. 21; Sharifa Tosheva, 'The Pilgrimage Books of Central Asia: Routes and Impressions (19th and early 20th centuries)', in *Central Asian Pilgrims*, 240.
69. Mirim Khan, *Hajjnoma-i Turkiy*, quoted in Can, *Spiritual Subjects*, 41–3. I here quote Can's translation of the original Chagatay.
70. Stetkevych, *Mantle Odes*, 274, n. 47.
71. This layer of meaning cannot, of course, be separated from the first. For example, ''Udhri passion' in the ninth couplet alludes to ideal love, a love in abstention from the beloved, but also refers to the tribe of Udhra inhabiting the northern part of al-Ḥidjāz in the region of Wādī 'l-Ḳurā. Many love stories, recounting a passionate desire for an unattainable beloved, chastity and faithfulness until death, were first told here in the eighth century, and an elegiac amatory genre emerged among poets of the tribe. ʿUdhrī love (*al-ḥubb al-ʿudhrī*) is a common theme in classical Arabic poetry and influenced Islamic philosophy and mysticism.
72. The fountain is described in detail by Paul the Silentiary in his sixth-century *ekphrasis* of Hagia Sophia: Paul the Silentiary, *Descriptio Sanctae Sophiae*

(Ἔκφρασις τοῦ ναοῦ τῆς Ἁγίας Σοφίας), ed. Claudio De Stefani, Bibliotheca scriptorum Graecorum et Romanorum Teubneriana (Berlin: De Gruyter, 2011), lines 594–604, 41.
73. A previously-unknown sunken fountain, built in the sixteenth century, was discovered in 2011: Haluk Çetinkaya, 'Ayasofya Meydanında Bir Çukurçeşme', *Sosyal Bilimler* 4 (2011): 34–9. See further: Kâzım Çeçen, *Mimar Sinan ve Kırk Çeşme Tesisleri* (Istanbul: ISKI, 1988); idem, *İstanbul'un Osmanlı Dönemi Su Yolları* (Istanbul: ISKI, 1999).

Chapter 3

The Calligraphic Arts in the Age of Ottoman Architectural Renovation

Emily Neumeier

Upon entering Hagia Sophia, a visitor's eyes tend immediately to drift upward to take in its cavernous interior (Figure 3.1).[1] And, when they do, one of the first things that a viewer is bound to notice are the roundels of Islamic calligraphy hanging below the central dome, interspersed amid the upper galleries. These gargantuan panels, whose stark gold lettering leaps out from a field of dark forest green, remain one of the most visually strik-

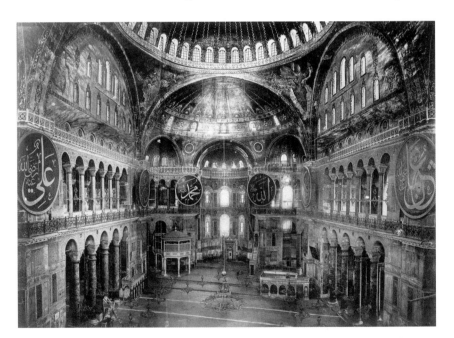

Figure 3.1 View of the interior of Hagia Sophia, Sébah & Joaillier, late nineteenth or early twentieth century. Library of Congress, Washington, DC, call no. LOT13554-2, no. 17.

ing interventions from the large-scale renovation of the building ordered by the Ottoman sultan Abdülmecid (r. 1839–61) and led by court architect Gaspare Fossati (1809–83) in the mid-nineteenth century. Even in one of the most famous architectural monuments in the world, with innumerable design features competing to attract one's attention, the calligraphic roundels remain impossible to ignore. In some ways, this series of monumental panels could be understood as a unicum, conceived for the demands of outfitting this particular architectural space. Especially in terms of their size, there is no doubt that these panels are distinctive. Each roundel is approximately 7.5 metres in diameter, spanning the entire height of the building's second level. The panels are still held to be some of the largest examples of Islamic calligraphy in the world, an impressive statistic more than a century and a half after their creation.[2]

One obvious explanation for the presence of these medallions in Hagia Sophia is their ability to punctuate the shift in the monument's function from the cathedral church of Byzantium to a sanctuary for Islamic prayer. It was as if these panels, as part of the Fossati restorations, were intended to function like bright flashing signs, announcing that this space was, ultimately, a mosque. It is strange to think that there would be any doubt about the matter four centuries after the conversion of the building, but perhaps there was a need to promote the patron Sultan Abdülmecid's role as the staunch protector of Islam, especially during a time when the ulema class feared that the wide-sweeping Tanzimat reforms would undermine their influence.[3] Concomitantly, the roundels may have worked to counterbalance the fact that the renovation mandated by the sultan included the uncovering of portions of the Byzantine mosaic programme, although the architects were careful to re-conceal all of the figural imagery after it was documented.[4] Even after Hagia Sophia became a world heritage monument in the twentieth century, the roundels continued to serve as prominent symbols of Islam. Yet in the recontextualised space of the secular museum, seen in tandem with the Byzantine decorations later restored in the 1930s, the panels also came to play their part in contributing to the notion of Hagia Sophia as a cosmopolitan stage for multi-culturalism across time.[5]

The significance of these calligraphic works, however, goes well beyond straightforward religious claims on this single building. The roundels can also be situated within a much broader context of restoration practices that included but were not exclusive to the repairs at Hagia Sophia, forming a proliferation of renovation projects across the Ottoman Empire throughout the long nineteenth century. This chapter will investigate how Islamic calligraphy played a pronounced role in such projects. The mosque at

Ayasofya was only one of many prominent architectural interiors that were retrofitted with oversized calligraphic panels executed by the court's leading artists, even some designed by the sultans themselves – all part of a co-ordinated, top-down public works effort to rejuvenate some of the most important landmarks in the empire. Further, the roundels at Hagia Sophia serve as a useful barometer for detecting the shifting aesthetics of architectural interiors over time. Specifically, they lead us to consider the significant transition in Ottoman mosque decoration from inscriptions fixed directly to the walls in tile and paint to independent calligraphic works that could be framed and hung in structures old and new. The calligraphic arts on display in Hagia Sophia are some of the most conspicuous and prominent examples of an important innovation in Ottoman art – the emergence of the framed panel, or *levha*.

The Calligraphy of Hagia Sophia

When Hagia Sophia was initially converted into a mosque upon the Ottoman conquest of Istanbul in 1453, there were no sweeping changes to the fundamental architectural scheme or even the decorative programme of the building. The Christian liturgical elements, including the iconostasis and altar, were removed to make way for the installation of the most essential pieces of mosque furniture, namely the mihrab and minbar. These were arranged slightly off-axis in the former apse area in order to face *qibla* (direction of the Ka'ba in Mecca).[6] It was only much later that the central prayer hall of the mosque would be adorned with monumental calligraphic panels. As discussed below, the first known examples were added in the seventeenth century, and it was during the Fossati restorations in the mid-nineteenth century that the plaques in question were evenly distributed around the main interior space at the gallery level, hung from the massive piers that support the building's dome and two semi-domes (Figure 3.2). The roundels bear the names of God and of several of the most revered individuals in the Islamic tradition.[7] Naturally, the panels with the names of God (Allah) and the Prophet Muhammad take pride of place in this arrangement, as they are located on the wall facing east in the direction of *qibla*.[8] Hanging on the four elephantine piers supporting the central dome are the roundels with the names of the *raşidin* (Ar. *rashidun*, 'the rightly guided'), the first four caliphs that succeeded Muhammad as the leader of the Muslim community after his death in 632 CE: Ebubekir, Ömer, Osman and Ali.[9] Back towards the main entrance to this central space, on the western side of the hall, are the two roundels with the names of Hasan and Hüseyin, the sons of Muhammad's daughter Fatima and Ali.

The Calligraphic Arts

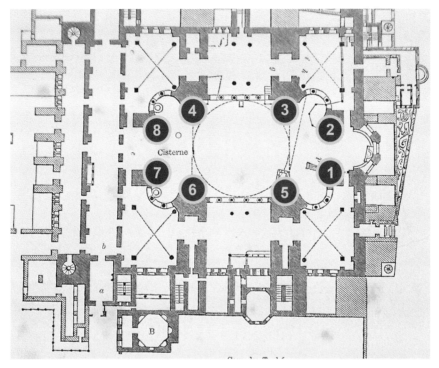

Figure 3.2 Diagram indicating the location of the calligraphic roundels placed in the interior of Hagia Sophia in the nineteenth century. Each roundel bears a revered name in the Islamic tradition: (1) Allah, (2) Muhammad, (3) Ömer [Umar], (4) Ali, (5) Ebubekir [Abu Bakr], (6) Osman [Uthman], (7) Hasan, (8) Hüseyin [Husayn]. The ground plan was adapted from Gaspare Fossati, *Aya Sofia, Constantinople: As Recently Restored by Order of H.M. the Sultan Abdul-Medjid* (London: R. & C. Colnagni & Co., 1852). Courtesy of the Gennadius Library, American School of Classical Studies at Athens.

At the bottom of the roundel bearing the name of Hüseyin, which would have been one of the last images to catch the eye of a visitor as they exited the main prayer hall, there is a calligraphic inscription – an artist's signature (Figure 3.3). The medallion of text spiralling upwards in a dense teardrop composition informs us that the calligraphic roundels in Hagia Sophia were designed by Kazasker Mustafa İzzet Efendi (1801–76) and completed in 1848–9 (AH 1265), that is, as part of the Fossati renovations.[10] This is the individual who was also responsible for the other major piece of calligraphy installed during the Fossati restorations, the circular composition at the apex of the central dome containing the Light Verse (*Nûr âyeti*) from the Qur'an (24:35).[11] Kazasker Mustafa İzzet Efendi was one of the most prominent court calligraphers under the reigns of both Sultan Mahmud II and Abdülmecid, and there are several other mosques

Emily Neumeier

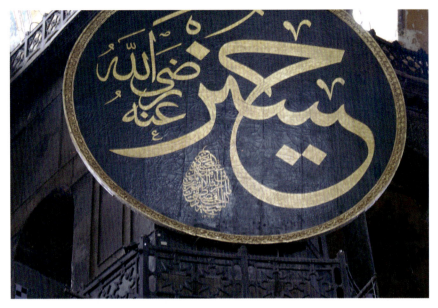

Figure 3.3 The roundel bearing the name of Hüseyin, with the artist's signature and date located at the bottom. Photo: author.

from the time period, both new and old, that are decorated with his work.[12] This includes the Hırka-i Şerif Mosque in Istanbul (c. 1851), which also features roundels with Sultan Abdülmecid's own calligraphy, here reduced to a much smaller scale to accommodate the proportions of the building (Figure 3.4).[13] Mustafa İzzet Efendi's efforts at Hagia Sophia were thus only part of a long list of royal commissions for large-scale calligraphic works to appear in imperial monuments.[14]

While Kazasker Mustafa İzzet Efendi was responsible for the calligraphic designs, there was an entire team of craftsmen behind the construction and installation of the panels at Hagia Sophia.[15] The roundels are composed of painted canvas (sailcloth) stretched on a wooden frame (Figure 3.5).[16] The skeleton of the wooden understructure is readily visible to a visitor standing in the upper galleries of Hagia Sophia. According to registers associated with the costs of the renovation project, the wood itself was linden, brought from the Istanbul shipyards: a material chosen for its high degree of flexibility, light weight and resistance to moisture.[17] Once the canvas had been stretched, Mustafa İzzet Efendi's compositions would have been transferred as an under-drawing, using a grid to ensure that the integrity of the original design be maintained even as it was magnified.[18] This method of enlarging calligraphic designs for architectural interiors is usually described in Turkish as the *murabba* ('square')

The Calligraphic Arts

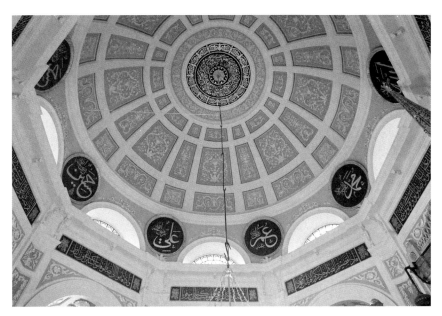

Figure 3.4 Interior of the Hırka-i Şerif Mosque, Istanbul. The calligraphic inscriptions located at the apex of the dome and below the spring line of the vaulting were designed by Kazasker Mustafa İzzet Efendi, while the roundels are the work of Sultan Abdülmecid. Photo: author.

 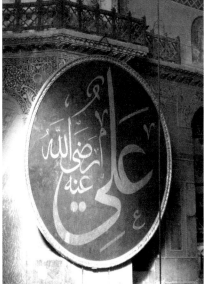

Figure 3.5 Front and rear view of the calligraphic roundels in Hagia Sophia, showing the wooden frame. Photos: author.

or *satranç* ('chessboard') technique, both terms referencing the use of a square matrix. The composition would have then been filled out with the green paint used for the background and the lettering covered with gold leaf.[19] The carved wooden frame, also covered with gold, was the last element added to the work before it was hung. Due to their immense size, the roundels must have been assembled on site; the completed panels would not have been able to pass through the doors. Interestingly, the roundels were produced by a multi-confessional team of craftsmen: while all of the individuals working on the calligraphic designs were Muslim, looking at their names we can see that the two carpenters responsible for the gilded frames – Dimitris and Andonis – were evidently Greek Christians.[20] It is tempting to compare the undulating scrollwork of the frames with the elaborately carved wooden iconostases found in churches throughout the empire, a trend that had come into vogue just a few decades earlier in the late eighteenth century.

The panels designed by Mustafa İzzet Efendi for the Fossati restorations were not created *sui generis*: they replaced a set of earlier calligraphic compositions that were added to the building approximately two hundred years earlier, in the mid-seventeenth century. In fact, the reason given by an official petition from the nineteenth century for the production of the new set of roundels was that the earlier panels were in need of renovation.[21] The first known depiction of the original set of panels appear in a series of drawings by Cornelius Loos, a young military officer who accompanied the Swedish King Karl XII to Istanbul in 1709 (Figure 3.6).[22] An eighteenth-century Ottoman account provides some further information about the plaques, stating that they were designed around 1650 CE (AH 1060) by Teknecizade İbrahim Efendi (d. 1688), an important calligrapher in his own day.[23] In a recent volume, Hasan Fırat Diker claims to have located the surviving panels stored away in the museum depot at Hagia Sophia.[24] He provides an accompanying photograph that is a partial view of what appears to be the plaque bearing the name of Muhammad, the image suggesting that the panels actually feature text in gold leaf on a matte black background (as opposed to the black text on a light ground indicated in the Loos sketches).[25] That being said, the Loos sketches provide some additional insight into the calligraphic works done by Teknecizade İbrahim, which are shown to have been rectangular in format, echoing the panels of marble revetment below. The drawings also reveal that there were only six plaques in this seventeenth-century set of calligraphic panels, bearing the names of God, Muhammad and the first four caliphs: the roundels with the names of Hasan and Hüseyin were a new addition during the Fossati restorations.[26] This was just one respect in

The Calligraphic Arts

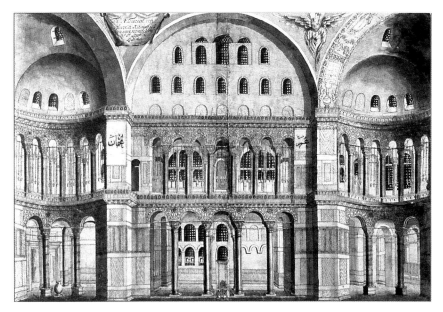

Figure 3.6 Cornelius Loos, Drawing of the Interior of Hagia Sophia, 1711. National Museum of Stockholm, inventory no. NMH THC 9107. Photo: Cecilia Heisser/ Nationalmuseum.

which the panels created by Kazasker Mustafa İzzet Efendi and his team were less of a duplication and more an innovative re-interpretation of previous interventions.

The Ottoman Age of Architectural Renovation

By the mid-eighteenth century, Ottoman imperial mosque complexes such as the ones dotting the hills along Istanbul's Golden Horn had increasingly fallen into disrepair. These circumstances were the natural result of the ambitious building campaigns launched by earlier generations. For example, the court architect Sinan (1490–1588) by his own count oversaw the construction of 136 mosques throughout the empire during his decades-long career, which spanned the reigns of three sultans.[27] These buildings were bound to require some updating and attention in due time. Consequently, the eighteenth and nineteenth centuries saw the emergence of mosque restoration as a significant form of architectural patronage for the sultan and the ruling elite.[28]

In Ottoman sources, the term most often used to describe restoration works – *tamirât* – is remarkably expansive in definition; it could refer to anything from the replacement of a gutter to the addition of an entirely

new structure. Examples on the ground are equally wide-ranging. Perhaps the most dramatic instance of patronage during this age of architectural renovation was the complete demolition and reconstruction of the Fatih Mosque, first constructed in the fifteenth century by Sultan Mehmed II, after its central dome collapsed during the famous earthquake of 1766.[29] The uptick in restoration projects can already be detected in the late eighteenth-century account *The Garden of the Mosques* (*Hadikat el-Cevami*), a guide to the religious monuments of Ottoman Istanbul written by Hafız Hüseyin Ayvansarayî. Throughout the text, which is organised as a compilation of individual entries for every mosque standing in the capital, Ayvansarayî makes sure to provide not only the names and relevant details about each building's founding patrons, but also the 'secondary donors' who contributed to the pious endowment (*vakıf*) in later centuries.[30] Even a brief perusal of *The Garden of the Mosques* reveals that, by the late eighteenth century, while the Ottomans continued the tradition of establishing new pious foundations, most notably the Nuruosmaniye (c. 1755) and Laleli complexes (c. 1783), they were just as busy sprucing up and adding on to the existing monuments of the city.[31] Just like a garden, buildings require constant attention and care – and sometimes extreme interventions – for them to continue to be used and appreciated.

As part of these renovation projects, the addition of calligraphic panels – and especially those bearing the revered names – became an important way to both update an interior and call attention to the significant investment made by the project's sponsor in the mosque space itself. Such panels can be found in the Fatih Mosque, which, again, was reconstructed in the second half of the eighteenth century, and it is clear that these calligraphic works continued to play an important role in renovation projects in subsequent decades.[32] This was the case at the Kılıç Ali Pasha Mosque in the Tophane neighbourhood of Istanbul, first constructed by the eponymous grand admiral in 1580–1. The large calligraphic roundels added to its interior in 1849–50 (AH 1266) were designed by Sultan Abdülmecid himself, who was well-known as an accomplished calligrapher (Figure 3.7). Just as in Hagia Sophia, the signature and date can be found on the roundel bearing the name of Hüseyin hanging on the western wall of the mosque: '*Ketebehu Abdülmecid ibn Mahmud Han 1266*'. It is especially interesting to note that these panels were executed only one year after Kazasker Mustafa İzzet Efendi's set was hung in Hagia Sophia, whose plan directly inspired the original design of the Kılıç Ali Pasha Mosque, albeit at a smaller scale.[33] The proliferation of such medallions in the late eighteenth and nineteenth centuries was not restricted to the capital. Similar sets of calligraphic panels can be found in the furthest reaches of the empire, such

The Calligraphic Arts

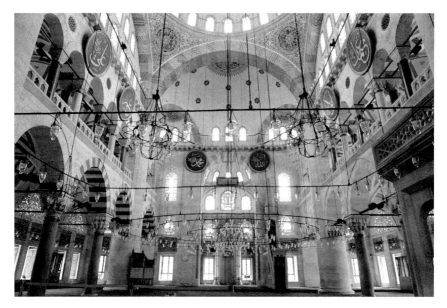

Figure 3.7 Interior of the Kılıç Ali Pasha Mosque in Tophane, Istanbul. Photo: author.

as the Great Mosque (Ulu Camii) of Adana, completed by Piri Mehmed Pasha, patriarch of the Ramazanoğlu family, in 1541.[34] In the mihrab area of the prayer hall, the blue-and-white İznik tiles from the first phases of construction in the sixteenth century are paired with a collection of green-and-gold calligraphic panels from a late nineteenth-century restoration (Figure 3.8).[35]

The sheer prevalence of these sets of roundels being added to mosques that were already centuries old directs our attention to the longer lives of buildings in the Ottoman Empire. Architectural history tends to favour origin stories: the most crucial data that any student first learns about a monument are the details of initial construction such as the names of the patron and architect and the date of completion. But in reality, a building does not stand frozen at a fixed point along a timeline in an art history textbook; rather, its biography unfolds as it accrues layers both material and metaphorical. This longue durée perspective reveals the remarkable fluidity of architectural spaces, which convey cultural meaning to multiple actors, stakeholders and audiences who encounter the monument over time.

Accordingly, the calligraphic works found hanging in Hagia Sophia could be understood not as a one-off, but as the reflection of a wider, dynamic tradition of architectural practice within the Ottoman Empire. A considerable amount of ink has been spilled exploring the impact of Hagia

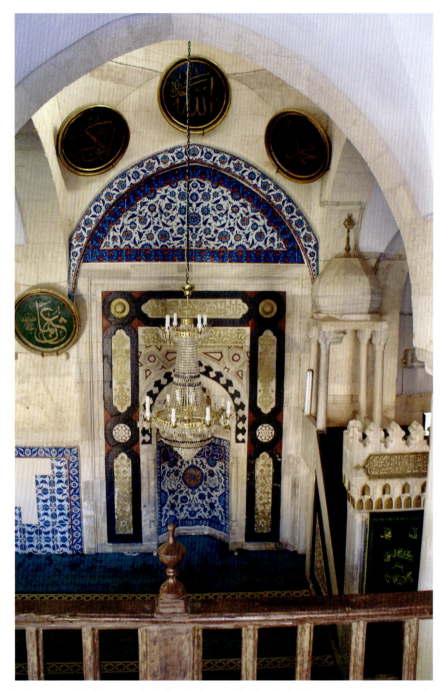

Figure 3.8 Interior view of the Great Mosque of Adana (also known as the Ramazanoğlu Mosque). Photo: author.

Sophia on Ottoman mosque architecture, especially in terms of structural principles like its complex domed vaulting system.[36] Yet perhaps this question could be turned around, and we could ask to what extent wider developments in the aesthetics of Ottoman architecture impacted the appearance of Hagia Sophia in its later life, and ultimately as we know it today.

New Formats for Architectural Epigraphy

The calligraphic roundels in the interior of Hagia Sophia represent a sea change in the aesthetics of Ottoman art and architecture, in which Islamic calligraphy migrates from the wall itself to separate, individual panels that are hung within an architectural space. This new approach to interior decoration raises the question: how does the sacred text – a quintessential feature of any mosque decoration – gradually come to be framed as an independent work of art? This is less of a difference of scale or even placement in the mosque space, and new constructions typically feature *levha* that appear alongside inscriptions carved or painted directly on the walls. In many ways, framed calligraphic works continue the long-established tradition of inscriptions serving as a central element of architectural ornament, a principle that especially came to the fore during the 'classical' age of Ottoman architecture in the sixteenth century, as can be appreciated in the interior from the Mosque of Sultan Murad III (also known as the Muradiye, c. 1583–5) in Manisa (Figure 3.9).[37] Yet, within these interiors, calligraphy served as just one component within a unified decorative programme – an ornamental 'skin' covering the walls of the mosque, such as the *qibla* wall in the Muradiye.[38] According to this aesthetic regime, which was increasingly codified by the central court workshops to create a coherent dynastic image, epigraphy appeared in a wide range of artistic media, from blue-and-white İznik tile to carved stone and painting on plaster – but always as one element of a grander scheme.

The roundels at Hagia Sophia, by contrast, constitute a particular form of artwork that came into its own in the long nineteenth century: the *levha*, or decorative panel, that could be framed and fixed to the wall.[39] Despite the production of the calligraphic placards for Hagia Sophia in the seventeenth century by Teknecizade Ibrahim, it seems that, in general, *levha* were relatively uncommon in Ottoman interiors at the time – though recent scholarship continues to unearth early examples, which for the most part seem to have been written on paper and pasted directly to a wooden backing.[40] Looking ahead to the mid-eighteenth century at the Nuruosmaniye mosque (c. 1755), we see that epigraphic inscriptions

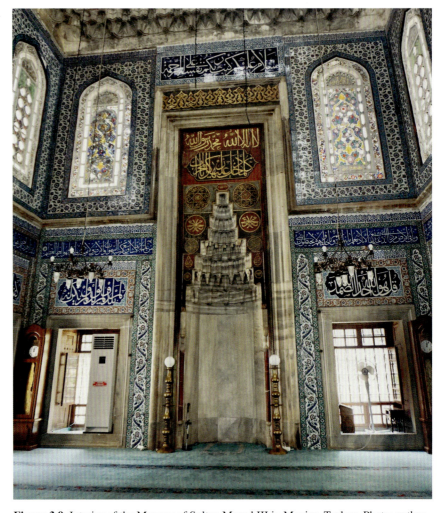

Figure 3.9 Interior of the Mosque of Sultan Murad III in Manisa, Turkey. Photo: author.

were still typically embedded in the wall. However, in this monument, which has come to be synonymous with the emergent Ottoman Baroque, its inscriptions are visually distinguished from the rest of the decorative scheme as individual cartouches, with these elements carved in high relief and framed by thick gold bands (Figure 3.10).[41] By the time the Hırka-ı Şerif Mosque was built, about a century after the Nuruosmaniye, Ottoman religious architecture was routinely outfitted with *levha*s that were hung on the wall (Figure 3.4).[42] Thus, while calligraphy continued to serve as an element integral to the surface decoration of a mosque, it also found new life in works of art that were self-contained and portable.

The Calligraphic Arts

Figure 3.10 Interior of the Nuruosmaniye Mosque, Istanbul. Photo: author.

In both new constructions and restoration projects like that at Hagia Sophia, one of the most common kinds of *levha* is the set of eight roundels bearing the revered names of Islam. The fact that this grouping is commonly referred to today in Turkish as a *cami takımı* ('mosque set') indicates how the revered names have become almost a ubiquitous feature of mosque decoration. But when did this trend begin? The majority of surviving roundel sets that can be dated were produced in the second half of the nineteenth century (i.e., after the Fossati restorations), suggesting that the vogue for this type of *levha* may have been inspired by Kazasker Mustafa's work in Hagia Sophia. Yet there is also evidence pointing to the widespread production of calligraphic roundels before these renovations took place. One important example can be found in the Başçavuş Mosque in Yozgat, a town in present-day Turkey about 200 kilometres due east of Ankara. This small, neighbourhood mosque was built in 1800–1 by one of the courtiers of the local Ottoman governor.[43] The interior features several trompe-l'oeil elements that are meant to imitate more costly materials, such as 'Dutch tiles' painted on the walls (Figure 3.11). Notably, the small upper gallery contains a series of calligraphic medallions that are painted in such a way as to create the impression of a three-dimensional panel with a wooden frame hung on the wall (Figure 3.12). The craftsmen enhanced this effect by adding shading around the border of the panel, as if the carved wooden frame were casting a shadow in the lamplight. The final

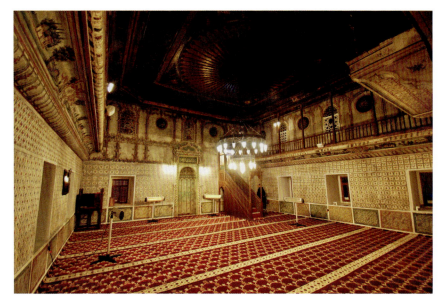

Figure 3.11 Interior view of the Başçavuş Mosque in Yozgat, Turkey. Photo: author.

detail that completes this illusion is a delicate red thread, from which this calligraphic panel 'hangs' on the wall. The Başçavuş Mosque serves as a gauge that can be used to measure the stylistic trends emanating from the imperial centre. This case study is an example of what could be described as the 'fake Louis Vuitton bag' principle of fashion: if you want to 'delineate the evolution of taste with unrivalled precision', as the art historian Mark Jones puts it, you need to look for the imitators.[44] The primacy of the *levha* as mosque decoration can thus already be established at the turn of the eighteenth century in Yozgat, and, about a half century later, this trend continues to find purchase, and is magnified to its greatest proportions, on the walls of Hagia Sophia.

How, then, can we account for the emergence of this new mode for the display of calligraphy within the Ottoman Empire? It has been argued that the trend towards independent panels bespeaks an interest in adapting the European fashion for framed oil-on-canvas painting.[45] By the end of the eighteenth century in Istanbul, this style of painting would have only been found in rarefied circles – like the residences of diplomats and non-Muslim subjects or the imperial palace – though it should be noted that prominent calligraphers of the time such as Mustafa Rakim (1757–1826) did frequent the court. While more research on the origins of the *levha* format is required, it seems likely that the concept of exhibiting calligraphy on panels was in dialogue with the broader European

The Calligraphic Arts

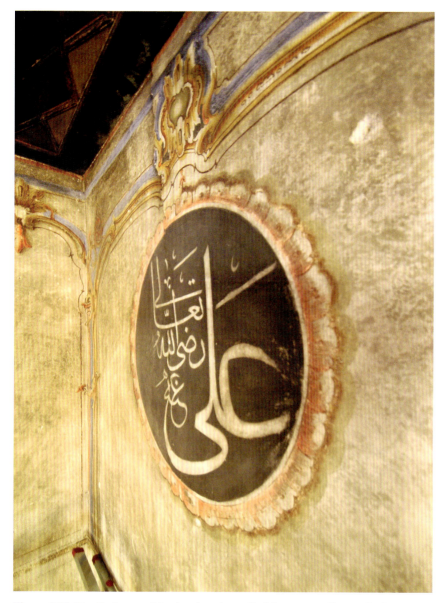

Figure 3.12 Detail of a roundel painted on the wall of the upper gallery at the Başçavuş Mosque in Yozgat, Turkey. Photo: author.

practice of framing and hanging all types of media, from canvas painting to mirrors, as architectural decoration. This point raises the 'inevitable' question of westernisation, and it seems appropriate to observe that, as Shirine Hamadeh has argued, an openness to European tastes – whether

in architecture, poetry or ornamentation – is in no way indicative of a wholesale adoption of Western cultural systems, but more of a selective re-imagining of unconventional forms in new settings.[46]

In any case, the act of framing itself communicates a certain perception of calligraphy and its status as a work of art. From the first centuries of Islam, calligraphy maintained a special position as a ubiquitous and celebrated art form. The earliest surviving Islamic monument, the Dome of the Rock in Jerusalem, features all around the upper registers of its interior numerous lengthy passages from the Qur'an.[47] The Arabic script, rendered in the architectural space in gold mosaic set against a blue ground, still preserves the thick and thin strokes of the cut nib – even when translated into another medium, the aesthetics of the pen is pre-eminent.[48] In a similar fashion, the craftsmen who produced the calligraphic panels in Hagia Sophia more than a millennium later carefully maintained the composition and hand of Kazasker Mustafa İzzet Efendi even when it was magnified to a gigantic scale. In the nineteenth-century Ottoman context, these panels were not just beautiful works of calligraphy, they were calligraphic designs from the hand of a well-known artist. Even viewers who cannot read the text can appreciate Mustafa İzzet Efendi's ability to create a balanced composition, with the sweeping curves of the letter forms complementing the circular gold frame, while maintaining a careful equilibrium with the considered placement of the diacritical marks above and below the main text.

Scholarship on Ottoman calligraphy has tended to focus on innovations in the form and style of different scripts. Yet it is critical to attend also to the introduction of new technologies in media and the resulting changes in how these calligraphic compositions were presented and viewed. Edhem Eldem has discussed how in the long nineteenth century there was a 'radical transformation of the visual perception of the written word in Ottoman lands', from the invention of an imperial coat of arms to the introduction of letterhead in government bureaucratic documents.[49] What can be added to this list is the proliferation of *levha* in architectural settings, which especially proved to be an effective method for renovating older spaces. As outlined above, although Ottoman sultans continued to commission new religious complexes, by the mid-eighteenth century restoration work on earlier structures had become a form of architectural patronage in and of itself. It is perhaps not a coincidence that around this time the sultanic monogram, or *tuğra*, became a standard feature of architectural ornament. The use of the *tuğra* was a tradition dating back to the first Ottoman sultans, but, before the eighteenth century, these imperial monograms were largely restricted to works on paper – at the beginning of royal orders, for

The Calligraphic Arts

example – and almost never appeared in architectural spaces.[50] During the age of Ottoman renovation, the imperial monogram began to appear on the walls of restored monuments, most typically crowning inscriptions added above the main entrance to commemorate the renovation efforts.[51] In fact, a *tuğra* of Sultan Abdülmecid composed of gold mosaic appears to have been executed for the Fossati restorations (see Figure I.5).[52] Today it can be seen in the narthex of Hagia Sophia, although it is not entirely clear when it was placed there. Like calligraphic panels, the sultan's *tuğra* served as a powerful – and, crucially, economic – intervention in an earlier structure, allowing patrons of a renovation project to mark the architectural space with a trace of their own legacy.

As can be seen in countless examples, the Ottoman craftsmen and architects working on restoration projects did not limit themselves to stabilising what was already there but would often heavily remodel the decoration programme of an earlier mosque. This process usually included the re-painting of interiors and the insertion of framed calligraphic works. This means that, during the long nineteenth century, the classical sixteenth-century mosque complexes of Istanbul were re-imagined in more recent styles: decked out floor to ceiling in swirling volutes, floral arrangements and trompe-l'oeil designs. This chapter in the history of Ottoman mosque architecture remains virtually unknown and unacknowledged today, primarily because conservators working in the 1950s and 1960s opted to remove the later decoration programmes, in favour of a more sober aesthetic that was believed to better reflect the state of these interiors at the moment of the buildings' foundation. The 'classical' sixteenth-century monuments could thus be mobilised as Turkey's cultural patrimony.[53]

One remarkable example of how the *levha* was deployed to upgrade an older mosque is the Süleymaniye in Istanbul. Commissioned by Sultan Süleyman I to serve as his own funerary complex, the mosque was completed in 1558, just a few years before the sultan's death. In the 1860s, the interior was completely redone in a baroque style, restorations supposedly overseen by Fossati himself.[54] The calligrapher Abdülfettah Efendi was responsible for renovating the inscriptions, and, on the basis of conservation studies undertaken in 2010 as part of the most recent renovation of the Süleymaniye, it appears that these interventions went beyond the casual touch-up: eight new black-and-gold medallions bearing the revered names were added in the semi-domes and main piers (Figure 3.13).[55] Moreover, two plaques of İznik tiles bearing the Fatiha, originating with the sixteenth-century foundation and located on the two main piers closest to the mihrab, were concealed under a layer of thick paint and replaced with Abdülfettah's own composition of the same text in

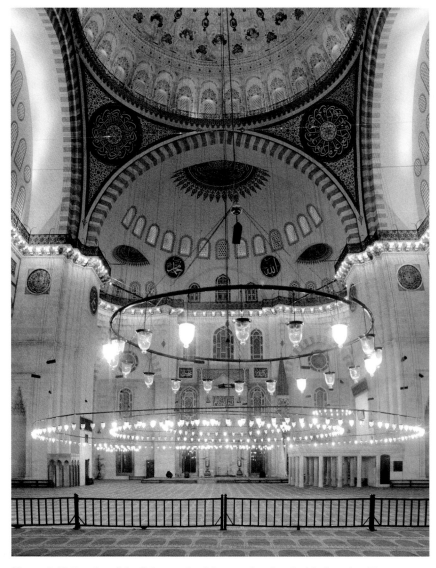

Figure 3.13 Interior of the Süleymaniye Mosque, showing the black-and-gold medallions added in the nineteenth century in the semi-dome of the mihrab area and on the main piers supporting the central dome. Photograph by Ggia, Wikimedia Commons.

gold leaf.[56] While these medallions were painted directly on the wall, they still participate in a *levha* aesthetic. Craftsmen enhanced the medallions by adding separate gilded wooden frames to surround the calligraphic compositions, creating the illusion of an individual panel that hangs on the wall. Apparently, the nineteenth-century restorers were not concerned

with preserving the integrity of the original decorative programme of the mosque. Instead, these artisans sought to enhance and improve upon the sixteenth-century designs. This mentality reveals an alternative approach to the past that was predicated on appropriating and modifying earlier structures: a key conceptual difference between the notions of renovation and preservation.

'Colors Which Arrest the Eye': Calligraphy as Spectacle

Like the mosaic *tuğra* of Abdülmecid I, the eight calligraphic panels hanging in Hagia Sophia function as prominent indexes of the stewardship of the Ottoman sultan. The medallions by no means blend in, and they have been situated to draw maximum attention from a visitor. The eye is naturally drawn to them, because they are hung on the main supporting piers of the building, interrupting the flow of the formal lines of the great arches, but also creating the illusion that the superstructure is floating, supported on these light, round panels – a nineteenth-century Ottoman re-imagining of the Justinianic 'dome of heaven'. If the tradition of hanging calligraphic panels in Hagia Sophia began with Teknecizade Ibrahim Efendi in the mid-seventeenth century, this concept was then realised to its full monumental potential by Mustafa İzzet Efendi almost exactly two hundred years later in the mid-nineteenth century. These two projects serve as convenient bookends for the broader history of calligraphy during the Ottoman age of architectural renovation. While the Fossati restorations are typically understood as a decisive break from previous efforts on behalf of the Ottoman state to convert and renovate pre-Ottoman monuments, the calligraphic medallions designed by Kazasker Mustafa for Hagia Sophia reinforce and continue earlier initiatives aimed at laying claim to this building.

By way of conclusion, consider two views of the post-Fossati Hagia Sophia (Figure 3.14; see also Figure 3.1). It is significant that, in his drawing of the contemporary space, Gaspare Fossati includes the calligraphic medallions, but minimises their scale in proportion to the rest of the building. This effect becomes even more obvious when we compare the drawing with a late nineteenth-century photograph of the interior. In a way, these two views point to the multiple audiences, both local and international, that were anticipated during the nineteenth-century renovations – and this does constitute a departure from earlier Ottoman restoration efforts.[57] A contemporary commentator writing for the *Edinburgh Review* also noted the contrast of Hagia Sophia's decorations competing in the interior space:

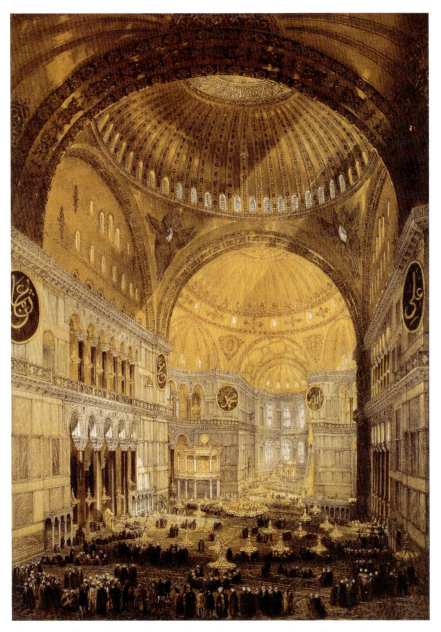

Figure 3.14 View of Hagia Sophia after the Fossati restorations: Gaspare Fossati, *Aya Sofia, Constantinople: As Recently Restored by Order of H.M. the Sultan Abdul-Medjid* (London: R. & C. Colnagni & Co., 1852), plate 24. Library of Congress, Washington, DC.

Accordingly, the winged seraphim at the angles of the buttresses which support the dome have been preserved, and, to a Christian visitor, appear in strange contrast with the gigantic Arabic inscriptions in gold and *colors which arrest the eye* upon either side of the nave and within the dome, to commemorate the four companions of the Prophet, Abu-bekr, Omar, Osman, and Ali.[58]

For foreign (i.e., western European) armchair viewers, emphasis is primarily placed on the formal beauty of the structural design and conservation of the Byzantine mosaics. Meanwhile, local visitors to the monument would have been immediately struck by the calligraphic medallions – a dramatic spectacle of gold and paint. These viewers also would have been able to recognise the roundels as part of a wider practice of adorning religious spaces with such works, leaving no question about the Ottoman sultan's intention to elevate the restoration of Hagia Sophia as one of the most consequential acts of architectural patronage during the long nineteenth century.

Notes

1. My sincere thanks to the participants of the 'Hagia Sophia in the Long Nineteenth Century' symposium at Ohio State University and İrvin Cemil Schick for offering their insights and comments on this project at various stages of its development.
2. Semavi Eyice, *Ayasofya* (Istanbul: Yapı Kredi, 1984), 42; Erdem Yücel, 'Ayasofya Levhalarının Hikayesi', *Türk Dünyası Tarih Dergisi* 45 (1990): 46; and Talip Mert, 'Archival Evidence on the Commissioning of Architectural Calligraphy in the Ottoman Empire', in Mohammad Gharipour and İrvin Cemil Schick (eds), *Calligraphy and Architecture in the Islamic World* (Edinburgh University Press, 2013), 235.
3. M. Şükrü Hanioğlu, *A Brief History of the Late Ottoman Empire* (Princeton: Princeton University Press, 2008), 74–5.
4. Gaspare Fossati, *Aya Sofia, Constantinople: As Recently Restored by Order of H.M. the Sultan Abdul-Medjid* (London: R. & C. Colnagni & Co., 1852), 2; Gülru Necipoğlu, 'The Life of an Imperial Monument: Hagia Sophia after Byzantium', in Robert Mark and Ahmet Çakmak (eds), *Hagia Sophia from the Age of Justinian to the Present* (Cambridge: Cambridge University Press, 1992), 221–2; Robert Nelson, *Hagia Sophia, 1850–1950: Holy Wisdom Modern Monument* (Chicago: University of Chicago Press, 2004), 30.
5. Though it should be noted that the roundels were removed in 1934 for restoration and only re-installed in 1949: Mahmud Kemal İnal, *Son Hattatlar* (Istanbul: Maarif Basımevi, 1955), 161.
6. Necipoğlu, 'The Life of an Imperial Monument', 204; Çiğdem Kafescioğlu, *Constantinopolis/Istanbul: Cultural Encounter, Imperial Vision, and the*

Construction of the Ottoman Capital (University Park, PA: Pennsylvania State University Press, 2009), 20–1; Hafız Hüseyin Ayvansarayî, *The Garden of the Mosques: Hafız Hüseyin al-Ayvansarayî's Guide to the Muslim Monuments of Istanbul*, ed. and trans. Howard Crane (Leiden: Brill, 2000), 6.

7. Each of these panels is composed of the name of the individual as well as a short prayer invoking blessings upon this figure written in a smaller script. These formulaic prayers are honorific phrases (*dürûd*) that conventionally accompany the name of God, the Prophet Muhammad, his family and companions. For example, the panel bearing the name of Ali in Hagia Sophia includes the phrase '*radiyallahü anh*' ('May God be well pleased with him').
8. In Ottoman Turkish sources, a pair of roundels with the names of God and Muhammad are usually referred to respectively as the *lafza-i celal* (the 'glorious name [of God]') and the *ism-i nebî* (the 'name of the Prophet [Muhammad]').
9. There are many varying transliterations of the names of the *raşidin* caliphs. Because these panels were created under Ottoman patronage, I will follow the conventional spellings transliterated from Ottoman Turkish. A set of roundels bearing the names of the first four caliphs are commonly referred to in primary and secondary Turkish sources as the *cihar-ı yar-ı güzin* ('the four distinguished friends'): Yücel, 'Ayasofya Levhalarının Hikayesi', 45.
10. The full inscription reads: '*Ketebehu'l Hac es-Seyyid Mustafa İzzet İmamu's-sani li emiri'l-mü'minin Abdülmecid Han*, AH 1265 (1848/49 CE)', indicating that Mustafa İzzet Efendi designed the roundels by order of Sultan Abdülmecid: Ahmet Akgündüz, Said Öztürk and Yaşar Baş, *Üç Devirde bir Mabed: Ayasofya* (Istanbul: Osmanlı Araştırmaları Vakfı Yayınları, 2005), 511. In the inscription, Mustafa İzzet Efendi is designated as a pious individual who had completed the hajj and held the position of the sultan's 'second imam', an honour conferred just a few years previously in 1845: Uğur Derman, 'Mustafa İzzet, Kazasker', in *Türkiye Diyanet Vakfı İslâm Ansiklopedisi*, vol. 31 (Istanbul: Türkiye Diyanet Vakfı, 2006), 304.
11. Derman, 'Mustafa İzzet, Kazasker', 306. Appropriately, this inscription is paired with a sun motif in the centre of this composition, with the metaphor of divine light further enhanced by the radiating ribs of the Byzantine dome that are covered in gold mosaic as well as the beams of natural light shining through the windows at the base of the drum.
12. Mustafa İzzet Efendi is said to have received his first calligraphy diploma (*icazet*) at a young age in 1818. His title 'Kazasker' reflects his bureaucratic position as the chief judge of the Rumeli province, a post he took up in 1857: ibid., 304–7. Several of his works that are today found in different library and museum collections were on view in an exhibition titled 'Kazasker İzzet Efendi' at the Topkapı Palace Museum from December 2014 until March 2015.

13. Baha Tanman, 'Hırka-i Şerif Camii', in *Türkiye Diyanet Vakfı İslâm Ansiklopedisi*, vol. 17 (Istanbul: Türkiye Diyanet Vakfı, 1998), 380.
14. A thorough account of these public works can be found in Derman, 'Mustafa İzzet, Kazasker', 306.
15. This team of craftsmen appears in an abundance of documents from the time, especially registers recording the payments of workers employed in the restoration project. These sources have been gathered and presented by Talip Mert: 'Kadıasker Mustafa İzzet Efendi', in İrvin Cemil Schick (ed.), *M. Uğur Derman Festschrift* (Istanbul: Sanbancı University, 2000): 411–15; and 'Ayasofya Levhaları', *Arşiv Dünyası* 10 (October 2007): 61. Also see Akgündüz et al., *Üç Devirde bir Mabed: Ayasofya*, 512.
16. Presidential State Ottoman Archives (T.C. Cumhurbaşbakanlığı Devlet Osmanlı Arşivleri, hereafter BOA), Istanbul, EV.d. 13403 (9 Cemaziyelahir 1264 H/13 May 1848 CE), cited in Mert, 'Ayasofya Levhaları', 61. Looking at the back of the roundels, the pieces of canvas have been arranged vertically and stitched together to achieve the desired size.
17. Akgündüz et al., *Üç Devirde bir Mabed: Ayasofya*, 510.
18. The original smaller compositions produced by Mustafa İzzet Efendi for the eight roundels can still be seen today in the mihrab area of Hagia Sophia: Derman, 'Mustafa İzzet, Kazasker', 306.
19. Expense registers list the green pigment, linseed oil, solvents, paintbrushes and gold leaf among the materials purchased to produce the roundels: Mert, 'Ayasofya Levhaları', 61.
20. Ibid., 58–9.
21. '*Kabir levhalarının tecdid lazım gelmek olduğundan*': BOA, Istanbul, İ.MSM. 25/692 (27 Rebiülevvel 1264 H/3 March 1848 CE), document cited in Mert, 'Kadıasker Mustafa İzzet Efendi', 411.
22. Eyice, *Ayasofya*, 42; Necipoğlu, 'The Life of an Imperial Monument', 218–20. These earlier panels can also be seen in prints included in the following two albums: Ignace Mouradja d'Ohsson, *Tableau Général de l'Empire Othoman*, vol. 1 (Paris: Firmin Didot, 1787–1820), plate 19; and Fossati, *Aya Sofia, Constantinople*, plate 24, a view of Hagia Sophia just before the mid-nineteenth-century restorations took place.
23. According to Ayvansarayî, the date of the panels' completion was inscribed on the roundel bearing the 'Glorious Name' of God: Ayvansarayî, *The Garden of the Mosques*, 6. Semavi Eyice speculates that Ayvansarayî, who died in 1752 CE, may have had an opportunity to inspect the panels when they were lowered for repairs in 1733–4 CE: Eyice, *Ayasofya*, 42.
24. Hasan Fırat Diker, *Ayasofya ve Onarımları* (Istanbul: Fatih Sultan Mehmet Vakıf Üniversitesi Yayınları, 2016), 82–3.
25. Ayvansarayî also describes the panels as being executed in *celi* calligraphy, a speciality of Teknecizade İbrahim Efendi: Ayvansarayî, *The Garden of the Mosques*, 6. The term '*celi*' refers to large-scale writing, which was usually executed with a wide pen made from bamboo or wood.

26. The other sketch by Loos (c. 1711) is in the National Museum of Stockholm, inventory number NMH THC 9104. We can also observe from this image that there were additional rectangular plaques hanging in the mihrab area inscribed with the *shahada*: Yasemin Sönmez, 'Ayasofya Külliyesi'nin Hat Levhaları ve Kitabeleri' (MA thesis, Selçuk University, 2018), 25. Yücel claims that the earlier set of seventeenth-century panels included the names of Hasan and Hüseyin ('Ayasofya Levhalarının Hikayesi', 45), but the official petition for the panels produced by Kazasker Mustafa İzzet Efendi explicitly states that these two roundels would be a new addition to the space: '*cenab-i Haseneyn dahi . . . ilave ve terkim eylemek*'; BOA, Istanbul, İ.MSM. 25/692 (27 Rebiülevvel 1264 H/3 March 1848 CE).
27. Sinan enumerates the mosque buildings that were constructed under his term as court architect in his autobiography: Mimar Sinan, *Sinan's Autobiographies: Five Sixteenth-century Texts*, ed. and trans. Howard Crane and Esra Akın (Leiden: Brill, 2006), 92–5.
28. This movement in architectural renovations continued into the first decades of the Turkish republic: see Ümit Fırat Açıkgöz, 'On the Uses and Meanings of Architectural Preservation in Early Republican Istanbul (1923–1950)', *Journal of the Ottoman and Turkish Studies Association* 1–2 (2014): 167–85.
29. Semavi Eyice, 'Fatih Camii ve Külliyesi', in *Türkiye Diyanet Vakfı İslâm Ansiklopedisi*, vol. 12 (Istanbul: Türkiye Diyanet Vakfı, 1995), 245–6; Ayvansarayî, *The Garden of the Mosques*, 12–13.
30. Ayvansarayî, *The Garden of the Mosques*, 4.
31. For the new mosque constructions of eighteenth-century Istanbul, see Ünver Rüstem, *Ottoman Baroque: The Architectural Refashioning of Eighteenth-century Istanbul* (Princeton: Princeton University Press, 2019).
32. On the basis of my own fieldwork, framed calligraphic panels bearing the revered names that appear to be added in later restoration phase can be seen in the following Istanbul mosques, listed in alphabetical order: Bala Süleyman Ağa (c. 1457 and rebuilt in 1862–3); Cezeri Kasım Pasha (c. 1515); Fatih Sultan Mehmed (c. 1463, rebuilt 1771); Fethiye (originally Pammakaristos Monastery c. 1294); Gül Mosque (originally constructed as a church in the late Byzantine period); Hacı Küçük Mosque (c. 1470 and rebuilt in 1872); Kılıç Ali Pasha Mosque (c. 1580–1); Mihrimah Sultan, Üsküdar (c. 1547); Mihrimah Sultan, Edirnekapı (c. 1565, roundels now removed); Murat Pasha (c. 1466); Şehzade (c. 1548); Sinan Pasha (c. 1554–5); Süleymaniye (c. 1557); Yavuz Sultan Selim (c. 1527–8); and the Yeni Camii (c. 1655). Beyond the capital in the Ottoman provinces, such panels can be found in the following religious foundations: Aydınoğlu Mehmet Bey, Birgi (c. 1312); Feyzullah Pasha, Atabey (c. 1657); Ulu Camii, Bursa (c. 1399); Yıldırım Bayezid, Bursa (c. 1395); Ulu Camii, Manisa (c. 1366–7); and the Ulu Camii, Adana (c. 1541).
33. Gülru Necipoğlu, *The Age of Sinan: Architectural Culture in the Ottoman Empire* (Princeton: Princeton University Press, 2005), 428.

34. Ali Osman Uysal, 'Adana Ulu Camii', *Vakıflar Dergisi* 19 (1985): 278.
35. A document from the Council of State (Şura-yı Devlet) papers approves the restoration of one of the minarets at the mosque in 1884, and it is quite possible that the roundels were added at that point in time: BOA, Istanbul, ŞD. 106/41 (25 Rebiülahir 1300 H/23 October 1884 CE).
36. Kafescioğlu, *Constantinopolis/Istanbul*, 20, 49; also see Zeynep Ahunbay and Metin Ahunbay, 'Structural Influences of Hagia Sophia on Ottoman Mosque Architecture', in Robert Mark and Ahmet Çakmak (eds), *Hagia Sophia from the Age of Justinian to the Present* (Cambridge: Cambridge University Press, 1992), 179–94.
37. Necipoğlu, *The Age of Sinan*, 263–4, 329–30.
38. Gülru Necipoğlu, *The Topkapı Scroll: Geometry and Ornament in Islamic Architecture* (Santa Monica, CA: Getty Center, 1995), 219; also see Gülru Necipoğlu, 'Early Modern Floral: The Agency of Ornament in Ottoman and Safavid Visual Cultures', in Gülru Necipoğlu and Alina Payne (eds), *Histories of Ornament: From Global to Local* (Princeton: Princeton University Press, 2006), 141.
39. Uğur Derman, 'Hat', in *Türkiye Diyanet Vakfı İslâm Ansiklopedisi*, vol. 16 (Istanbul: Türkiye Diyanet Vakfı, 1997), 435; Filiz Çağman, 'The Art of Ottoman Calligraphy', in Filiz Çağman (ed.), *Ottoman Calligraphy from the Sakıp Sabancı Museum, Istanbul*, exhibition catalogue (Istanbul: Sakıp Sabancı Museum, 2008), 53–4.
40. For these recent discoveries, see Nuria Garcia Masip, 'Notes from the Field', *Historians of Islamic Art Association Newsletter*, 7 February 2022, 4. While it is difficult to prove the absence of a particular feature from architectural interiors, especially one that could so easily be removed in subsequent phases, it can be observed that various sixteenth-century sources regarding building construction do not explicitly mention the production of calligraphic panels. For example, the account registers for the Süleymaniye mosque in Istanbul do not mention any materials that would be associated with panels such as canvas cloth or wood for frames or a plaque made from wood: Ömer Lutfi Barkan, *Süleymaniye Cami ve İmareti İnşaatı (1550–1557)*, vol. 2 (Ankara: Türk Tarih Kurumu Basimevi, 1979), 173–89.
41. Rüstem, *Ottoman Baroque*, 144–5.
42. Derman, 'Hat', 435.
43. According to the foundation inscription, this mosque was constructed by Halil Ağa, the *başçavuş* (sergeant major) in the service of the influential provincial governor Çapanoğlu Süleyman Bey: Hakkı Acun, *Bozok Sancağı (Yozgat İli)'nda Türk Mimarisi* (Ankara: Türk Tarih Kurumu Yayınları, 2005), 71.
44. Mark Jones, 'Introduction: Why Fakes?', in Mark Jones (ed.), *Fake?: The Art of Deception*, exhibition catalogue (London: British Museum, 1990), 13.
45. Çağman, 'The Art of Ottoman Calligraphy', 53.

46. Shirine Hamadeh, 'Ottoman Expressions of Early Modernity and the "Inevitable" Question of Decline', *Journal of the Society of Architectural Historians* 63/1 (2004): 34. Also see Rüstem, *Ottoman Baroque*, 8–9.
47. Oleg Grabar, *The Dome of the Rock* (Cambridge, MA: Belknap Press, 2006), 91–2.
48. Sheila Blair, *Islamic Calligraphy* (Edinburgh: Edinburgh University Press, 2006), 91–4; Alain George, *The Rise of Islamic Calligraphy* (London: Saqi, 2010), 65.
49. Edhem Eldem, 'Writing Less, Saying More: Calligraphy and Modernisation in the Last Ottoman Century', in Mohammad Gharipour and İrvin Cemil Schick (eds), *Calligraphy and Architecture in the Islamic World* (Edinburgh University Press, 2013), 467.
50. Philippe Bora Keskiner, 'Sultan Ahmed III (r. 1703–1730) as a Calligrapher and Patron of Calligraphy' (Ph.D. diss., School of Oriental and African Studies, 2012), 232.
51. Notable examples include the Eski Camii in Edirne (c. 1402 and restored in 1866) and the entrance into the second courtyard of the Topkapı Palace, which features *tuğra*s of Sultan Mustafa III (c. 1759) and Mahmud II (c. 1815).
52. Semavi Eyice suggests that Fossati had artists create this mosaic panel for the sultan after the patron's desire to leave all the Byzantine mosaics in the building uncovered had met with an outcry from more conservative circles: Eyice, *Ayasofya*, 46.
53. Açıkgöz, 'On the Uses and Meanings of Architectural Preservation in Early Republican Istanbul (1923–1950)', 180–1.
54. Gülru Necipoğlu-Kafadar, 'The Süleymaniye Complex in Istanbul: An Interpretation', *Muqarnas* 3 (1985): 106.
55. Uğur Derman, 'Abdülfettah Efendi', in *Türkiye Diyanet Vakfı İslâm Ansiklopedisi*, vol. 1 (Istanbul: Türkiye Diyanet Vakfı, 1988), 203.
56. As part of the 2010 restoration of the Süleymaniye, the corners of the original blue-and-white İznik tiles were uncovered and can be seen today: M. Hüsrev Subaşı, 'Süleymaniye Camii Hatları 2010 Restorasyonu', *Vakıf Restorasyon Yıllığı* 3 (2011): 142–9.
57. Edhem Eldem notes the extent to which the image of Hagia Sophia was commodified in the late nineteenth century through the explosion of postcards, which were marketed to both foreign and domestic travellers. In most examples of postcards showing interior views, the roundels are prominently featured: Eldem, 'Ayasofya: Kilise, Cami, Abide, Müze, Simge', *Toplumsal Tarih* 254 (February 2015), 81.
58. Emphasis is my own. 'The Church and Mosque of St. Sophia', *Edinburgh Review*, 121/248 (February 1865), 475.

Chapter 4

From the Mouth of Angels: Folkloric Hagia Sophia

Benjamin Anderson

This chapter distinguishes two images of Hagia Sophia as represented in folklore during the long nineteenth century. The first, by far the most familiar, renders Hagia Sophia into a symbol of Greek irredentism by means of a song. The second, far less familiar, appears in the works of Ottoman Greek scholars. These two folkloric Hagia Sophias form a natural pair. The first joins certainty regarding the building's meaning to a disregard for its matter. The second joins ideological ambiguity to a keen interest in the building's history, structure, décor and form.

The first printed anthology of Greek folk songs ('chants populaires') appeared in Paris in two volumes (1824–5) collected, translated and annotated by Claude Fauriel. A passionate republican and man of letters, Fauriel never went to Greece, but gathered songs from correspondents in Greece, Venice and Trieste.[1] His second volume includes a song on the capture of Constantinople, at least according to the title that he furnished ('La prise de Constantinople').[2] The Greek text is demotic and metrical, set in the fifteen-syllable *politikós stíhos* ('political verse' or 'verse of the city'), the 'predominant meter of Greek folk poetry'.[3] It begins with a lament:

> They've taken the city, they've taken it! They've taken Salonika!
> And they've taken Hagia Sophia, the great church,
> Where there are three hundred small bells and sixty-two large bells,
> For each bell a priest, for each priest a deacon.

The first line introduces the first of several ambiguities. It may describe the capture both of Constantinople, known in demotic Greek simply as 'the city', and of Salonika. Alternatively, 'They've taken Salonika' may specify the (single) city in question. The following lines do not clarify, since both Constantinople and Salonika boast a 'great church' of Hagia Sophia.

The song continues with the description of a liturgical celebration:

At the moment when the Sacrament, Emperor of the Kosmos, exited,
A voice descends from heaven, from the mouth of angels.
'Stop the mass, lower the sacrament,
And send a message to Francia, come and take them:
Take the golden cross, and the holy gospel
And the holy altar, so that it might not be defiled'.

Just as Fauriel's title confidently situates the action of the poem in Constantinople, so too does his own translation specify the threat: *afin que les (Turks) ne la souillent pas*, 'so that they (the Turks) might not defile it'. Once more, the Greek is more ambiguous, not supplying a subject. Additionally, the invocation of 'Francia' recalls an earlier capture of the city, 1204, when indeed the Franks (in the words of a contemporary historian) 'pulled down the ciborium of the Great Church that weighed many tens of thousands of pounds of the purest silver and was thickly overlaid with gold'.[4]

The final three lines of the text are more ambiguous still:

And when the Virgin heard this, the pictures cried.
'Be still, blessed lady, do not weep, do not cry.
Again with the years, with the ages, again these things are yours'.

Here there are two key questions, neither of which can be answered on the basis of the text alone. First, who is speaking? Are the 'pictures' identical with the 'voice ... from the mouth of angels' that first interrupted the mass? Second, what do they say? The concluding phrase – the present-tense πάλε δικά σου εἶναι, 'again these things are yours' – can be read either as a prophecy of future events, or as a description of an ongoing state of affairs.

Fauriel's translation opts strongly for the first option: *(toutes ces choses) seront de nouveau à toi* '(all these things) will be yours again'. However, if the verb were rendered literally, in the present tense, then the adverb, πάλε, would signify differently. As Michael Herzfeld observed:

There is ... no guarantee that [the adverb] *pali* must mean 'again' in a temporal sense. It also commonly has the meaning of 'still', in the sense of 'whatever the case may be'. If we regloss the line to remove the intimation of future, historically conceived time, it acquires a radically different cast: 'And still, whatever the times may bring, it is *still* yours'.[5]

Fauriel published the poem in 1825, during the Greek War of Independence from Ottoman rule. For him, the historical conjuncture resolved the textual ambiguities. He thus interpreted the song as

an artifact and an expression of a patriotic hope which three and a half centuries of Turkish oppression have failed to extinguish among the Greeks, of the hope one day to return, with the aid of the Franks, to the possession of Constantinople and of all the lands of the Greek language. Current events in Greece, whatever the result, seem better suited to confirm than to dash this hope; it only appears that the idea of Frankish aid will no longer play a part in it.[6]

Fauriel thus became the first commentator to interpret the song by means of the ideology that we now call Greek irredentism, or the *megáli idea*, 'the Great Idea'.

The song acquired fame in Greece and abroad, many more versions were published, and many more scholars advanced versions of Fauriel's interpretation. The song's last line has been so frequently discussed that it supplies both the title and a central case study for Herzfeld's history of the discipline of *laografía* (folklore) in modern Greece. Herzfeld showed that the concluding pronoun shifted in later publications from the 'yours' printed by Fauriel to a first-person plural, thus reading 'ours once more'. He remarks: 'In [the pronoun shift] lies a whole conception of the Hellenes' place in the world, of their identity as a people, and of the territorial implications of the Great Idea.'[7] A more recent commentator, Nikos Magouliotis, describes the song as 'a well-known piece of Greek nationalist folklore: a 19th-century folk-song that prophesized an eventual Greek reconquest of Istanbul and Hagia Sophia, a myth that has been at the core of Greek religious fundamentalism and nationalism for about two centuries'.[8]

In this potent conception, Hagia Sophia distils both the cultural heritage and the territorial ambitions of the Greek nation. It is a conception that may penetrate the subconscious from an early age. For example, in the winter of 1930, a group of schoolchildren on Naxos, said to be gifted with prophecy, dreamt that 'Hagia Sophia in Istanbul will revert to Orthodox Christian control' and imagined 'King Constantine leading the Greek Nation back to Istanbul and reclaiming Hagia Sophia'.[9] It may also inform the highest levels of diplomacy. For example, on 29 May 2020, the Greek foreign ministry objected to 'the reading of passages of the Quran inside Hagia Sophia', to which the Turkish president replied: 'Greece is not the one administering this land, so it should avoid making such remarks.'[10] At both levels, the subconscious and the official, Hagia Sophia operates simultaneously as a historical monument and as a metonym for territorial sovereignty.

This is a profound cathexis, through which a symbol is fused with a nation. It recalls Durkheim's account of modern totemism: 'The soldier who dies for his flag dies for his country, but the idea of the flag is actually in the foreground of his consciousness.'[11] As the object becomes

a symbol, its material reality recedes. Durkheim writes: 'We know what the flag is for the soldier, but in itself it is only a bit of cloth.'[12] Similarly, as Magouliotis writes, 'the thematisation of Hagia Sophia in the Greek national and historical imaginary has little to do with its architecture and materiality and more with the religious and territorial symbolisms that have been projected onto it'.[13] The text published by Fauriel describes a building that is like any other church, insofar as it has a cross and a Bible and an altar, but it is much bigger than most, with many bells and clergy. All of this is true of Hagia Sophia, but none of it requires knowledge of its structure, its plan, its peculiarities. Neither singer nor listener need ever have seen the church to follow the song.

This is the most familiar folkloric Hagia Sophia. It emerged in the nineteenth century, in the context of the Greek War of Independence and the growing pains of the young Greek state. It successfully distilled the Great Idea in a symbol, with little reference to the material fabric of the structure. And it remains potent today, continuing to inform public discourse regarding the proper use of the building.

In what follows, I seek to distinguish a second folkloric Hagia Sophia. It too emerges in the nineteenth century, primarily in the works of Ottoman Greeks (*Rhomaioi* in Greek, *Rumlar* in Turkish), especially those living in Constantinople. I will be concerned with four authors in particular: Patriarch Konstantios I (1770–1859), Skarlatos Byzantios (1797–1878), Jean Nicolaïdès (1846–93) and Eugène Michael Antoniades (1870–1944). Konstantios and Byzantios wrote primarily in Greek, Antoniades in Greek and French, and Nicolaides in French. All four engaged texts in other languages, especially English, French and Turkish. Konstantios's work, for its part, was translated into English, French, Karamanlidika and Ottoman Turkish. All four authors, in brief, practised 'a literary activity which deserves better than anything else the epithet "Ottoman"'.[14]

Most notably in the present context, all four authors engaged popular traditions about Hagia Sophia. By contrast with Fauriel and his successors, they were far less eager to resolve those traditions into definitive ideological statements, and they were deeply invested in the architecture and materiality of the building itself. Notably, all of them devote particular attention to the angels executed in mosaics in the pendentives beneath the building's great dome (see Figure 3.1).

Empiricism and Foreign Reproach: Patriarch Konstantios I

Konstantios, Patriarch of Constantinople from 1830 to 1834, was born in that same city in 1770, and died on Antigoni, in the Prince's Islands, in

1859. Despite his traditional ecclesiastical education, Konstantios became 'a cautious and moderate reformer, selectively receptive to radical enlightened ideas such as political liberalism, patriotism, universal education, and even the selective use of demotic Greek'.[15] Described by his biographer, Theodoros Aristokles, as 'the most archaeological patriarch',[16] Konstantios wrote books on the history and monuments of Alexandria (1803), Cyprus (1819), Constantinople (1820) and Egypt (1838), in addition to a pamphlet on Hagia Sophia (1849).

The most widely read of his books is *Κωνσταντινιάς παλαιά τε και νεωτέρα ήτοι περιγραφή Κωνσταντινουπόλεως* ('Konstantinias, Ancient and Modern, or, a Description of Constantinople'), which was first published in Venice in 1820. Further Greek editions followed in 1824 and 1844, in addition to translations and adaptations in French, Ottoman Turkish, Karamanlidika and English.[17] The terms 'ancient' and 'modern' designate the two halves of the book, of which the former is concerned with Byzantine architecture and topography, the latter with the Ottoman city.

The *Konstantinias* is programmatically empirical. As Haris Theoderelis-Rigas and Firuzan Melike Sümertaş write, 'its avowed objective was to ascertain and "construct" the material aspects of the ancient city based on information either provided in earlier literature or acquired through the author's own observations'.[18] Konstantios was a careful observer of physical geography, historical remains and inscriptions. He was also explicitly critical of the (to his mind) hyperbolic and idealising accounts of Byzantine authors. Take, for example, the start of his chapter on Hagia Sophia:

> The historians of Byzantion, prompted by an extreme piety, have deviated so far from the truth as to set forth many exaggerations regarding this greatest and most splendid of churches. Owing in part to its extraordinary height, width, and length; in part to the beauty and brilliance of its many great columns and variegated marbles, the grace of its form, the harmony of its proportions according to the architecture of its age, and above all to its antiquity, it has ever been admired by the foreign races; whereas it is judged and believed by our own (owing equally to respect and to piety) as a wonder exceeding nature, a work without compare, and a proof of greatness and pride in beauty (δεῖγμα μεγαλουργίας, καὶ περὶ τὰ καλὰ φιλοτιμίας).[19]

Konstantios's own description partakes of both approaches, those of 'the foreign races' and of 'our own'. He aspires to a quantitative empiricism, essaying measurements of the building's height, width and length. To demonstrate the harmony of its proportions, he borrows a chart from the work of 'a certain English traveler', which compares the dimensions

of Hagia Sophia to those of ancient temples (Hera at Samos, Demeter at Eleusis, etc.) and modern churches (including St Peter's in Rome and St Paul's in London) (Figure 4.1).[20] The traveller can be identified as James Dallaway, former chaplain to the British embassy in Istanbul, who published a nearly identical chart twenty-three years earlier.[21]

In fact, a great deal of Konstantios's account of Hagia Sophia either paraphrases or engages in dialogue with Dallaway. Already Konstantios's opening critique of the Byzantine historians, quoted above, bears comparison with the beginning of Dallaway's own description of Hagia Sophia:

> Many almost incredible histories of this edifice may be found in the Byzantine writers, who in their zeal for their religion did not confine themselves within the bounds of truth; whilst they dwelt with prolixity on the account of this magnificent temple. Hence arose that high degree of veneration, in which it is held by the modern Greeks, who indulge the most extravagant notions of its decided superiority over any church in the known world, and retain with infinite credulity the traditions of its former excellence.[22]

Despite this aloof introduction, Dallaway himself twice prefers Hagia Sophia to other famous churches. First, he praises the 'flatness' of the dome, which has 'a most imposing effect; and if the great vault of heaven be the idea intended, with a happier imitation, than at St. Peter's in Rome'.[23] Second, he praises the view of the dome from the interior, which 'produces an air of grandeur and stupendous effect, such as might have been supposed far beyond human powers. In this point of consideration it is to be preferred to the churches of St. Peter [in Rome] and St. Paul [in London].'[24] These are, no accident, the very two comparisons that Konstantios permits himself, and in nearly identical terms.[25]

By reading Konstantios's text alongside Dallaway's, we gain insight into the difficulties that faced an Ottoman Greek intellectual who would, at the start of the nineteenth century, claim Hagia Sophia as 'a proof of greatness and pride in beauty'. First, there was the reproach of exaggeration (Dallaway's 'extravagant notions' of the 'modern Greeks'), itself a version of an ancient topos ('Graecia mendax', or 'lying Greece'). Konstantios accordingly limits his praise to the empirically verifiable. However (second difficulty), opportunities for physical inspection of the building were scarce for Christians without diplomatic pull. As Dallaway wrote, 'It is forbidden to any but a musulman to enter the church of Santa Sophia without a firhmàn, or written order from the sultan, of which I twice availed myself'.[26] As a result, Konstantios's account of the interior mostly draws on foreign authors, and offers little of the first-hand inspection that he supplies for the other monuments of the city.

Σελ. 89

ΣΗΜΕΙΩΣΙΣ ΤΩΝ ΚΤΙΡΙΩΝ.	ΤΑΞΙΣ ΑΡΧΙΤΕΚΤΟΝΙΚΗΣ	ΕΠΟΧΑΙ Καθ' ἃς ἐκτίσθησαν.	ΜΗΚΟΣ Πόδ. / Δάκ.	ΕΥΡΟΣ Πόδ. / Δάκ.	ΥΨΟΣ Πόδ. / Δάκ.	ΑΡΧΙΤΕΚΤΟΝΕΣ
Ἱερὸν τῆς Ἥρας ἐν Σάμῳ.	Δωρικῆς ὑπαίθρου.	»	»	»	»	Ῥοῖκος.
Ἱερὸν τῆς Διμητρος ἐν Ἐλευσίνι.	Διαχωροῦν 30 χιλιάδας ἀνθρώπων.	»	»	»	»	Ἴκτινος.
Ἱερὸν τοῦ Διὸς ἐν Ἀκραγάντι.	Δωρικῆς.	»	283 / 4	33 / 4	»	Φαιακίδης.
Ἱερὸν τοῦ Διὸς ἐν Ὀλυμπίᾳ.	Δωρικῆς.	»	200	105	»	»
Ἱερὸν τῆς Ἀρτέμιδος ἐν Ἐφέσῳ.	Δωρικῆς.	Ἀθρόας ὠκείως.	425	220	»	Χερσίφρων.
Ἁγία Σοφία ἐν Κωνσταντινουπόλει.	Στρέψεται τάξεως.	ΣΤ'. Αἰῶνι.	269	243	»	Ἀνθέμιος καὶ Ἰσίδωρος.
Τὸ Τζαμι κατὰ τῆς κατὰ τὴν Ἱερουσαλὴμ Καρδούλης.	Ὠκοδομήθη ἀπὸ τῶν ἐρειπίων ἑνὸς ἀρχαίου Ναοῦ τοῦ Ἰακοῦ	Η'. Αἰῶνι.	500	258 / 4	»	»
Ναὸς ὁ ἐν Πίσης (Πίζα).	Γοθικῆς.	ΙΑ'. Αἰῶνι.	345 / 10	220 / 10	»	Ῥοσαῖος.
Ναὸς ὁ τοῦ Ἁγίου Διονυσίου ἐν Παρισίοις.	Ῥωαίνως.	ΙΒ'. Αἰῶνι.	275	32 / 6	»	Συγήρ.
Ναὸς ὁ ἐν Ἀμβιανοῖς (Ἀμιὲν) τῆς Γαλλίας.	Ῥωαίνως.	ΙΓ'. Αἰῶνι.	315	110 / 2	»	Λυζάργος.
Ναὸς ὁ ἐν Τολέδῳ.	Κατὰ μαίρος.	ΙΓ'. Ῥωαίνως.	336 / 8	168 / 4	»	Πέρες.
Ναὸς ὁ ἐν Σιέναι, ἢ Σιένη τῆς Ἰταλίας.	Γοθικῆς.	ΙΔ'. Αἰῶνι.	307 / 6	183 / 9	»	Γ. διὰ Πίζα.
Ναὸς τῆς Θεσσέου ἐν Παρισίοις.	Ῥωαίνως.	ΙΔ'. Ῥωαίνως.	344 / 2	130	»	Ι. Ῥά.
Ναὸς ὁ ἐν Φλωρεντίᾳ.	Ῥωμαίκης.	ΙΕ'. Αἰῶνι.	575	415	»	Βρουνελέσκης.
Ναὸς τῆς Ἁγίας Ἰουστίνης ἐν Παταβίῳ.	Κατὰ μαίρος.	ΙΕ'. Ῥωαίνως.	306 / 8	41 / 8	»	Α. Βρυόσκις.
Ναὸς ὁ τοῦ Ἁγίου Πέτρου ἐν Ῥώμῃ.	Ἐξ Ἑλληνικῶν Τάξεων, διαχωροῦν 15 χιλ. ἀνθρώπων.	ΙΣΤ'. Αἰῶνι.	638	500	100	Μιχαὴλ ὁ Ἀγγελος.
Ναὸς ὁ τοῦ Ἁγίου Παύλου ἐν Λονδίνῳ.	Ἐξ Ἑλληνικῶν Τάξεων.	ΙΖ'. Αἰῶνι.	446	250	»	Χρεστ. Βρήν.

Figure 4.1 Comparison of the dimensions of Hagia Sophia with those of other monuments of world architecture. Konstantios, *Κωνσταντινιάς παλαιά τε και νεωτέρα ήτοι περιγραφή Κωνσταντινουπόλεως* (Constantinople: Dimitrios Paspalis, 1844), 89. New York Public Library.

Nevertheless, I suspect that Konstantios did manage to enter the building at least once before he wrote the *Konstantinias*. Consider his account of the dome. Here, first, is Dallaway's description:

> The whole concave from the windows is incrusted with mosaic formed with small tessarae [*sic*], not exceeding a square of the eighth of an inch, and composed in a vitrified substance, resembling glass, called by Vitruvius 'smaltum'. Excepting four figures of colossal size representing seraphim, it is intirely gilt, decayed in many parts from extreme age, but not intentionally defaced.[27]

Konstantios's account again follows a similar trajectory:

> The interior of the dome, above the portals by which the church is illuminated, was entirely outfitted with pieces of gold glass, called mosaic (Μωσίον); and, excepting the four great cherubim in the four angles of the arches, which sight can barely distinguish (τὰ ὁποῖα μόλις ἡ ὅρασις δύναται νὰ διαχωρίσῃ), all the other venerable forms [composed] by means of tesserae (διὰ ψηφίδων) have been covered with plaster, so too the Pantokrator at the center of the dome.[28]

Despite the similarities, Konstantios diverges from Dallaway in two key respects. First, he mentions figural mosaics no longer visible, which he must know from his reading. Second, he qualifies his account of the angels in the pendentives with a key phrase: 'which sight can barely distinguish'. This seems empirically based, and conjures a visitor who, once admitted, strains to perceive beings previously known only from hearsay.

Konstantios rarely makes explicit mention of folklore. If his dismissal of those who view Hagia Sophia 'as a wonder exceeding nature' is any indication, he probably held popular traditions in low esteem. Nevertheless, his account of the dome intimates an interaction between folklore and empiricism. Stories told about the building focus the attention of the visitor on details that might otherwise escape notice. Minute inspection of the building's particulars takes the place of vague and extravagant praise.

Folklore as Expanded Empiricism: Skarlatos Byzantios and Eugène Michael Antoniades

The restorations carried out by Gaspare Fossati in 1847–9 revealed, if only for a time, many figural mosaics previously covered with plaster.[29] At the same time, an imperial desire to promote the restoration led to greater access for non-Muslims, both through printed images and in-person visits.[30] Theodoros Aristokles later recalled that he was able to visit during this interval, 'like many others, as entry was free at that time'.[31]

Konstantios himself published a short pamphlet on the history of the church in 1849, twenty-nine years after the first edition of the

Konstantinias. The new text was explicitly occasioned by the increased access. Konstantios begins by praising both the restorers and their imperial patron, Sultan Abdülmecid, and devotes some interesting pages to the mosaic of the South-west Vestibule, which he had clearly seen while it was uncovered.[32]

The first local account of the building to take full advantage of the increased access appeared two years later. Its author, Skarlatos Byzantios, was born in 1797, by his own account in Constantinople.[33] In 1830, he moved first to Greece, then to Paris to further his antiquarian research. Once back in Athens, he embarked upon a public career, which culminated in a twenty-three-year term as director of primary education for the Hellenic Kingdom. Despite his duties, he returned periodically to Constantinople, eventually publishing three formidable tomes (in 1851, 1862 and 1869, respectively) on the history and topography of his native city. Byzantios died in Athens in 1878.

Byzantios's volumes share a common title, *Η Κωνσταντινούπολις: ή περιγραφή τοπογραφική, αρχαιολογική και ιστορική* ('Constantinople: A Topographical, Archaeological, and Historical Description'). Their scope is commensurate with their subject. They are composed in a literary style, while also incorporating fragments of daily speech, Greek and Turkish; embrace a range of literary, archaeological and epigraphic sources; and betray a deep curiosity about the lives of the city's many communities.

Byzantios's description of Hagia Sophia occupies over fifty pages of his first volume.[34] He begins by following Konstantios in his critique of Byzantine hyperbole:

> Hardly any other ancient monument can boast of having attracted the attention of so many authors, both ancient and modern, all of whom unanimously express an almost compulsive admiration for it, largely reflecting the exaggerated praises sung by Byzantine historians. The limits of this approach have been justly indicated in L'Abbé's sober and detailed evaluation of its virtues and faults.[35]

The deference displayed to the French author is uncharacteristic. Byzantios was often a stringent critic of the 'ridiculous lies' found in foreign (European) accounts of the eastern Mediterranean, both its history and its present condition.[36]

By contrast, Byzantios admired the city's inhabitants, regardless of class or nation, for their local knowledge. He writes: 'Serious, disciplined history cannot reject popular oral traditions and narratives out of hand, without taking them into serious consideration and without even mentioning them.'[37] Thus, while he too is an empiricist, his empiricism is broader

than that of Konstantios, embracing not only the physical remains of antiquity, but also the lived experience of contemporary inhabitants. As Stephanos Pesmazoglou writes, Byzantios was 'a social anthropologist before the emergence of the discipline'.[38]

If Byzantios thus distinguishes the folklore about Hagia Sophia from the exaggerations of Byzantine rhetors, he nevertheless locates its origins in Byzantine literature, specifically in the ninth-century *Diegesis*. He accepts without comment some of the figures given in this text, and questions others, before ironically glossing its more supernatural accounts:

> Storehouses were filled by apparitions and architectural tight-spots were resolved by means of angelic revelation. In short, there was some metaphysical explanation about anything that transpired, with the result that still today, the miraculous legends pertaining to this church continue to be passed down from one generation to another, not only among Christians but even among the Ottomans, many of whom claim to have seen with their own eyes the allegedly incorruptible bodies of the dead in its deep catacombs and even heard their chanting during the Easter Vigil![39]

In this passage, Byzantios draws a direct line from Byzantine literature to contemporary Constantinopolitan folklore, both 'Christian' and 'Ottoman'.[40]

Byzantios's most sustained account of the folklore about Hagia Sophia addresses the angels in the pendentives:

> On each of these four triangles, formed at the eight meeting points of the four great arches, one may still discern one of four Seraphs or six-winged angels, rendered in mosaic. Although Islamic tradition has long known the names of the four prominent Archangels as Gabriel, Michael, Raphael and Israel, their longstanding rejection of anthropomorphic depictions of the sacred has led them to cover them up with plates, bearing the monograms of the four caliphs. Others claim that the mosaics actually depict the four Evangelists, while the Turks interpret them as depictions of bats and claim that once they had been plastered over, bats started for the first time to enter and nest inside the church. Yet others purport that up until Muhammad's arrival, the depictions used to speak miraculously and predict various momentous events, and that they were silenced by his arrival. During the monument's renovation that was completed two years ago, these were the only depictions that were not gilded over by the Turks, who identified them with the *melâ'ike-i mukarrebîn* ['angels near at hand'], as depicted in Persian books, perhaps a distant echo of the ancient *Farohar*, as Layard has suggested.[41]

This passage adumbrates the full scope of Byzantios's capacious empiricism: from the visual geometry of the structure, through the material

Folkloric Hagia Sophia

archaeology of the building, to the full range of popular and scholarly interpretations.

As an archaeologist, Byzantios is careless. Only the two eastern seraphim were substantially preserved in the nineteenth century, but (as Cyril Mango notes) 'travelers almost invariably speak of all four even if they only actually saw two'.[42] None of them was obscured by the famous calligraphic panels, which were situated lower, at the gallery level and on the piers.

As a folklorist, Byzantios records a telling range of responses to the visible data, each of which exemplifies a different mode of interpretation. Thus, to read the figures as evangelists implies familiarity with the decoration of Byzantine and later Orthodox churches, which customarily place the authors of the gospels in the four squinches or pendentives at the base of the dome.[43] It is, in short, a formal-structural interpretation. To see them as bats, by contrast, entails a visual response to the forms of the angels' wings. It is a sensory-empirical interpretation, to which the accompanying story ties an ancient belief that images of noxious beasts repel their prototypes.[44]

The prophetic angels recall the song published by Fauriel, and the 'voice . . . from heaven, from the mouth of angels' that interrupts the mass. Byzantios is conscious, of course, of the nexus between Hagia Sophia and territorial sovereignty. In the introduction to his second volume (1862) he writes:

> And in truth, one did hope a decade or so ago that Western Europe would mount a crusade to shore up the Ottoman throne, and that the combined English and French fleet would anchor in the Bay of Amykos, and that the blond nations (the English and the French [οἱ Ἀγγλογάλλοι]) would come to a halt in the heart of the City of the Seven Hills, outside the church of Hagia Sophia! But our own era has also produced fantasies of this sort.[45]

Here Byzantios ironises brilliantly, reading the outbreak of the Crimean War through Byzantine lore about the Crusades.

However, in his own account of the mosaics' speech, Byzantios has a different interlocutor in mind. The *Seyahatnâme* ('Book of Travels') of Ottoman litterateur Evliya Çelebi (d. c. 1685) did not appear in print until 1834, when the Oriental Translation Fund published selections in an English translation by Joseph von Hammer; the first printed selections from the original Turkish appeared nine years later.[46] Byzantios certainly knew Evliya's text, either in the original or in Hammer's version,[47] and his account of the mosaics in the pendentives recalls the following passage from Hammer:

there are, at the four angles supporting the great cupola, four angels, no doubt the four archangels, Jebráyíl (Gabriel), Míkáyíl (Michael), Isráfíl, and 'Azráyíl, standing with their wings extended, each 56 cubits high. Before the birth of the prophet, these four angels used to speak, and give notice of all the dangers which threatened the empire and the city of Islámból; but since his Highness appeared, all talismans have ceased to act.[48]

Evliya's account underlies two of Byzantios's claims: that the Turks know the names of the four angels; and that the angels once spoke, but were silenced by the coming of the Prophet.

Byzantios's concluding observation on the angels is by far his most startling and original. He remarks that the seraphim, alone among the mosaics uncovered by the Fossatis, were not subsequently concealed by plaster, as 'the Turks . . . identified them with the *melâ'ike-i mukarrebîn*', or 'angels near at hand'. The reference is to Qur'an 4:172, 'The Messiah [Christ] will not disdain to be a servant of God, neither the angels who are near stationed to Him'. The 'Persian books' in which (Byzantios continues) these angels are depicted must be illustrated manuscripts. Consider, for example, the angel Jibrîl, as he appears to Muhammad in a sixteenth-century Ottoman copy of the *Siyer-i Nebi* ('Life of the Prophet') (Figure 4.2). The concluding clause, finally, posits a Persian origin for these figures pre-dating both Christianity and Islam: 'the ancient Farohar', the winged figure in the circle. As an authority, Byzantios cites the English archaeologist Austen Henry Layard, whose study of this ancient motif traced its origins in Assyrian lore and its afterlives in ancient (pre-Christian) Greek and pre-Islamic 'Syro-Arabian' religion (Figure 4.3).[49]

This is, in other words, a scholarly-historical interpretation of the mosaics, and it appears to be Byzantios's own. We may elaborate as follows: both the Byzantine mosaics and the Ottoman paintings derive from a shared, Persian source. Byzantios's account of the folklore about the mosaics is thus commensurate with his account of the long life of the *Diegesis*; both posit a shared root for Byzantine and Ottoman knowledge about the building. And that shared root is emphatically Eastern, a theme that recurs repeatedly in Byzantios's treatment of Hagia Sophia. Thus, in another passage, he notes 'the forty columns of the ground floor', commenting: 'In the Asiatic monumental architecture, the number forty is considered to be a mark of grandeur. The ruins of Persepolis are for that reason, to this day, known as *Chehel Sotun*, that is, "Forty Columns".'[50] Here again, Hagia Sophia is placed within a specifically 'Asiatic' tradition, whose origins precede both Christianity and Islam.

In short, while Konstantios's account of Hagia Sophia pointed the way to a synthesis of folklore and empiricism, Byzantios gives us that

Folkloric Hagia Sophia

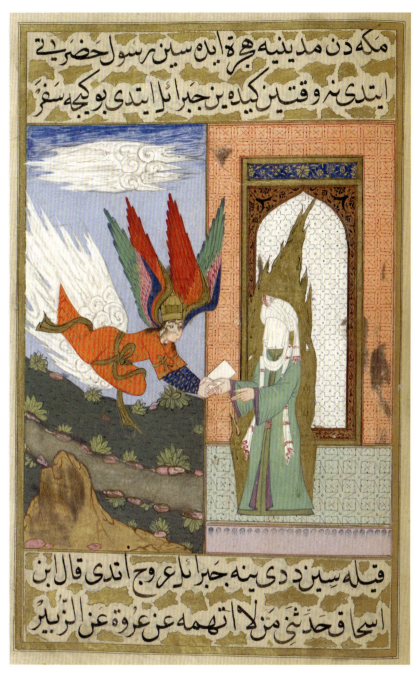

Figure 4.2 The angel Jibrîl delivers a message from God to Muhammad, ordering him to leave Mecca and go to Medina. *Siyer-i Nebi*, 1594–5, Turk. ms. 3, Spencer Collection, New York Public Library.

448 NINEVEH AND ITS REMAINS. [Chap. VII.

king in battle, it shoots, against the enemies of the Assyrians, an arrow, which has a head in the shape of a trident. If it presides over a triumph, its action resembles that of the king, the right hand being elevated, and the left holding the unbent bow; if over a religious ceremony, it carries a ring, or raises the extended right hand. This emblem does not always preserve the form of the winged figure in the circle, but sometimes assumes that of a winged globe, wheel, or disk, either plain, or ornamented with leaves like a flower. In this shape, its resemblance to the winged globe of Egypt cannot be overlooked.*

Emblems of the Deity. (N.W. Palace, Nimroud.)

* This is one of the representations most intimately connected with Egypt, resembling the symbol found on the cornices of tablets as early as the twelfth dynasty. In Egypt it was the sun, with the wings of a scarab; a red solar disk, and two pendent uræi. It is called the "Hut" (the name of the Coptic Atfoo, or Edfoo, Apollinopolis magna). M. Lajard, as I have already observed, endeavours to derive the Egyp-

Figure 4.3 Austen Henry Layard, *Nineveh and its Remains* (London: John Murray, 1849), II.448. Cornell University Library.

synthesis in fully developed form. The contrast with Fauriel is striking. Whereas Fauriel's account ties an abstract conception of the building to a specifically modern notion of the nation, Byzantios seeks the primeval, shared origins of Greek and Turkish culture in the oral and written traditions about a specific aspect of the building: the mosaics of the angels in the pendentives. Instead of a metonym for territorial sovereignty, Hagia Sophia becomes a case study in cultural translation.

During the second half of the nineteenth century, Ottoman Greek intellectuals continued to pursue the empirical study of the Byzantine monuments of Constantinople.[51] The Hellenic Philological Society of Constantinople played a leading role in this effort, both through the publication of a learned journal and by pioneering the use of photography to document standing architecture.[52]

In relation to Hagia Sophia, these efforts culminated in the work of Eugène Michael Antoniades. Antoniades was born in Constantinople in 1870 and moved to Paris in 1893, where he pursued a distinguished career as an astronomer, dying a French citizen in occupied Paris, 1944.[53] In 1904, Antoniades received permission from the Ottoman government to carry out a survey of Hagia Sophia; he writes that the petition was initiated by the banker Theodoros Ambrosios Mavrogoratos and approved by the grand vizier, Ferid Pasha.[54] The results are found in the three splendid volumes of the *Ἔκφρασις τῆς Ἁγίας Σοφίας* ('Description of Hagia Sophia'), published in Athens between 1907 and 1909, and dedicated to Sultan Abdülhamid. Antoniades was the author both of the detailed and scholarly text and of the vast majority of images, photographed and drawn: 'some 800 pages, 750 drawings and 100 plates'.[55]

Antoniades's volumes constitute the most systematic and comprehensive description of the great church ever published. Like Byzantios, so too does Antoniades exhibit a robust interest in folklore. Antoniades devotes six pages to 'the beliefs about the church', once more beginning with the *Diegesis* and continuing to present-day Turkish stories, here culled from various published accounts, including Byzantios.[56] Also like Byzantinos, Antoniades exhibits a particular interest in the stories about seraphim. His account of the pendentives concludes with the excerpt from Byzantios analysed above, quoted verbatim.[57] In a short piece on the church written for the popular French press in 1913, Antoniades reprises once more the story from Evliya: 'The four enormous seraphims in the pendentives of the dome, which look like whirlwinds of feathers, once uttered prophecies of the future; but they have become forever silent after the coming of Muhammad.'[58]

In short, Byzantios and Antoniades exhibit a shared approach to the folklore about Hagia Sophia. Both base their accounts primarily on published sources; and both seek to harmonise, when possible, the popular traditions about the building, by tracing them back to common sources, Byzantine or even earlier.

Many Voices: Jean Nicolaïdès

Our final author, Jean Nicolaïdès, pursued a markedly different path. He collected oral accounts of the building from the city's living inhabitants, which he did not seek to harmonise with each other, instead allowing their differences to become apparent.

Jean Nicolaïdès was born in 1846 in İncesu, near Kayseri.[59] A talented schoolboy, he continued his studies in Constantinople from the age of 17, also giving lessons to the children of wealthy Greeks. At the age of 25, he moved to Chios, where he continued to work as a teacher, and at the age of 34 he travelled to France and met the folklorist Henry Carnoy, who became his collaborator in research. Their first joint volume, the *Popular Traditions of Asia Minor*, was published in 1889, followed by the *Folklore of Constantinople* in 1894: one year after Nicolaïdès's death.

The *Folklore of Constantinople* interests us primarily on account of two consecutive chapters: 'The Mosque Saint Sophia', and 'The Beliefs of the Christians about Saint Sophia'. The stories in the former chapter are attributed to Muslim informants, such as 'Ibrahim, from Trebizond, Turk, student in theology, 27 years old, [interviewed] in 1886'.[60] Those in the latter chapter are attributed to Christian informants, such as 'Christaki Djismodji, postal bureaucrat, born in Constantinople, 40 years old, [interviewed] in 1887'.[61]

The two chapters are distinguished not only by the religion of the informants, but also by the character of the stories. Those told by Muslims are concerned with the material fabric of the building, and with the traces of past events that are still visible. According to one, the mortar of Hagia Sophia was mixed with the saliva of the Prophet. According to another, when Mehmed the Conqueror leaned against a wall of the building, he left a dent that can still be seen. Mehmed also struck a column with his sword, splitting it in two; this too is still visible. The Prophet Khidr once tried to turn the building's axis to *qibla*; the imprint of his arms is still shown. And Mehmed, once more, placed a bloody hand on the interior wall, so high up as to prove that he was a giant.

The stories told by Christians, by contrast, are about things that are hidden away. For example, one story concerns a kind of nook, open only

during Easter, where an old oil lamp burns, and nods in respect to any Christian who discovers it. Another story tells of a golden door that 'the Turks' may not open without releasing great misfortune for the Empire. Or, at greater length, consider the following story:

> A grocer's assistant, out running errands, passed the court of Hagia Sophia and saw a door open before him; he went inside, and mass was in progress. He assisted at the service, and then attempted to leave, but the crowd of other assistants rendered exit difficult. When finally he left, he returned directly to the grocer, and went back to work. Another boy expressed astonishment and asked him who he was. 'The grocer's assistant', he replied. 'Not true', said the other boy, 'I am the grocer's assistant'. And the master entered and recognized his old employee. 'Where have you been?' he asked. 'You've been gone a year and we have sought you in vain'. The boy replied, 'I ran some errands, but as I passed Saint Sophia, I went inside and assisted at the service'. For he had no idea that he had been shut in the basilica for a whole year. For this reason, it is believed that, once a year, there is a private service in the church of Hagia Sophia; and that those assistants who are unable to leave at once, remain inside until the following Easter.
> — Tale told by M. Chistos, a money-changer born in Neapolis [Nevşehir], 48 years old.[62]

There is a clear difference between the stories told by Muslims regarding specific, visible elements within the building, and those told by Christians about secret places and invisible doors. Despite increasing access for non-Muslim elites, it was still difficult for humbler folk to enter the building; Nicolaïdès writes explicitly of 'the Christian who is lucky enough to gain access' to the interior.[63]

Of equal interest is the notion of a perpetual mass and an eternal flame, both of which maintain the Christian function of the building. Recall the last line of the poem collected by Fauriel, with which we began. Often freely translated as a prophecy, 'all these will be yours again', it is more literally an expression of an ongoing state of affairs, 'these things are still yours'. If the free translation permitted interpretation of the poem as a call to conquest, the literal translation seems more appropriate to Nicolaïdès's Christian, Ottoman subjects, who know that, at its core and despite changes in rule, Hagia Sophia is still a church.

Notably, Nicolaïdès sets one final story in a chapter of its own, after the beliefs of the Muslims and those of the Christians, with the title 'Khidr and the Drunkard':

> Hamdi Hoca, an Ottoman subject and student of theology, told us the following story. One day during Ramadan, a drunk man went to stretch out

under the dome of Hagia Sophia. Meanwhile the faithful gathered there to pray and to listen to the homily of the imam. As the drunkard lay on his back, Khidr approach him and said, 'Are you not ashamed to lie here in this state?' The man seized Khidr by the arm and pointed to the cupola. Khidr saw the angels of God delivering homilies of their own, and he understood that the drunkard was on his back to better comprehend their discourse.[64]

The angels are, of course, the mosaics of the seraphim in the pendentives. But what is the content of their discourse? The decoration of the building supplies a possible answer: the Light Verse, Qur'an 24:35, inscribed at the summit of the cupola, in between the angels, by the calligrapher Kazasker Mustafa İzzet Effendi in 1848–9. But the story as related by Nicolaïdès is only concerned to signal its difference from the official discourse, 'the homily of the imam'. In place of the harmonisation of 'Asiatic' traditions, Byzantine and Ottoman, essayed by Byzantios, we have here a story told by a Muslim (Hamdi Hoca) to a Christian (Nicolaïdès) that anchors the possibility of alternative, unofficial interpretations of Hagia Sophia within the very fabric and décor of its dome.

From the Mouth of Angels

Let us summarise the foregoing. The most familiar folkloric Hagia Sophia emerges through the resolution of the ambiguities of the poem first published by Fauriel. The building becomes a metonym for the territorial ambitions of the Greek Kingdom, and its materiality becomes incidental to its meaning. This chapter has distinguished a less familiar, fundamentally empirical, folkloric Hagia Sophia, through the works of four Ottoman Greek writers. Patriarch Konstantios I, while not explicitly concerned with folklore, established the necessity of empirical (sensory-perceptive) inspection of the building, in part to avoid the foreign reproach of exaggeration. Konstantios signals his own, first-hand, knowledge of the structure in his account of the seraphim, 'which sight can barely distinguish'.

Konstantios could not conduct a systematic survey of the building himself, but succeeding generations of Ottoman Greeks enjoyed greater access, resulting in the progressively more detailed and comprehensive descriptions of Skarlatos Byzantios and Eugène Michael Antoniades. Both made room for folklore within their accounts, and both paid particular attention to the variety of popular explanations offered for the seraphim in the pendentives. Both, finally, set those traditions within a much deeper history of reception: from the Byzantine *Diegesis*, through

the *Seyahatnâme* of Evliya Çelebi, and continuing to the present day. In Byzantios's words, 'the miraculous legends pertaining to this church continue to be passed down from one generation to another, not only among Christians but even among the Ottomans'. This was a historical and harmonising approach, situated at a very high social level, among authors who enjoyed the favour of the Ottoman court and seemingly unfettered access to the building.

If folklore forms a supplement to the empiricism of Byzantios and Antoniades, it is the primary focus of Jean Nicolaïdès, who worked outside the walls of Hagia Sophia in the streets of Istanbul. His chapters work against the harmonising tendency of Byzantios and Antoniades, distinguishing between Christian and Muslim traditions about the building, and rendering plainly the impact of the accompanying power differential. The interior of Hagia Sophia, its walls and columns, were familiar to non-elite Muslims, but not, however, to non-elite Christians, who were left to speculate about hidden lamps and secret masses. By inscribing a continued Christian presence within the fabric of the structure, these stories constructed a foil to the official, imperial discourse about the building.

Nor was this a solely Christian pursuit – the story of Khidr and the drunkard, told by a Muslim 'student of theology', counterposes the homily of the imam to the homily of the seraphim. Indeed, no figure better exemplifies the empirical approach to the folklore about Hagia Sophia than the drunkard, who, as Khidr realised, lay on his back to better comprehend the angels' discourse. Hamdi Hoca does not say what the drunkard heard, so we are free to speculate. Perhaps it was the verse inscribed beside the angels, 'God is the light of the heavens and the earth'; and perhaps it was a promise, 'again these things are yours'.

Notes

1. Michael Herzfeld, *Ours Once More: Folklore, Ideology, and the Making of Modern Greece* (Austin: University of Texas Press, 1982), 26–9.
2. Claude Fauriel, *Chants populaires de la Grèce modern* (Paris: Didot, 1824–5), II.23–4 (Greek text and French translation). Unless otherwise specified, all English translations in this chapter are my own.
3. Roderick Beaton, *Folk Poetry of Modern Greece* (Cambridge: Cambridge University Press, 1980), the quotation at 75.
4. *O City of Byzantium: Annals of Niketas Choniatēs*, trans. Harry J. Magoulias (Detroit: Wayne State University Press, 1984), 357.
5. Herzfeld, *Ours Once More*, 134.
6. Fauriel, *Chants populaires*, II.22.
7. Herzfeld, *Ours Once More*, 132.

8. Nikos Magouliotis, 'Hagia Sophia and the Greeks: National Myth and Architectural Histriography', *Stambouline*, 2 December 2020, www.stambouline.info/2020/12/hagia-sophia-and-greeks.html (accessed 27 July 2023).
9. Charles Stewart, *Dreaming and Historical Consciousness in Island Greece* (Chicago: University of Chicago Press, 2017), 102.
10. 'Ministry of Foreign Affairs Announcement on Today's Reading from the Quran in Hagia Sophia, on the Anniversary of the Fall of Constantinople', 29 May 2020; 'Hagia Sophia Decision Does Not Concern Greece, Erdoğan Says', *Daily Sabah*, 9 June 2020.
11. Emile Durkheim, *The Elementary Forms of Religious Life*, trans. Karen E. Fields (New York: The Free Press, 1995), 222.
12. Durkheim, *Elementary Forms*, 228.
13. Magouliotis, 'Hagia Sophia'.
14. Johann Strauss, 'Who Read What in the Ottoman Empire (19th–20th Centuries)?', *Middle Eastern Literatures* 6 (2003): 39–76; the quotation at 40. The concept of a multilingual Ottoman literature is further developed by multiple contributors to two anthologies: Marilyn Booth (ed.), *Migrating Texts: Circulating Translations around the Ottoman Mediterranean* (Edinburgh: Edinburgh University Press, 2019); and Marilyn Booth and Claire Savina (eds), *Ottoman Translations: Circulating Texts from Bombay to Paris* (Edinburgh: Edinburgh University Press, 2023).
15. Haris Theodorelis-Rigas and Firuzan Melike Sümertaş, 'Archaeology as Epic: Language, Transmission and Politics in the Editions of Patriarch Konstantios I's *Konstantinias*', in Evangelia Balta (ed.), *Following the Traces of Turkish-Speaking Christians of Anatolia* (Cambridge: The Department of Near Eastern Languages and Civilizations, Harvard University, 2021), 103–36; the quotation at 111.
16. Theodoros Aristokles, *Κωνσταντίου Α΄, του από Σιναίου αοιδίμου πατριάρχου Κωνσταντινουπόλεως του Βυζαντίου, Βιογραφία* (Constantinople: Proodos, 1866), 16: 'ἀρχαιολογικώτατος Πατριάρχης'.
17. On the work's publication, translation and adaptation, see Theodorelis-Rigas and Sümertaş, 'Archaeology as Epic',
18. Theodorelis-Rigas and Sümertaş, 'Archaeology as Epic', 115.
19. Konstantios, *Κωνσταντινιάς παλαιά τε και νεωτέρα ήτοι περιγραφή Κωνσταντινουπόλεως* (Constantinople: Dimitrios Paspalis, 1844), 82 (passage translated). Cf. (for further criticism) at 35–6.
20. Konstantios, *Κωνσταντινιάς*, 89.
21. James Dallaway, *Constantinople Ancient and Modern, with Excursions to the Shores and Islands of Archipelago and to the Troad* (London: T. Bensley, 1797); the chart at 54–5.
22. Ibid., 51.
23. Ibid., 52–3.
24. Ibid., 56.
25. Konstantios, *Κωνσταντινιάς*, 85 and 87.

26. Dallaway, *Constantinople*, 51.
27. Ibid., 53.
28. Konstantios, *Κωνσταντινιάς*, 87.
29. See especially Cyril Mango, *Materials for the Study of the Mosaics of St. Sophia at Istanbul* (Washington: The Dumbarton Oaks Research Library and Collection, 1962).
30. On the printed images, see the contribution of Asli Menevse to this volume; and on in-person visits, see the contribution of A. Hilâl Uğurlu.
31. Aristokles, *Κωνσταντίου Α´*, 403, fn. 1; this passage translated in Mango, *Materials*, 135.
32. Konstantios, *Πραγματεία αρχαιολογική περί του ναού της Αγίας Σοφίας* (Constantinople: I. Lazarides, 1849), 1 and 17–19. The pamphlet was subsequently republished as an appendix to Aristokles, *Κωνσταντίου Α´*, 387–407.
33. On his life and works, see especially Stephanos Pesmazoglou, 'Skarlatos Vyzantios's *Κωνσταντινούπολις*: Difference and Fusion', in Lorens Tanatar Baruh and Vangelis Kechriotis (eds), *Economy and Society on Both Shores of the Aegean* (Athens: Alpha Bank Historical Archives, 2010), 23–78; Firuzan Melike Sümertaş, review of Skarlatos Byzantios, *Constantinople*, *Yıllık: Annual of Istanbul Studies* 1 (2019): 213–15 (birth in Constantinople at 213); and Firuzan Melike Sümertaş, 'Ortak Bir Mirasın Çevresindeki Vatandaşlar: Geç Osmanlı Dönemi İstanbul'unda Gelenek, Bilgelik ve Kültürel Alışveriş/ Fellow Citizens Around a Shared Heritage: Tradition, Erudition, and Cultural Interchange in Late Ottoman Istanbul', in Brigitte Pitarakis (ed.), *İstanbul'dan Bizans'a: Yeniden Keşfin Yolları, 1800–1955/From Istanbul to Byzantium: Paths to Rediscovery, 1800–1955* (Istanbul: Pera Museum, 2021), 144–63; here at 148–51 (birth elsewhere than Constantinople).
34. Skarlatos Byzantios, *Η Κωνσταντινούπολις: ή περιγραφή τοπογραφική, αρχαιολογική και ιστορική* (Athens: Andreou Koromela, 1851–69), I.464–517. For translation and commentary, see Skarlatos Byzantios, *Constantinople: A Topographical, Archaeological, and Historical Description*, trans. Haris Theodorelis-Rigas (Istanbul: Istos, 2019), 632–99.
35. Byzantios, *Κωνσταντινούπολις*, I.464; translation (modified) after Byzantios, *Constantinople*, 632. The reference is to M.L.M. [Louis Avril], *Temples anciens et modernes: observations historiques et critiques sur les plus célèbres monumens d'architecture Grecque et Gothique* (Paris: 1774).
36. Pesmazoglou, 'Skarlatos Vyzantios', 49–53; the quotation (from Byzantios, *Κωνσταντινούπολις*, II.θ) at 49.
37. Byzantios, *Κωνσταντινούπολις*, III.ιβ; here quoted after Pesmazoglou, 'Skarlatos Vyzantios', 35.
38. Pesmazoglou, 'Skarlatos Vyzantios', 31.
39. Byzantios, *Κωνσταντινούπολις*, I.467; translation after Byzantios, *Constantinople*, 635.

40. As Pesmazoglou writes, he 'incorporated Ottoman history – with all its discontinuities – into a continuum with Byzantine history'. 'Skarlatos Vyzantios', 44–5.
41. Byzantios, *Κωνσταντινούπολις*, I.644; translation after Byzantios, *Constantinople*, 644.
42. Mango, *Materials*, 84.
43. For a list of Byzantine examples, see Ernst Kitzinger, 'The Portraits of the Evangelists in the Cappella Palatina in Palermo', in Katharina Bierbrauer, Peter K. Klein and Willibald Sauerländer (eds), *Studien zur mittelalterlichen Kunst, 800–1250: Festschrift für Florentine Mütherich zum 70. Geburtstag* (Munich: Prestel-Verlag, 1985), 190, fn. 2.
44. See e.g. W. L. Dulière, 'Protection permanente contres des animals nuisibles assure par Apollonius de Tyane dans Byzance et Antioche: evolution de son mythe', *Byzantinische Zeitschrift* 64 (1970): 247–77; Finbarr Barry Flood, 'Image Against Nature: Spolia as Apotropaia in Byzantine and the *dār al-Islām*', *The Medieval History Journal* 9 (2006): 143–66.
45. Byzantios, *Κωνσταντινούπολις*, I.644; translation (modified) after Pesmazoglou, 'Skarlatos Vyzantios', 52.
46. Caroline Finkel, 'Joseph von Hammer-Purgstall's English Translation of the First Books of Evliya Çelebi's *Seyahatnâme* (Book of Travels)', *Journal of the Royal Asiatic Society* Series 3, 25 (2015): 41–55.
47. Pesmazoglou, 'Skarlatos Byzantios', 31.
48. Joseph von Hammer, *Narrative of Travels in Europe, Asia, and Africa, in the Seventeenth Century, by Evliyá Efendí* (London: The Oriental Translation Fund, 1834), 56.
49. Austen Henry Layard, *Nineveh and Its Remains* (London: John Murray, 1849), II.447–50.
50. Byzantios, *Κωνσταντινούπολις*, I.476; translation after Byzantios, *Constantinople*, 646.
51. Robert Ousterhout, 'The Rediscovery of Constantinople and the Beginnings of Byzantine Archaeology: A Historiographic Survey', in Zainab Bahrani, Zeynep Çelik and Edhem Eldem (eds), *Scramble for the Past: A Story of Archaeology in the Ottoman Empire, 1753–1914* (Istanbul: SALT, 2011), 181–211; Sümertaş, 'Ortak Bir Mirasın Çevresindeki Vatandaşlar'.
52. For the use of photography, see Artemis Papatheodorou, 'Photography and Other Media at the Service of Ottoman Archaeology', *Diyâr* 1 (2020): 108–28, especially at 116–23. On the Literary Society in general, see Charēs Exertzoglou, *Η Εθνική Ταυτότητα στην Κωνσταντινούπολη: Ο Ελληνικός Φιλολογικός Σύλλογος Κωνσταντινουπόλεως 1861–1912* (Athens: Ekdoseis Nefelē, 1996); and George A. Vassiadis, *The Syllogos Movement of Constantinople and Ottoman Greek Education 1861–1923* (Athens: Centre for Asia Minor Studies, 2007). On its politics, see Artemis Papatheodorou, 'The Hellenic Literary Society at Constantinople between Ottomanism and Greek Irredentism', *Yıllık: Annual of Istanbul Studies* 4 (2022): 115–19.

Folkloric Hagia Sophia

53. On his life, see Richard McKim, 'The Life and Times of E. M. Antoniadi, 1870–1944. Part 1: An Astronomer in the Making', *Journal of the British Astronomical Association* 103 (1993): 164–70; and idem, 'The Life and Times of E. M. Antoniadi, 1870–1944. Part 2: The Meudon Years', *Journal of the British Astronomical Association* 103 (1993): 219–27.
54. Eugène Michael Antoniades, Ἔκφρασις τῆς Ἁγίας Σοφίας (Athens: Sakellarios, 1907–9), I.α-γ.
55. McKim, 'Life and Times', 170, fn. 59.
56. Antoniades, Ἔκφρασις, I.33–8.
57. Ibid., III.78.
58. Eugène Antoniadi, 'La merveille des basiliques: Sainte-Sophie de Constantionple', *Je Sais Tout* 102 (1913): 107–16.
59. For the following account of his life, see the preface (signed 'C. de W.') to Jean Nicolaïdès, *Contes licencieux de Constantinople et de l'Asie Mineure* (Paris: Kleinbronn, 1906), vii–xiii. See further Arzu Öztürkmen, 'From Constantinople to Istanbul: Two Sources on the Historical Folklore of a City', *Asian Folklore Studies* 61 (2002): 271–94.
60. Henry Carnoy and Jean Nicolaïdès, *Folklore de Constantinople* (Paris: Emile Lechevalier, 1894), 27.
61. Ibid., 34.
62. Ibid., 35–6.
63. Ibid., 34.
64. Ibid., 39–40.

Chapter 5

The Other Ayasofya: The Restoration of Thessaloniki's Ayasofya Mosque, 1890–1911

Sotirios Dimitriadis

In 1908, the French architect Marcel Le Tourneau gave a lecture at the Académie des Inscriptions on the Byzantine architecture present in Thessaloniki. By that point, Le Tourneau had visited the Ottoman port city twice, on stipends given to him by the French Ministry of Public Instruction and the Fine Arts. The purpose of his trips was to catalogue and sketch the city's monuments in the wake of destruction caused by the fire of 1890 and the earthquake of 1902. After his return from Thessaloniki, Le Tourneau described to a rapt audience how he had entered the deserted church of Hagia Sophia, or the mosque of Ayasofya to the Ottomans, and discovered its amazing mosaic decorations now revealed thanks to the fire, having been covered with plaster since the building's conversion to a mosque in the sixteenth century (Figure 5.1). In his account, Le Tourneau described how he approached the Ottoman authorities with these findings, impressing upon them the importance of his discovery and inspiring them to finally repair the damaged monument. His lecture was received warmly, and Le Tourneau published two articles on Thessaloniki's extant Byzantine monuments together with prominent Byzantinist Charles Diehl before his untimely death on the eve of the First World War.[1]

Le Tourneau's foray into Thessaloniki's damaged mosque was but a single incident in the building's long history. In this chapter, I will trace Ayasofya's restoration by the Ottoman authorities at the turn of the twentieth century, a transitory period that covers the final years of Ottoman rule over the city and the wider region. Ayasofya is representative of the Ottomans' engagement with the Byzantine past, in terms both of its historical symbolism and the monumental remnants of that history within the empire's cityscapes. Tracing Ayasofya's restoration, I will refer to discourses and practices by a number of actors – European scholars, Ottoman administrators and local Thessalonikan antiquarians – and in

The Other Ayasofya

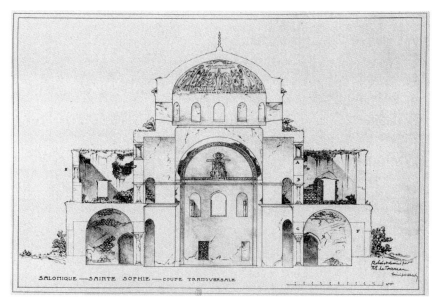

Figure 5.1 Transverse section of the Ayasofya Mosque. Marcel Le Tourneau, Charles Diehl and Henri Saladin, *Les monuments chrétiens de Salonique* (Paris: Ernest Laroux, 1908), plate XLI.

the process highlight how their interplay helped change perceptions of the building itself and its place in the urban fabric. These developments were, as I will argue, evident in the monumentalisation of Ayasofya and other sites in the city as well as in evolving practices of restoration and conservation. They were also influenced by wider processes in motion at the time – Ottoman urban reforms, the never-ending conflicts about the fate of Ottoman Macedonia and, at the very end of the period in question, the 1913 annexation of the city by Greece.

My project aims to link the expanding literature on the history of archaeology, and specifically Ottoman antiquarianism, to the urban transformation of Thessaloniki and other major cities of the empire during its Age of Reform. Recent studies on archaeology in the Ottoman Empire reflect on how the excavation, study and ownership of antiquities collided with major issues facing the empire in the nineteenth century: the urgently-enacted modernising reforms, pressure from the Great Powers of Europe, and emerging national movements among the empire's subject peoples.[2] The Ottomans initially treated excavation permits as a means of currying favour or extracting profit from European diplomats, only to be blindsided when Greek antiquity was weaponised against the empire by Greek revolutionaries and their European advocates.[3] By the end of

the century, as part of its modernising reforms, the Ottoman Empire had developed its own archaeological service and museum collections, and Ottoman archaeologists like Osman Hamdi Bey were carrying out their own excavations on Ottoman soil.[4] Informed by European imperialism, Hamidian administrators understood these projects to be a demonstration of the Ottomans' ability to participate in modern scientific endeavours as well as proof of the empire's effective control over its peripheral regions.

In the same period, that same milieu attempted to reformulate the Ottoman (art-)historical imagination, aiming to forge a new symbolic identity for the empire. While these intellectuals largely drew from eclectic readings of Islamic architectural history, their relationship to the Byzantine past remained ambivalent. Having been conquered by the early Ottoman sultans, Byzantium retained a significant symbolic and ideological power for both European and Ottoman Christians. This became all the more important in the nineteenth century, a historical conjuncture where the empire felt challenged by these two groups. Starting with the restoration of Istanbul's Ayasofya Mosque by the Fossati brothers, the restorations of select former Byzantine monuments made accommodations for their Christian elements. These projects, Thessaloniki's Ayasofya being a good example, demonstrated the Ottoman government's affinity with modern-day scholarly practices and its respect for its non-Muslim subjects while diffusing rival claims to these same monuments by inscribing them within the symbolic universe of Ottoman imperialism.[5]

Ultimately, the restoration works in Thessaloniki did not solely depend on debates among Ottoman intellectuals and administrators; they were carried out against the backdrop of a thirty-year period of rapid urban transformation.[6] Starting with the demolition of Thessaloniki's coastal walls in 1869 and their replacement with a quay, local authorities had embarked on a series of initiatives to modernise the city's urban fabric according to contemporary standards in a similar manner to Istanbul and other major centres of the empire. The 1890 fire that badly damaged Ayasofya and destroyed extensive parts of Thessaloniki's historical core provided the authorities with an opportunity to introduce a new city plan and implement a grid pattern in the affected area.[7] Local elites invested significant sums in the booming real estate market and the Ottoman state endowed the expanding city with major works of infrastructure, modern amenities and new public buildings, including the Hamidiye or New Mosque, built in 1904 in Thessaloniki's emergent suburbs.[8]

Ayasofya's connection to the changing cityscape explains both the initial delay in its restoration and the form it eventually took. Its own pious endowment had seen its income remain stagnant as the local property

market became commercialised, and it could not provide the funds needed for the repairs. Modernisers among the local authorities and the city's Muslim elite were unwilling to invest their limited funds in what they considered a traditional neighbourhood mosque. It was only when the building was linked to a broader discourse of archaeological scholarship and imperial prestige that interest in its restoration and the necessary resources materialised.

This chapter is based on two main sets of primary sources: the Ottoman state archives in Istanbul (*T.C. Cumhurbaşkanlığı Osmanlı Arşivleri*, henceforth BOA) and the records of the Byzantine Research Fund (BRF), part of the archival collections of the British School of Athens. The Ottoman material provides us with information about the damage caused to Ayasofya by the fire and preliminary measures taken by authorities for the building's repairs. Unfortunately, the archive's catalogued material does not directly address the repairs of 1907–11. The archives of Istanbul's Archaeological Museum, whose architects and archaeologists were responsible for the project, were closed off to researchers at the time of writing, so they could not be consulted. The relevant details were drawn from secondary and published accounts, including scholarly articles from the period, Ottoman Thessaloniki's polyglot press and reports by the visiting scholars of the BRF.

Thessaloniki's Byzantine Heritage

As one of the largest cities in the Mediterranean, and thanks to its strategic and commercial importance, Thessaloniki had been graced with many monumental buildings dating back to late antiquity and the Byzantine period. Ayasofya was built in the Middle Byzantine period, possibly in the seventh century, as a church dedicated to God's Divine Wisdom. Like its more famous namesake in Istanbul, it is a cross-domed church. The building's interior was richly decorated by mosaics, laid in successive phases. The figural mosaics present today date from the early ninth century and replaced earlier aniconic decoration representative of Iconoclast art. They include an image of the Theotokos in the apse and a Mosaic of the Ascension in the dome, surrounded by Mary, the Twelve Apostles and two angels.[9]

After the conquest of the city by the Ottomans in 1430 and the conversion of the church of Hagios Dimitrios into the Kasımiye Mosque by the late fifteenth century, Ayasofya briefly functioned as the cathedral for the city's Orthodox population. In 1526, the governor of Rumelia and later grand vizier İbrahim Paşa, upon his return from the Ottoman victory at Mohacs, decided to claim the building and convert it into a

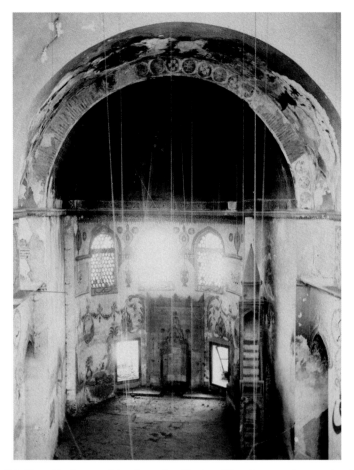

Figure 5.2 The mihrab area of the Ayasofya Mosque. The photograph was taken by Walter Sykes George in 1907, after the interior had been cleaned and before the restoration was complete. Both the mosaic of the apse and the Late Ottoman wall paintings are visible. Byzantine Research Fund 02-01-07-104.

mosque, attaching it to his personal pious foundation. The mosque was formally named the Makbul İbrahim Paşa Mosque after its benefactor, but remained popularly known as Ayasofya. The new administrators made some minor structural changes, adding a mihrab and a minaret to the building. A colonnaded portico was built to function as an outside prayer space (*son cemaat mahalli*). The rich mosaic decoration was not destroyed but was instead covered by layers of white plaster and wallpaper banners that carried Qur'anic inscriptions (Figure 5.2).[10]

Together with a series of new construction projects, the conversion of Byzantine churches was meant to advance the transformation of

Thessaloniki into a typical Ottoman city and jumpstart population and commercial development. The members of the Ottoman elite who founded the new mosques, either seizing them (as in this case) or constructing them anew, endowed them with significant mobile and immobile assets, both in the city itself and in its outskirts. These pious endowments (Tr. *vakıf*, plural *evkâf*; Ar. *waqf*) were tasked with maintaining religious and charitable services, thus turning the mosque complexes into not only places of congregation for the local Muslims but also hubs of commerce and the urban crafts.[11]

Thessaloniki's Ayasofya was itself endowed with numerous properties in the city, whose incomes funded the maintenance of the building, the salaries of its religious functionaries and caretakers, and a number of other services, including a school. The conversion of Ayasofya was meant to signify the ascendancy of Thessaloniki's Muslim element over the Greek Orthodox population, serving as the most prominent mosque in Thessaloniki's downtown area for most of the Ottoman period. The process of Thessaloniki's Islamisation was upended, however, as the mosque's conversion was taking place. In the early sixteenth century, the Ottomans had opened their borders to Sephardic Jews expelled from Spain and Italy. Over the years, many of these refugees settled in Thessaloniki, and the city's Jewish community soon grew to become one of the largest in the Mediterranean; by the end of the nineteenth century more than half of the city's population was Jewish.[12] The neighbourhood around the mosque was ethnically and religiously diverse, as it lay at the point where the quarters of the three communities intersected, with a slight Jewish predominance.[13] Nonetheless, the activity of its pious endowment remained a major factor in the local economy until the nineteenth century, even as the city's fortunes waxed and waned.

As the centuries passed, Thessalonikans began to attribute mystical importance to their city's oldest buildings.[14] For example, in the 1830s, during a long spell of drought, a local Muslim elder dreamed of Sultan Mahmud himself, who instructed him to go to Ayasofya and look for a particular ancient pillar. The next day, the elder recounted his dream to Thessaloniki's Islamic judge and together they went to the mosque and located the pillar in question. Hidden in a niche, they found an ancient volume of the Holy Qur'an. The miracle was complete, when a specific *sura* (or Qur'anic verse) was recited and it began to rain. The judge then sent a missive to Istanbul with a report of what had occurred.[15]

Incidentally, the 1830s also witnessed the arrival of the first European travellers and scholars in Thessaloniki. Having visited what is today

southern Greece since the late eighteenth century, they now began to include Thessaloniki and its environs in their itineraries. Their mission was to demystify the remains of antiquity through archaeology as a scholarly discipline and, if possible, retrieve material examples of antiquity for the collections of their patrons in Western Europe. Initially, these visiting scholars were mostly preoccupied with ancient Greek and Roman finds. Thessaloniki seems to have been a treasure trove for Greek and Latin inscriptions, as well as for Roman and Christian sarcophagi. Perhaps the best known and most dramatic case was the retrieval of the four caryatid statues locally known as the Incantadas by French archaeologist E. Miller in 1864.[16]

The second half of the nineteenth century saw an increase in scholarly interest in the Byzantine period, fuelled in part by the growing European fascination with the Middle Ages, as evidenced in Romantic literature and the Arts and Crafts movement, and in part by the mid-nineteenth-century Fossati restoration of Hagia Sophia in Istanbul and the publicity it received. As scholars of Byzantine art and architecture began to arrive in the Ottoman Empire with their textbooks, sketchbooks and cameras, Thessaloniki became one of the stops on their journey. The inclusion of the city in Texier and Pullan's authoritative volume established it as a site of major interest for European scholarship, perhaps second in importance only to Istanbul.[17]

Not all archaeologists in Thessaloniki and the Ottoman Empire were European. The involvement of the newly founded Imperial Archaeological Museum in Istanbul in the region remained minimal until the end of the century. However, a generation of local scholars emerged who began to carry out fieldwork in relevant sites, correct European scholarly publications and publish their own findings. Greek Macedonian scholars, who were trained in Classics, usually at the University of Athens, and associated with literary societies and journals in Athens, Istanbul and the diaspora, sought to bring the region's ancient heritage to light. Margaritis Dimitsas from Ohrid in northern Macedonia published two volumes of transliterations of inscriptions under the evocative title 'Macedonia in Talking Stones and Surviving Monuments'.[18] Petros Papageorgiou, the headmaster of Thessaloniki's Greek high school, collected Greek inscriptions from around the city and surveyed the city's Byzantine mosques with the assistance of his colleague Hasan Efendi.[19] This preoccupation with antiquity quickly became an essential part of Greek Macedonian identity, and archaeological findings were cited in support of arguments in the increasingly violent conflicts between Greek and Bulgarian partisans over the fate of the region.[20]

The Other Ayasofya

The 1890 Fire and the Rebuilding of Thessaloniki

In 1890, the need to record and better preserve Thessaloniki's architectural heritage became urgent after a major calamity. In early September, a large fire burned through Thessaloniki's centre for two days, with devastating results. Entire neighbourhoods were destroyed, thousands of residents were left homeless, and several public buildings burned down, including the Greek Orthodox cathedral and several synagogues. The mosque of Ayasofya was severely damaged.[21] A preliminary report on necessary reconstruction work prepared by the Ottoman authorities in September 1900 provides us with some idea of the scale of the damage. The wooden components of the building, including the frames of doors and windows, the roof that surrounded and partially obscured the cupola, and the minaret's tip, were all completely destroyed. Even though most of the walls and columns were made of more durable materials, namely stone and marble, they had also been damaged by the fire. Walls and stairs had cracked, the decorative plaster and reliefs had fallen off the walls, and the portico was badly damaged (Figures 5.3, 5.4).[22]

The destruction was widely reported in the European press, and donations for the relief of the homeless and the reconstruction of the city began pouring in. One such well-wisher was Edwin Freshfield, a British solicitor, Doctor of Philosophy at Cambridge, and enthusiast for all things Byzantine. Freshfield had been appointed member of the Board of Trustees at the British School of Athens and would be instrumental in the founding of the Byzantine Research and Publication Fund in 1908.[23] In the fall of 1890, he financed Robert Weir Schultz and Sidney Barnsley to travel to Thessaloniki and sketch and photograph its monuments, with a special focus on Ayasofya.[24] In April 1891, Freshfield sent a detailed proposal for the restoration of the 'Church of Santa Sophia at Thessalonica' to the Ottoman embassy in London, enclosing plans, drawings and photographs; the Ottoman ambassador politely declined the offer.[25] Freshfield eventually commissioned Barnsley to design and build his own church at Lower Kingswood in Surrey. Incidentally, Barnsley's design resembles not Ayasofya but another Byzantine monument of Thessaloniki, Agios Nikolaos Orfanos.

In the fifteen years that followed, Thessaloniki witnessed a great deal of reconstruction that included a number of ambitious infrastructure projects and several major public buildings.[26] The municipality rebuilt the affected area according to a new plan, establishing the city centre as a mixed-use residential/commercial area full of modern apartment buildings.[27] The street that passed in front of the mosque (the Ayasofya Boulevard) was

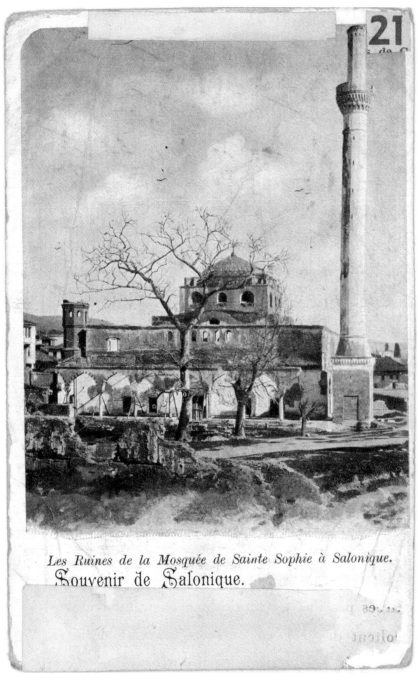

Figure 5.3 Ayasofya and its courtyard after the 1890 fire. Digital archive of the History Center of Thessaloniki, Postcard nr. 1419.

The Other Ayasofya

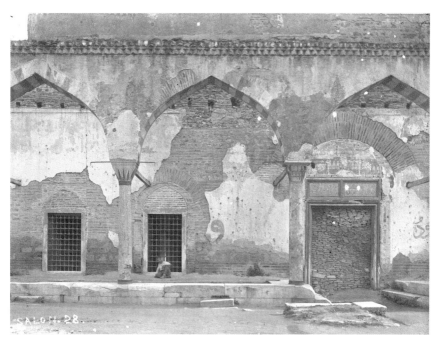

Figure 5.4 The mosque's portico (*son cemaat mahalli*) following the 1890 fire. Deutsches Archäologisches Institut Athen, Thessaloniki Negativnummer 28.

extended to the waterfront and developed into one of the main thoroughfares of the city centre.[28] The restoration of Ayasofya itself, however, failed to materialise. The initial assessment of the damage estimated the cost of fully restoring the mosque at 350,000 Ottoman *kuruş*.[29] The pious endowment of the mosque, which would traditionally have been responsible for the repairs, proved unable to raise the necessary sums by itself, pointing to broader changes in the role of such endowments during the Late Ottoman period. The centralising reforms of the 1830s brought the endowments and their finances under the control of the Ottoman government and dues collected from *vakıf* properties were routinely redirected to fill holes in the persistent budgetary deficit.[30] However, my research in Thessaloniki has shown that, against the backdrop of a booming real-estate market and significant public and private investment, the dues collected in the endowed properties remained constant instead of following market prices or even inflation. The gradual marginalisation of the endowments from the urban economy was one of the major processes underscoring Thessaloniki's urban transformation during that period.[31]

At the same time, after several decades of modernising reforms, the endowments had lost their monopoly over charitable activity. By the late

nineteenth century, the Ottoman government had made tentative steps towards a system of public education, especially at the secondary level, operating outside the parochial scope of the traditional Qur'anic schools. Echoing similar trends among the city's Jews and Orthodox Christians, Thessaloniki's Muslim community organised fundraising campaigns in support of public schools. The community was also involved in relief efforts on behalf of Muslim refugees who began arriving in the region from the Balkans after the Ottoman defeat by Russia in the war of 1877–8.[32] At that point, the link between charity and the religious realm, which had been exemplified in the pious endowments, had weakened. Civic engagement was now a marker of modernity and Thessaloniki's Muslims were determined not to be left behind their Jewish and Christian compatriots.[33] Thus, it is no surprise that repairing Ayasofya was not a priority for either state or the non-state elites. Instead, they preferred to endow a new mosque, the Hamidiye Mosque (also known as the New Mosque), built by Levantine architect Vitaliano Posseli in the city's affluent suburbs, rather than mobilise in support of Ayasofya's restoration.[34]

In that context, it was no coincidence that, aside from the erection of scaffolding to protect what remained of the building from collapse, the first systematic intervention in the site was connected not to restoration works but to the reconstruction taking place around the mosque. In June 1892, workers digging during the construction of an apartment building belonging to local Jewish entrepreneur Raphael Mosseri accidentally discovered a small set of subterranean rooms, part of a small catacomb complex. The Ottoman authorities ordered a halt to further construction and sent a delegation of local scholars to inspect the site. A team of four teachers, two from the Greek and two from the Ottoman high school, including Papageorgiou, surveyed each room, measuring their dimensions and describing the decoration in a detailed report to the Ottoman authorities (Figures 5.5, 5.6).[35]

The discovery of the catacombs, which were later attributed to John the Baptist, galvanised the city's Greek Orthodox Diocese, who petitioned the provincial government. They protested that it was a scandal for Mosseri, who was Jewish, to privately own a site of religious significance for their community. The dispute was resolved about a year later when the municipality expropriated the plot and transferred its ownership to the endowment (*harim*) of Ayasofya. This return to the ethno-religious status quo apparently satisfied the Greek Orthodox community.[36] Apart from the survey of the catacombs, the site of the ruined mosque seems to have remained undisturbed in the years that followed, despite the occasional call to action. The one exception was the removal of Ayasofya's marble

The Other Ayasofya

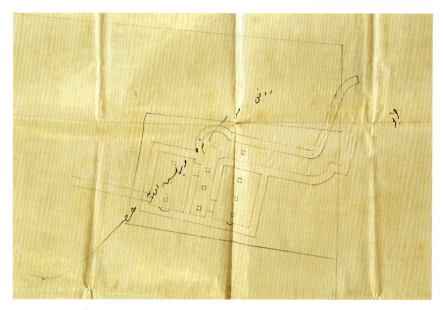

Figure 5.5 The catacombs superimposed on a street plan for the reconstruction of the area. BOA, ŞD 2602/3, 25 September 1892.

pulpit, a Byzantine artifact that had served both church and mosque, and its transfer to the Archaeological Museum in Istanbul.[37]

The 1907–1911 Restoration

In 1905, Marcel Le Tourneau visited Thessaloniki for the first time, tasked with recording the Byzantine monuments of the city. Le Tourneau later recounted how, when he first visited Ayasofya, he realised that the fire had loosened the wallpaper that had partially covered the mosaics. In his enthusiasm, he started pulling down sheets of paper and plaster himself (a suspension of disbelief is perhaps necessary here).[38] At the same time, the Ottoman authorities were trying to co-ordinate between different government ministries to finally secure the necessary funds for the mosque's restoration. A dispatch sent by the Grand Vizirate to the Ministry of Finance in May 1904 urged the approval of the relevant budget, since 'in two years' time, the repairs would end up costing twice as much'.[39] When Le Tourneau returned to the city in 1907, endowed with fresh funding and an Ottoman permit for research on site, he could rely on the full co-operation of the Ottoman authorities, with Hilmi Paşa, Inspector General of Rumelia, pledging 1,600 Ottoman *liras*, or about half of the projected cost for the restoration of both the mosque and its mosaics. The rest

Figure 5.6 Thessaloniki, Catacombs of St John the Baptist. Photo: author.

would be covered by the Ottoman Finance Ministry. Overall responsibility was given to Edhem Bey, then architect at the Archaeological Museum in Istanbul, and local architect Pietro Arrigoni was appointed as chief engineer.[40]

The Other Ayasofya

While Le Tourneau's arrival seems to have simply coincided with the independent efforts of the Ottoman authorities for Ayasofya's restoration, his intervention may have contributed to the inclusion of the Byzantine mosaics in the restoration project. Le Tourneau was contracted to consult on the project and fully clear the mosaics, though he was already complaining about the 'overzealous' Ottoman designs on the building. The British Byzantinist Walter George also visited in 1907 with a grant from the BRF and was also critical of the works as compared to the contemporary restoration of the Kasımiye Mosque, or Hagios Dimitrios, since 'there had been more money to spend'.[41] The mosque's interior and exterior walls had been heavily plastered, but at least the mosaics had been fully cleared and restored. The side roofs over the wings were removed, revealing the tympanon and a row of windows. The courtyard was cleared of rubble and the old Byzantine gateway, which had been damaged in the fire, was pulled down and replaced with an eclecticist archway.[42]

In 1908, after he presented his findings again at the French Académie des Inscriptions, Le Tourneau was taken to task by Papageorgiou, the Greek headmaster, who, reporting on the ongoing restorations for the French-language *Journal de Salonique*, cast doubt on Le Tourneau's claim to have 'first discovered' mosaics that had been known both to scholarship since Texier and to locals.[43] In his response in the paper, as well as in his article co-published with Charles Diehl in 1909, Le Tourneau tempered his statements; he had not suggested that the mosaics had been completely unknown, but rather that earlier publications had been incomplete. He had not been the first to discover them, but the first to fully clear them, and therefore the first to properly study them. Likewise, he denied claiming that the mosaics had been completely covered up, but that the figures had been obscured under painted wallpaper strips.[44]

Work on the mosque continued until May 1911, when the building was reopened on the occasion of Sultan Mehmed V's visit to Thessaloniki. This event brought about a series of beautification projects in the city, which included the demolition of the ramparts that surrounded the White Tower. At the same time, the imminent visit also prompted the authorities to accelerate the rate of the construction work, which had been lagging behind schedule.[45] The imperial visit, part of a tour of the Ottoman Balkans by the sultan, was meant to manifest both the empire's engagement in the region and the popular support it enjoyed. Ayasofya served as the sultan's *selamlık* mosque, where he observed the Friday noon prayers – the repaired mosaics respectfully hidden behind white curtains (Figure 5.7).

The restoration of the Ayasofya Mosque consciously employed established tropes of Ottoman imperial symbolism in its work. The Fossati

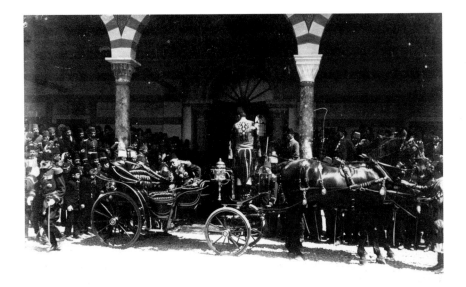

Figure 5.7 Sultan Mehmed V disembarks as his carriage draws to a halt in front of the mosque's entrance. Digital archive of the History Center of Thessaloniki, photograph G12.

restorations had demonstrated to the Ottomans the appeal of Byzantine heritage to both the 'learned European public' and the empire's own Orthodox Christian subjects. The restoration work in Thessaloniki took a page from the Fossati playbook. Restoring and highlighting the mosque's Byzantine decorative elements endowed Thessaloniki with a monument of great historical significance while also serving as testament to the tolerant values of the empire and the competence of its archaeologists and architects. At the same time, by inscribing of the elements within a larger set of Islamic iconography Ottoman officials defused the potential for counter-claims on the monument.

The Greeks Arrive

It is perhaps ironic that only a year after the sultan's visit, the project of Ottoman empire-building in the region collapsed in the course of the Balkan Wars. Thessaloniki and about half of Ottoman Macedonia were incorporated into the Greek state, and the new administration utilised a very different conceptualisation of history and the built past from its predecessors'. Archaeology in Greece had a long history and strong administrative and legal traditions. Already by the summer of 1913, just after the outcome of the war had been decided, the Greek administration founded

an Ephorate of Antiquities in Thessaloniki and began implementing Greek laws on antiquities in the so-called New Lands. They forced collectors to declare their possessions, cracked down on smugglers and regulated excavations and sites in the region, the earliest ones being the French missions in Thasos and Olynthos. The service was manned by archaeologists from Old Greece, as well as scholars of local origin, including architect Aristotelis Zachos from Velesa, who would later be made responsible for the restoration of Hagios Dimitrios, which had been transferred to the Greek Orthodox Church, only to be heavily damaged in the fire of 1917.

Ayasofya was front and centre of this transition between archaeological regimes. On 5 July 1913, while the Second Balkan War still raged, the Greek authorities issued a first list of protected monuments that included Ayasofya along with seven other Byzantine mosques. At about that time, these same buildings were taken from the city's Muslim community and converted back into churches, a decision that incidentally initiated a century of conflicts between the newly established parish committees and the Ephorate about who had final say over the sites. Ayasofya, now again Hagia Sophia, went through another round of 'restorations' aimed at excising Islamic elements from the building. The Islamic decorative elements were all removed from the interior, and the mihrab was demolished. The Hamidian arched gate was replaced by a replica of the Byzantine structure that had been removed, and the minaret was pulled down in 1924 along with all other minarets in the city.[46] The plaster was excised from the cupola to reveal the brickwork. The portico survived until it was destroyed by a bomb during the Second World War (Figure 5.8).

The Ottoman archaeologists' encounters with Thessaloniki's architectural heritage were meant to be an application of modern scholarship and conservation practices aimed at embedding artistic elements of the symbolic other, in this case the Byzantines, within the broader imperial ideology. That hierarchal eclecticism corresponded with the broader political and ideological vision of the late Ottoman leadership. Conversely, the ultimate aim of archaeology in the Greek Kingdom was the restoration of buildings and sites to their 'authentic' condition. The excision of Islamic elements was intended to re-integrate the architectural monuments into the historical continuum of Hellenism, which had been interrupted by the Ottoman conquest. By turning the clock back to before 1430, archaeologists helped vindicate Greece's 'historical rights' over an ethnically diverse and politically disputed region.

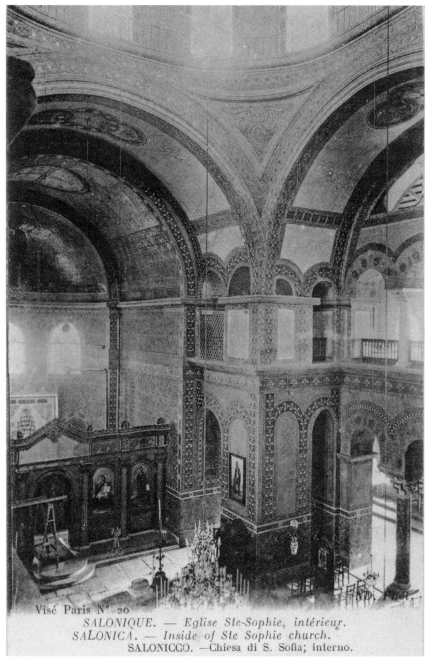

Figure 5.8 The interior of the building, shortly after its reconversion to a church. The mihrab is still visible behind the iconostasis. Digital archive of the History Center of Thessaloniki, postcard no. 1501.

Notes

1. Marcel Le Tourneau and Charles Diehl, 'Les mosaïques de Sainte-Sophie de Salonique', *Monuments et Mémoires* 16 (1909): 39–58; Marcel Le Tourneau, Charles Diehl and Henri Saladin, *Les monuments chrétiens de Salonique* (Paris: Ernest Leroux, 1908), vii–viii, 137–8.
2. See the contributions in Zaynab Bahrani, Zeynep Çelik and Edhem Eldem (eds), *Scramble for the Past: A Story of Archaeology in the Ottoman Empire, 1753–1914* (Istanbul: SALT, 2011).
3. Edhem Eldem, 'From Blissful Indifference to Anguished Concern: Ottoman Perceptions of Antiquities, 1799–1869', in Bahrani et al., *Scramble for the Past*, 281–330, especially 295ff.
4. Wendy Shaw, *Possessors and Possessed: Museums, Archaeology, and the Visualization of History in the Late Ottoman Empire* (Berkeley, CA: University of California Press, 2003).
5. Ahmet Ersoy, *Architecture and the Late Ottoman Historical Imagery: Reconfiguring the Architectural Past in a Modernizing Empire* (Farnham: Ashgate, 2015), 139–40.
6. The urban history of late Ottoman Thessaloniki has been studied by, among others, Meropi Anastassiadou, *Salonique, une ville Ottoman a l'âge des réformes* (Leiden: Brill, 1997), and Mark Mazower, *Salonica, City of Ghosts: Christians, Muslims, and Jews, 1430–1950* (London: HarperCollins, 2004).
7. For information on late Ottoman 'town-planning' fires, see Alexandra Yerolympos, *Urban Transformations in the Balkans* (Thessaloniki: University Studio Press, 1996); also Zeynep Çelik, *The Remaking of Istanbul: Portrait of an Ottoman City in the Nineteenth Century* (Seattle: University of Washington Press, 1986).
8. Vasilis Kolonas, *Η Θεσσαλονίκη εκτός των τειχών: Εικονογραφία της συνοικίας των εξοχών* [Thessaloniki *Extra-muros*: Description of the Exohes Neighbourhood] (Thessaloniki: University Studio Press, 2015), 176–9.
9. For the history and the architecture of the building, see Kalliopi Theoharidou, *The Architecture of Hagia Sophia, Thessaloniki: From its Erection to the Turkish Conquest* (Oxford: BAR International Series 399, 1989); also the discussion in Robert Ousterhout, *Eastern Medieval Architecture: The Building Traditions of Byzantium and Neighboring Lands* (Oxford: Oxford University Press, 2019), 252–4.
10. Theoharidou, *Architecture*, 176–7.
11. R. Peters and R. Deghuilem, 'Waḳf', in P. Bearman et al. (eds), *Encyclopaedia of Islam, Second Edition* (Leiden: Brill, 2000), 59–63, 87–92.
12. For population estimates, see among others Kemal Karpat, *Ottoman Population, 1830–1914: Demographic and Social Characteristics* (Madison, WI: University of Wisconsin Press, 1985), 134–5 and 166–7.

13. Vasileios Dimitriadis, *Τοπογραφία της Θεσσαλονίκης κατά την εποχή της τουρκοκρατίας* [A Topography of Thessaloniki under the Turks, 430–1912] (Thessaloniki: EMS, 1983), 162.
14. Benjamin Anderson cautions against ahistorical, 'folklore' explanations of native perceptions of antiquities. See Anderson, '"An Alternative Discourse": Local Interpreters of Antiquities in the Ottoman Empire', *Journal of Field Archaeology* 40 (2015): 450–60.
15. Edhem Eldem, 'A New Look at an Ancient City: Thessaloniki in Ottoman Archaeology, 1832–1912', in Dimitris Keridis and John Brady Kiesling (eds), *Thessaloniki: A City in Transition, 1912–2012* (London: Routledge, 2020), 105–25.
16. Mazower, *Salonica*, 216–20.
17. Charles Texier and Richard Pullan, *Byzantine Architecture: Illustrated by Examples of Edifices Erected in the East during the Earliest Ages of Christianity* (London: Day & Son, 1864); for Ayasofya, see 142–5, plates XXXIX–XXXXI.
18. Margaritis Dimitsas, *Η Μακεδονία εν λίθοις φθεγγομένοις και μνημείοις σωζομένοις*, in two volumes (Athens: Perris Press, 1896).
19. Petros Papageorgiou, 'Τρεις Ανέκδοται ψηφιδωταί περιγραφαί της Αγίας Σοφίας της εν Θεσσαλονίκη' [Three Unpublished Mosaic Inscriptions of Hagia Sophia in Thessaloniki], *Eikonografimeni Estia* XVII, 36/40 (1893): 218–19.
20. For the link between archaeology and Greek nationalism, see Yannis Hamilakis, *The Nation and its Ruins: Antiquity, Archaeology, and National Imagination in Greece* (New York: Oxford University Press, 2007).
21. Foreign Office 78/4287, Blunt to White, telegrams of 4, 5 and 6 September.
22. BOA, TFR.I.SL 106/10501, undated.
23. For a family biography, see Judy Slinn, *A History of Freshfield, the Firm* (London: Freshfields, 1984). For the Freshfields' sponsorship of Byzantine archaeology, see David Winfield, 'The British Contribution to Fieldwork in Byzantine Studies: An Introductory Survey', in Robin Cormack and Elizabeth Jeffreys (eds), *Through the Looking Glass: Byzantium through British Eyes. Papers from the Twenty-ninth Spring Symposium of Byzantine Studies, London, March 1995* (London: Society for the Promotion of Byzantine Studies, 2000), 57–65.
24. On Schultz and Barnsley's trip and scholarship, see Amalia Kakissis, 'The Byzantine Research Fund Archive: Encounters of Arts and Crafts Architects in Byzantium', in Eleni Calligas, Paschalis Kitromilides and Michael Llewellyn Smith (eds), *Scholars, Travels, Archives: Greek History and Culture through the British School at Athens. Proceedings of a Conference held at the National Hellenic Research Foundation, Athens, 6–7 October 2006* (London: British School at Athens, 2009), 125–44.
25. BOA, HR.SFR 3/388-49, 21 April 1891.

26. Alexandra Yerolympos and Vassilis Kolonas, 'Un urbanisme cosmopolite', in Gilles Veinstein (ed.), *Salonique, 1850–1918. La 'ville des juifs' et la réveil des Balkans* (Paris: Autrement, 1992), 158–76.
27. Evangelos Chekimoglou and Thaleia Mantopoulou-Panagiotopoulou, *Ιστορία της επιχειρηματικοτήτας στη Θεσσαλονίκη, t. B₂: Η οθωμανική περίοδος* [The History of Entrepreneurship in Thessaloniki, v. II₂: The Ottoman Period] (Thessaloniki: Politistikē Hetaireia Epicheirēmatiōn Voreiou Hellados, 2004), 19–20.
28. Dimitriadis, *Τοπογραφία*, 162.
29. BOA, TFR.I.SL 106/10501, undated; BEO 2341/175548, 13 Mayıs 1320 [26 May 1904].
30. For the reform of the endowment system in Damascus, see Astrid Meier, '*Waqf* in Name Only: Early Tanzimat *Waqf* Reforms in the Province of Damascus', in Jens Hanssen, Thomas Philipp and Stefan Weber (eds), *The Empire in the City: Arab Provincial Capitals in the Late Ottoman Period* (Beirut: Ergon Verlag, 2002), 201–18.
31. Huri Islamoglu, 'Property as Contested Domain: A Reevaluation of the Ottoman Land Code of 1858', in Roger Owen (ed.), *New Perspectives on Property and Land in the Middle East* (Cambridge, MA: Harvard University Press, 2000), 3–61.
32. Dilek Akyalçın-Kaya, 'Immigration into Ottoman Territory: The Case of Salonica in the Late 19th Century', in Ulrike Freitag et al. (eds), *The City in the Ottoman Empire: Migration and the Making of Urban Modernity* (London: Routledge, 2011), 177–89.
33. Sotirios Dimitriadis, 'Visions of Ottomanism in Late Ottoman Education: The *Islahhane* of Thessaloniki, 1874–1924', *Die Welt des Islams* 56 (2016): 415–37.
34. Vasilis Kolonas and Lena Papamathaiaki, *O αρχιτέκτονας Vitaliano Poselli: το έργο του στη Θεσσαλονίκη* [Architect Vitaliano Posseli and his Work in Thessaloniki] (Thessaloniki: Paratiritis, 1990).
35. BOA, ŞD 2602/3, 13 Eylül 1308 [25 September 1892].
36. BOA, DH.MKT 91/19, 10 Temmuz 1309 [22 July 1893] and 25 Eylül 1309 [7 October 1893].
37. BOA, DH.MKT 865/84, 9 and 16 Haziran 1320 [22 and 29 June 1904].
38. Diehl and Le Tourneau, 'Mosaïques', 39–41; Diehl, Le Tourneau and Saladin, *Monuments Chrétiens*, 137–9.
39. BOA, BEO 2341/175548, 13 Mayıs 1320 [26 May 1904].
40. Ibid.
41. Le Tourneau also prepared a report on the restoration of Eski Cuma Mosque, the former Byzantine Church of the Acheiropoiitos. BRF, George to Schultz, 30 June 1909. For George's visit to Thessaloniki and the contemporary restoration works at the Kasımiye Mosque/Hagios Dimitrios, see Robin Cormack, 'The Mosaic Decoration of S. Demetrios, Thessaloniki: A Re-Examination in

the Light of the Drawings of W. S. George', *The Annual of the British School at Athens* 64 (1969): 17–52.
42. Theoharidou, *Architecture*, 177–80.
43. *Le Journal de Salonique* 1261, 2 July 1908; and 1262, 6 July 1908.
44. *Le Journal de Salonique* 1271, 30 July 1908.
45. The Ottoman government budgeted an extra 75,000 *kuruş* for the second phase of restoration works, starting in 1909. The sum was covered by the Ministry for Pious Endowments. BOA, BEO 4017/301268, 21 Eylül 1327 [4 October 1909]; 6 Mart 1328 [19 March 1910].
46. The single exception was the minaret of Thessaloniki's Rotunda, formerly the Hortacı Mosque.

Chapter 6

'That Domed Feeling': A Byzantine Synagogue in Cleveland

Robert S. Nelson

Back then, no more than a century ago, European and American architects had at their disposal a rich language of European architecture from antiquity through the eighteenth century. The nineteenth century was the high-point of this architectural pluralism. Architects, clients and their publics understood these vocabularies of form, but then that repertory of style gradually disappeared, supplanted by the personal styles of architects or architectural movements. Historicist architecture came to be regarded as eclectic – a motley, disparate, even incoherent array of styles – as its architectural language or semantics of form ceased to be understood. The decades between the First and Second World Wars witnessed the confrontation between a nineteenth-century historicism that lingered into the inter-war period and a modernism that rejected the past. Since victors write history, an avant-garde architectural history arose that glorified the modernist revolution, provided enabling fictions for why the new was better than the old, and relegated what came before to historical oblivion. In America, modernism had become hegemonic by the 1960s, and its social and political offspring, urban renewal, purified cities of their now unfashionable older structures.

Without access to earlier styles, architects lost their ability to compose meaningful structures understood by the public.[1] Once, the classical orders had been employed for banks and governmental buildings to lend them the *gravitas* of antiquity, the Gothic became the standard idiom for Protestant churches, and Catholic churches imitated the Romanesque or varieties of Renaissance and Baroque architecture with special reference to churches in Rome. American synagogues constituted a special variant of this history. Jewish congregations embraced modernism more readily than did Christian denominations. In Germany, modernist synagogues were built from the 1910s, as seen, for example, in the 1914 Essen synagogue, so

massive and monumental that it defied Nazi plans to raze it.[2] For the most part, modernism appeared in American synagogues only in the 1950s, abetted by the immigration of German architects, as in the case of Eric Mendelsohn and his 1950 Park Synagogue in Cleveland Heights, Ohio.[3]

Historicist synagogues did not have a long history before this period. Prior to the nineteenth century, synagogues adopted inconspicuous local styles in order to blend into the prevailing built environment, just as Jews themselves assimilated into European and American society. First in Europe and then in America, nineteenth-century synagogues combined elements from Spanish Islamic architecture to create what are known as Moorish synagogues, the prime example in America being the Plum Street Temple in Cincinnati, now the Isaac M. Wise Temple.[4] From the later nineteenth century up until the Second World War, American synagogues also adopted a variety of styles, even the Gothic, but the classical was preferred during the first two decades of the twentieth century. However, by the 1920s, new developments globally and locally led American rabbis and their congregations to represent the Palestinian roots of Judaism through early Byzantine architecture. These buildings constitute the last stages of nineteenth-century historicism. Their connection with Byzantine buildings, especially Hagia Sophia, is the focus of this chapter. That relationship can, in turn, aid us in understanding the fascinating afterlife of the church then mosque a decade before the Turkish Council of Ministers secularised it. In its decree, the Council acknowledged that the mosque of Aya Sofya was a 'unique architectural monument of art' and stated that by its action 'humanity [will] gain a new institution of knowledge', a culmination of the West's long engagement with the building.[5]

Two synagogues dedicated in the fall of 1924 exemplify what has become known as the Byzantine synagogue. One, the Temple Isaiah in Chicago (presently KAM Isaiah Israel), was designed by Alfred Alschuler; I have discussed it elsewhere.[6] For this reason, and because this chapter was first delivered as a paper at a conference held at Ohio State University, I want to consider the other synagogue, that of Congregation Tifereth Israel in Cleveland, Ohio, the larger of the two buildings (Figures 6.1–6.6, 6.10).[7] Its architect was Charles R. Greco, who later built Byzantine synagogues in Miami Beach, Florida, Hartford, Connecticut and Erie, Pennsylvania, and a second one in Cleveland. Common to these Byzantine synagogues is a broad, low dome over the sanctuary that is modelled more or less faithfully on that of the great sixth-century cathedral of Constantinople.

In the following discussion of Tifereth Israel, also known as the Temple, I will examine the building and its connections with Hagia Sophia, explore the contributions of its rabbi, building committee and architect, and

conclude with local responses to the new Temple and the 'domed feeling' it created. As is inscribed on the façade today, the building has become the Maltz Performing Arts Center and a part of Case Western Reserve University.[8] The transferral of ownership in 2010 was the culmination of the gradual withdrawal of the congregation from the city of Cleveland.

The Building, its Antecedents and Hagia Sophia

The circumstances that led to the dedication of the Temple of Tifereth Israel in 1924 are complex and not well-documented, but before that context is discussed, the building itself must be introduced. Its oddly-shaped triangular site was formed where the busy E. 105th Street and the quieter Ansel Road converged at an acute angle (Figure 6.3).[9] Further back in the plot, the former street is twenty feet lower than the latter, a feature that Greco exploited to separate ancillary spaces from the sanctuary in front. Classrooms are entered from Ansel Road and an auditorium from E. 105th Street. Though challenging architecturally, the plot overlooks the bucolic Rockefeller Park on the other side of E. 105th Street and is near the Cleveland Museum of Art and Severance Hall, the home of the Cleveland Orchestra. Behind the Temple when it was built was Mt. Sinai Hospital, which the larger Jewish community supported; nearby were the homes of many congregation members. Today the hospital and other buildings in the area are no longer standing, and Ansel Road has been rerouted, hence the utility of older aerial photographs (Figure 6.3). Greco designed the new Temple so that its principal façade faced the convergence of the roads. The location recalls the aforementioned Essen synagogue, which was also built between converging streets and similarly located the social and educational sections of the complex behind the sanctuary. By choosing a seven-sided sanctuary, Greco managed to have a side parallel with each road.

The complex is a triangle with the apex excised to make a façade with flanking turrets for men's and women's restrooms (Figures 6.1, 6.2). Beyond the vestibule, the seven-sided sanctuary fans out to provide auditorium seating and then narrows to the bimah and ark, made of carved walnut (Figures 6.4, 6.5). Two sides of the heptagon, decorated with multiple arches, frame the bimah. Balconies, faced with quarter-sawed oak, jut through the arches of the four remaining sides (Figure 6.6). On their parapets are symbols of the twelve tribes of Israel. Around the sanctuary space, broad arches and tall, engaged corner columns unify the space (Figures 6.5, 6.6). At the top of each of the seven sides of the sanctuary, five narrow lancet windows afford some light; a central chandelier provides additional

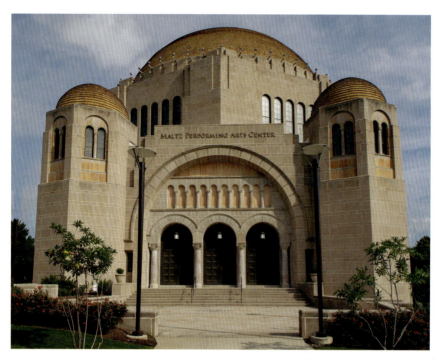

Figure 6.1 Temple Tifereth Israel, Cleveland, main façade, 1924. Photo: author.

Figure 6.2 Temple Tifereth Israel, plan. Richard R. Stanwood, 'Temple Tifereth Israel, Cleveland, Charles R. Greco, Architect', *The Architectural Forum* 42, 5 (November 1925).

Figure 6.3 Temple Tifereth Israel, older aerial view. Photo: Archives of The Temple-Tifereth Israel, Beachwood, Ohio.

Figure 6.4 Temple Tifereth Israel, vestibule. Photo: author.

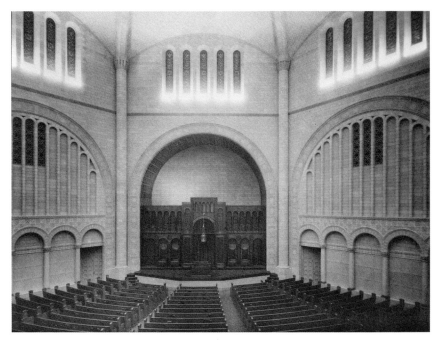

Figure 6.5 Temple Tifereth Israel, interior view to bimah. Photo: Archives of The Temple-Tifereth Israel, Beachwood, Ohio.

ilumination. Each of the glazed lancets has a word, the five words of each side compose a sentence, and the seven sentences affirm fundamentals of the Jewish religion.[10] Guastavino tile covers the interior and forms the thin inner surface of the double shell dome.

The heptagon shape of the sanctuary gives it properties not usually encountered in architecture. Unlike a polygon with an even number, a heptagon has no parallel sides. Thus, by orienting the sanctuary towards the bimah, there could be no corresponding entrance side parallel with it. The heptagon thus comes to a point at the engaged column in the middle of the entrance side and directly opposite the ark (Figure 6.6). The architect masked the odd space that results with a broad, richly decorated vestibule with stairs at each end (Figure 6.4). Walking through the main door, congregants saw a square outlined in red marble on the floor. Inside are four intertwined circles, a common device of Byzantine ornamental floors; a larger pattern with more circles, for example, is found at Hagia Sophia and the eleventh-century church of Hosios Loukas.[11] Intersecting circles also appear in the sanctuary windows and were described as Byzantine.[12] At the centre of the floor design is a bronze medallion with the Star of David. A rich array of coloured marble decorates the walls of the

A Byzantine Synagogue in Cleveland

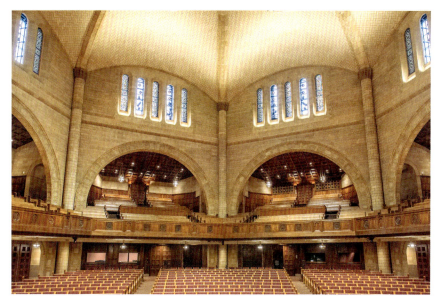

Figure 6.6 Temple Tifereth Israel, interior view to entrance. Photo: author.

vestibule, as it does Hagia Sophia, but a Byzantine model closer to the Cleveland synagogue is the decoration of Hosios Loukas, as published in a two-page colour reproduction by Robert Weir Schultz and Sidney Howard Barnsley.[13]

Above the entrance, the forward edge of the heptagonal sanctuary walls juts out like a ship's prow (Figure 6.1). Yet, because of the visual strength of the other elements of the façade, the projecting corner of the heptagon does not seem discordant. The flanking turrets with their small domes imitating the sanctuary dome are also seven-sided and similarly point outwards. In between the turrets, a broad arch spans the three entrance doors and an arcade above. The arches of the arcade anticipate the arches of the sanctuary walls and the arcade of the ark.

When introduced to Greco's original, even radical, creation, the congregation might have drawn some comfort from features comparable with those of their former temple on Willson, now E. 55th Street, presently the Friendship Baptist Church (Figure 6.7). That Richardsonian Romanesque building of 1894 also has flanking turrets and the standard three-arched entrances with a small corbel frieze of arches above. The church that purchased the building closed off the central tower, which was ringed by windows and would have been an important light source. That tower, modelled on Richardson's Trinity Church in Boston, must once have added grandeur and solemnity to the synagogue's sanctuary.[14] The dome of what

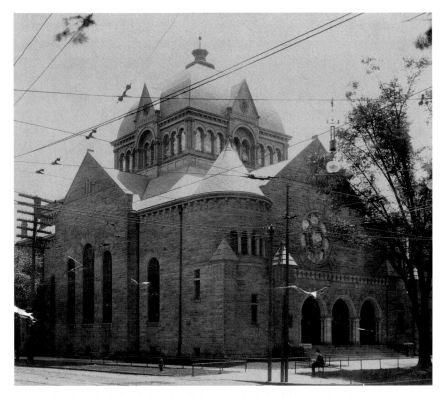

Figure 6.7 Temple Tifereth Israel, 1894, currently Friendship Baptist Church, Cleveland. Photo: Cleveland Public Library.

became known as the University Circle Temple greatly enhanced that effect. The prior Romanesque temple resembled in style and plan nearby churches on E. 55th Street, thereby equating the Jewish and Christian congregations.[15] The new synagogue and its great dome sought even greater distinction. It was, and is, a unique building, and its prominent location in Cleveland soon made it a civic landmark.

What distinguishes the synagogues of 1894 and 1924 is more than exterior surfaces. Above all, it is the difference between a tower and a dome. The later temple's dome envelops all within and offers unimpeded views of the service taking place on the bimah. Its low dome on a short drum contrasts with the high-pitched domes on tall drums which St Peter's Basilica in Rome inspired throughout Europe and America and which became the model for national and state capitols in the United States. Greco instead adopted the dome of Hagia Sophia, a structure that Charles Follen McKim of the celebrated firm McKim, Mead and White termed 'the most perfect dome in the world' (Figure 6.8).[16] Low and high domes

A Byzantine Synagogue in Cleveland

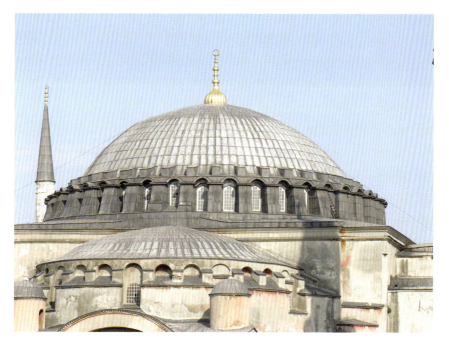

Figure 6.8 Hagia Sophia, Istanbul, dome. Photo: author.

form different interior spaces. The former oversails the entire auditorium; the latter punches a large hole through the vault, and then rises high above it, as seen, for example, at the former B'nai Jeshurun Temple of 1906, also located on E. 55th Street, not far from the earlier synagogue of Tifereth Israel. What the low dome gives up in terms of the exterior visibility it makes up for in the internal coherence of the worship space.

In adapting the dome of Hagia Sophia for the synagogue, Greco kept the short buttresses between the windows of the Byzantine church and moved the windows down to the sides of the heptagon. The row of short, vertical projections that remains on the drum of the Byzantine dome is decorative, not structural, because the building's sturdy steel frame replaced the massive masonry buttresses of the sixth-century church.[17] Elimination of the arched windows of Hagia Sophia has made the Temple's dome appear more severe and abstract, as befits a design that has many Art Deco elements. With these changes, the dome also resembles the higher-pitched domes of the nineteenth-century Tiferet Yisrael and Hurva synagogues in Jerusalem, as seen in an early twentieth-century photograph (Figure 6.9). Both were destroyed in 1948, but have recently been rebuilt. The Ottoman sultan's chief architect designed the Hurva Synagogue in an Ottoman or Byzantine style. The domes of both synagogues stemmed from Ottoman

Robert S. Nelson

Figure 6.9 Domes of the Tifaret Yisrael (left) and Hurva (right) synagogues, Jerusalem, c. 1900. Photo: J. F. Jarvis, Library of Congress Prints and Photographs Division, Washington, DC.

mosques, themselves adapted from Hagia Sophia centuries earlier; domes in general then became a common sight in Jerusalem.[18] Greco's dome thus refers simultaneously to Byzantine and Byzantine revival architecture, as well as to Jerusalem itself. As a multivalent symbol, Hagia Sophia and its replications served diverse, even contradictory, purposes in the nineteenth and twentieth centuries.

Connections with Hagia Sophia do not end with the dome. The columns on the façade of the University Circle Temple have modified Ionic capitals with corner volutes embedded in spikey acanthus leaves (Figure 6.10). The capitals imitate those of the great nave columns on the ground level of Hagia Sophia (Figure 6.11). An elegant knot at the centre of the synagogue capitals replaces the Greek monogram. The general carving style of these capitals resembles the abstracted naturalism of late antique capitals more generally, but the volutes and the central motif tie them back to specific Byzantine originals.

The surface treatment of the exterior limestone creates alternating bands of smooth and textured stone. This banding also makes reference to Hagia Sophia. Richard R. Stanwood, who published an article about the Temple shortly after it opened, wrote that the banding recalled 'Sancta Sophia and other buildings of the Near East'.[19] What it resembles, however, is not the original Hagia Sophia, but the building as restored by the Fossati brothers in the mid-nineteenth century with stripes painted on the stucco cladding in the manner of the actual banded masonry of medieval Italian

A Byzantine Synagogue in Cleveland

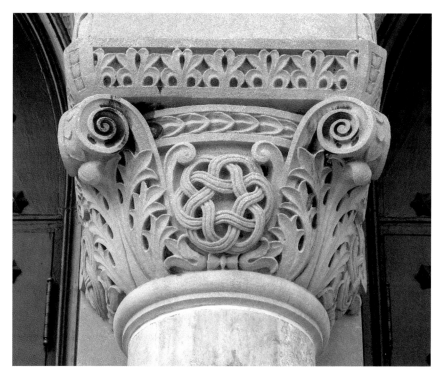

Figure 6.10 Temple Tifereth Israel, façade capital. Photo: author.

churches. Yet this does not imply that Stanwood or Greco knew Hagia Sophia directly, because nineteenth-century photographs showed the striped restoration of Hagia Sophia.[20] Greco probably had seen the photos of Sébah and Joaillier in some form or another. They appeared in various general publications in the earlier decades of the twentieth century.[21] Later repainting in a single colour eliminated the stripes. Both Stanwood and Greco were Boston architects, who must have known each other, because Stanwood's review appeared only months after the completion of the Temple and has information that only Greco could have provided.[22] Thus, the article reads like a business review written by a friend of the owner.

References to Byzantine architecture continue in the interior. The heptangular auditorium has five windows on each side (Figures 6.5, 6.6). These emulate the ring of windows around the dome of Hagia Sophia (Figure 6.8). Beneath the broad arch of the sides that flank the bimah are two rows of arches (Figure 6.5). On the ground level these are blind arches, except for those that frame doorways. The five arches here repeat the same number of arches on the north and south sides of the nave of Hagia Sophia, albeit on a smaller scale. Above the ground-level arcade

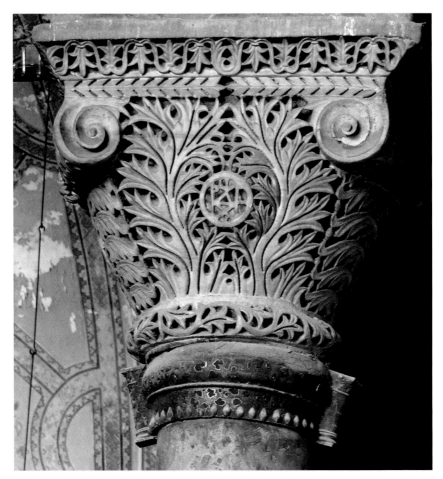

Figure 6.11 Hagia Sophia, Istanbul, nave capital. Photo: author.

in the synagogue are thirteen narrow arches, three of which have lancet windows. The number of narrow arches also increases on the second level of the nave elevation of Hagia Sophia, but only to seven. By combining arches and windows, Greco merged the second and the third levels of the nave elevation of Hagia Sophia and made the arches narrower and more numerous, creating an abstract pattern.

At the back of the bimah is a double-storey *scaenae frons* (Figure 6.5). Here Greco may have been thinking of the iconostasis of an Orthodox Christian church, a feature not attested at Hagia Sophia due to its later life as a mosque, but commonly found in Orthodox churches in America. He may also have been referring to the bimah of the prior Temple on E. 55th Street, which was also made of wood and had a small arcade on

the balustrade of the choir balcony above the ark.[23] Nonetheless, Greco's bimah is finer and more elaborate with its two levels of arcades as found on the iconostasis.

The Rabbi and the Building Committee

The archives of the Temple and the papers of Abba Hillel Silver clarify the genesis of the University Circle Temple, the selection of Charles Greco of Boston as architect and the role of the new Rabbi. Since the later nineteenth century, two Cleveland Reform congregations, Tifereth Israel and Anshe Chesed, were regarded as the most prominent by virtue of social status, wealth and impressive buildings.[24] The latter had built a new brick synagogue in 1912 on the then fashionable Euclid Avenue. It had a low dome and Byzantine details here and there, such as a version of John Ruskin's lily capital from San Marco on a side entrance.[25] From 1914, Tifereth Israel had wanted to replace its E. 55th Street building because the congregation had outgrown it. However, it had failed to find a suitable property, according to the congregation president.[26] Nonetheless, pressure to build continued to grow, so that a subsequent president declared that while nothing could be done until the First World War ended, 'then we shall build a Temple that shall stand as a monument to Judaism and Peace'.[27] As promised, The Temple began searching for a building site after the War and secured a plot in 1920.[28]

Three years earlier, Tifereth Israel had selected as its new leader Rabbi Abba Hillel Silver, then presiding over a small congregation in Wheeling, West Virginia. Born in 1893, he emigrated in 1902 with his rabbi father and family to the Lower East Side of New York. He completed high school in 1911 and four years later college and seminary at the University of Cincinnati and Hebrew Union College, respectively.[29] In hiring Silver, the Cleveland congregation made an audacious decision to call to a major pulpit someone two years out of seminary, a move that recalled their selection of their prior rabbi, Moses Gries, when he was twenty-four.[30] Silver was an immediate success, in part because of what newspapers described as his 'remarkable oratory' and his 'powerful, rich voice of vibrant quality'.[31] When he arrived, Tifereth Israel had 725 families; within two years that number had grown to 916, and by 1924 to 1,200.[32] In 1921 the appreciative congregation raised Silver's compensation from $10,000 to $12,000, and two years later to $15,000 plus a Cadillac. By 1925 he was earning $20,000, quite a raise from his initial salary of $2,500 in West Virginia ten years prior.[33] Silver remained at Tifereth Israel until his death in 1963 and was succeeded by his son.

On 18 June 1920, Silver wrote to the chairman of the New Temple Building Committee, L. M. Wolf, to provide programmatic details for the new complex. He began by suggesting that it would be best if the style of the structure were left until

> after we shall have seen some of the more representative Temple structures of the country. There is, as you know, no distinctive Jewish architecture. In most lands Temple architecture reacted to the general prevailing architectural style. We have in this country Temple[s] in the severe Classic style, Romanesque, Italian Renaissance and also in the Moorish. The Moorish, because of its Eastern flavor, approaches nearer, perhaps, to a characteristic Jewish type. However, few congregations have ventured in recent years to build in this style.[34]

Silver continued that the size of the building should respond to current and future needs and should include a sanctuary for 2,000, a memorial chapel for 180–200, a boardroom, a choir room, a rabbi's study, ladies' and men's rooms, at least twenty-four classrooms each to accommodate thirty-five people, a multi-purpose assembly room for 1,000 people, a gymnasium, a library, a room for committee meetings that could also be used as a reading room, and executive offices. He got most of what he wanted, including the visits to other synagogues.

During the summer of 1920, he and the Building Committee toured East Coast synagogues. Back in Cleveland, the committee met on 23 September 1920 and heard reports about 'Temples in Philadelphia, Newark, 88th Street Temple in New York, the Temple in Boston, and the Jewish Center in New York'.[35] Excepting the synagogue or synagogues in Philadelphia, the others can readily be identified. Most were completed in the first two decades of the twentieth century and some only a few years before the committee's reconnaissance.

The Newark temple (1911–14) must have been the building designed by New York City architect Albert S. Gottlieb for B'nai Jeshurun. The brick structure still occupies a commanding position overlooking Newark, even if the congregation has long since moved to the suburbs.[36] A photo taken with a wide-angle lens shows a structure modelled on Hagia Sophia for its dome and San Marco, Venice, for the narrow balconies set between the supporting piers (Figures 6.12, 6.13). Of all the synagogues the Building Committee visited, Gottlieb's design offered the closest analogy with the broad unified interior of the University Circle Temple. Both buildings also have Guastavino tile on the interior. Initially concerned about its acoustics, Rabbi Silver wrote his counterpart in the Newark synagogue, who responded with high praise for its sound quality.[37]

A Byzantine Synagogue in Cleveland

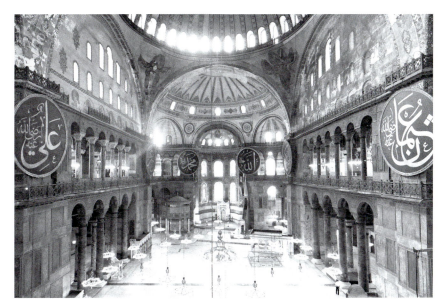

Figure 6.12 Hagia Sophia, Istanbul, view to apse. Photo: Walter Denny.

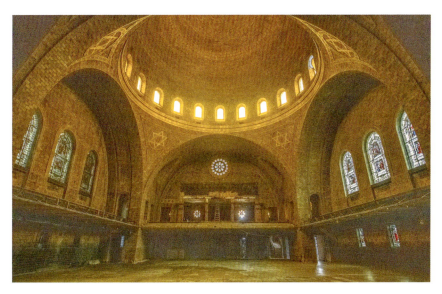

Figure 6.13 Newark, former B'nai Jeshuran, 1915. Photo: author.

At B'nai Jeshurun on W. 88th Street in Manhattan from 1917, the committee encountered a tall, heavily ornamented entry arch and a small dome of stained glass inside. The broad dome and centralised plan of the Cleveland temple were difficult to achieve in Manhattan because of

Manhattan's long, rectangular lots. A domed square or polygon would not be an efficient use of the valuable land, and hence New York synagogues and churches favoured rectangular buildings in the basilica tradition.

In Boston, the synagogue closest in style to Tifereth Israel is Temple Ohabei Shalom, which also has interesting references to Hagia Sophia in Istanbul. However, this synagogue, designed by Clarence Blackall, was dedicated a year after the Cleveland synagogue.[38] Instead, the Building Committee most likely visited the synagogue Blackall built for Adath Israel in 1907, for it had referred to itself as 'the Temple' since the nineteenth century.[39] This building, now part of Boston University, is a domed cube with geometric designs on the exterior. According to Blackall, it replicated the Temple in Jerusalem.[40]

The 1918 Jewish centre on the Upper West Side of New York would have been of interest because it was an early example of a synagogue that provided more than worship space, or what is known as a synagogue centre or *Shul with Pool*, to quote the title of a book on the subject.[41] Silver initially wanted a version of the synagogue centre; he asked for a gymnasium, although no pool, and he described the auditorium and classrooms as 'the Temple Center'.[42] The gym was not built, and he later would write that Tifereth Israel had moved away from the synagogue centre model and was focusing on 'purely educational activities of a religious and specifically Jewish character'.[43]

Plausible candidates for Philadelphia synagogues visited include the Henry S. Frank Memorial Synagogue, a small building designed by Arnold W. Brunner on the grounds of the Jewish Hospital, now the Albert Einstein Medical Center. Its architecture imitates recently published ancient synagogues of Palestine.[44] That connection might have led Rabbi Silver to visit it because of his strong interest in that region, but it was much too small for the Cleveland congregation. If personal connections, not architecture, were the determining factor, the committee would have visited the massive Renaissance revival temple of Keneseth Israel, a reform congregation, at 1717 North Broad Street in Philadelphia. Built in 1891, the temple was destroyed by fire in the 1950s save for an ancillary structure that was sold to Temple University. Old photographs of the synagogue show a high Renaissance dome and a tall bell tower modelled after the campanile of San Marco, Venice.[45] Abraham J. Feldman, a childhood friend of Abba Hillel Silver, was first associate, then acting rabbi of Keneseth Israel from 1920 to 1925. Afterwards, Feldman served until 1968 at Congregation Beth Israel in West Hartford, Connecticut. Charles Greco designed their new temple, completed in 1936.[46] Rabbi

Feldman must have known of Greco's work through his friendship with Silver.

After hearing reports about these synagogues, the Building Committee discussed the type of building they should commission and resolved that they would instruct the architects to follow Rabbi Silver's specifications that he had submitted the previous summer.[47] The question of the style of the new synagogue was apparently left to the architect chosen. By December 1920, the Committee had resolved to stage a competition and asked six architects to submit proposals, according to two documents in the archives of Tifereth Israel. One is a letter of 8 December 1920 inviting Charles R. Greco to design two buildings, a Temple and a Temple Meeting House, according to the programme that Silver had previously proposed to the Committee.[48] The total cost of both buildings should not be greater than $800,000. We know the names of the other architects involved because of a second letter to the Temple from the secretary of the Cleveland chapter of the American Institute of Architects (AIA). They rejected the Temple's competition:

> After careful consideration of the subject, we regret to inform you that members of the Institute cannot participate in your competition, because, your program does not harmonize with the form of competition that the Institute considers to be for the best interests of both Owner and Architect.

Consequently, the secretary sent a copy of the letter to 'all the invited competitors' and listed them.[49]

In addition to Greco, they were Cram and Ferguson of Boston, Albert S. Gottlieb of New York, Walker and Weeks in Cleveland, Geo. B. Post & Sons of New York and Hubbell & Benes in Cleveland. This was a diverse group, and some firms would appear to be more relevant than others. The range of architects chosen shows that the Building Committee and presumably Silver, one of its members, were still far from articulating the style of the new synagogue, but the list of competitors nonetheless demonstrates the congregation's ambitions. Most firms were well-known and had significant records of accomplishment.

Cram and Ferguson were the leading proponents of the Gothic revival in America, although they occasionally designed in a classical and even a quasi-Byzantine style. In Cleveland, they had designed the Church of the Covenant of 1907; they had no prior experience with synagogues.[50] Albert S. Gottlieb of New York built the Newark synagogue that the committee visited. In 1916, he had delivered a paper about the architecture of synagogues to a meeting of the Central Conference of American [Reform] Rabbis, so he was known in Jewish circles.[51] Walker and Weeks had

clients in Cleveland and elsewhere in the Midwest and specialised in commercial and residential architecture. They had designed a few churches but no synagogues.[52]

The sons of George B. Post had continued the New York firm after the death of its founder in 1913. Their Cleveland office designed the downtown Statler Hotel (1911–12), which Tifereth Israel often used for congregational meetings. Across the street from the Statler, at a prominent intersection, Post & Sons had built the grand Cleveland Trust Company Building (1905–8); its interior has an impressive circular atrium with a leaded glass dome. The firm's principal commissions were banks, hotels and other commercial structures, but they had built a few churches but apparently no synagogues.[53] Finally, Hubbell & Benes, a prominent Cleveland firm, had built a number of important public buildings in the city, but again few churches and evidently no synagogues.[54] Their speciality was the Classical Revival. In 1900, Benes had designed the classical Wade Memorial Chapel with exquisite stained glass windows and mosaics, and in 1916, the firm built the neo-classical Cleveland Museum of Art, located not far from the land bought for the new Temple. Hubbell & Benes was especially active after the First World War, the period of the Tifereth Israel commission.[55]

Because of the aforementioned letter from the Cleveland AIA, all competitors withdrew except Charles Greco, who telegrammed that he would compete and 'would not be withdrawn by any third party'.[56] The Building Committee revised the terms of the competition to placate the AIA, to no avail.[57] Next, it sought another perspective from the Cleveland firm of Lehman & Schmitt.[58] Charles Morris of the firm submitted its proposal, which has not been found, but it can be surmised that it was in the grand Beaux-Arts style in which Morris had been trained. He initially came to Cleveland to work on the firm's Cuyahoga County Court House, completed in 1911, a major Beaux-Arts building in downtown Cleveland.[59] Lehman & Schmitt would have been a logical firm to approach because they had designed the synagogue's current building in 1894, when Israel Lehman was a member of the synagogue board.[60]

Besides Morris, the Building Committee also rejected Alfred Alschuler, who was then designing Temple Isaiah, the aforementioned Byzantine synagogue in Chicago, which was also dedicated in the fall of 1924. In early December 1920, Alschuler had asked to join the competition.[61] A couple of months after everything had been decided, Albert Kahn of Detroit inquired about the project through a letter from the rabbi of the Detroit Congregation Beth El to Silver.[62] Kahn had previously built classical synagogues for that congregation in 1903 and 1922.[63] Silver

promptly responded that an architect had already been selected. It might be presumed that Alschuler and Kahn, both Jewish architects experienced in designing synagogues, might have had an advantage with the Building Committee. To their credit, its members were open to the best proposal no matter the religion of the architect, but it was a position that drew criticism. One member of the Congregation wrote to Silver complaining that the committee should only consider Jewish architects and correctly observed that for their churches, Catholics and Protestants chose architects of their own denominations.

The Architect

However, in selecting Charles R. Greco, a Catholic,[64] Tifereth Israel was just as adventuresome as it had been three years earlier in hiring Abba Hillel Silver. In terms of résumés, Greco's appears not to have been in the same league as his initial competitors, although his career has been difficult to investigate. I have not found any papers or designs by him other than what was published by local Jewish newspapers.[65] Only his numerous buildings appear to remain from a long career (1907–60). Born 15 October 1873 to Letterio Greco and Catherine Reggio, he attended Lawrence Scientific School, an applied science programme at Harvard University.[66] He began working for the Boston firms of Wait and Cutter and Peabody and Stearns before opening his own practice in 1907.[67]

Prior to the commission from Tifereth Israel, Greco had designed schools, churches and numerous private houses in the Boston area. In the 1910s, he built the churches of the Blessed Sacrament in Jamaica Plain, Boston (1911–17), St Patrick's in Brockton, MA (1912) and St Mary's in Quincy, MA (1917), among others. In 1919, Greco was in competition to design the Basilica of the National Shrine of the Immaculate Conception in Washington, DC, the largest Catholic church in the Western hemisphere. The firm of Maginnis and Walsh secured the project instead, but the fact that Greco was considered attests to his standing at the time.[68]

His work in Cleveland began in 1917 with the Moses Montefiore Home in Cleveland Heights.[69] The same year he designed several private homes in the area and established a branch office in Cleveland. The Montefiore Home must have brought him to the attention of the Building Committee of Tifereth Israel. In turn, his work there led to other local projects, especially a new synagogue for Congregation B'nai Jeshurun in Cleveland Heights that opened in 1926, not far from the Montefiore Home. Groundbreaking for that building took place in February 1924, as the Temple was being completed. The synagogue for B'nai Jeshurun also has Byzantine

elements, in particular a twelve-sided dome, modelled on that of the polygonal dome of the Katholikon of Hosios Loukas in Greece.[70] It demonstrates that Greco continued to make good use of the book of Schultz and Barnsley.

After being awarded the commission for the Temple in April 1921, Charles Greco set to work elaborating the initial proposal that he had submitted the previous January.[71] By the summer, he was sharing preliminary drawings with Rabbi Silver on vacation in New Hampshire.[72] On 28 November 1921, Greco met with the Building Committee to show them the state of the project. He then must have presented renderings of the new building because one was published in the *Jewish Independent* for 16 December 1921. The latter wrote that the drawings for the Temple were 'practically completed'. That was not the case, as Greco submitted the final plans only at a meeting of the Building Committee the next May.[73]

Construction bids were due 3 August 1922, and the next November, the congregation authorised spending $1.2 million on the building and assuming a mortgage for $400,000.[74] At that time, the *Jewish Independent* published a drawing of the façade.[75] Excavation began on 4 December 1922, and the cornerstone of the new Temple was laid the following May.[76] Construction continued through 1923 and into the next year. By April 1924, the façade and upper levels were completed, and attention turned to the interior.[77] The last service in the old temple was held on 15 June. The new synagogue was dedicated 19–21 September 1924 and finished at a cost of $1,246,168.31.[78]

Local Response

How was Greco's finest building received? Its first and primary audience was Rabbi Silver, who had seemed to have a good grasp of synagogue architecture in his previously cited proposal from 18 June 1920. Silver began with a discussion of Jewish architecture, correctly observing that Jews did not have their own architectural style and instead conformed to prevailing local styles. He then added that

> our structure must in some way be distinctive. It should be readily distinguished from other religious structures. It must not look like a bank or a public library. It must subtly, but effectively, create a religious atmosphere, and in its symbolism at least bespeak a Jewish house of worship.[79]

These criteria ruled out the classical façade with columns, as seen on banks or public libraries or in Albert Kahn's Beth El Temple in Detroit

of 1922 and other classically inspired temples.[80] To be different from other religious buildings, the Temple should not adopt the Episcopalian Gothic or the Catholic Baroque styles. As noted above, Silver had also dismissed the Moorish style by proclaiming it outmoded. He would have had personal experience of it, because he had studied in Cincinnati, where the foremost Reform temple was the previously mentioned Plum Street synagogue of 1859, and his first post was in Wheeling, West Virginia at the Moorish Eoff Street Temple, no longer extant.[81]

In his unpublished autobiography written towards the end of this life, Rabbi Silver described the new Temple as 'a beautiful structure in a modified Byzantine style', then quoted from the Stanwood article before continuing in his own words:

> [The Temple] has been described as 'a building which is not only architecturally satisfying, but which expresses in itself the deeply religious spirit and essential unity of the Jewish faith.' It was built before the vogue developed to build *functional* structures.
>
> I have always had strong reservations on the trends in contemporary church architecture . . . A church design which is merely untraditional, which deliberately startles by its feats of novelty, which embodies abstractions in constant need of commentary, or which attempts to make the religious edifice 'functional' in the mechanical sense of the term . . . misses . . . the very unique and redemptive contribution which a house of worship can make to the beset and troubled spirit of modern man . . .
>
> When a man enters a church or synagogue to pray . . . he should be moved to exclaim not 'How modern! How functional! How sensationally different!' but, 'This is none other than a house of God and this is a gate to heaven'.[82]

Such is the sum total of his architectural commentary on the new building.

Thus, it is necessary to turn back to Stanwood's review of the building, for he writes with an insider's knowledge in addressing the building's Byzantine elements:

> The architect and the committee felt from the beginning that the architectural treatment of the new building should not be based on any of the usual styles, but should rather be developed from the basic forms of those regions where the Jewish race passed the period of its national existence, taking only such motifs from various sources as could be welded into a harmonious entity. The outcome has been a type which is, perhaps, more Byzantine than anything else, but which is still not too oriental in feeling to prevent a transition without undue shock from the mass of the temple to the more modern and practical regularity of the school and other everyday portions of the group of buildings.[83]

In the creation of the University Circle Temple, the rabbi, Building Committee and architect came to agree about form and meaning. The result is a distinguished building unlike other religious architecture in Cleveland or anywhere else in America at the time. In the years that followed, the Temple influenced other synagogues by various means, including a rabbi network.[84] Its fame was due to others appreciating what Silver and Stanwood, and by extension Greco, regarded as its success in conveying 'the essential unity of the Jewish faith'. The low dome of Hagia Sophia played no small part in this effect. Ruth Dancyger, temple historian and long-time member of Tifereth Israel, spoke about the sanctuary's 'vastness, that domed feeling', which 'bowled over' those that saw it for the first time,[85] just as the Great Church of Constantinople was, in the words of the sixth-century historian Procopius, 'stupendous to those who see it and altogether incredible to those who hear of it'.[86]

Notes

1. For a more sympathetic treatment of modernist religious architecture, see the essays in Anat Geva (ed.), *Modernism and American Mid-20th Century Sacred Architecture* (New York: Routledge, 2019). This study would not have been possible without the generous aid in Cleveland of Arnie Berger, Jane Rothstein, Sean Martin and many others. I am grateful for their introductions to the city and its archives.
2. Carol Herselle Krinsky, *Synagogues of Europe: Architecture, History, Meaning* (New York: Architectural History Foundation, 1985), 285–8.
3. Walter C. Leedy Jr, *Eric Mendelsohn's Park Synagogue: Architecture and Community* (Kent, OH: Kent State University Press, 2012).
4. For images at the important site, see *Synagogues 360*, https://synagogues360.bh.org.il/gallery/isaac-m-wise-temple/ (accessed 27 July 2023).
5. Robert S. Nelson, *Hagia Sophia, 1850–1950: Holy Wisdom Modern Monument* (Chicago: University of Chicago Press, 2004), 180.
6. Robert S. Nelson, 'The Byzantine Synagogue of Alfred Alschuler', *Images: A Journal of Jewish Art and Visual Culture* 11 (2018): 5–42.
7. General accounts: Rachel Wischnitzer, *Synagogue Architecture in the United States: History and Interpretation* (Philadelphia: Jewish Publication Society of America, 1955), 110, 113–14; Samuel Gruber, *American Synagogues: A Century of Architecture and Jewish Community* (New York: Rizzoli, 2003), 48–53. In what follows, frequent reference will be made to the archives of Tifereth Israel (ATI) and the papers of their rabbi Abba Hillel Silver (AHS Papers) at the Western Reserve Historical Society. For the latter, I have used a set of over 200 microfilm rolls of those papers at Yale University. I must acknowledge the generosity and support of people in Cleveland: Jane

Rothstein and Arnold Berger of Temple Tifereth Israel; Jordan Davis, building manager of the Maltz Performing Arts Center, Elizabeth Bolman and Elina Gertsman of Case Western Reserve University, and Martin Hauserman and Charles Mocsiran of the Archives of the Cleveland City Council. I thank Prof. Alanna Cooper for the addition of the Eire Synagogue to the list of Greco's work.

8. 'Photo Gallery'. *Maltz Performing Arts Center | Case Western Reserve University*, 7 May 2018, https://case.edu/maltzcenter/about-center/photo-gallery (accessed 5 March 2020).
9. The angle at which the two streets meet is less than 24 degrees, according to Richard R. Stanwood, 'Temple Tifereth Israel, Cleveland Charles R. Greco, Architect', *The Architectural Forum* 42/5 (November 1925): 257.
10. 'Description of The New Temple', in *Dedication Number, Twenty-fourth Annual of The Temple*, 1924–5. ATI.
11. Thomas F. Mathews, *The Byzantine Churches of Istanbul: A Photographic Survey* (University Park, PA: Pennsylvania State University Press, 1976), fig. 31-63. The marble floor of Hosios Loukas appeared in Robert Weir Schultz and Sidney Howard Barnsley, *The Monastery of Saint Luke of Stiris in Phocis and the Dependent Monastery of Saint Nicolas in the Fields, Near Skripou, in Bæotia* (London: Macmillan, 1901), fig. 19, pls 20–3, a book available at Harvard, where Greco studied.
12. Stanwood, 'Temple Tifereth Israel', 259.
13. Schultz and Barnsley, *Monastery of Saint Luke of Stiris*, pl. 41.
14. Wischnitzer, *Synagogue Architecture*, 104.
15. Eric Johannesen, *Cleveland Architecture, 1876–1976* (Cleveland: Western Reserve Historical Society, 1996), 53–4.
16. Andrew S. Dolkart, *Morningside Heights: A History of Its Architecture & Development* (New York: Columbia University Press, 1998), 134.
17. As seen in the construction photograph in Greenberg, 'Cleveland Synagogues', at https://www.clevelandjewishhistory.net/syn/ti-circle.htm (accessed 15 March 2020).
18. See the photograph of Tiferet Yisrael, the Hurva, and other buildings with smaller domes in a report about the decision to rebuild it: http://elderofziyon.blogspot.com/2014/03/major-synagogue-destroyed-by-jordan-in.html#.U0fqP_ldV8E) (accessed 29 March 2020).
19. Stanwood, 'Temple Tifereth Israel', 257.
20. Nelson, *Hagia Sophia*, figs 56–8, 72.
21. Ibid., fig. 77.
22. Richard R. Stanwood (b. 1884, Harvard 1906), from an old New England family, was eleven years younger than Greco and had graduated from Harvard with a BA and MA, presumably in architecture, because he was in 'the Scientific School', in which architecture was taught. For his position in the Stanwood family, see Ethel Stanwood Bolton, *A History of the Stanwood Family in America* (Boston: Rockwell and Churchill, 1899), 254.

Stanwood's design for a brick house is illustrated in *The Brickbuilder* 23 (3 March 1914): 69.
23. As attested in old photographs in ATI. Minimal alterations were made to the back of the bimah in its conversion to a church.
24. Lloyd P. Gartner, *History of the Jews of Cleveland* (Cleveland: Western Reserve Historical Society, 1987), 142.
25. Nelson, *Hagia Sophia*, fig. 38.
26. Document from long-serving Congregation President Martin Marks in ATI.
27. ATI.
28. ATI.
29. Marc Lee Raphael, *Abba Hillel Silver: A Profile in American Judaism* (New York: Holmes & Meier, 1989), 1–16.
30. An observation I owe to Arnold Berger.
31. Raphael, *Silver*, 27–8.
32. Congregation Tifereth Israel, *The Temple 1850–1950* (Cleveland, 1950), 28; Raphael, *Silver*, 41
33. Ruth Dancyger, *Temple Tifereth Israel: One Hundred and Fifty Years 1850–2000* (Cleveland: R. Dancyger, 1999), 17, 24; Raphael, *Silver*, 17, 42–3.
34. AHS Papers, microfilm 54.
35. Ibid.
36. William B. Helmreich, *The Enduring Community: The Jews of Newark and Metrowest* (New Brunswick: Transaction Publishers, 1999), 237–9.
37. Rabbi Solomon Foster to AHS, 27 March 1923. AHS Papers, microfilm roll 54.
38. David Kaufman, 'Temples in the American Athens: A History of the Synagogues of Boston', in Jonathan D. Sarna et al. (eds), *The Jews of Boston* (New Haven: Yale University Press, 2005), 203–5.
39. Kaufman, 'Temples in the American Athens', 181.
40. 602 Commonwealth Avenue, occupied 1906–26. The congregation would then erect a similarly severe classical structure and decades later abruptly join a modernist structure to it. See Kaufman, 'Temples in the American Athens', 184.
41. David Kaufman, *Shul with a Pool: The 'Synagogue-Center' in American Jewish History* (Hanover, NH: University Press of New England, 1999). Also see Wischnitzer, *Synagogue Architecture*, 161–8.
42. See n. 32.
43. AHS letter of 9 May 1927 to Leo C. Fuller of Temple Isaiah, St Louis. The letter had been written to seek advice about what type of temple they should build. AHS Papers, microfilm 54.
44. Steven Fine, *Art and Judaism in the Greco-Roman World: Toward a New Jewish Archaeology* (Cambridge: Cambridge University Press, 2005), 12–21.
45. Julian Preisler, *Historic Synagogues of Philadelphia and the Delaware Valley* (Charleston, SC: History Press, 2009), 70–2; Wischnitzer, *Synagogue Architecture*, 94–5.

46. Wischnitzer, *Synagogue Architecture*, 114.
47. See n. 34.
48. Ibid.
49. AHS Papers, microfilm 54. On such competitions and the evolving position of the AIA, see Sarah Bradford Landau, 'Coming to Terms: Architecture Competitions in America and the Emerging Profession, 1789–1922', in Hélène Lipstadt (ed.), *The Experimental Tradition: Essays on Competition in Architecture* (New York: Princeton Architectural Press, 1989), 53–78. I owe this reference to my colleague Craig Buckley.
50. The firm's project list through 1920 has no synagogues, according to Ethan Anthony, *The Architecture of Ralph Adams Cram and his Office* (New York: Norton, 2007), 241–3.
51. Albert S. Gottlieb, 'Synagogue and Sunday School Architecture', reprint of a paper read before the Central Conference of American Rabbis at Wildwood, NJ, 3 July 1916, https://archive.org/details/synagoguesundays00gott/page/n1 (accessed 6 March 2020). He repeated material from the latter in 'Synagogue Architecture: Past and Future', in *The American Hebrew & Jewish Messenger*, 11 April 1919.
52. A listing of the firm's commissions through 1920 can be found in Eric Johannesen, *A Cleveland Legacy: The Architecture of Walker and Weeks* (Kent, OH: Kent State University Press, 1999), 143–62.
53. Sarah Bradford Landau, *George B. Post, Architect: Picturesque Designer and Determined Realist* (New York: Monacelli Press, 1998), 151–7.
54. *Encyclopedia of Cleveland History*, https://case.edu/ech/articles/h/hubbell-benes (accessed 6 March 2020). See also http://planning.city.cleveland.oh.us/landmark/arch/archDetail.php?afil=&archID=285&sk=death&sd=ASC (accessed 6 March 2020). The Wikipedia listing of their work contains commercial and civic building, residences and two churches, but no synagogues: https://en.wikipedia.org/wiki/Hubbell_%26_Benes (accessed 6 March 2020).
55. Johannesen, *Cleveland Architecture*, 122–6.
56. 'Memorandum of Work on The Temple', 19 April 1921. AHS Papers, microfilm roll 54.
57. Ibid. 'Mr. Koblitz [of Tifereth Israel] told Mr. Reed and Mr. Mayer of . . . [our Cleveland] office that the Committee was trying to work out some scheme which would be acceptable to the Institute and suggested that they were considering paying each competitor for sketches with the hope that this would satisfy the requirements or that they might possibly yet employ an Advisor.'
58. Ibid. Here Greco implies the existence of another competitor, who is confirmed and identified in a letter from Herman Moss to AHS, 30 April 1921: AHS Papers, microfilm 54.
59. 'Lehman and Schmitt', *Encyclopedia of Cleveland History*, https://case.edu/ech/articles/l/lehman-and-schmitt (accessed 6 March 2020).
60. Dancyger, *Temple Tifereth Israel*, 9.

61. Letter of L. M. Wolf, chair of the Building Committee, to AHS, 8 December 1920, wanting to know what to write to 'Mr. Alschuler, of Chicago, concerning his desire to enter the competition of architects for presentation of plans for the new temple'. AHS Papers, microfilm roll 54.
62. Letter from Rabbi Leo M. Franklin to AHS, 1 June 1921. Silver replied on 3 June. AHS Papers, microfilm 54.
63. On these buildings and a later Byzantine synagogue that Kahn designed for Congregation Shaaray Zedek in Detroit, see Samuel Gruber, 'Samuel Gruber's Jewish Art & Monuments: Albert Kahn's Other Synagogue: Shaaray Zedek', *Samuel Gruber's Jewish Art & Monuments*, 21 July 2012, http://samgrubersjewishartmonuments.blogspot.com/2012/07/albert-kahns-other-synagogue-shaaray.html. (accessed 6 March 2020).
64. Greco was a member of the Knights of Columbus, a Catholic fraternal organisation: *Cambridge Sentinel* 18/44 (31 December 1921): 14. https://cambridge.dlconsulting.com/cgi-bin/cambridge?a=d&d=Sentinel19211231-01&e=-------en-20--1--txt-txIN------- (accessed 6 March 2020).
65. *The Jewish Independent*, 16 December 1921, 10 November 1922.
66. In spite of several major donations, the Lawrence Scientific School was not a success at Harvard and was dissolved in 1906. See Bruce Sinclair, 'Harvard, MIT, and the Ideal Technical Education', in Clark A. Elliott and Margaret W. Rossiter (eds), *Science at Harvard University: Historical Perspectives* (Bethlehem, PA: Lehigh University Press, 1992), 76–95.
67. Accessed 6 March 2020. Also Greco's obituary in *The Boston Globe* (23 February 1963), 18.
68. Geraldine M. Rohling, 'The Blessing of the Land', *Mary's Shrine* 80/2 (Fall/Winter 2019), not paginated, available at https://www.nationalshrine.org/wp-content/uploads/Basilica-Marys-Shrine-Fall-Winter-2019.pdf (last accessed 6 March 2020). At the 21 February 1919 meeting of the Trustees of the Catholic University of America, the committee on the National Shrine reported that it had met on 8 January 1919 and discussed possible architects, including Greco. However, the committee unanimously recommended the architect Charles Maginnis of Boston, and that the church be in the Romanesque style. I thank Dr Geraldine M. Rohling, the Archivist-Curator of the National Shrine, for this information.
69. Sir Moses Montefiore Home for the Aged & Infirm Israelites, a residential complex in a Georgian style. See *Encyclopedia of Cleveland History*, https://case.edu/ech/articles/m/montefiore-home (accessed 6 March 2020). The home later moved, and the building on Mayfield Road was torn down. Illustrations and ground plans can be found in Charles R. Greco, 'Montefiore Home, Cleveland Heights, Ohio', *Architectural Forum* 33 (November 1920): pls. 67–9.
70. Illustrated in Marian J. Morton, *Cleveland Heights: The Making of an Urban Suburb* (Charleston, SC: Arcadia, 2002), 105. The latter has a good discussion of Jewish immigration to the area: 104–22. The dome of Hosios Loukas

was available to Greco in Schultz and Barnsley, *Monastery of Saint Luke of Stiris in Phocis*, pl. 2.
71. From Charles R. Greco, 'Memorandum of Work on The Temple', 19 April 1921. AHS Papers, microfilm roll 54.
72. Letter of Greco to AHS, 4 August 1921. AHS Papers, microfilm roll 54.
73. AHS telegram to Wolf on 11 May 1922. 'Greco will arrive Tuesday morning with completed plans and specifications. Advise calling meeting of the Building Committee Tuesday evening.' The next Tuesday was 16 May. AHS Papers, microfilm 54.
74. 'Schedule Specifications for the Temple and Temple Meeting House', minutes of Special Meeting of the Congregation, 5 November 1922. ATI.
75. See note 64.
76. *The Temple 1850–1950*, 33.
77. Construction photographs. ATI.
78. *Jewish Review and Observer*, 13 June 1924, 'Farewell to the Old Temple', *The Temple 1850–1950*, 33; *Dedication Number, Twenty-fourth Annual of The Temple East 105th Street at Ansel Road Cleveland, Ohio 1924–25*, 14. ATI.
79. See n. 34.
80. Wischnitzer, *Synagogue Architecture*, 95–103.
81. Temple Shalo, 'History'. http://www.templeshalomwv.com/history.html (accessed 27 July 2023).
82. Abba Hillel Silver, (unpublished) *Autobiography*, book 1. AHS Papers, microfilm roll 211. (Emphasis in the original.)
83. Stanwood, 'Temple Tifereth Israel', 260. Silver's spirituality and mission, well conveyed here, are also apparent in the non-standard cornerstone inscription: 'Dedicated to the service of one God, the fellowship of all His children and the prophetic mission of His people Israel. Congregation Tifereth Israel 1923 · 5683.' See https://www.clevelandjewishhistory.net/syn/ti-circle-photos.htm#pic2 (accessed 27 July 2023). I thank Arnold Berger for this information.
84. On 24 November 1924, Rabbi Samuel R. Shillman of Mizpah Congregation in Chattanooga, TN wrote Silver asking for 'pictures and some plans', as his congregation was planning a new building. AHS Papers, microfilm roll 54. However, the Georgian structure that was built has no relation to the Temple in Cleveland. On 29 December 1924, Rabbi Ephraim Frisch of Temple Beth-El in San Antonio, TX wrote Silver to introduce the architect of the new synagogue they were planning and to ask if the architect could 'inspect your temple'. AHS Papers, microfilm roll 54. The San Antonio congregation would build a centralised Byzantine synagogue, decorated, however, with Spanish ornament befitting its location. See Wischnitzer, *Synagogue Architecture*, 117, fig. 87.
85. 'Walking into Sanctuary', https://clevelandhistorical.org/items/show/40 (accessed 7 March 2020): 'When people come, particularly people who are

not Jewish, they are *bowled over* with that sanctuary. Part of it [is] . . . its vastness that domed feeling . . . [t]he reaction to that sanctuary is *totally* emotional, and people *adore* coming in there' (emphasis hers), interview from 2 July 2008. On the same site, listen also to the interview with Sue Koletsky about the spiritual quality of the sanctuary, 'A Very Spiritual Feeling', https://clevelandhistorical.org/files/show/409 (accessed 27 July 2023).

86. Cyril Mango, *The Art of the Byzantine Empire 312–1453: Sources and Documents* (Englewood Cliffs, NJ: Prentice-Hall, 1972), 72, 74.

Chapter 7

The Monument of the Present: The Fossati Restoration of Hagia Sophia (1847–9)

Asli Menevse

A May 1846 *irade* by Sultan Abdülmecid I declared Hagia Sophia to be 'an esteemed and ancient monument' whose importance is 'well-established'; 'hence', the document maintained, the prolongation of its state of desolation '*before the general regard*' was 'neither appropriate nor fitting'.[1] Consequently, an ambitious restoration project was launched in 1847 under the technical and aesthetic authority of the Swiss-Italian architect Gaspare Fossati, and under the engaged attention of the Ottoman bureaucrats and the young sultan.[2] The most urgent interventions concentrated on the consolidation of the compromised main dome and on redressing the static instability that slanted twelve columns in the upper gallery. The structural consolidation was followed by attending to the missing or damaged decorations, executing a cohesive stucco programme throughout the structure, and repairing and painting the exterior walls. Finally, the architect provided the ancient edifice with new additions, including a new imperial loge for the Sultan. Yet, the aspect of the restoration that would attract the most popular and scholarly attention arose by coincidence: the uncovering (and then the restoration and recovering) of the figural mosaics that were unseen and forgotten for generations.

The majority of this impressive project was completed in two years, and the building was reopened for worship during Ramadan of 1849.[3] The technical aspects of the restoration have been described by historians of art and architecture,[4] while the official correspondences that reveal the bureaucratic and financial backdrop of the project have been brought to light by scholars of Ottoman history.[5] However, these accounts overlook two crucial details that influenced this project from its inception: its reception by intended audiences and the political ambitions of those involved.[6]

Concerns about reception, demonstrated by the importance placed on 'general regard' even in the earliest official calls for restoration,[7] had

informed political practice especially since the recent reforms in the empire had amplified the attention of its European peers. Less than a decade before the first executive order concerning the restoration, the Ottoman government announced its commitment to providing legal protection for the lives and property of all its subjects, regardless of their religious and cultural identities, in a declaration known as the Edict of Gülhane.[8] Enacting a fundamental shift in the relationship between political authority, the public and the law, the edict also signalled the increasing primacy of a centralised bureaucracy that would function both as the designer and the implementer of reforms during the following period of re-organisation, known as the Tanzimat. News of these changes in the empire would bring international political attention to the sultan, the bureaucratic elite and, especially, the grand vizier Mustafa Reshid Pasha.

This heightened political visibility coincided with an ongoing dissemination of images from the empire to the West, sustained by the increasingly popular and available medium of illustrated print publications. The translation of distant lands and cultures into images did not start in the nineteenth century, but the century's new, cheaper and more accessible technologies of visual reproduction expanded its pace and reach. Dubbed by Robert Nelson as turning 'sites into sights', this process reduced the Ottoman imperial capital and its monuments, especially Hagia Sophia, into a set of images.[9] On the tail of this historical conjunction, the Ottoman Empire and its monuments were assimilated into romantic scenes of ruin and decay, allegorising the effects of time's progress on a purportedly sedentary cultural and political entity. For instance, published just a year before the Gülhane Edict, William Bartlett's illustrations for Julia Pardoe's popular travel book showed the imperial capital as 'hapless, dilapidated, on the verge of ruin'.[10] On the brink of Tanzimat reforms, then, the dominant image of the empire was as a fading relic without a future.

Instead of thinking about the processes that transformed the empire into a series of mass-produced images (and texts) as unwelcome and one-sided, one must remember that the Tanzimat elite devised strategies to create and manage their public image. The political aims of curating public appearances for international audiences influenced the execution of projects such as the intentionally monumental university [*Dâr'ülfünûn*] building.[11] Placed on the shore of the Sea of Marmara, steps away from Hagia Sophia, the building was ordered to be 'visually accessible both from the sea and land . . . especially to the gaze of foreign eyes [*bâ-husûs enzâr-ı ecnebiyye*]' as architectural testimony to the empire's educational and scientific ambitions.[12] Another opportunity for visibility was presented by the emergence of newspapers, which provided the basis for

a bureaucratically-led 'public relations campaign' that can be traced in numerous references to public opinion [*efkâr-ı umûmiyye*].[13]

The efforts to frame and instruct foreign attention also responded to a need for images of Ottomanness as a prophetic mirror that could make coherent the diverse ambitions and ideals of the Tanzimat and reflect them to its audiences at home. While the reforms exceeded their political and legal frameworks and spilled into the emergent public sphere with clear signals of change, the Ottomans could see the new civic functions of the state reflected in new architectural projects. These monumental additions to the urban space, such as the new university building, provided opportunities for the state to manage its public visibility.[14] Considering the role of architecture in the shaping of identity in a rapidly changing imperial landscape, Ahmet Ersoy identifies the later decades of the Tanzimat as 'an intense experimentation in reimagining the relations between the Ottoman self, its others, and the world'.[15] Within such political-spatial economies, the image of the famous monument, restored to its full splendour, represented a restoration in another sense, as an architectural metonym for the reforms that aimed to restore the empire's image before both domestic and international eyes.

Together with the endeavours to promote it in the international arena, the 1847–9 restoration of Hagia Sophia can be considered as a precursor to the concentrated attempts at imperial self-representation in the second half of the century. To that end, I trace the aims of the actors who restored, reframed and represented Hagia Sophia as a promising image for the empire in the mid-nineteenth century alongside recorded receptions of their efforts in the mass media: newspapers, magazines and, especially, the lithograph album designed by Gaspare Fossati and funded by the Ottoman court. Through these acts of image-making and -unmaking, the restoration emerged as a medium for communicating the aspirations of its patrons.

Writing the Empire: The Restoration in the Ottoman and European Press

Between curious couch travellers, self-proclaimed experts on the Orient and contemporary specialists of ancient edifices, news of the restoration coming from Constantinople was welcomed by a wide international audience. The principal agent that sustained the flow of information from the Ottoman capital to European audiences was the French-language newspaper of the city, *Journal de Constantinople* (Figure 7.1). The newspaper was instrumental in shaping the restoration's reception outside the empire, since newspapers, magazines and even journals of architecture and

Figure 7.1 First page of the *Journal de Constantinople. Écho de l'Orient* (29 July 1849). Atatürk Kitaplığı, Istanbul. Digitised and catalogued by Salt Research, https://archives.saltresearch.org/handle/123456789/129307 (accessed 16 January 2023).

archaeology in European capitals would republish the news as it appeared in the *Journal*.[16] In addition to offering technical details of the restoration, the *Journal* also provided political and historical context that aimed to influence its audience's perception and opinion of the geographically distant, yet highly publicised, effort to restore the celebrated monument.

Throughout the restoration, the *Journal* regularly informed its readers of Sultan Abdülmecid's ongoing visits to the site and his careful attention to the most minute details of the project. The newspaper presented these visits as testimony to the sultan's refined appreciation of antiquities and his dedication to advancing the study of history and the arts. These stories accompanied reports about the new museum of antiquities established in Hagia Eirene [*Cebhâne*]. According to the *Journal*, the new museum was evidence that 'the taste for the arts of ancients [and] of historical monuments', which is 'essentially a characteristic of the civilisation of Europe', is 'developing and taking further root in Turkey, evidenced by the sultan's warm welcome to all the artists and art scholars who visit the Ottoman capital'.[17] Such promotions of the empire's 'sincere interest in the monuments and antiquities'[18] intended to bring Europe and the Ottomans closer through their patronage of art and history. This publicity foreshadowed later efforts of the Tanzimat elite to present the empire as a modern, enlightened political entity that valued and protected its non-Islamic cultural heritage.[19]

The sultan's visits to the new institution, and his particular fondness for the Greek and Roman antiquities section, were part of this steady stream of news, occasionally including highlights such as his special interest in a statue of the goddess Diana that had recently been unearthed and brought to the museum.[20] As intended by its authors, this news was picked up by European periodicals and newspapers and reached a larger audience. However, some European editors were inclined to report the news with bias, influenced by recent history. For example, the Paris-based *Bulletin des Arts* implicitly evoked the Greek War of Independence when it relayed its doubts about 'this newfound appreciation of the Turcs for Greek artifacts and culture'.[21] Displaying further impudence, it questioned the capability and sincerity of Ottoman bureaucrats and called for the French ambassador in Constantinople to step in and bring the artifacts to the safety of Paris's museums.[22] Although such skewing of its carefully constructed news indicates the publication's limited control over its reception, the *Journal*'s efforts proved long-lasting. Two decades later, for instance, August Choisy would refer to the museum of antiquities in Hagia Eirene as proof that a conciliation between the figural arts and Islam marked a change in the empire.[23]

Among the many reports of the restoration published in the *Journal*, one would prove to be especially popular. Eclipsing almost all other accounts of the restoration published in Europe in the following decades, this story appealed to the curiosity of many readers, whether they be motivated by antiquarian enthusiasm or political intrigue. Fuelled to a certain extent by general excitement about their rediscovery, the story of the sultan's first encounter with the ancient mosaics was widely reproduced. According to the *Journal de Constantinople*, the sultan was especially taken with a mosaic that depicted 'one of the last Greek emperors',[24] which prompted him to order Fossati, in French, to 'preserve them [the mosaics] with a layer of plaster so they will not be lost for history and for art'.[25] This story about the art-loving, forward-thinking, francophone sultan was immediately picked up by European papers and journals. This time, although the details and the assessment of the story in the European media were rather inconsistent, the ruler was depicted in a considerably positive light, indicating that the *Journal* largely succeeded in its efforts to use the restoration to represent the regime favourably. The professional journal *Revue Archéologique* compared the 'enlightened attention' of the sultan to the gross negligence of his ancestors and identified him as a new type of ruler in the East, without challenging Western perceptions of previous Ottoman rulers.[26] He was cast as an idealist with a great love of beauty, yet also as sensible and adaptable. His order to re-cover the mosaics with a light layer of plaster, which could be removed 'when the Muslim prejudices [were] silenced in the future', became an indicator of this art-lover's political acumen.[27] As this version of the story distanced the sultan from his predecessors, his insistence on the value of the mosaics likewise separated him from his pious subjects. If the restoration project was intended to improve perceptions of the empire, the positive light cast on the empire's ruler did not extend to his people. Yet there was some hope for the unenlightened masses in these accounts, which challenged the assumptions of cultural stagnancy. The sultan's reported reference to the future inadvertently introduced a conciliation between his ideals and the piety of his subjects, as he demanded the process be carried out in a reversible manner.[28] Reversibility would become a central concern of restoration practice and theory as they developed, but, as noted by Sabine Schlüter, it was not yet part of the nineteenth-century discourse on historical monuments.[29] This popular restoration anecdote, on the other hand, presented reversibility not as a technical but as a political measure, embodying respect for the past, sensibility in the present and hope for the future.

In contrast to the political terms in which popular publications framed the restoration, professional journals focused more on the technical and

intellectual qualifications of the project and its architect. The *Revue Générale de L'Architecture et des Travaux Public*, the official publication of professionals and scholars of monuments in France, provided its own commentary on an exact reproduction of the story as it appeared in the *Journal*. The article showed a mistrust for the restoration and called for a revision of the project with 'absolute preservation' in mind, which would necessitate leaving behind the 'religious sensitivity of the ancient Turks', who had condemned the mosaics to obscurity for centuries.[30] Casting doubt over the approach and goals of the restoration, and too impatient to wait for the 'future moment' anticipated in the anecdote, the editorial declared that if the restoration project did not immediately aim for the original Justinianic design, it would become a sacrilege. Indeed, techniques for restoring and caring for ancient cathedrals were being widely discussed in both professional and amateur circles in Europe. Just three years previously, in the pages of the same publication, César-Denis Daly had voiced his concerns regarding Eugène Viollet-le-Duc's restoration programme for Notre Dame of Paris, which aimed to restore the cathedral to its 'original' splendour. In his objection to the project, Daly criticised Viollet-le-Duc's vision for intervening excessively: 'It is adding what does not exist and, as a result, removing what is there; it is completion according to a more or less vague ideal.'[31] In the midst of debates over how true restoration projects should be to 'original' designs, the Fossati restoration was carried out in a time of heated international discourse concerning the identity and fate of historical monuments. These discussions attest to another attentive audience of the restoration. But Fossati was well aware of his peers' inquisitive gaze.[32] The architect's attempts to promote the project, which I will discuss below, were not aimed exclusively at serving his patron, who had been placed in the company of progressive monarchs who appreciated art and maintained historical monuments. Fossati also intended to increase his status and gain respect from his peers who were studying and restoring medieval monuments across Europe.

The Ottoman actors involved with the restoration found a crucial ally in this international community of professionals. The artist and 'Oriental art' connoisseur Adalbert de Beaumont would hold a pivotal position as a mediator between the Ottoman actors and European audiences. Both his personal affiliation with Fossati, which would get him the job of writing the French texts for the restoration's commemorative album, and the connections he had established in Constantinople as an enthusiast of Ottoman arts lent credibility to his assessments of the project's political and social significance. Revealing an ideological alignment with the domestic efforts, de Beaumont's texts present an attractive amalgam of

aesthetic appreciation, historical exposé, political analysis and gossip. His detailed account of the restoration's inauguration ceremony for the popular newspaper *L'Illustration*, for example, presented the project as courageous and intelligent work and advised readers to regard it as an example of both architectural expertise and diplomatic talent.[33] Significant in its acknowledgement of the restoration as a mission of diplomacy for the Ottomans, de Beaumont displayed his own diplomatic skills when he diverged from the European narratives of Mehmed II's conversion of the basilica by demanding justice for the conqueror sultan who, according to him, had 'saved the temple from devastation by his army', and had called for Muslims to pray 'to glorify, in another form, the God [who was] worshiped there the day before'.[34] Assuming his position as a cultural mediator, de Beaumont narrowed the divide between the East and Europe and between Christianity and Islam while presenting the preservation of the empire's non-Islamic inheritance as an essential part of Ottoman tradition, not as a sign of westernisation.

De Beaumont strategically straddled his identities of both French art connoisseur and publicist for the Ottomans. For *Revue Orientale*, he reported that the sultan asked the most pious of his entourage, 'is it not impossible in this century of progress to hide these precious paintings [the mosaics]? If we were to destroy these ancient works, the foreigner would regard us as barbarians.'[35] De Beaumont's explicit inclusion of this concern must have attracted the attention of his readers. The reference to 'the foreigner' is a subtle nod to the reader, appealing to their pride by acknowledging their agency in deciding the modernity or barbarism of the Turks. However, de Beaumont clearly influences the decision of the reader. He instructs them to turn the direction of their critical gaze inwards and question whether those who regard the Ottomans as barbarians could show tolerance and respect to another faith's temple, as the Ottomans showed to Hagia Sophia. Positioning barbarism at the heart of Western Europe, he reminds the reader of the destruction brought to the Eastern Roman world by the Crusades. More strikingly, he reverses the assumption of the East as dilapidated by asking his European audience to compare the splendidly restored Hagia Sophia with their own 'desecrated and . . . mutilated' cathedrals.[36]

These ideological acrobatics were central to de Beaumont's reporting of the inauguration ceremony on 13 July 1849, the second Friday of the holy month of Ramadan, for *L'Illustration*, which in itself was a spectacular staging of the Tanzimat before domestic and international audiences.[37] De Beaumont reported that this elaborate public ceremony was attended by 'the entire population of Istanbul, Galata, and Scutari' as

well as by foreign journalists and ambassadors.[38] The sultan, as a worldly patron of the restoration and spiritual leader of the Muslim faith, arrived at the building on a white horse with a large entourage of bureaucrats and clergy, corresponding to both the sultan's roles. After his procession, he was received at the threshold of the monument by both a group of ulema and Gaspare Fossati and his brother.[39] After delivering a speech, the Sultan gestured for the Fossati brothers to approach him and thanked them personally and on behalf of his people. The positioning of two Christian European architects next to high-ranking ulema was a ceremonial declaration of the new identity of the monument, and by extension the empire. This new identity would be further developed, this time graphically, by important publicity efforts after the completion of the restoration.

The Sight of Empire: The Lithography Album of the Restoration (1852)

The album of lithographs commemorating the restoration was published in London on 1 June 1852. It includes a preface by de Beaumont and a content section that provides short descriptions for the twenty-five lithographic plates. The first fourteen plates show different sections of the interior from various vantage points, plates fifteen to nineteen show the exterior of the building,[40] the next four plates provide a panorama of the imperial capital from one of the minarets, and the final two scenes present the state of the edifice before the restoration for comparison. One of the panoramic views includes the university, also built by Fossati in neo-classical style, seizing the opportunity to merge the empire's progressive ambitions for the future with its respect for the past.[41] The plates were based on sketches done by Fossati and were translated to lithographic prints by the celebrity British printmaker Louis Haghe.[42] As noted by Nelson, this album became 'an important lens through which Hagia Sophia would be viewed for many decades'.[43] This lens not only influenced those curious about the ancient monument but also informed those focused on the empire that had restored the monument.

A lithography album published in London, consisting of prints executed by a Belgian-born British printmaker, based on images created by a Swiss-Italian architect and texts written by a French Orientalist, should raise questions about the cultural and political identity of the album. However, despite the multiple steps and agents involved in its creation, the Fossati album is stylistically and ideologically coherent. From the start, the album dispels any potential doubts about its patronage and identity with its frontispiece (Figure 7.2). The uppermost part of this primary plate is reserved

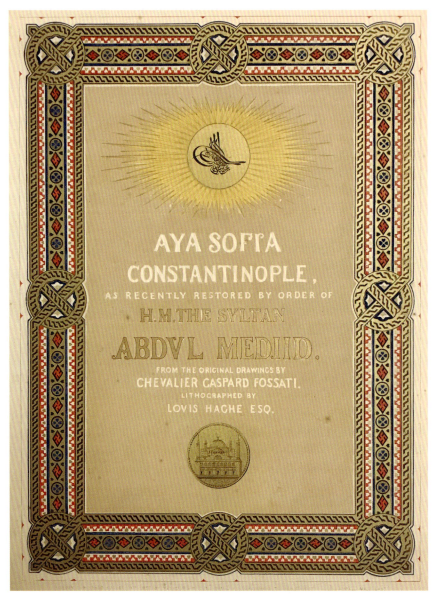

Figure 7.2 Frontispiece from Gaspare Fossati's lithography album, *Aya Sofia, Constantinople, as Recently Restored by Order of H.M. the Sultan Abdul-Medjid* (1852). Lithographs by Louis Haghe; the design of the border is attributed to Owen Jones. Kroch Library, Cornell University, Ithaca, NY. Photo: author.

for the *tuğra* of Sultan Abdülmecid, presented amid a brilliant sunburst. This imperial marker is accompanied by gilded letters reading 'Ayasofya, Constantinople, as recently restored by the order of H.M. The Sultan Abdul Medjid'. In a much humbler font, the insignia and the name of the glorious patron are followed by the names and the deeds of the artists, and this English title page is completed with a reproduction of the commemorative medal commissioned from James Robertson in Istanbul for the inauguration ceremony.[44] Under the presence of the imperial insignia, the empire and its imperial agents are brought together by an interlace border that simultaneously evokes 'arabesque' ornaments and insular manuscripts.

Recognising it as an opportunity for publicity, the Ottoman court had agreed to finance the lithographs Fossati planned to publish after the restoration. This use of 'graphic diplomacy' was not unique to late Ottoman history. In the late eighteenth and early nineteenth centuries, elite imperial agents, such as the dragoman Ignatius Mouradgea d'Ohsson and the court artist Antoine-Ignace Melling, had appropriated the medium of the illustrated travel book to complicate the dominant image of the empire in the international arena.[45] This desire to partake in the making of the empire's international image would continue with increasingly centralised official efforts in the later years of the Tanzimat through publications such as *Usul-i Mi'mari-i 'Osmani [L'Architecture Ottomane]* and *Elbise-i 'Osmaniyye: Les Costumes populaires de la Turquie*.[46]

According to a document in the Ottoman archives, funding was provided for the publication of eighty coloured editions, one hundred large editions and four hundred small editions.[47] The different editions of varying qualities show a desire to reach a base beyond the traditional audience for the expensive illustrated travel and costume books of the previous century.[48] In the strictest sense, both large editions were coloured – the lower-quality editions were made through the process of colour lithography and dominated by cool earth tones, sage greens and greys, while the higher-quality editions were animated by touches of primary colours that seem to have been added by expert hands after the printing process.[49] A quick comparison between these editions shows the discrepancy between the overall feeling they effectuate, as the extra step that distinguishes the 'coloured' edition restores the structure to its full splendour (Figures 7.3, 7.4). This applied colour also allows the human figures to step out of the functional role of staffage and possess movement and individual stories. As they come to life, so does the building they occupy, and those who might seem to be timeless cultural archetypes become temporally locatable by their clothes, the narratives they inspire and, most importantly, the specific historical moment in the life of the monument they are occupying.[50]

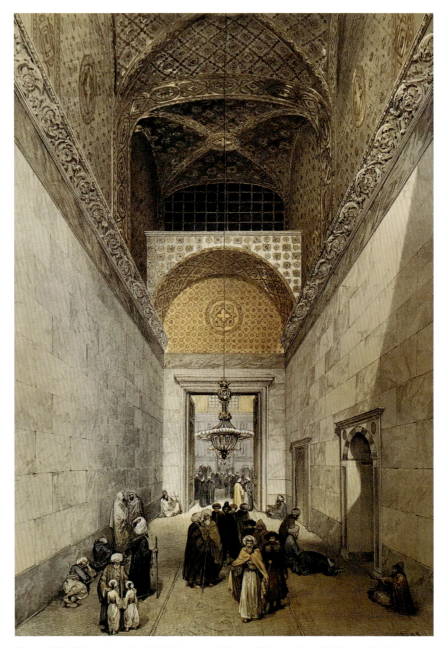

Figure 7.3 'View from the Main Entrance' [Entrée Principale de la Mosquée], Plate 1 from the Fossati album (1852). Bibliothèque Nationale de France, Paris. Photo: author.

Fossati Restoration of Hagia Sophia

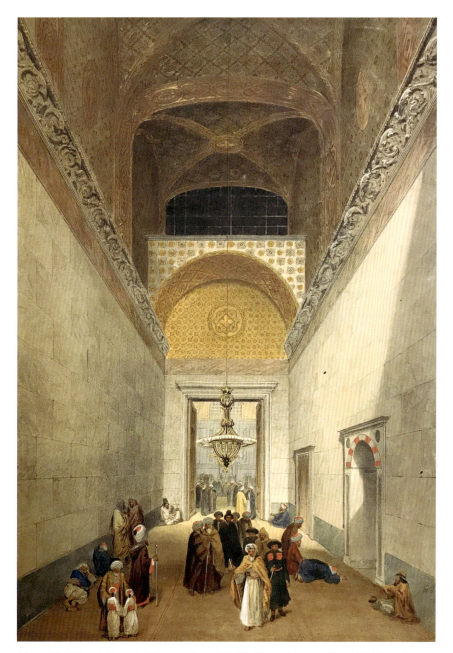

Figure 7.4 Plate 1 from the Fossati album (1852). Kroch Library, Cornell University, Ithaca, NY. Photo: author.

At first glance, we recognise that Fossati's views diverged from the traditional European representations of Hagia Sophia, which almost always preferred to show the monument axially. The space, in the most literal sense of the word, is thereby sacrificed to the architectural representation (Figures 7.5, 7.6). In these earlier images, Hagia Sophia cannot be experienced by bodies, there are no routes for wandering legs or rests for yearning eyes that crave novel details; the figures in traditional attire function as gatekeepers who dictate a distance from which the building could be experienced as a *sight* (Figure 7.5). The inclusion of decaying architectural elements affords a picturesque ruin: the crumbling wooden beam under the arch, the weathered carpet and the imaginary half-broken column on the right ensure this effect, while the stupefying exaggeration of the monument's size furthers the sense of alterity. As such, this image does not represent a true building but an architectural idea stuck in and slowly being destroyed by time. Conversely, the Hagia Sophia of the Fossati album belongs to the moment when it was captured in its lithographs: a testament to the recent restoration, presenting a direct causality between the monument's capacity for such contemporaneity and its timelessness.

This manner of picturing the ancient temple complicated deep-rooted perceptions of the Ottoman state and society, just as the articles of the *Journal* or the reports of de Beaumont had endeavoured to do. At least two features of the album justify this reading. The first is the vantage points Fossati chose in order to give an indirect view of each architectural element he represented. To depict the interior of the ancient temple as Fossati did, one must have an intimate knowledge of the space that can only be acquired by walking in it. Fossati's eye and drawings allow the viewer to not only occupy the space but also to share each historical moment of the monument with the figures in these prints. Secondly, the figures, engaged in different activities, challenge presumptions about the function of the building and the identity of its visitors.

This second feature of the Fossati album, which ensures that the beholder is not visiting the newly restored monument alone, is central to my concerns. None of these figures offers, in Goethe's words, 'an observer representative of all observers' through which the beholder can have absolute access to the space.[51] On the contrary: multiple subjects account for different possible relations to the monument. Surprisingly, most scholarly accounts of the album do not mention the presence of figures, or if they do, they speak in passing of 'traditionally-clad believers' as Nelson did[52] or of 'staffage' as Schlüter identified them.[53] Traditionally, human or animal figures were included in representations of monuments and archaeological sites for mostly decorative purposes, to enliven the otherwise inert space.

Fossati Restoration of Hagia Sophia

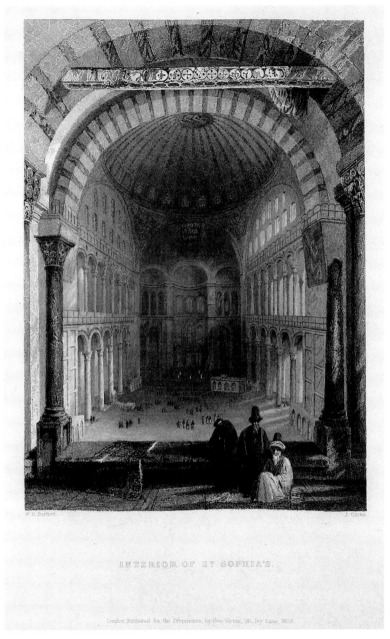

Figure 7.5 W. H. Bartlett, 'View from the West Gallery'. Julia Pardoe, *The Beauties of the Bosphorus by Miss Pardoe. Illustrated in a series of views of Constantinople and its environs, from original drawings, by W. H. Bartlett* (London, 1838). Reproduced with the permission of Aikaterini Laskaridis Foundation Library, Piraeus, Greece.

Asli Menevse

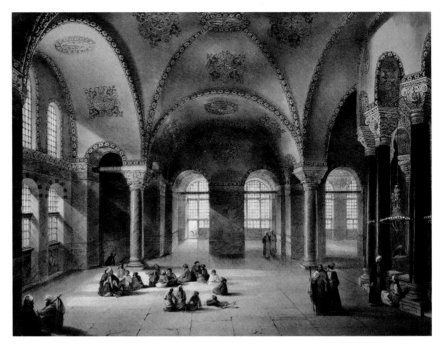

Figure 7.6 'View of the Upper Gallery' [Vue de la Galerie Supérieure], Plate 11 from the Fossati album (1852). Kroch Library, Cornell University, Ithaca, NY. Photo: author.

Portrayed in set types, as we have seen in Bartlett's depiction, these figures would be devoid of individual identity and any capacity for narrative so that they would not distract the viewer from the real subject of the representation. Or, more practically, they sometimes gave a sense of perspective or scale. Such figures are subordinate to the space in which they are represented, superfluous appendages to an already-complete body. Even if some figures inform and enhance the emotional economy of the composition, they do not particularly expand or enrich the viewer's knowledge of life in the space.[54] A careful look, however, reveals that the Fossati figures have a function beyond satisfying Orientalist expectations or a simple adherence to the conventions of the picturesque. These scenes, just like the monument they depict, bring together the diverse audiences invested in different aspects and identities of the building, and the supposedly hostile or clashing social and cultural identities coexist in the same picture plane. This coexistence becomes a measure of the project's success on behalf of the empire and its architect. Through these plates, the actors of the restoration showed the world the masterful political and aesthetic balance to which they aspired.[55]

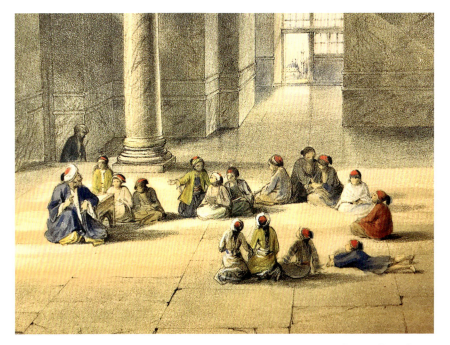

Figure 7.7 Detail from Plate 11 of the Fossati album (1852). Kroch Library, Cornell University, Ithaca, NY. Photo: author.

Scenes such as the eleventh plate from the album, which shows a group of children gathered around a clergyman for religious instruction on the west gallery of the building, breathe life into the ancient monument with their candid realism (Figure 7.7). The diversity of the children's poses evokes a sense of intimacy: from an attentive turn towards the instructor, who comfortably rests his elbow over the lectern, to others discretely chatting among themselves; from the figure who turns his back with curled shoulders of disinterest to the boy who listens to the lecture lying down on his belly. Quotidian scenes such as this colour the temple with a secular vivacity that resembles Viollet-le-Duc's contemporaneous theories about the (Gothic) cathedral as the heart of civic life. As we will see, the children have an important function among all the figures with which Fossati populated his scenes, especially considering the significance of seeing playful children on the west gallery where just a decade ago Bartlett had placed three figures who seemed as weathered and still as the building they occupied (Figure 7.5).

The novelty of the album's figures comes to a sharper focus in the tenth plate. This scene provides a diagonal view of the upper gallery, dramatically stretched due to the position of our gaze. The elongated vault is

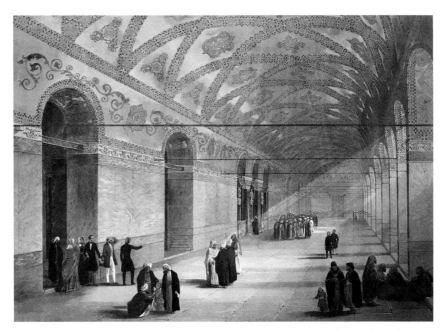

Figure 7.8 'Entrance of the Upper Gallery' [Entrée du Gynécée ou Galerie Supérieure], Plate 10 from the Fossati album (1852). Kroch Library, Cornell University, Ithaca, NY. Photo: author.

covered with the yellowish ochre and elaborate patterns of the stucco that Fossati and the painter Fornari had recently executed, and which appears in the coloured print as if gilded (Figure 7.8).[56] A large group of clergymen approaches the viewer from the far end of this extended architectural space. A few steps ahead of this group are two men in long navy-coloured frocks with red fezzes, exhibiting the recently modernised uniforms of the empire's officers and civil servants. Adorned in the new official fashion of the empire, they contrast with a seated group consisting of travellers from North African provinces in the right foreground and another two that converse with Mevlevi dervishes towards the middle ground. At first, it appears as if Fossati is harking back to the European costume album tradition. Yet, lacking classificatory organisation and the textual anchoring of captions, these figures demonstrate dazzling cultural diversity, offering imperial heterogeneity in a package of inclusion and coexistence.[57] As such, the Fossati album presents a challenge to the assessments of the early Tanzimat as a period of imposed uniformity, exemplified by its promotion of Europeanised attire and fezzes to communicate a homogeneous Ottomanness. Contrary to these assumptions, in almost all the interior views of Hagia Sophia the traditional costumes and the new Western-style

uniforms of the reforms coexist in compositions that level any assumed hierarchies between the wearers.[58]

Moreover, these individuals are engaged in everyday activities and interact with each other in a representational space that also includes the assumed consumers of their alterity and diversity. From the shadows of the arch closest to the viewer, an Ottoman guide in modern attire emerges to bring a group of European tourists, two men and two women, into this already motley band of visitors.[59] These well-dressed upper- or upper-middle-class European visitors at the heart of a Muslim empire consciously depart from the usual stock figures. Hence, this scene upsets not only the conventions of costume albums but also those of illustrated travel accounts that would include unassuming native figures in their depictions of ancient sites, but rarely, if ever, Europeans.[60] It is possible to see these foreign figures as surrogates for the viewer of the album, dictating the terms of European presence at the heart of the empire. Indeed, the first European to enter the building raises his gaze to the ceiling, his hand on his temple in awe of what he sees. This gaze is one of astonishment, not scrutinising or scientifically impartial. Behind this group of Europeans stands a man with a long cloak and turban who does not seem bothered by the presence of foreigners in the imperial mosque. Initially, one might find the juxta-position between the group of dervishes and the European tourists to be a compositional device that emphasises differences for a certain effect. Here, the inclusion of a child who is surrounded by three men in traditional clothing, one crouched down to engage with the child at her eye level, instructs the tone of the scene. This charming interaction between a young girl and the men enables a sense of familiarity, and to the European who 'visits' the monument via the album of Fossati, the men with turbans, large beards and long coats no longer communicate an insurmountable alterity.

The ninth plate of the album presents the new imperial loge [*hünkâr mahfili*], which was celebrated by its architect Fossati for its Byzantine style in a lecture delivered before an elite audience in Istanbul, achieving such a complete formal agreement with the rest of the monument that 'one might believe it was built at the same era as the rest' (Figure 7.9).[61] However, this aesthetic achievement does not occupy centre-stage in the composition. In agreement with the majority of the interior scenes from the album, crowned with a radiating golden sun emblematic of the sultan, the loge is situated obliquely to the central axis of the picture space. As this angle masterfully frames the loge between two columns, it also separates the gilded main section, exclusive to the Sultan, from its white marble corridor that extends across the far end of the composition like a lace ribbon.

Asli Menevse

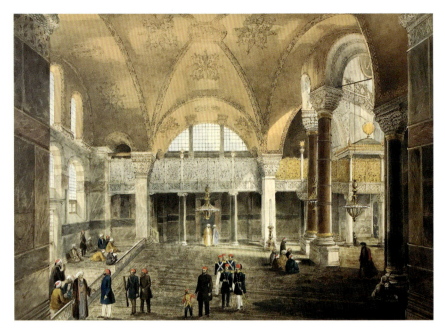

Figure 7.9 'The New Imperial Loge' (Hünkâr Mahfili) [Vue de la Nouvelle Tribune Impériale – Prise de Face], Plate 9 from the Fossati album (1852). Kroch Library, Cornell University, Ithaca, NY. Photo: author.

In his lecture, Fossati assured the domestic audience that this addition was executed 'without risking to spoil the whole and the existing harmony' of the monument.[62] This desire to communicate the achievements to a domestic audience reminds us again that the agents of the restoration did not regard Europe as sole arbiter in the assessment of their efforts. Besides, the formal concerns of unity and harmony, which were regularly stressed in all accounts of the restoration by both the architect and de Beaumont[63] and echoed the written accounts of the original design in the sixth century, extend the historical applicability of Nelson's judgement that '[the] harmony was a political as well as an aesthetic ideal'.[64] In a time of fundamental changes often assessed as a clash between tradition and progress, the restoration of the ancient monument could be used to offer an image of harmony between past and present to both domestic and foreign onlookers.[65] The scene at hand masterfully achieves this. First, we see a diverse congregation engaged in various activities. At the centre of the action is a group consisting of state officials, guards and a young child holding the hand of a man, all dressed in the new official fashion. The head of this group, in the long blue frock coat, leaves the others behind to converse with an old man in traditional garb in the left corner. The reason for

their presence, their identities and the content of the conversation are open for speculation. However, the regal attire of the child and the uniforms of the rest of the entourage suggest that we are in the presence of political authority.[66] This presence does not interrupt the routine of the worshippers, who continue their prayers and conversations, marking such official visits as commonplace. The only person who responds to their arrival is the previously mentioned old man in a floor-length robe, sporting a long white beard and a traditional turban. Lacking the comparative organisation of a costume album, the juxtaposition between him and the state official does not invite inspection of their differences; their shared status as visitors to the ancient edifice, coupled with their congenial interaction, place them in a shared cultural universe.

This is an implicit counter-narrative to the dominant description of Ottoman modernisation as an irresolvable battle between a reactionary clergy and a secular-reformist bureaucracy. This narrative had also coloured European speculations about the project's significance. In these accounts, news of the restoration became a barometer that determined the religious pressure on the reformist political authority. For instance, the famous anecdote of the mosaics became a parable for Ottoman secularisation on the pages of *La Revue Indépendante*. The journal reported the sultan's appreciation of the figural mosaics with a sensational question: 'Are the gods leaving Constantinople?'[67] The French architect and artist Félix Pigeory, on the other hand, analysed the same anecdote in the context of ideological strife to argue for the fragility of the Tanzimat reforms. Reminding his readers of the recent memory of bloody conflict between Abdülmecid's reformist father Mahmud II and his religious adversaries, Pigeory declared that the sultan's fear of reactionaries must have been decisive in his decision to re-plaster the mosaics he so much admired.[68] These accounts brought to the surface the tension between an empire of reforms that agents like *Journal de Constantinople* were promoting and an empire of tradition that the long-established assumptions and historical analysis ceaselessly reproduced. Fossati's album, as we will continue to see, patiently weaved the story of restoration as an architectural counter-narrative, promising an imminent reconciliation of tradition and reform. Hence, the gentle mundaneness of an encounter between men in uniform and old worshippers in robes and turbans becomes a statement of social and political harmony.

The fifth plate from the album, which depicts the view of the entrance from the north to capture an array of worshippers belonging to different schools of Islam, likewise interrupts this narrative (Figure 7.10). At the centre, a pasha, his guard and his scribe are lined axially along the nave

Asli Menevse

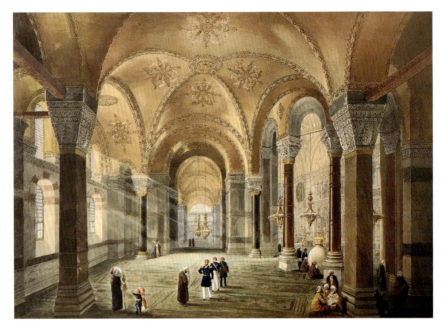

Figure 7.10 'The View from the North Aisle' [Vue de l'Entrée du Côté du Nord], Plate 5 from the Fossati album (1852). Kroch Library, Cornell University, Ithaca, NY. Photo: author.

and are greeted with a slight bow of the head by a clergyman. In an article for *Revue Orientale*, de Beaumont claimed that the lives of the Fossati brothers were in danger throughout the restoration, threatened by the traditional religious elite who saw the restoration as the culmination of a process that started with the reforms of Selim III and Mahmud II which aimed to undermine their power and privilege.[69] The resolute sultan, if we are to believe the testimony of de Beaumont, sent the most fanatical imams to Mecca under the pretext of a pious mission in order to keep them away from the ancient temple.[70] Several stories, and even scholarly histories of the restoration, played into this hostile dynamic between the old and the progressive forces in the empire, and a friend of the restoration such as de Beaumont was not immune to their long-lasting authority and sensation value. Filtered through these lenses, the presence of this group clad in modern uniforms could communicate the power of secular authority over the waning traditional authority of ulema. However, the presence of the two children, one boy and one girl, who are visually connected to the pasha and his group via their shared fashion sets a different tone. Their playful interaction with a dervish shifts the scene from a possible political commentary on the over-addressed hostility between the

modern and traditional, secular and religious actors in the empire, while on an allegorical level bringing tradition and the future together in mutual recognition. Hagia Sophia then becomes a site of communion, where a pasha brings children for religious or even aesthetic education as the supposedly hostile positions greet each other peacefully within the rhythm of everyday life.[71] Now, it is time to revisit de Beaumont's cautionary tale of fanatical believers. Despite the hostility that the author attributed to the religious spectators of the restoration, Fossati wrote to him in a letter that if one day a misfortune should reduce him to absolute poverty, he knew that he could go to the public fountain by Hagia Sophia where the good Muslims of the city would provide him with bread and sustenance until the end of his days.[72]

A close analysis of one plate complicates the narrative of a harmonious coexistence between tradition, everyday life and political authority. The eleventh scene from the album depicts political authority as a presence that intervenes in the space and the lives of the people. The viewer of the composition is positioned before a dark foreground that gradually sheds its shadows into a brilliantly lit background. The vaults of the north nave seem caressed by the rays of the setting sun, acknowledged in the corresponding descriptive text as Fossati's attempt to capture the 'marvelous effects' of natural light in the recently restored monument (Figure 7.11).[73] The focus of this graphic appreciation of light is the platform identified in the same descriptive content pages as the 'grand vizier's place'.[74] The haloed architectural enclosure – which was likely designed by Fossati as the rest of the recent additions had been – is occupied by a solitary figure in a dark navy overcoat; his face is turned towards the sun, and he is separated from a group of worshippers both by an enclosure and by a group of soldiers in uniform who remain under the shadow of the barrel vault (Figure 7.12).[75] Here, the heavenly effect of light that many medieval and modern commentators remarked upon acquires a modern and secular tone when it falls over this 'enlightened' representative of the government.

Thus, Fossati inserts one of the most important agents of the restoration, the grand vizier Mustafa Reshid Pasha, into the album.[76] The numerous executive documents about the public-facing aspects of the project, such as details of the crucial reopening ceremony, bore either the stamp of the Sultan's Advisory Council [*Meclis-i Vâlâ*] under the leadership of the Pasha or a stamp directly from his office [*Sadâret*]. As eagerly reported by the francophone press of the empire, he had personally paid visits to the site of restoration to survey its progress.[77] Arguably one of the most significant actors in the reforms, Mustafa Reshid Pasha embodied the modern Ottoman statesman who could move seamlessly between Ottoman and

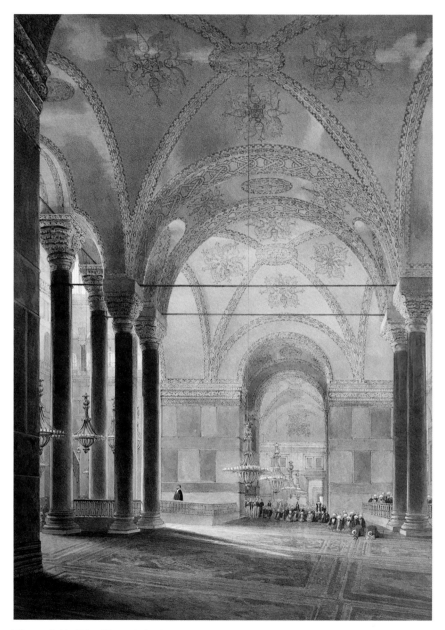

Figure 7.11 'The View of the Grand Vizier's Place' [La Place Reservée au Grand Vizier, vue prise du même point, en regardant le porche], Plate 7 from the Fossati album (1852). Kroch Library, Cornell University, Ithaca, NY. Photo: author.

Figure 7.12 Detail from Plate 7 of the Fossati album (1852). Kroch Library, Cornell University, Ithaca, NY. Photo: author.

European milieux. Hence, Gaspare Fossati's inclusion of the famous pasha explicates the restoration project as an extension of the vision and aspirations that led the empire to modernisation.[78] The role of the pasha was also recognised, and occasionally amplified, in the Western press. In its rather delayed examination of the Fossati album, the *Edinburgh Review* 'gratefully applauds', as would 'every lover of art', the then-deceased Sultan Abdülmecid for the liberal attitude he showed in supporting the uncovering and documentation of the mosaics.[79] Although it is 'impossible not to regard the late Sultan Abdul Medjid as a benefactor to Christian art', he was not the only Ottoman patron of the arts worthy of celebration. The success of the project, the journal maintains, owed much to the 'enlightened liberality of Redschid Pacha'.[80] Five years after the completion of the restoration, *The Athenaeum* had similarly pushed the sultan to the background and attributed the restoration to 'Redschid Pacha's love of Art'.[81] The pasha was celebrated thus in European sources as a man of reform who was comparable to the sultan in his love of the arts.[82] The presence of the architect of the Tanzimat reforms in the album decidedly restores Hagia Sophia and its congregation to the same temporal moment as their intended audience. The bureaucracy, as the executive authority over the design and implementation of the reforms, is inscribed in the Fossati album with numerous scenes that include public officials and retinues of bureaucrats, although neither

possesses the arresting authority this scene affords to the famous pasha. Yet, the powerful statesman is dwarfed by the architecture. The heightened proportional difference between the architecture and its elite visitor further monumentalises the structure. The realism of the scene gives a sense of ephemerality to the figures, who are placed on the stage of a monumental temporal reach, even if one of those figures had, in the present, the authority to alter that very stage.

The sultan and the pasha had saved the building from ruin in the present, but according to some, they also secured its future through other acts of benevolence. *The Edinburgh Review* reports that when the 'fanatical' Muslims demanded the destruction of the recovered mosaics, the will of the Ottoman court firmly stood against theirs and allowed Wilhelm Salzenberg to reproduce them in the most minute detail, thus saving them forever in this form for future generations of students of art and architecture.[83] Salzenberg was an engineering teacher sent to Constantinople by the Prussian king Friedrich Wilhelm IV to document the ancient monument. After acquiring permission from the authorities and Fossati himself, Salzenberg made a series of architectural drawings of the monument and documented the uncovered mosaics before a new layer of plaster hid them again. The resulting images were published in 1854, and this volume would rival the Fossati album's ambitions to secure the monument's meaning for the remainder of the century.

In many regards, Salzenberg's work surpassed Fossati's album as the definitive pictorial representation of the monument in the nineteenth century. Fossati's images stand in stark contrast to the surgical precision of Salzenberg's cross-sections, which were carefully analysed and celebrated for their mastery over the subject and their value for professional use (Figures 7.13, 7.14). The Fossati album was ultimately dismissed in professional circles for lacking the architectural and scientific approach of its Prussian counterpart. Evidently, Fossati did not aim to provide scientific accuracy; his illustrations offer romantic single-point perspectival views of the architectural space. By contrast, Salzenberg's plates present orthographic projections that deconstruct the interior space into measurable planes. Although both are part and parcel of European visual culture, the long-lasting disregard for the divergent aims behind the utilisation of these two distinct languages of architectural illustration assessed them within a flawed comparative framework that judged Salzenberg's plates to be valuable records due to their scientific authority and forwent productive discussion of Fossati's scenes as historical documents.

This framework was in place as early as the first years following the publication of the Fossati album. In its review of the Fossati images

Fossati Restoration of Hagia Sophia

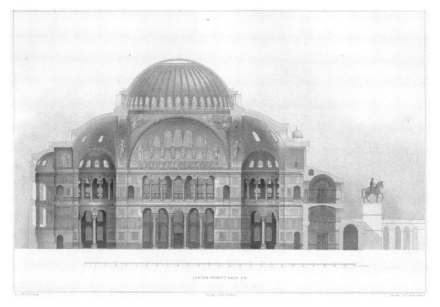

Figure 7.13 Wilhelm Salzenberg, *Alt-christliche Baudenkmale von Constantinopel vom V. bis XII. Jahrhundert* (Berlin: Ernst & Korn, 1854), Bl. IX. Universitätsbibliothek Heidelberg.

in 1854, *The Athenaeum* was far from sympathetic. Calling the album 'an instance of a great subject badly handled', the popular British art and literature magazine did not hold back from enumerating its 'many heinous defects'. Among them, the lack of architectural accuracy and the 'unmeaning' figures that populate the scenes – that is, perspectival views and real people – offended the sensibilities of the editors the most.[84] One exception to such negative assessments was the previously mentioned article from *The Edinburgh Review*, whose editors extended their enthusiastic endorsement of the restoration to the lithography album while lamenting the lack of attention in Britain to such a great publication.[85]

Excluding such exceptions, between the two visual languages competing to provide an authoritative depiction of Hagia Sophia, the scientific and historicist interests would continue to privilege Salzenberg's measured projections. This would afford these images an authority to stand in for Hagia Sophia. Unsurprisingly, then, Lethaby and Swainson's famous 1894 monograph on the monument would devote the entire chapter on the Fossati restoration to a word-by-word English translation of Salzenberg's text from his album and a series of dry descriptions of his plates. This complete abandonment of authorial control to Salzenberg was interrupted

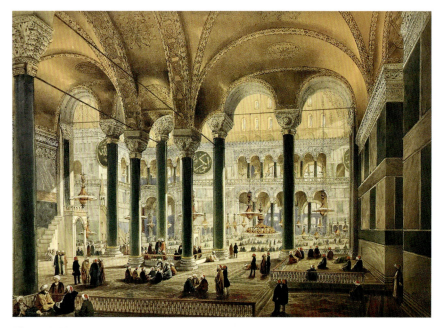

Figure 7.14 'The View of the Central Nave from the North Aisle' [Vue Centrale de la Nef du Nord], Plate 6 from the Fossati album (1852). Kroch Library, Cornell University, Ithaca, NY. Photo: author.

only by a short but acerbic assessment of the Fossati project by the authors: they were '"restorations" in the worst sense'.[86]

Conversely, when Fossati had first pitched his idea for a lithography album of Hagia Sophia in a letter addressed to an unidentified high-ranking individual to secure patronage for the publication, he described the function of such a publication in scientific terms, as an instrument to awaken professional interest in Byzantine art and to rectify widespread misconceptions about the building.[87] The letter conceived the scientific benefits of such an endeavour as being of the utmost priority, and identified its audiences as imperial academies, archaeology schools and libraries. Yet, when one looks at the Ottoman publication that appeared in 1852 next to its Prussian competition, the motivation, intended use and audience for the work appear at odds with what the architect had communicated in his letter. The Fossati scenes unmistakably provide viewers with a modern monument, filled with impressions about the contemporary political and social life in the empire that had sponsored its recent restoration. Conversely, the Salzenberg images focus strictly on the Byzantine identity of the monument and try to 'restore' the modern-day monument to an imagined unaltered state as it was assumed to have existed at its

conception,[88] a long-lasting tendency in the study of historical monuments, which privileges their births over their lives. The result is an inert form that is no longer open to the transforming touches of people and time, and its promise of historical and stylistic authenticity is a construction that denies its own artifice.[89] Inevitably, the restoration that enabled Salzenberg to show the original mosaics to the international public edited out the processes and agents that had enabled such revelation. This is the price of reducing the monument to an archetype of Byzantine religious architecture, a relic of early Christianity. Fossati, on the other hand, depicted a living structure whose value comes from its capacity to communicate its life, from conception to the present moment, with an implicit suggestion that this vision of aesthetic harmony and cultural diversity can function as a wishful mirror for contemporary Ottoman society.[90] Each read a radically different story from the walls and arches of the same monument, and each is in line with the political positions of their benefactors. Fossati was working for a progressive Ottoman sultan during a period of reforms; Salzenberg's patron was a conservative Prussian king whose authority was shaken by the revolutionary episodes of 1848. Thus, the former's look at the past was filled with expectations for change and the future, while the latter searched for a distant past that could provide scaffolding for his authority amid threats of change. As Nelson succinctly assessed the matter, 'for once, the East looks forward; and the West, backward'.[91]

Conclusion

Now, let us return to the restoration itself that occasioned all these publicity efforts and diverse receptions. In his assessment of the restoration, de Beaumont, an artist himself, celebrated Fossati as an artist-architect who, according to the author, strived for visual unity in his restoration of the monument.[92] This attention to unity and harmony, and the neo-Byzantine character of the new additions, call for an induction of the project into the nineteenth-century European historicism, 'into which the building was soon to be enfolded'.[93] Although it was motivated by political aspirations, just as most of its contemporaries in Western Europe were, unlike them this restoration did not aspire to return the monument to an imaginary original state. The restoration and its framing in the Fossati album show a historicist awareness of the multiple, and seemingly irreconcilable, histories and identities of the ancient building. This wish to resolve the conflicting roles of Byzantine cathedral, historical monument and functioning imperial mosque was motivated by political concerns that were also at the heart of the representational regime of Fossati's lithographs.

Schlüter acknowledges this intention by characterising the project as a 'synthetic idea of restoration', executed without establishing hierarchies between styles and periods, with equal treatment of all elements of the building without regard to what, who or when.[94] This position permits the building to don its multiple identities at the same time. In essence, one can argue that this *longue durée* approach is distinctly modern. Conversely, most twentieth-century critiques of the restoration draw attention to the additions and inventions by Fossati and hold these efforts to the technical and ethical standards of the modern restorations. Teteriatnikov, for instance, claims that the restoration reflected the contemporary tastes of European and Ottoman courts, causing the ancient monument to 'resemble the interior of 19th-century European Palaces'.[95] These accounts disregard the objective of establishing a dialogue between the monument's original moment of conception and its revival under the patronage of Abdülmecid.

The aspiration to bridge the structure's past and present identities was the organising principle of the previously mentioned lecture that explained the significance of the restoration to the elite residents of the imperial city. In this text, Fossati enumerated the deeds of Justinian at length to frame the efforts of his patron. Descriptions of Justinian's generosity in providing the funds for such a monumental undertaking, the amount of precious materials used in the construction and decoration, the vast transportation networks established to bring these materials and objects to the capital and the great number of workers and artisans who took part in the project were balanced symmetrically with descriptions narrating those efforts undertaken during the restoration under the benevolence of the sultan, who was presented to the audience as the 'glorious Sultan Abdul Medjid', 'worthy of as much glory as the Immortal founder of the building, and as famous and as venerated'.[96] This renewed relationship with the empire's inherited cultural artifacts deserved recognition, especially during a period labelled as a break from the past. As Choay instructs,

> to break with the past means neither to abolish its memory, nor to destroy its monuments, but to conserve both in a dialectical movement that simultaneously assumes and transcends their original historical signification, by integrating it into a new semantic stratum.[97]

The restoration of Hagia Sophia, the new antiquities museum, and the framing of them in printed media together indicate such a break, made possible by a practical expansion and revision of the empire's repertoire of imperial monuments and histories.

The rhetorical and visual framing of the 1847–9 restoration of Hagia Sophia reached out to the pre-Ottoman past of the imperial capital and

revised the imperial discourse of conversion and possession to a modern political administration's guardianship over a monument of world heritage. As the historical signification of the monumental temple was being re-invented in Europe, the opportunity to picture Hagia Sophia and its custodians as rightful participants in a hegemonic conception of civilisation was seized by the Ottomans. Gérard de Nerval, in a short essay titled *Les Arts à Constantinople et Chez les Orientaux*, used the Fossati restoration as a counter-example to European biases against Islam.[98] For his argument, he referenced the 'Oriental newspapers', specifically a certain Monsieur Nogués who had been informing Europeans with his news of arts and antiquities patronage in the Ottoman Empire.[99] The man Nerval was referring to was George Nogués, who was behind the most detailed accounts of the restoration for *Journal de Constantinople*. In his last article, Nogués declared that the restoration marked a new force in the empire, exemplifying the transformative power of the arts over a society. Yet, instead of positing a game of catch-up between the Ottoman Empire and the more civilised Europe, he disrupted the narrative. He declared that when so-called civilised Europe had been taken by the winds of violence and terror – in an implicit reference to the then-recent revolutions of 1848 – the so-called 'barbaric' and 'fanatical' Ottoman Empire appeared so free and tranquil, especially through its focus on the arts. On the road of civilisation, the empire proved its maturity.[100] By conjuring the image of Europe in the grip of violence and barbarism, he posited a reflection of the Ottoman Empire *as* the restored Hagia Sophia.

Nogués also declared that the political will behind the restoration understood that the arts are a 'gleaming envelope presented to the attention of foreigners; its lure will attract them, but its content will keep them'.[101] The Hagia Sophia restoration was such a gilded envelope, and its content was presented in the Fossati album. It provided an allegorical model for a modern Ottoman nation exactly when the Tanzimat was searching for forms that communicated social and political cohesion.[102] The figures on its plates weave a narrative throughout the album with individual passages that bring tourists and worshippers, bureaucrats and clergyman, and the building's identities as mosque, cathedral and monument together. This communion communicates an imperial past that speaks of longevity, a present that spells harmonious diversity, and a future that promises to be as brilliant as the newly restored edifice. Upon their arrival in Istanbul a decade prior, the Fossati brothers had received a commission quite unusual in the Ottoman context, a monument for the Tanzimat edict.[103] Although the commemorative column to the Tanzimat reforms never had the chance to migrate from the pages of Fossati's sketchbook to Istanbul's changing

urban space, Fossati's lithographic album of the Hagia Sophia restoration is a monument on paper that records the apprehensive optimism of that expectant moment.

Notes

1. BOA, İrade, Dahiliye, no. 6734. 20 May 1846 [24 Cemaziyelevvel 1262].
2. Gaspare Fossati was hired with his brother Giuseppe to work on the restoration in 1847. The architect and his brother had arrived in Constantinople to build the Russian Embassy in 1837. Fossati constructed buildings for two significant institutions of this reform period, *Dâr'ül-fünûn* [The University] and the State Archives. For Tanzimat politics and Fossati's role in its architectural expression, see Göksün Akyürek, 'Political Ideals and Their Architectural Visibility: Gaspare Fossati's Projects for Tanzimat Istanbul', in Paolo Girardelli and Ezio Godoli (eds), *Italian Architects and Builders in the Ottoman Empire and Modern Turkey: Design across Borders* (Newcastle upon Tyne: Cambridge Scholars Publishing, 2017), 45–62.
3. The restoration of the exterior continued well into 1851. Because the mosque was opened in 1849 for devotion with an official inauguration ceremony, the end date of the restoration is usually acknowledged as 1849. Hasan Fırat Diker, *Ayasofya ve Onarımları* (Istanbul: Fatih Sultan Mehmet Vakıf Üniversitesi Yayınları, 2016), 105.
4. Sabine Schlüter, *Gaspare Fossatis Restaurierung Der Hagia Sophia in Istanbul 1847–49*, Neue Berner Schriften Zur Kunst, Bd. 6 (Bern: Peter Lang, 1999). Diker, *Ayasofya*, 103–23. Sema Doğan, 'Sultan Abdülmecid Döneminde İstanbul-Ayasofya Camii'ndeki Onarımlar ve Çalışmaları Aktaran Belgeler', *Bilig* 49 (2009): 1–34. Robert S. Nelson, *Hagia Sophia, 1850–1950: Holy Wisdom Modern Monument* (Chicago: University of Chicago Press, 2004), 29–50.
5. Erdem Yücel, 'Ayasofya Onarımları ve Vakıf Arşivinde Bulunan Bazı Belgeler', *Vakıflar Dergisi* 10 (1973): 219–28. Ahmet Akgündüz, Said Öztürk and Yaşar Baş, *Üç Devirde Bir Mabed: Ayasofya* (İstanbul: Osmanlı Araştırmaları Vakfı, 2005).
6. In the existing literature on the Ottoman Hagia Sophia, the question of the international audience and its bearing on the restoration's conception appears only in passing. For example, Diker limits himself to mentioning the increase in the international interest on Hagia Sophia as possibly relevant in explaining the ambitious scope of the restoration at a time of financial difficulties. Diker, *Ayasofya*, 113. Necipoğlu, on the other hand, refers to the commemorative medals of the project and the lithography album of Gaspare Fossati as relevant in explaining the international and scholarly attention on Hagia Sophia later in the century. Gülru Necipoğlu, 'The Life of an Imperial Monument: Hagia Sophia After Byzantium', in Robert Mark and Ahmet

Fossati Restoration of Hagia Sophia

S. Çakmak (eds), *Hagia Sophia: From the Age of Justinian to the Present* (Cambridge: Cambridge University Press, 1992), 224–5. Finally, Edhem Eldem's short article, which extends the museumification process of Hagia Sophia back to the Ottoman nineteenth century, might be an exception. Although Eldem does not focus on the Fossati restoration in this work, the data he provides about the post-restoration rise in the number of European visitors to the monument and his analysis of bureaucratic processes implemented to allow such tourism are valuable details regarding the afterlife of the efforts analysed in the present study. Edhem Eldem, 'Ayasofya: Kilise, Cami, Abide, Müze, Simge', *Toplumsal Tarih* 254 (February 2015): 76–85.

7. See the above-mentioned *irade* from May 1846. BOA, İrade, Dahiliye, no. 6734.
8. *Tanzimat* refers to the period of reforms and pragmatic responses to domestic problems and international pressures that ushered in the re-organisation of the Ottoman cultural and political institutions between the Edict of Gülhane in 1839 and the First Constitution in 1876.
9. This process of the monument's transformation into an image is a thread that runs through Robert Nelson's important study of modern Hagia Sophia. But for a concentrated discussion, see especially Nelson, *Hagia Sophia*, 73–104.
10. Elisabeth A. Fraser, *Mediterranean Encounters: Artists between Europe and the Ottoman Empire, 1774–1839* (University Park, Pennsylvania: Pennsylvania State University Press, 2017), 152 and 235–8.
11. This project was also executed under Gaspare Fossati in the neo-classical style.
12. BOA, İrade, Meclis-i Mahsûs, no. 657. As referenced in Akyürek, 'Political Ideals', 50–1.
13. Roderic H. Davison, 'Ottoman Public Relations in the Nineteenth Century: How the Sublime Porte Tried to Influence European Public Opinion', in *Nineteenth Century Ottoman Diplomacy and Reforms* (Istanbul: Isis Press, 1999), 351.
14. Akyürek, 'Political Ideals', 45.
15. Ahmet Ersoy, *Architecture and the Late Ottoman Historical Imaginary: Reconfiguring the Architectural Past in a Modernizing Empire* (Farnham, England: Ashgate, 2015), 8.
16. For example, 'La Restauration de Sainte-Sophie', *Revue Générale L'Architecture et Des Travaux Publics* 7 (1847): 365–6. In addition, the 26 August 1847 news of the restoration published in *Journal* appeared verbatim (save for *bisantin*, which gets corrected as *byzantin*) in the Parisian newspaper *Le Constitutionnel*. 'On Lit Dans Le Journal de Constantinople . . .', *Le Constitutionnel: Journal du Commerce, Politique, et Littéraire*, 12 September 1847.
17. 'Le Gout Des Arts Des Antiquités . . .', *Journal de Constantinople*, 21 June 1847.

18. The *Journal* also published the sultan's call for the provincial officers to identify and send antiquities found in their territories to enrich the collection of the museum. *Journal de Constantinople* reports that the governor of Jerusalem, Zarif Mustafa Pacha, was among the first to respond, sending a bas-relief to the capital. 'Nous avons déjà eu occasion de parler du musée d'antiquités ...', *Journal de Constantinople*, 1 November 1847. The *Journal* also reported that when the bas-relief arrived at the museum two weeks later, the sultan immediately visited the museum to see the artifact with his own eyes. *Journal de Constantinople*, 16 November 1847.
19. A later example of such publicity was the officially-funded guidebook *Der Bosphor und Constantinopel* (a French edition appeared under the title *Le Bosphore et Constantinople: Description topographique et historique*), written by Philipp Anton Dethier, the director of the Imperial Museum of Antiquities in Istanbul, for the occasion of the 1873 Vienna exposition and focusing specifically on the Byzantine heritage of the city. Ahmet Ersoy, 'A Sartorial Tribute to Late Tanzimat Ottomanism: The Elbise-i 'Osmaniyye Album', *Muqarnas* 20 (2003): 190. Furthermore, centralised efforts that gave the city a new face in the second half of the nineteenth century used restoration and the incorporation of the Byzantine monuments and sites into the urban plan as an organising concern. These changes included the clearing of the area around Hagia Sophia and the Hippodrome (1865) that led to the visual isolation of the buildings, like the historical monuments in European capitals, as a prerequisite for monumentalisation. See Zeynep Çelik, *The Remaking of Istanbul: Portrait of an Ottoman City in the Nineteenth Century* (Seattle: University of Washington Press, 1986).
20. *Journal de Constantinople*, 1 September 1847.
21. 'Étranger-Asie', *Bulletin Des Arts: Guides des Amateurs de Tableaux, Dessins, Estampes, Livres, Manuscrits, Autographes, Médailles et Antiquités*, 10 June 1847. Indeed, the travel accounts of the previous decades that focused on the non-Islamic architectural inheritance of the empire 'serve[d] as pretexts for writers to revile the oppression of the Turks and their supposed wanton destruction of valuable objects and sites'. Fraser, *Mediterranean Encounters*, 171.
22. Ibid.
23. Auguste Choisy, *L'Asie Mineure et les Turcs en 1875; Souvenirs de Voyage* (Paris: Firmin-Didot, 1876), 46. Citing the sculptures and reliefs he encountered in the ancient monument, Choisy also tells us that there were a few Ottoman subjects among those who regularly visited the museum.
24. The mosaic mentioned in the anecdote was probably the one on the tympanum of the south-west entrance of the building that depicted emperors Justinian and Constantine presenting Hagia Sophia and Constantinople respectively to the Virgin and infant Christ. It is easy to understand why the Sultan might have an added interest in the two historical rulers celebrated by the mosaic. A new mosaic of the sultan's *tuğra* commissioned to the artist

Lanzoni would soon place Abdülmecid in this lineage of the major rulers of the imperial city.
25. *Journal de Constantinople*, 26 August 1847.
26. 'Découvertes et Nouvelles', *Revue Archéologique Ou Recueil de Documents et des Mémoires Relatifs à L'Étude Des Monuments, a La Numismatique, et La Philologique de L'Antiquité et Du Moyen Age, Publié Par Les Principaux Archéologues* 2 (October 1850–March 1851): 713–14. The article also erroneously dates the initial covering of the mosaics to the fall of Constantinople (1453) and attributes the decision to the conqueror, Mehmed II (1451–81).
27. Ibid.
28. The story was also confirmed by its primary witness. Gaspare Fossati recounts in a letter that the mosaics truly pleased the sultan but, aware of the prejudices of his Muslim subjects towards figural representation, he advised the architect to cover them with a light layer of plaster 'in a way that they can be uncovered when the religious law allows it'. The text is reproduced in its French original in the appendix of Schlüter, *Restaurierung*. See especially 187 and 189–90.
29. Schlüter, *Restaurierung*, 82.
30. 'La Restauration de Sainte-Sophie', *Revue Generale L'Architecture et Des Travaux Publics* 7 (1847): 365–6.
31. César Daly, 'Restauration projetée de Notre-Dame de Paris', *Revue Générale de l'Architecture et des Travaux Publics* 4 (1843): 140. As quoted and translated in Michael Camille, *The Gargoyles of Notre-Dame: Medievalism and the Monsters of Modernity* (Chicago: University of Chicago Press, 2009), 7.
32. The architect and art historian Félix Pigeory visited the building a year after the inauguration, and, although he was not greatly impressed with the city and its monuments, he wrote to the sculptor and director of Paris museums Comte de Nieuwerkerke that Fossati had managed to achieve a complete and harmonious final product (27–30 August). Letter from Felix Pigeory to M. Le Comte de Nieuwerkerke, director general of the museums, published as 'Les Pelerins d'Orient: Simples Lettres', *Revue des Beaux-Arts: Tribune des Artistes* 3 (1852): 8–10. The collected letters of Pigeory from his trip, including this one (the fourth letter), were republished as Félix Pigeory, *Les pèlerins d'Orient, lettres artistiques et historiques sur un voyage dans les provinces danubiennes, la Turquie, la Syrie et la Palestine* (Paris: E. Dentu), 1854. Fossati references his larger professional community on a few occasions, once in the lecture on the restoration where he writes that his ingenious and bold interventions 'attained with full success and obtained the approval of the most distinguished men of art', and in a letter to a bureaucrat where he refers to consultations with 'several distinguished colleagues'. See Schlüter, *Restaurierung*, 180 and 185.
33. Adalbert de Beaumont, 'Cérémonie d'inauguration de La Mosquée de Sainte-Sophie de Constantinople, Restaurée Par Messieurs Fossati', *L'Illustration:*

Universel, 25 August 1849, 405. In the later editions of the popular travel literature series, Joanne's *Voyage Illustré* added Adalbert's text in the section about Hagia Sophia. We can assume that this allowed Adalbert's opinions about the restoration and Ottoman reforms to reach a more popular audience base. Adolphe Laurent Joanne, *Voyage illustré dans les cinq parties du monde en 1846, 1847, 1848, 1849* (Paris: Aux Bureaux de l'Illustration, 1850), 149.

34. Ibid. Gülru Necipoğlu has showed that the Ottoman attitude towards Hagia Sophia should be understood as a dialogue with regions' cultural history and fluctuating cultural and political contexts rather than a stable narrative of conquest and ownership. Necipoğlu, 'Life of an Imperial Monument', 195–225.
35. Adalbert de Beaumont, 'Restauration de Sainte-Sophie de Constantinople: Decouverte Des Anciennes Mosaiques', *Revue Orientale et Algérienne* 1 (February 1852): 169–70.
36. Ibid.
37. Adalbert de Beaumont, 'Cérémonie d'inauguration', *L'Illustration*, 25 August 1849, 405.
38. Ibid.
39. Ibid.
40. Schlüter notes that, while all the interior scenes are based on Fossati's sketches, the exterior views of the monument seem to be based on drawings by a German artist who visited the city at that time. Schlüter, *Restaurierung*, 93.
41. The panorama captured from the minaret provided an opportunity also for Fossati to showcase his success as an architect of great civic projects. This scene (Plate 20) directly looks at the newly-finished *Dâr'ül-fünûn* [University] building.
42. Belgian by birth, Louis Haghe built a career as a highly successful topographical printmaker in the early to mid-nineteenth century. In the late 1830s, he made the lithographs after the sketches from David Roberts' surveys of archaeological sites and monuments in Egypt, Sudan, Syria and Jerusalem. Depicting vast landscapes and monumental structures dotted with stereotyped natives, these prints follow the conventions of the art of topographical survey in nineteenth-century European antiquarianism and early archaeology. He also took advantage of the popular interest in Gothic architecture and created a series of lithographs under the title *Architecture of Middle Ages in Germany and Netherlands*.
43. Nelson, *Hagia Sophia*, 31.
44. The designs of Robertson were sent to the imperial mint and carried an Ottoman caption that included the names of Fossati and Robertson and the line 'In Memory of the Restoration'. During its transformation from three-dimensional object to the frontispiece in London, this caption became a shadowy scribble. BOA, Sadâret, Nezâret-Devâir, nos 33 and 49.

These commemorative medals were ordered in gold, silver and bronze, and bestowed on those who partook in the realisation of the project. Gaspare and Guiseppe Fossati each received a silver medal. BOA, Sadâret, Mühimme Kalemi, no. 32/3.

45. The Ottoman Armenian dragoman Ignatius Mouradgea d'Ohsson's *Tableau général de L'Empire Othoman* appeared in three volumes between 1787 and 1820. Declaring in his opening that 'Nothing in Islam, nothing in law and authority of the sultans of the Ottoman Empire, is contrary to reasoned governance and the enlightened cultivation of the arts and sciences'. D'Ohsson explicitly states his aim as a defence of the empire and Islam. Antoine-Ignace Melling was a court artist and imperial insider who, as convincingly illustrated by Elisabeth Fraser, had an acute understanding of the Ottoman elite and imperial ideology. His *Voyage Pittoresque de Constantinople et des Rives du Bosphore* (1819), with its historically and geographically specific vision captured with an insider's eye, was far different from the Orientalist depictions of the imperial city in the preceding European travel literature. My characterisation of the agents behind the diverse publicity efforts of the Fossati restoration, and especially the complexity of their identities and allegiances, benefited greatly from the compelling and critical analyses in Fraser, *Mediterranean Encounters*, 99–160.

46. Ahmet Ersoy's scholarship cogently stressed and explained the importance of such efforts within the political and cultural atmosphere of the late Tanzimat, urging a reassessment of the essentialist narratives that made the nineteenth-century Ottoman Empire a subject of the Orientalist gaze without acknowledging the Ottoman agency in self-representation. See Ersoy, 'Sartorial Tribute' and *Architecture*. Both of these examples were produced on the occasion of the 1873 Vienna World's Fair.

47. Hariciye, Tercüme Odası., 419/33.

48. Fraser reminds us that despite the evidently elite audience of the eighteenth-century illustrated travel books, their influence often reached beyond the confines of this small group. Fraser, *Mediterranean Encounters*, 21–2.

49. The hand-coloured editions also vary among themselves; some are more luxurious than others. For example, the specimen from the collection of the S. P. Lohia Foundation is more richly coloured than its counterpart in the Cornell University Rare Books Collection. See catalogue no. 1219 in the S. P. Lohia Hand-Colored Rare Book Collection, https://www.splrarebooks.com/collection/view/aya-sofia-constantinople-as-recently-restored-by-order-of-h.m.-the-sultan-a (accessed 27 July 2023). For my analysis of this fascinating but largely ignored source, I look at plates from the coloured edition hosted in the Kroch Library of Cornell University.

50. Cynthia Wall reminds us of the recognisable traits of staffage that will allow the beholder to 'identify' them historically and culturally would cause the composition to leap 'the generic fence', for example turning a landscape into

a history. Cynthia Wall, *Grammars of Approach: Landscape, Narrative, and the Linguistic Picturesque* (Chicago: University of Chicago Press, 2019), 78.
51. In the German original: 'als Betrachter, als Repräsentant von Allen'. As referenced and translated in Wall, *Grammars of Approach*, 210.
52. Nelson, *Hagia Sophia*, 33.
53. Schlüter, *Restaurierung*, 116. Hélène Morlier is the only author who acknowledges that there are different figural groups identifiable by their diverse garments that, she writes, might indicate recent changes taking place in the empire. However, she does not venture beyond this passing observation. See Hélène Morlier, 'Before the Corpus: Byzantine Mosaics in Istanbul in Nineteenth-Century French Guide-Books', *Journal of Mosaic Research* 8 (2015): 85.
54. Wall, *Grammars of Approach*, 77.
55. Schlüter's work on the Fossati restoration stands alone in its appreciation of Fossati's achievement in this regard. According to the author, the Fossati restoration reflects the simultaneous appreciation of the ritual space and the historical monument. Schlüter, *Gaspare Restaurierung*, 133.
56. At a moment when news, no matter how minor, of the restoration was occupying the pages of the *Journal de Constantinople*, Fornari's name first appears as that of the artist who did the decorative paintings for the theatre inaugurated at Hasbahçe after the fire that destroyed the famous Bosco theatre in 1847. In a spectacle that would bring together technological and artistic advancements, the theatre was inaugurated with the staging of an opera in celebration of the two steamships built under the orders of the sultan. 'Nouvelles Diverses', *Journal de Constantinople*, 5 June 1847. Fornari also executed two frescoes that depict the holy cities Mecca and Medina on the vault of the main chamber of the sultan's new loge, in addition to his extensive work throughout the monument, whether the painting of the faux marbles, or the designs that decorated the layer of plaster that covered the mosaics. Schlüter, *Restaurierung*, 183.
57. Fraser makes the point that by linking diversity to visual pleasure, the variety of Ottoman costumes afforded a positive view of the empire and had the potential to challenge the rhetoric of nationalist independence movements of the nineteenth century with 'the potential for delight at its nearly overwhelming inclusiveness'. Fraser, *Mediterranean Encounters*, 190–1. My analysis here diverges from Nelson's account, which argues that 'Together with the inauguration ceremony, the album helps us appreciate the monument's fundamental alterity for European audiences ... [It is] without a doubt Muslim and Ottoman, and the frontispiece has something of the character of a decorated Qur'an. Yet from a certain Turkish perspective, the representation of the venerable Mosque of Aya Sofya in a French English book with reproductions done in a traditional European manner would have appeared modern and progressive.' As my account aspires to

show, the medium and the language of the album were not the sole points of intersection where alterity was transformed into familiarity. Nelson, *Hagia Sophia*, 31.

58. In his analysis of the *Elbise-i 'Osmaniyye: Les Costumes populaires de la Turquie* commissioned by the Ottoman government for the 1873 Vienna World's Fair, Ahmet Ersoy makes this argument explicit: 'the multi-ethnic unity conveyed by these syncretic tableaux [in the *Elbise*] was diametrically opposed to that defined and imposed by the early Tanzimat reformers, which entailed rigorous dress codes on the official level, promoting uniform Europeanised attire and the fez as the ubiquitous markers of the new and more homogenous Ottoman identity'. Ersoy, 'Sartorial Tribute'. 195. As an exception to this generalisation, the image of the empire as captured on the folios of the Fossati album enacts a lineage with the *Elbise*, which according to Ersoy 'testifies to the ambiguities, contradictions, and incurable optimism of official Ottoman discourse as it sought to define the terms by which a modern and overarching Tanzimat identity could be reconciled with tradition and cultural diversity' (ibid., 201).

59. The restoration emerges as an important step in the gradual monumentalisation of the building since the eighteenth century and can be traced in the accounts of the Western visitors. We know from Miss Pardoe's account from the early nineteenth century that the procedure for obtaining the *firman* that would allow non-Muslims to visit Hagia Sophia was a privilege reserved to an elite minority. Julia Pardoe, *The Beauties of the Bosphorus Illustrated by W. H. Bartlett* (London: George Virtue, 1838), 60. However, as the century progressed, the process became increasingly available. Many similar documents reveal a standardised bureaucratic process between the embassies and the administration around mid-century. This trend can be followed in the statistics gathered by Edhem Eldem based on the paperwork trail of the appeals of permission, which would stop after 1861, when it was no longer necessary to acquire a *firman* to visit Hagia Sophia. Eldem, 'Ayasofya', 79; also see Thornbury's description of his experience in W. Thornbury, 'Sainte-Sophie', *Revue Brittanique, Nouvelle Serie Decannele* 4 (July 1861): 50–3.

60. Fraser, *Mediterranean Encounters*, 25.

61. Quoted in Schlüter, *Restaurierung*, 182.

62. Ibid., 183. The structure was raised over the ancient columns donated by the sultan himself, a decision that ceremonially repeats the imperial use of spolia in the original conception of the building.

63. Sabine Schlüter identifies an audience composed of Muslim bureaucrats of the central government, numerous Christian residents of the imperial city, and representatives of the European press. Significantly, the lecture was delivered by an Ottoman official and not by the architect himself. Schlüter, *Restaurierung*, 88 and 121. One can regard this as an official claim to authorship of the project as well as an attempt to extend Fossati's technical

concerns with architectural harmony into a discourse on social and political harmony.
64. Nelson, *Hagia Sophia*, 18. To make this point Nelson quotes the sixth-century Byzantine historian Procopius, whose impression of Hagia Sophia is 'of "a single and most extraordinary harmony" that does "not permit the spectator to linger much over" details, even if each aspect "attracts the eye and draws it on irresistibly to itself"'.
65. Although it is outside the scope and interests of this article to evaluate the future success of this vision of harmony, it was remarked by scholars that the following decades of the Tanzimat 'bred more dissonance and expediency than harmony and uniformity'. Ersoy, *Architecture*, 8.
66. Perhaps the purpose of their visit is not regular worship. As opposed to the regular congregation who takes their shoes off before entering the building, all the members of this group are still wearing their shoes, or at least some 'special galoshes' that a European traveller saw 'Europeanized Turcs' wear when they visit the building. See W. Thornbury, 'Sainte-Sophie', 57. In his account of the monument, Gautier mentions exchanging his boots for special slippers provided by his Ottoman guide before entering the mosque. Théophile Gautier, *Constantinople of To-Day*, trans. Robert Howe Gould (London: David Bogue, 1854), 273–82.
67. 'Nouvelles Diverses', *La revue Indépendante [Annales des Sciences, des Arts, et de L'Industrie]*, 1847, 258.
68. Felix Pigeory, 'Les Pèlerins d'Orient', 8–10. Later in the same letter, Pigeory's stroll around Hagia Sophia and the Hippodrome are coloured by visions of violence. As he ponders the violence of time that turns great Rome into a few ruinous artifacts, that distant historical moment merges with a recent one, the 1826 revolt of Janissaries against Mahmud II and his reforms. Pigeory's knowledge relies on the 1844 novel *Les Janissaires* by Alphonse Royer, who was in Constantinople during the Janissary revolts and witnessed them.
69. Adalbert de Beaumont, 'Restauration de Sainte-Sophie', 161.
70. Ibid.
71. Although the children might appear as emotive devices in my analyses, we should also bear in mind they also are metonyms for the future, especially important at a time when the empire was presented as lacking one, forever stuck in an anachronistic present.
72. Adalbert de Beaumont, 'Restauration de Sainte-Sophie', 161.
73. 'Planche 7, Vue Prise du même point, en regardant le porche: L'artiste, dans cette vue, a essayé de rendre l'effet merveilleux que produisent les lignes variées des voûtes, lorsque les rayons du soleil couchant, entrant par la grande fenêtre, font resplendir de mille feux, l'or et les pierreries des mosaïques, l'estrade qu'un voit au premier plan est la place réservée au Grand Vizir'. Gaspari Fossati and Adalbert de Beaumont, *Aya Sofia, Constantinople, as Recently Restored by Order of H. M. the Sultan Abdul-*

Medjid. From the Original Drawing by Chevalier Gaspard Fossati. Lithographed by L. Haghe, Esq* (London: Colnaghi & Co., 1852).
74. Ibid.
75. Despite the numerous references to the newly built loge of the sultan in the personal notes of Fossati and the secondary literature on the restoration, there is a silence around the more modest 'grand vizier's place'. For example, his lecture on the restoration affords significant attention to the sultan's loge yet does not mention a tribune to the office of the grand vizier. This absence becomes louder considering the exhaustive list the lecture afforded on every new addition to the ancient building, down to the straw mats to be placed under the new carpets. Similarly, the scholarship on the restoration fails to mention any structure that corresponds to what de Beaumont identifies in the album as the 'grand vizier's place'.
76. Adalbert de Beaumont reports that sometimes the sultan enjoyed praying at the grand vizier's tribune. Considering the explicit identification of the scene in the album as *place réservée au Grand Vizir*, I contend that it is safe to identify the figure as Mustafa Reshid Pasha. Adalbert de Beaumont, 'Restauration de Sainte-Sophie', 173.
77. These accounts create an ambiguous parallel between the pasha and the sultan. Both figures' visits are framed in francophone newspapers around their shared appreciation for the recently uncovered mosaics. See e.g. 'Nouvelles Diverses', *Journal de Constantinople*, 9 May 1849, 2.
78. Mustafa Reshid Pasha was also an important patron for Fossati. Akyürek notes that official commissions of the Fossati brothers diminished after the passing of Mustafa Reshid Pasha, which must have informed Gaspare Fossati's decision to leave the Ottoman capital shortly after the statesman's death in 1858. See Akyürek, 'Political Ideals', 46, fn. 3.
79. 'The Church and Mosque of St. Sophia', *The Edinburgh Review* 121, no. 248 (February 1865): 458. The article from *The Edinburgh Review* was translated into French and republished as 'Saint-Sophie de Constantinople, Église et Mosquée', *Britannique* 4 (July 1865): 5–49.
80. 'The Church and Mosque of St. Sophia', 479–80.
81. 'New Publications: Aya Sofia as recently restored by the order of H.M. the Sultan Abdul Medjid, from the original drawings by Chevalier Gaspare Fossati', in *The Athenaeum*, 8 July 1854, 850.
82. G. [Georges] Nogués, 'Feuilleton. Restauration de Sainte-Sophie à Constantinople', *Journal de Constantinople: Écho de l'Orient*, 29 July 1849; see also 'New Publications: Aya Sofia as recently restored by the order of H.M. the Sultan Abdul Medjid, from the original drawings by Chevalier Gaspare Fossati', in *The Athenaeum*, 8 July 1854, 850.
83. 'The Church and Mosque of St. Sophia', 480.
84. 'New Publications: Aya Sofia as recently restored by the order of H.M. the Sultan Abdul Medjid, from the original drawings by Chevalier Gaspare Fossati', *The Athenaeum*, 8 July 1854, 850.

85. 'The Church and Mosque of St. Sophia', 459.
86. Harold Swainson and W. R. Lethaby, *The Church of 'Sancta Sophia', Constantinople, a Study of Byzantine Building* (London: Macmillan, 1894), 148–72.
87. Schlüter, *Restaurierung*, especially 190–1. There has been speculation about the intended recipient of the French-language letter.
88. One wonders how different the album would have been if another court had financed the project. Conversely, perhaps the mysterious recipient of the letter rejected the architect's calls for patronage precisely because the material at hand was decidedly Ottoman. As a third speculation, perhaps the letter was intended to describe another album that was never realised. De Beaumont mentions another publication that Fossati is working on, which focuses on the mosaics he had uncovered, although there is no mention of another album elsewhere. Adalbert de Beaumont, 'Restauration de Sainte-Sophie', 172.
89. Inescapably, Salzenberg's reconstruction of the Justinianic church was determined by the architect's historicist sensibilities. Despite the scientific authority that derived from its visual language, Salzenberg's reconstruction and his plates misplaced the equestrian statue of Justinian before the west façade and erroneously dated the ninth- or tenth-century mosaics of the building to its conception in the sixth century. Nelson, *Hagia Sophia*, 33 and 44.
90. For a discussion of nineteenth-century approaches to architectural space in Europe, see Kevin D. Murphy, 'The Gothic Cathedral and the Historiographies of Space', in Stephanie Glaser (ed.), *The Idea of the Gothic Cathedral: Interdisciplinary Perspectives on the Meanings of the Medieval Edifice in the Modern Period* (Turnhout: Brepols, 2018), 131–46.
91. Nelson, *Hagia Sophia*, 41.
92. Adalbert de Beaumont, 'Cérémonie d'Inauguration', 405.
93. Nelson, *Hagia Sophia*, 31–3.
94. Schlüter, *Restaurierung*, 119–20 and 130.
95. Natalia Teteriatnikov, *Mosaics of Hagia Sophia, Istanbul, the Fossati Restoration, and the Work of the Byzantine Institute* (Washington, DC: Dumbarton Oaks Research Library and Collection, 1998), 29–30.
96. Schlüter, *Restaurierung*, 177–9.
97. Françoise Choay, *The Invention of the Historic Monument* (Cambridge: Cambridge University Press, 2001), 75.
98. Gérard de Nerval, 'Les Arts à Constantinople et Chez Les Orientaux', in *Oeuvres Complètes de Gérard de Nerval* 3 (Paris: Michel Lévy Frères, 1867–77), 303.
99. Ibid., 307.
100. G. [Georges] Nogués, 'Feuilleton. Restauration de Sainte-Sophie à Constantinople', *Journal de Constantinople: Écho de l'Orient*, 29 July 1849.

101. Ibid.
102. In his assessment of the *Usul-i Mi'mari-i 'Osmani*, Ersoy shows how the history of Ottoman art and architecture became a strategic site for the Ottoman reformers to reconcile the 'revised dynastic allegiance and a secular sense of "Ottoman nationhood"', effecting an imagined national character for the empire that could be used in domestic and international political arenas. Ahmet Ersoy, *Architecture*, 9ff.
103. The monument comprised a free-standing column on which the entire edict would be inscribed. The four corners of the column would be guarded by lion sculptures, which would also function as fountains. For an image of Fossati's design for the monument, see 'Monument dell' Hatt-Cheriff 1840', in *1809–1883, Gaspare Fossati: Architetto Pittore, Pittore Architetto* (Lugano: Fidia Edizioni d'Arte, 1992), 97. For a short account of the monument see Akyürek, 'Political Ideals', 48–9. The newspapers announced preparations for two monuments, one to be erected at the imperial gardens of Gülhane, where the edict was declared, and the other to be placed in the popular and more crowded Bayezid Square. *Takvim-i Vakayi,* 11 October 1840 and 24 October 1840; *Ceride-i Havâdis,* 18 October 1840 and 6 December 1840.

Chapter 8

From Ceremony to Spectacle: Changing Perceptions of Hagia Sophia through the Night of Power (*Laylat al-Qadr*) Prayer Ceremonies

Ayşe Hilâl Uğurlu

In September 1808, prominent Ottoman provincial magnates started to arrive in Istanbul. They were all summoned to attend a general consultative assembly that aimed to deliberate how to bring an end to the ongoing political crisis.[1] When the governor of Konya, Kadı Abdurrahman Pasha, came to the Ottoman capital, he conveyed to Sultan Mahmud II (r. 1808–39) his desire to visit the imperial mosques, since he had never had the chance to be in Istanbul during the holy month of Ramadan. Cabi Ömer Efendi (d. c. 1814), an amateur Istanbulite historian, records that Kadı Abdurrahman Pasha was given permission to visit any mosque he desired, and additionally a *firman* was issued for him to be able to 'view and contemplate' (*seyr ü temaşa*)[2] Hagia Sophia and other places in Istanbul.[3]

Why did a Muslim Ottoman notable such as Kadı Abdurrahman Pasha need permission, much less a *firman*, to visit the mosques of the capital just like non-Muslim visitors did? Given the turbulent political context, and that the pasha in question was just one of many power magnates waiting outside the city walls with their armed forces, one might conclude that this was a special occasion in a delicate time and that a permission was necessary. Even if that was the case, however, why did Cabi Ömer Efendi separate the concept of 'visiting mosques' from 'viewing and contemplating Hagia Sophia and other places' in particular? What were these 'other places', and why was Hagia Sophia, which had been the palatial imperial mosque for the last 350 years, classified as a place for *seyr ü temaşa*? Did Kadı Abdurrahman Pasha's visit indicate the beginning of a change in the object of *seyr ü temaşa* in the minds of Ottomans?

Taking these questions as a point of departure, this chapter explores the gradual change in the perception of Hagia Sophia over the course of the long nineteenth century. It locates the roots of this process within Ottoman

society, as exemplified above by the case of Kadı Abdurrahman Pasha. By focusing on the highly significant annual religious ceremonies taking place on the Night of Power (*Laylat al-Qadr*), and by investigating the attendance of different groups – from sultans to non-Muslim Europeans – at this ceremony, I demonstrate that Hagia Sophia, once merely a place of worship, gradually turned into a scene of a spectacle. This transformation occurred in three stages.

From its conversion into an imperial mosque by the Ottoman Sultan Mehmed II (r. 1444–6, 1451–81) in the mid-fifteenth century, Hagia Sophia embodied the 'conquest' of Constantinople, the religious and political centre of Eastern Christendom, by the Ottomans. From the late eighteenth century, this symbolically significant building became a destination for many Ottoman subjects from across the empire that reminded them, just as it did the governor of Konya, of the glory of their state. By granting permissions to its desirous subjects, the Ottoman state created a new 'legitimation tool', which I consider to be the first stage of the transformation process. The second stage began with the gradual normalisation of the presence of non-Muslim foreigners within the building, once again with the permission of the state. During this stage, while the building became a meeting place, its image was simultaneously contested between Ottoman and foreign interests. Finally, in the third stage, which took place in the final decades of Hagia Sophia's life as a mosque, its image returned to an 'internally-directed' spectacle that supported the new Turkish Republic's policies of Turkification. By distinguishing these three stages, I demonstrate the increasing aspiration of the Ottoman imperial centre to utilise the symbolic power of the monument. In doing so, I argue that as the 'real power' of the Ottoman state declined, Hagia Sophia was increasingly presented, represented and exhibited as an Islamic living monument.[4]

Changing Practices of Visitation in Istanbul

The Fossati album (1852) – which I will touch upon again later in this chapter – contains twenty-five lithographs that reveal important information about how Hagia Sophia became an object of *seyr ü temaşa*. The images depict not only the building itself, but also the common practices that took place within.[5] Those that illustrate the interior of the mosque demonstrate that the main space under the dome and the side aisles was used by Muslims to perform prayers, to study or read, to attend classes or to privately contemplate – typical functions of any of the city's imperial mosques (Figure 8.1). The images of the upper galleries depict a more unusual scene, however. European visitors escorted by Ottoman hosts,

Ayşe Hilâl Uğurlu

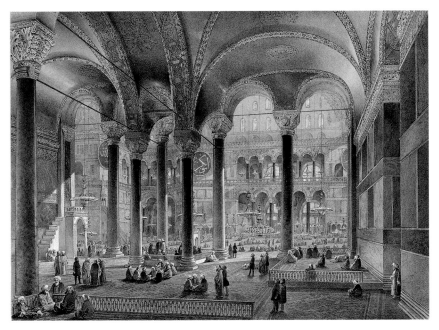

Figure 8.1 A plate from the Fossati album (1852) showing the interior view of the Hagia Sophia Mosque, drawn from the lower north gallery. https://commons.wikimedia.org/wiki/File:Vue_centrale_de_la_nef_du_nord_-_Fossati_Gaspard_-_1852.jpg (accessed 16 January 2023).

as well as various Ottoman women and men from different classes and groups, wander through the building and most probably praise its beauty (Figure 8.2). The fact that the white marble floor of the upper galleries was not furnished with protective mats (*hasır*) or carpets like the main prayer hall is consistent with this depiction.[6] In many travellers' accounts from the second half of the nineteenth century, visitors describe wearing large leather slippers on top of their shoes that they removed in the upper galleries.[7] An article in the *Globe* on the travels of Crown Prince Frederick of Prussia to the East in 1869 mentions that the old custom of removing one's shoes before entering Hagia Sophia was only dispensed with for select royal visitors, such as the crown prince. He declined this honour, however, and 'was content to see the Church from a gallery'.[8] This account demonstrates the perception, at least in the second half of the nineteenth century, that the main hall functioned as a mosque but the upper galleries were a place to view and enjoy the building's beauty.

The change in the object of *seyr ü temaşa*, as perceived and enacted by the Ottomans,[9] assumed a physical expression with the adoption of Western concepts of urban planning in the second half of the nineteenth

From Ceremony to Spectacle

Figure 8.2 A plate from the Fossati album (1852) showing the upper galleries of Hagia Sophia from the north-west. https://commons.wikimedia.org/wiki/File:Entr%C3%A9e _du_gyn%C3%A9c%C3%A9e,_ou_galerie_sup%C3%A9rieure_-_Fossati_Gaspard_-_1 852.jpg (accessed 16 January 2023).

century.[10] In accordance with the shifts taking place in major capitals of Europe, particularly in Paris,[11] infrastructural reforms would aim to turn Istanbul into a more 'agreeable' (*commode*) place by, for example, clearing the immediate surroundings of significant buildings to create 'monuments'.[12] Urban hygiene would similarly become a major concern of the Ottoman administration. Sanitation included not only urban spaces, but also interiors. The interior spaces of the imperial mosques were regularly ordered to be cleaned, especially before the arrival of prominent visitors.[13] In 1859, a radical internal cleaning was undertaken in the Süleymaniye Mosque.[14] Until then, the galleries of some imperial mosques, particularly Süleymaniye, were used as safe deposits.[15] They were 'full of boxes, bags, bales of merchandise, and all sorts of valuables which were left there for security'.[16] After the cleaning, however, these old deposits located in the Süleymaniye Mosque were sold and the proceeds were kept in the imperial treasury until their owners claimed them.[17] Likewise, Richard Cunningham McCormick Jr, the future eminent American politician and journalist, wrote that the side aisles of Hagia Sophia were being used as storehouses by people who would like to 'deposit their wealth under

the immediate protection of god'.[18] Internal cleanings were accompanied by attempts to isolate these structures on the exterior. In 1868, the Commission of Road Improvement put forth a proposal to tear down the wooden houses adjacent to Hagia Sophia and around the Süleymaniye complex in order to provide unobstructed views of these monuments.[19]

In one of his city letters (*şehir mektupları*) that was published in the newspaper *Basiret* on 26 August 1871, Ali Efendi (d. 1910) gave an account of his encounter with a couple of plates that were hung on the exterior wall of a residence in Cadde-i Kebir (Grand Rue de Pera), Beyoğlu. Although his main intention in writing about these images was to criticise the albumesque plate that depicted various social groups, including women, with 'inappropriate' appearances, he specified that the other showed the interior of Hagia Sophia. He specifically states his delight and satisfaction in viewing and contemplating that plate (*Bunun temaşasıyla pek ziyade mütelezziz oldum*).[20] Both an image of Hagia Sophia being hung on a wall in an urban context and passersby enjoying it just like any other image attest to the changing perception of the building in the eyes of the Istanbulites in the second half of the nineteenth century.

The imperial mosques of the Ottoman capital, particularly Hagia Sophia, had always been an attraction to the visitors of the city. Seventeenth-century European travellers often refer to the difficulty of obtaining permission to visit Hagia Sophia, or to secret visits in disguise.[21] However, both the archival documents and travelogues reveal the gradual easing of these prohibitions from the mid-eighteenth century onwards. From then on, it was a common practice for ambassadors to visit Hagia Sophia and other imperial mosques after their arrival or before leaving the Ottoman capital.[22] In the nineteenth century, with the advent of novel means of transportation such as railways and steamships, an increase in the number of hotels, and the global trend of travelling, more European travellers flooded Constantinople.[23] At the same time, it became relatively easier for these Europeans to obtain permissions to visit the imperial mosques. In 1854, after his visit to Hagia Sophia, an anonymous British traveller wrote that the Ottoman government, 'knowing the veneration with which it [Hagia Sophia] is regarded by Christians of all nations', turned the admissions into a 'source of revenue'.[24]

This became so common that, in 1892, two officials were assigned to accompany and guide the non-Muslims who would visit Hagia Sophia, Sultan Ahmed and Süleymaniye.[25] Once a *firman* was issued by the sultan at the request of a foreign ambassador or on the arrival of a traveller of great rank, word quickly spread among the resident European populations of the city. Anyone who wanted to join the tour could do so, as if they

themselves had a *firman*.[26] Georgina Adelaide Müller, who visited the city in 1894, gives a detailed account of her visit to the building during a Friday prayer, which confirms this more welcoming attitude towards non-Muslims visiting the imperial mosques, especially Hagia Sophia.[27] This went a step further, however, when the court started issuing passes to non-Muslims that permitted them to watch the Night of Power ceremonies (*kadir gecesi rüsumu*) within Hagia Sophia.

Sultans and the Night of Power Ceremonies

Ramadan, being the only month of the year mentioned in the Qur'an,[28] was and still is considered the most sacred month, namely 'the Sultan of the Eleven Months', in the Islamic world.[29] The twenty-seventh (or, in some years, the twenty-sixth) night of Ramadan, the 'Night of Power', carries major religious importance for Muslims, as it is believed to be the night when the Prophet Muhammad started receiving the Qur'anic revelations. It is described in the Qur'an as a night 'better than a thousand months', granting extra power to every prayer performed during that night.[30] Ottoman sultans, as the caliphs of the faith, were expected to be exemplary models to their subjects. It was customary for them to spend the Night of Power performing prayers and devotions in Hagia Sophia among their subjects. The earliest known account of a sultan attending this ceremony in the Hagia Sophia dates back to the reign of Murad III (r. 1574–95).[31]

In the course of the Russian War of 1828–9, when Mahmud II was temporarily residing in the Rami Çiftliği Barracks on the outskirts of Istanbul, he was asked by the Kaimakam Pasha whether he was going to attend the Night of Power ceremonies at Hagia Sophia as usual.[32] Kaimakam Pasha also mentioned another option, the Eyüp Sultan Mosque, which was suggested by the sultan as it was closer to the Rami Çiftliği Barracks (Figure 8.3). However, considering the inadequacy of the road pavements and the excessive distance for travelling at night, he eliminated this option by himself. In his written reply, Mahmud states that he had asked the *sheikhu'l-islam* if it was acceptable not to perform the customary Night of Power prayer in Hagia Sophia that year, and that he had received an affirmative answer. The *sheikhu'l-islam*, declaring that the performance of the Night of Power prayer in the mosque with the congregation was a later innovation (*emr-ü bid'at*), saw no harm in abandoning it. According to Mahmud, however, since some religious zealots had practised this custom for a long time and all the common people had become accustomed to it, he felt obliged to respect the custom and decided to attend the ceremony

Figure 8.3 A nineteenth-century map of Istanbul, showing major imperial mosques that were visited by sultans during Night of Power ceremonies. C. Stolpe, 1882. 'Map of Constantinople', modified by the author. https://commons.wikimedia.org/wiki/File:Plan_von_Constantinopel_mit_den_Vorst%C3%A4dten,_dem_Hafen,_und_einem_Theile_des_Bosporus.jpg (accessed 16 January 2023).

in Hagia Sophia as his predecessors had done. Mahmud's response reveals both the significance of this ceremony for the general public at the beginning of the nineteenth century and the changing attitude of the sultans towards this custom.

In the following decades, during the reigns of Sultans Abdülmecid (r. 1839–61) and Abdülaziz (r.1861–76), royal attendance at the Night of Power prayers shifted from Hagia Sophia to the Nusretiye Mosque. In the accounts of Balıkhane Nazırı Ali Rıza Bey (1842–1928), the director of the imperial fish market, who provides detailed information about city life in Istanbul during the second half of the nineteenth century, depicts the festivities as follows:

> The clock tower, the training field of the barracks and both the sea and land routes that the Sultan passed, used to be decorated with oil lamps and lanterns. Various fireworks and illuminations used to be displayed. To view and contemplate (*seyr-ü temaşa*) that spectacle, all Tophane Square used to be filled and the carts of the imperial harem would be taken into the training field [next to] the barracks. The rooms on the upper floors of the shops across the street were rented [by the public] and the houses overlooking the training field from the upper hills would become insufficient to contain any more guests.[33]

Similarly, a newspaper account from 13 June 1856 describes the flamboyant celebrations of the Night of Power in Istanbul, and specifically in Tophane, as the sultan attended the prayer in the nearby Nusretiye Mosque.[34] The article recounts the ostentatious illuminations, decorations and fireworks that formed the chief features of the festival in great detail, as well as both the cheerful wait of the crowds for the arrival of the sultan and the long silent delay for the end of the prayer. One might relate the magnificence of this specific celebration to the probable need among Istanbulites for enjoyment and elation in the aftermath of the Crimean War. However, there exist many accounts that depict the Night of Power ceremonies of earlier or later years that were similarly ostentatious. It is striking that, over just a few decades, not only had the inhabitants of Istanbul become accustomed to a major change of locus in a long-lived tradition, but also their perception of an imperial mosque was changed from a place of worship into the backdrop of a spectacle, especially on a holiday that carries great religious significance.

The shift in the court's preferred residence from the walled city towards the shores of the Bosphorus during the first half of the nineteenth century, followed in 1856 by its permanent transfer to the Dolmabahçe Palace, must have necessitated this change due to the proximity of the mosque to the new palace.[35] When Abdülhamid II (r. 1877–1909) transferred the

Ayşe Hilâl Uğurlu

court from Dolmabahçe to the Yıldız Palace, he continued this new tradition, attending the prayer on the Night of Power in the Nusretiye Mosque. Though, when the construction of the Hamidiye Mosque near his palace in Yıldız was completed in 1885, he made it his predominant choice for almost all stately processions, including the Night of Power ceremonies.[36] Hagia Sophia, however, continued to be a popular locale for the Night of Power prayers despite the sultan's absence. Moreover, it became the setting of a new practice, which brings us back to its shifting role within the Ottoman political agenda.

Worshippers and Spectators: Night of Power in Hagia Sophia

On the twenty-seventh night of Ramadan in 1881, the British ambassador visited Hagia Sophia accompanied by a group including the British naval engineer William J. J. Spry and the author Mary H. Jay. Their accounts of that night differ from earlier narratives on Hagia Sophia.[37] Mary H. Jay sought to describe Hagia Sophia both externally and internally, but also to portray the significant religious ceremony that they attended as spectators within the mosque during a Night of Power. Admitting the difficulty, if not the impossibility, of such a visit half a century earlier, she wrote that

> ... times have changed. There are now few mosques to which during the hours of daylight, *bakshish* and an easily procured *tezkereh* will not give the desired permission to enter. Not so, however, for the services at the Santa Sophia upon the Night of Power; and to obtain a *firman* for this implies no small influence in high quarters.[38]

The small group of Europeans was accompanied by a certain Mehmed Pasha, Tahir Bey, and a few other Turkish men. These hosts, most probably appointed by the court, met them at the foot of the Galata Bridge, drove them to Hagia Sophia and escorted them inside (Figure 8.4). Apparently, there were seats prepared beforehand for these non-Muslim visitors in the upper western gallery – in Mary Jay's words, 'the very best place for seeing all that goes on'.[39] The hosts provided the group with explanations about the ceremony from time to time. While this was not an isolated occurrence, the practice itself was unique to Hagia Sophia. Even though similar religious ceremonies were taking place in other imperial mosques during the Night of Power, non-Muslim Europeans were not allowed to watch them within these mosques.

The timing of the establishment of such a practice was also not coincidental. It was a time when the Ottoman territorial integrity was under serious physical threat. 'Maintenance of Istanbul as the capital city' was

From Ceremony to Spectacle

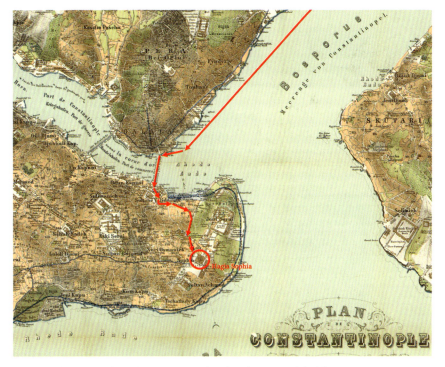

Figure 8.4 A detail from the same map showing the route of the European group (including Mary H. Jay) from Büyükdere to Hagia Sophia. C. Stolpe, 1882, 'Map of Constantinople', modified by the author. https://commons.wikimedia.org/wiki/File:Plan_von_Constantinopel_mit_den_Vorst%C3%A4dten,_dem_Hafen,_und_einem_Theile_des_Bosporus.jpg (accessed 16 January 2023).

one of the 'four pillars of the state' (*dört rükn-ü devlet*), which, as Reşid Pasha (d. 1858) put it, was in immense danger.[40] In 1878, the Russians, who considered themselves the Orthodox successors of the Byzantine empire[41] and had claims over Istanbul, were at San Stefanos (today Yeşilköy), a stone's throw from the capital. Many contemporary Russian authors were writing openly about these claims. For example, in his widely read and discussed *Russia and Europe*, Nikolay Danilevsky (1822–85) stated that Istanbul should be the capital of the unified Slavic world ruled by an Orthodox emperor.[42] Fyodor Dostoyevsky (1821–81), moreover, wrote in his *Diary of a Writer*:

> first a Te Deum[43] would be officiated in the Saint Sophia Church; there upon the Patriarch would consecrate it anew; by that day, I believe, a bell would have been brought from Moscow; the Sultan would be sent to a proper place and this would be the end of everything.[44]

249

In another chapter that he wrote during the Turko-Russian war, dated to 1877, he furthered his claims and wrote: 'Constantinople must be ours, conquered by us, Russians, from the Turks, and remain ours forever'.[45]

The Russian goal of recapturing Constantinople and making it Tsargrad was almost inseparable from the desire to reconsecrate Hagia Sophia. These ideas were also reflected in European newspapers. For instance, in 1877 a passage from a semi-official Belgrade journal, which stated that the Russian dynasty was destined to 'fulfil the great Slavonic mission' by 'plant[ing] the orthodox cross on St. Sophia at Constantinople', was reprinted by various newspapers from Berlin to Belfast.[46] Coming closest to achieving these goals at San Stefanos in 1878, the Russians performed 'a solemn religious ceremony' after the peace treaty that confirmed the Ottoman defeat was signed.[47] The field altar used during the rite faced in the direction of Hagia Sophia, stressing its symbolic importance to the Russians. Many European newspapers gave wide coverage to the news of peace as well as to this symbolically significant *Te Deum*.[48]

The importance attached to Istanbul, and Hagia Sophia in particular, by the Russians must have made the Islamic function and Muslim appropriation of the building more important in the eyes of the Ottomans. Correspondingly, due to the re-orientation of imperial policies towards Islam, and with Pan-Islamism being increasingly favoured by Abdülhamid II, the Islamic character of the city, as well as the idealised universal role of the caliph, gained more significance.[49] A myth of Hagia Sophia being the scene of the alleged transfer of power from al-Mutawakkil to Selim I, which had been invented at the beginning of the nineteenth century, was also re-awakened around this time.[50] In addition to re-appropriating the monument, this narrative bolstered the promotion of the caliphate not only within the empire, but actually more so to an international audience.[51] In this context, exhibiting Hagia Sophia as a living, functioning imperial mosque and emphasising its Muslim character to Europeans must have become more important.

Of course, there were also attempts to refashion the imperial imagery of the mosque early in the century. In 1847, Abdülmecid commissioned the brothers Gaspare and Giuseppe Fossati, two European architects who had recently designed the Russian embassy in Istanbul, for this project. This choice was noteworthy, particularly in the context of tense relations between Russia and the Ottoman Empire. Some interventions that were carried out alongside the necessary structural reinforcements and renovations were especially symbolic. For example, the replacement of the rectangular-shaped epigraphic panels – inscribed with the names of Allah, Muhammad, the first four Sunni caliphs and the two grandsons

of the Prophet – with eight colossal circular calligraphic medallions was intended to 'proclaim Islam's power more forcefully'.[52]

The original Byzantine layers of the building that were revealed during the restoration played a similar symbolic role. Since this project coincided with the rising interest in Byzantine art history in Europe and the United States, documentation of the original mosaic decorations attracted the attention of Western scholars.[53] The initiative both to document and to cover these decorations was probably seen and promoted as a tool of re-appropriation by the Ottomans. Correspondingly, when the Fossati brothers published an album in 1852, three years after the grand inauguration ceremony, which contained twenty-five coloured lithographs of both the interior and exterior of the building, all the illustrations emphasised the monument's Muslim character through lively scenes depicting its daily Islamic use, rather than the newly revealed Byzantine decoration.[54]

In the late nineteenth century, due to the recently rediscovered Byzantine heritage of Hagia Sophia, the number of publications that underscored its Christian character increased in Europe. These included, for example, its depiction as a Byzantine church, another illustration that portrayed the Greek king, some other rulers and priests in front of it, and even cigarette papers that contained pictures of the Greek dynasty and Hagia Sophia.[55] The Ottoman court fought against this challenge, sometimes by enforcing restrictions on these materials inside the empire, and sometimes by sending its official responses to certain articles.[56] Another way the government dealt with this issue was by granting permissions to Western scholars and artists for taking photographs or making drawings of Hagia Sophia, both from the interior and exterior.[57] In this way, 'real' images of the 'mosque' were being produced, accompanied by new publications, and disseminated in Europe as a response to the previously-mentioned images that depicted it as a church.[58]

According to an official document dated to 1892, forty years after its publication, the copies of the Fossati album, which had been kept in Ragıb Pasha Library until then, and other books related to Hagia Sophia were ordered to be distributed to the libraries of the palace and some governmental offices.[59] Along with the intention to keep these 'precious' books safe, as described in the documents, another motivation must have been to exhibit them to prominent European visitors. Thus, the copy that was ordered for the palace makes sense, since European officials and guests were received in the palace every week after the Friday processions by the sultan.[60] In this context, the contemporaneous practice of enabling European visitors to watch one of the most impressive religious ceremonies within the very building that was considered the incarnation of the

Muslim victory over Christendom emphasised the Muslim possession of the building – and thus the city itself.

Starting in the last quarter of the nineteenth century, enabling non-Muslim groups to attend the Night of Power ceremonies in Hagia Sophia as spectators became a usual practice, and these groups grew larger over time. On 12 May 1923, months before the proclamation of the Republic of Turkey, scores of Europeans wanting to watch the Night of Power ceremony from the upper galleries of Hagia Sophia vied for a permit that could be obtained by official requests of an embassy. Lists of names for thirty-six Italian, forty-three American, fifty-two French and twenty-six English men and women – embassy staff, naval officers or civilians – were given to the administration.[61] Additionally, the American embassy requested one hundred extra tickets for distribution on further request, and some minor additions to the name list were made by the French embassy. On 13 May 1923, almost three hundred Europeans watched the ceremony one last time under the Ottoman rule.[62] It had become more organised, more institutionalised, and definitely more crowded since Mary H. Jay's visit in the early years of 1880s. The mosque and the ceremony, which consisted of dozens of *rakats* of prayers, devotions, recitations and chants, were now the object of a spectacle that propagated the Islamic symbolism of the monument.

This rapid change can also be traced through various tourist guidebooks. For example, the later editions of *Murray's Handbook for Travellers in Constantinople* added a note for those in the city during the Night of Power, advising them to visit Hagia Sophia about one hour after sunset to see the illuminations.[63] At the same time, the renowned Byzantinist Alexander van Millingen (d. 1915) wrote that there was 'no more impressive religious service in the world than that celebrated, under the dome of S. Sophia, on "The night of power", in the season of Ramazan'.[64] Other guidebooks, such as the *Guide to Greece, Archipelago, Constantinople, The Coast of Asia Minor, Crete and Cyprus*, published in 1908, or Demetrius Coufopoulos's *A Guide to Constantinople* of 1910, would more directly point to this new practice, the former saying:

> The night of power, *kadr geyjesi* is celebrated on the 27th Ramazan (5th January 1902). St. Sophia is illuminated on that night and visitors are allowed into the galleries on payment of 20 piasters, where they may witness the very impressive service.[65]

After the proclamation of the Republic of Turkey in 1923, this practice continued to be carried out in Hagia Sophia until 1934.[66] However, this time it acquired another meaning and became a platform for the new republic's propagation of its religious reforms. In 1932, two years

From Ceremony to Spectacle

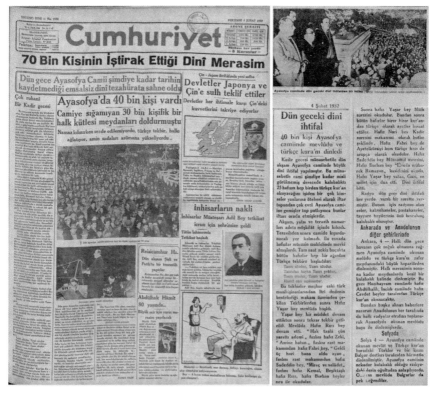

Figure 8.5 Newspaper clips about the Night of Power ceremony held in Hagia Sophia on 4 February 1932. *Cumhuriyet* and *Akşam*.

before Hagia Sophia was converted into a museum, the Night of Power ceremony was conducted with an unprecedented attendance. The next day, all the newspapers published long reports on the ceremony (Figure 8.5).[67] Judging from these reports, everything seemed like a scaled-up version of the previous ceremonies, yet with one significant difference: all the prayers, devotions, recitations and chants – even the *adhan* – were now in Turkish. A debate that had its roots in the last quarter of the nineteenth century found a new course with the establishment of the new state, and its first trial was implemented at this ceremony.[68] In fact, the Turkification of the language of all prayers, including the *adhan*, was written into law three days before the ceremony and the first Turkish *adhan* was recited in the Fatih mosque. The Night of Power ceremony, however, presented it to the whole country.[69]

According to the newspaper reports, approximately 40,000 Muslims attended the ceremony and 4,000 European non-Muslim women and men

253

watched.[70] Additionally, it was broadcast in the major squares of Ankara and other big cities in Anatolia, and in this way millions of people in various parts of Turkey had been a part of the ceremony. On this religiously significant night, Hagia Sophia was once again in the spotlight.[71] However, in contrast to the early modern period, it did not function as a tool of legitimation, nor were the Night of Power celebrations a spectacle that (re)appropriated the monument and the city as in the nineteenth century. This time, it was a tool for the propaganda of the Turkification policies of the new government, specifically in the sphere of religious practices – an important component of the wider project of nation-building. The Europeans who watched the ceremony were no longer the primary audience, but they were present to witness the transformation.

The conversion of Hagia Sophia into a museum in 1934 did not prevent its utilisation as a political tool. Its re-conversion into a mosque has been promised by many right-wing political parties since the 1950s and various attempts have been made to use it – at least partially – for daily prayers.[72] Along with these attempts, popular demand among the conservatives also became more visible and stronger from the early 2000s.[73] Thousands attended massive morning-prayers and prayers performed on the anniversary of the conquest (*Fetih Namazı*), 29 May, to support the desired re-conversion. In 2016, for the first time in eighty-two years, a Qur'an recitation took place in Hagia Sophia, yet again on a Night of Power. It was broadcast live on many national TV channels. The *sura* selected for this specific event, *Sura Al-Fath*, was also noteworthy and well-suited to the significance of Hagia Sophia as a symbol of 'conquest' (*fetih* in Turkish). This re-invented tradition of the Night of Power prayers in Hagia Sophia continued until 2020. The Night of Power was once again celebrated with the broadcasting of recitations and chants from the building, followed by another major event ten days later. This time, on the 567th anniversary of the 'conquest' of Istanbul (29 May), a comprehensive programme of celebrations was held, and the centre of these activities again involved Hagia Sophia. After the recitation of the *Sura Al-Fath*, a specially prepared three-dimensional visualisation of the 'conquest' was projected onto a city-wall-shaped surface built right in front of Hagia Sophia, further stressing its symbolic importance (Figure 8.6).[74] Two months after this spectacle, on 24 July 2020, the ruling Justice and Development Party (AKP) ended the eighty-six-year-old debate and changed the status of Hagia Sophia back into that of a mosque, following a ruling by the Turkish Council of State.[75] This highly political decision and symbolic act caused controversial reactions and polarised the public further. While it manifested the achievement of a long-awaited dream for many people, many others perceived it as a

From Ceremony to Spectacle

Figure 8.6 A scene from the 3D Mapping Show held in 2020 for the 567th anniversary of the conquest of Istanbul. A screenshot extracted from 'Istanbul'un Fethi 567. yıl – 3D Video Mapping Gösterisi 2020', https://www.youtube.com/watch?v=qrXR41sZR7I (accessed 16 January 2023).

threat not only to one of the world's greatest architectural and cultural landmarks, but also to the secular foundation of Turkey.[76] It appears that the dispute will not end in the near future. However, it is safe to say that no matter what its function may be, the Hagia Sophia will continue to be the stage for spectacles with various underlying political agendas.

Notes

1. *I am grateful to Drs Emily Neumeier and Benjamin Anderson for their kind invitation to contribute to the Hagia Sophia in the Long Nineteenth Century Symposium and also for their efforts in editing this volume. Also, I'd like to thank Günseli Gürel, Mehmet Kentel and Elvan Baştürk Cobb for their invaluable suggestions. For further information on the relationship between the Ottoman province and the imperial capital at the beginning of the nineteenth century, see: Ali Yaycıoğlu, *Partners of the Empire: The Crisis of the Ottoman Order in the Age of Revolutions* (Stanford, CA: Stanford University Press, 2017).
2. The Ottoman concept of *seyr ü temaşa* is rather difficult to translate into English. While Cengiz Şişman employed 'to watch and gaze', Edhem Eldem opted for 'to view and contemplate'. In this article, whenever possible, I will use the original Ottoman phrase, and otherwise I will follow Eldem's translation.
3. Câbî Ömer Efendi, *Câbî Tarihi (Tarih-i Sultan Selim-i Salis ve Mahmud-ı Sani) Tahlil ve. Tenkidi Metin*, ed. M. A. Beyhan (Ankara: TTK, 2003), 260.

255

'Kadı Paşa hazretlerinin, Asitane-i aliyye'de, Ramazan-ı şerifde bulunduğu olmayup ve cami'-i şerifleri ziyaret arzu eylediği, Padişah-ı keramet-alude hazrederine aks olmağla, her kangı cevami' ve Asitane'de kande dilerse Ayasofya ve gayrı mahallere gidüp seyrü temaşasına ruhsat-ı aliyye ile ferman i'tası istima' olunup ve tebdil çok mahalde görülmüştür'.

4. Selim Deringil, 'Legitimacy Structures in The Ottoman State: The Reign of Abdülhamid II (1876–1909)', *IJMES* 23 (1991): 345–59.
5. Gaspare Fossati, *Aya Sofia Constantinople, As Recently Restored by Order of H.M. the Sultan Abdul Medjid* (London: Colnaghi & Co., 1852).
6. Significantly, the overall size of the hand-woven carpets commissioned in 1797 to replace the old carpets of the mosque match the surface area of the ground floor alone: BOA C. İKTS.20–960. This might mean there were carpets in the galleries that were not replaced at that time, or alternatively that there were no carpets on the first floor at all. In any case, at least from the early nineteenth century, the galleries were not covered with carpets. See e.g. Thomas Watkins, 'An Interesting Description of Constantinople; With Some Curious Particulars of the Turkish Court', *Universal Magazine of Knowledge and Pleasure*, August 1793, 93.
7. G. A. Müller is one of the travellers who mentions that these slippers had to be worn over one's shoes to enter the main prayer hall if the visitor did not want to go barefoot: Georgina Adelaide Müller, *Letters from Constantinople* (London: Longmans, Green and Co., 1897), 73. For other examples, see: John Reid, *Turkey and the Turks: Being the Present State of the Ottoman Empire* (London: Clarke Printers, 1840), 226–30; Mary H. Jay, 'The Night of Power', *Eastern Daily Press*, 21 November 1887, 6. One such slipper is even included in a catalogue of 'extraordinary curiosities' that had been collected by officers of the US Army and Navy and subsequently exhibited in the National Institute for the Promotion of Science: *A Popular Catalogue of the Extraordinary Curiosities in the National Institute* (Washington, DC: Alfred Hunter, 1856), 24.
8. *Globe*, 19 November 1869.
9. In the seventeenth century, the renowned traveller Evliya Çelebi described the north-eastern border of the Süleymaniye Mosque's outer courtyard, which was left without a wall, as an appropriate location from which to watch and enjoy the city: Evliya Çelebi b. Derviş Muhammed Zıllî, *Evliya Çelebi Seyahatnamesi, Topkapı Sarayı Kütüphanesi Bağdat 304 Numaralı Yazmanın Transkripsiyonu Dizini*, 10 vols, ed. O. Ş. Gökyay (Istanbul: YKY, 1996–2007), 1:72: 'Ammâ bu tarafda haremin dîvârı olmayub şehr-i İslâmbol'u temâşa içün bir kenâr sedd-i dıvâr-ı pes çekilmişdir. Cümle cemaat anda meks edüp Hünkâr sarayı ve Üsküdar'ı ve Boğazhisâr'ı ve Beşiktaş'ı ve Tophâne ve Galata ve Kasımpaşa ve Okmeydanı serâpâ nümâyandır. Ve halic-i İslâmbol ve Boğaz içre bâdbânların küşâde edüp niçe bin pereme ve kayık ve gayrı keştîlerin şinâverlik etdikleri birer birer râyegân bir harem-i seyr-i cihan yerdir'. Primary sources reveal the fact that the object of *seyr ü*

temaşa prior to the eighteenth century was the landscapes, gardens, the sea, or spectacles such as various festivals, ceremonies and military drills.
10. See: Zeynep Çelik, *The Remaking of Istanbul: Portrait of an Ottoman City in the Nineteenth Century* (Seattle: University of Washington Press, 1986).
11. For information on nineteenth-century urban modernisation projects in European cities, see: Donald J. Olsen, *The City as a Work of Art: London · Paris · Vienna* (New Haven, Yale University Press, 1986); Marshall Berman, 'Petersburg: The Modernism of Underdevelopment', in *All That is Solid Melts into Air: The Experience of Modernity* (New York: Penguin, 1988), 173–287; David Harvey, *Paris: Capital of Modernity* (New York: Routledge, 2003).
12. Françoise Choay, *The Invention of the Historic Monument*, trans. L. M. O'Connell (Cambridge: Cambridge University Press, 2001), esp. 82–4.
13. For example, BOA BEO 2017–151218.
14. BOA A.MKT.MHM. 159–86.
15. See: Henry Christmas, *The Sultan of Turkey, Abdul Medjid Khan* (London: John Farquhar Shaw, 1854), 42; Charles Pertusier, *Picturesque Promenades in and Near Constantinople and on the Waters of the Bosphorus* (London: Sir Richard Phillips & Co., 1820), 68; Georgina Adelaide Müller, *Ondokuzuncu Asır Biterken İstanbul'un Saltanatlı Günleri* (Istanbul: Dergah Yayınları, 2010), 62–3; Julie Pardoe, *The Beauties of the Bosphorus* (London: George Virtue, 1839), 81–2; Gérard de Nerval, *Voyage en Orient*, 3 vols (Paris: La Pléiade-Gallimard, 1984), 2:783; *The London Illustrated News*, 24 September 1853.
16. Christmas, *The Sultan of Turkey*, 42.
17. However, this cleaning operation did not seem to end this tradition for good. Georgina Adelaide Muller notes that the side aisles of Süleymaniye were still being used as a safe-deposit, though she may be echoing earlier travellers' accounts: Müller, *Letters from Constantinople*, 79.
18. Richard Cunningham McCormick Jr, *St. Paul's to St. Sophia; or, Sketchings in Europe* (New York: Sheldon & Co., 1860), 362.
19. Osman Nuri Ergin, *Mecelle-i Umur-ı Belediye*, 9 vols (Istanbul: İBB Kültür İşleri Daire Başkanlığı Yayınları, 1995) 2:953–4.
20. Basîretçi Ali Efendi, *İstanbul Mektupları*, ed. Nuri Sağlam (Istanbul: Kitabevi, 2001), 51–2.
21. The travelogues of Jean-Baptiste Tavernier (d. 1689), Jean de Thevenot (d. 1667), Guillaume-Joseph Grelot (b. 1638, d. ?) and Antoine Galland (d. 1715) are some examples of these seventeenth-century accounts. Michèle Longino argues that these travellers intentionally exaggerated the hardship they experienced in entering mosques, especially Hagia Sophia, to make their travelogues more interesting and attractive to their readers: Michèle Longino, *French Travel Writing in the Ottoman Empire: Marseilles to Constantinople 1650–1700* (London: Routledge, 2015). The renowned British writer and traveller Julia Pardoe (d. 1862), who resided in Istanbul between the years

1836 and 1837, also exhibits the same attitude when she writes about her visit to Hagia Sophia and Sultan Ahmed in disguise: Julia Pardoe, *The City of the Sultan and Domestic Manners of the Turks, in 1836*, 3 vols (London: Henry Colburn, 1838), 2:40–61.

22. BOA HAT 240–13406; HAT 267–15551. See also: Alphonse de Lamartine, *A Pilgrimage to the Holy Land: Comprising Recollections, Sketches and Reflections*, 2 vols (New York: D. Appleton & Co., 1848), 2:219–21.
23. Vilma Hastaoglou-Martindis, 'Visions of Constantinople/Istanbul from the Nineteenth Century Guidebooks', *Journeys* 4/2 (2004): 46–68.
24. *Dundee, Perth and Cupar Advertiser*, 13 October 1854.
25. BOA BEO 24–1741.
26. For various cases of Europeans receiving firmans to visit imperial mosques, see: *Oracle and the Daily Advertiser*, 10 June 1801; *London Courier and Evening Gazette*, 9 July 1801; John Reid, *Turkey and the Turks, Being the Present State of the Ottoman Empire* (London: Clarke Printers, 1840), 226; *Devizes and Wiltshire Gazette*, 28 May 1840; *Dundee, Perth and Cupar Advertiser*, 13 and 17 October 1854; *Daily Telegraph & Courier (London)*, 3 November 1869; *Worcestershire Chronicle*, 20 January 1877.
27. Müller, *Letters from Constantinople*, 74–6.
28. Qur'an 2:183: 'Ramadan is the (month) in which the Qur'an was sent down, as a guide to mankind and a clear guidance and judgment (so that mankind will distinguish from right and wrong)'.
29. Besides the widely shared religious importance, this month was also sociopolitically significant for the Ottoman administration. It was seen as an(other) opportunity for strengthening the hierarchy among the members of the three significant social groups – men of pen (*kalemiye*), men of word (*ilmiye*) and men of sword (*seyfiye*) – and re-manifesting their absolute loyalty to the sultan. According to the history accounts (*vekayinameler*) and protocol registers from the eighteenth century, high-ranking members of these social groups would visit each other and break fast together in *iftar* banquets during Ramadan. These visits took place during the last five days of Ramadan and were called the (early) holiday celebrations (*bayramlaşma*). For a general overview of Ramadan in Ottoman Istanbul, see: François Georgeon, *Osmanlıdan Cumhuriyete İstanbul'da Ramazan*, trans. A. Tümertekin (Istanbul: İş Bankası Kültür Yayınları, 2018).
30. Martin Plessner, 'Ramaḍān', in P. Bearman et al. (eds), *Encyclopaedia of Islam*, vol. 8, 2nd edn (Leiden: Brill, 1995), http://dx.doi.org/10.1163/1573 -3912_islam_SIM_6208 (accessed 28 July 2023).
31. Selânikî Mustafa Efendi, *Tarih-i Selaniki* (Istanbul: Matbaa-ı Âmire, 1864), 134: 'Padişah-ı dindar şeb-i kadirde Ayasofyaya namaza çıktıkları ve ertesi divan olub kula mevacib çıkdığıdır'.
32. BOA HAT 736–34920.
33. Balıkhane Nazırı Ali Rıza Bey, *Eski Zamanlarda İstanbul Hayatı*, ed. Ali Şükrü Çoruk (Istanbul: Kitabevi, 2017), 223.

34. *Evening Mail*, 13 June 1856. For similar accounts of the Night of Power ceremony that took place in Tophane with the participation of the sultan, from earlier and later years, see: *Evening Mail*, 3–6 December 1841; *The Morning Post*, 3 May 1860; *The Morning Post*, 23 February 1866; *Pall Mall Gazette*, 28 October 1876: 5.
35. This change also triggered a new attitude towards the walled city, as it started to be seen and presented as a living museum that showcased the roots and glorious history of the Ottoman Empire, which was in an ongoing process of modernisation. See: Pınar Aykaç, 'Musealization as an Urban Process: The Transformation of the Sultanahmet District in Istanbul's Historic Peninsula', *Journal of Urban History* (2019): 1–27; Nilay Özlü, 'Single P(a)lace, Multiple Narratives: The Topkapı Palace in Western Travel Accounts from the Eighteenth to the Twentieth Century', in M. Gharipour and N. Özlü (eds), *The City in the Islamic World: Depictions by Western Travelers* (London: Routledge, 2015), 168–88.
36. These processions also included Friday prayers and Royal *mawlid* Ceremonies for the Prophet Mohammad that were customarily held in the Sultan Ahmed Mosque. The only exception was the ceremony of the visitation of the Holy Mantle. Every year, on the fifteenth day of Ramadan, the sultan and his entire entourage would go to the Topkapı Palace and visit the Holy Mantle in the chamber of the holy relics. This was the only ceremony that Abdülhamid II continued to practise in its accustomed place. See: Hakan Karateke, *Padişahım Çok Yaşa! Osmanlı Devletinin Son Yüzyılında Merasimler* (Istanbul: Kitap Yayınevi, 2004); Şâdiye Osmanoğlu, *Hayatımın acı ve tatlı günleri* (Istanbul: Bedir Yayınevi, 1966), 25–7; Ayşe Osmanoğlu, *Babam Sultan Abdülhamid* (Istanbul: Selis Kitaplar, 2008).
37. Esther Singleton, *Turkey and the Balkan States as Described by Great Writers* (New York: Dodd, Mead and Co., 1908), 124–7. Mary H. Jay's account of her visit to Hagia Sophia was later published in the local newspaper. See: *Eastern Daily Express*, 21 November 1887. For William J. J. Spry's account, see: Singleton, *Turkey and the Balkan States*, 124–7.
38. *Eastern Daily Express*, 21 November 1887.
39. *Eastern Daily Express*, 21 November 1887. The chairs that were assigned to the non-Muslim visitors in the 1880s were later, in the 1890s, found ugly and sloppy. Special chairs and sofas furnished with an upholstery fabric called *Damasko* were ordered to replace them. See: BOA BEO 749–56175.
40. Deringil, 'Legitimacy Structures'. Similarly, Ahmed Cevdet Pasha believed that the Ottoman state was based on four foundational pillars, one of which was the capital: Ahmed Cevdet Paşa, *Tezakir*, ed. C. Baysun, 4 vols (Ankara: Türk Tarih Kurumu Basımevi, 1986), 1:85: 'Devlet-i Aliyye dört esas üzere müesses olup bunlar ile her nasıl istenilir ise idaresi ve ilerlemesi kabil olur ve bunlardan her kangısı nakıs olur ise idâre kabil olmaz. Dört esas budur. Millet-i İslâmiyye, devlet-i Türkiyye, salâtîn-i Osmaniyye, pâyıtahtı-ı İstanbul'.

41. For an overview on the rise of Pan-Slavism in Russia in the mid-nineteenth century, see: Benedict Humphrey Sumner, 'Russia and Panslavism in the Eighteen-Seventies', *Transactions of the Royal Historical Society* 18 (1935): 25–52; Hans Kohn, *Pan-Slavism: Its History and Ideology* (Notre Dame: University of Notre Dame Press, 1953); Denis Vovchenko, *Containing Balkan Nationalism: Imperial Russia and Ottoman Christians, 1856–1914* (New York: Oxford University Press, 2016); and Aslı Yiğit Gülseven, 'Rethinking Russian pan-Slavism in the Ottoman Balkans: N. P. Ignatiev and the Slavic Benevolent Committee (1856–77)', *Middle Eastern Studies* 53/3 (2017): 332–48.
42. See: Nikolai Iakovlevich Danilevskii (trans. S. M. Woodburn), *Russia and Europe: The Slavic World's Political and Cultural Relations with the Germanic-Roman West* (Bloomington, IN: Slavica, 2013), esp. 318–19.
43. Merriam Webster Dictionary defines the term *Te Deum* as 'a liturgical Christian hymn of praise to God'. In this context, it refers to a short religious service based on the hymn *Te Deum Laudamus*.
44. Fyodor M. Dostoyevsky, *The Diary of a Writer*, ed. and trans. B. Brasol (New York: George Braziller, 1919), 441–2.
45. Ibid., 904.
46. See: *Belfast Telegraph*, 12 May 1877.
47. 'Peace Ceremonial at San Stefano (Reuter's Telegram)', *South Wales Daily News*, 6 March 1878, 3.
48. For example, see: *Illustrated London News*, 16 March 1878, 239; *The Graphic*, 9 March 1878, 242.
49. For an overview of Pan-Islamist ideologies adopted by the Hamidian regime, see: Jacob M. Landau, *The Politics of Pan-Islam: Ideology and Organisation* (Oxford: Clarendon Press, 1994), esp. ch.1; Azmi Özcan, *Pan-Islamism: Indian Muslims, the Ottomans and Britain (1877–1924)* (Leiden: Brill, 1997), 23–63; Selim Deringil, 'New Approaches to the Study of the Ottoman Nineteenth Century', in Ç. Kafescioğlu and L. Thys-Şenocak (eds), *Abdullah Kuran için Yazılar* (Istanbul: Yapı Kredi Yayınları, 1999), 345–8; François Georgeon (trans. A. Berktay), *Sultan Abdülhamid* (Istanbul: İletişim, 2012).
50. Gülru Necipoğlu, 'The Life of an Imperial Monument: Hagia Sophia after Byzantium', in R. Mark and A. Cakmak (eds), *Hagia Sophia: From the Age of Justinian to the Present* (London: Cambridge University Press, 1992), 195–225, esp. 221; Abridged Turkish Translation: Gülru Necipoğlu, 'Bir İmparatorluk Anıtının Öyküsü: Bizans'tan Sonra Ayasofya', *Toplumsal Tarih* 254 (2015): 63–75; Halil İnalcık, 'Osmanlı Padişahı', *Ankara Üniversitesi SBF Dergisi* 13 (1958): 68–79, esp. 70. Also, for two accounts of the narrative, from the late-eighteenth and nineteenth centuries respectively, see: Ignatius Mouradgea d'Ohsson, *Tableau général de l'empire ottoman* (Paris: Imprimerie de Monsieur, 1787), 1:89; Tayyâr-zâde Atâ, *Osmanlı Saray Tarihi: Tarih-i Enderûn*, ed. M. Arslan, 5 vols (Istanbul: Kitabevi, 2011) 1:320.

51. Deringil, *Legitimacy Structures*, 345–59.
52. Necipoğlu, 'Hagia Sophia after Byzantium', 223.
53. Robert S. Nelson, *Hagia Sophia, 1850–1950. Holy Wisdom Modern Monument* (Chicago: University of Chicago Press, 2004), 36.
54. Gaspare Fossati, *Aya Sofia Constantinople, As Recently Restored by Order of H.M. the Sultan Abdul Medjid* (London: Colnaghi & Co., 1852). For the images within the album, see https://iiif.lib.harvard.edu/manifests/view/drs:46174231$15i (accessed 28 July 2023). See also: Nelson, *Hagia Sophia*, 29–50, esp. 31.
55. BOA BEO 3595–269624; BEO 3775–283070; DH.İD. 200–9. For examples of newspaper accounts, see: 'A Great Domed Church', *New York Times*, 20 August 1877; and 'Art Glories of Saint Sophia; Sealed Beauties of Saint Sophia at Constantinople May Be Revealed When Sultan's Capital Passes into Other Hands', *New York Times*, 29 June 1919.
56. For examples of restriction see: BOA BEO 3595–269624; BEO 3775–283070; DH.İD. 200–9. For various responses in writing, see: BOA A.AMD. 75-13; and Süleyman Kâni İrtem, *Abdülhamid Devrinde Hafiyelik ve Sansür: Abdülhamid'e Verilen Jurnaller* (Istanbul: Temel Yayınları, 1999), 241–5.
57. Theodor Mavrokordato (d. 1941) and Eugenios Mihail Antoniadis (d. 1944) were given permission to photograph and prepare architectural drawings of Hagia Sophia in 1904. Antoniadis included these images in his three-volume book entitled Ἔκφρασις τῆς Ἁγίας Σοφίας, that was published in 1907 (see BOA, DH.MKT. 871–35). The Byzantinist Alexander van Millingen (d. 1915) and the artists Arthur Edward Henderson (d. 1956) and Vladimir Plotnikov (d. 1917) were among those who were granted permission. See: BOA Y.MTV. 272–106; BEO 1408–105545; BEO 1188–89039.
58. For the discussions of the Allied Powers of the First World War on the fate of Constantinople, and the symbolic significance Hagia Sophia played in these discussions, see: Nelson, *Hagia Sophia*, 120–8.
59. BOA Y.A.HUS. 269–141.
60. Karateke, *Padişahım Çok Yaşa!*; A. Hilâl Uğurlu, 'Perform Your Prayers in Mosques!: Changing Spatial and Political Relations in Nineteenth-Century Ottoman Istanbul', in A .H. Uğurlu and S. Yalman (eds), *The Friday Mosque in the City: Liminality, Ritual, and Politics* (Bristol, Chicago: Intellect Books, 2020), 221–50.
61. BOA HR.IM. 47–37.
62. This ceremony took place six months after the formal abolishment of the Ottoman monarchy by the Turkish Parliament in Ankara on 1 November 1922, and five months before the proclamation of the new republic on 19 October 1923.
63. *Handbook for Travellers in Constantiople* (London: John Murray, 1839, 1845, 1871, 1878, 1900, 1907).
64. Alexander van Millingen, *Constantinople*, painted by W. Goble (London: Black, 1906). Also, Millingen was given permission to visit Hagia Sophia

along with some other mosques and draw their pictures in 1905. See: BOA BEO 2607–195459 and Y.MTV. 272–106.

65. *Guide to Greece, The Archipelago, Constantinople, The Coasts of Asia Minor, Crete and Cyprus* (London: Macmillan & Co., 1908), 118; Demetrius Coufopoulos, *A Guide to Constantinople* (London: A. & C. Black, 1910), esp. 62. Coufopoulos also recommends his readers to visit the galleries of Hagia Sophia on Ramadan nights, 'when the mosque is illuminated, and the Turks are to be seen at prayer'.

66. For the news of participation in this customary ceremony in 1929, see: *İkdam*, 9 March 1929. Various ministries of the Republican Turkey had reported their opinions on the museumification of Hagia Sophia in late 1934 and its conversion was approved by Atatürk and twelve ministers of the cabinet on 24 November (Cabinet Decree no: 2/1589, dated 24/11/1934). For the conversion of Hagia Sophia into a museum after the proclamation of the Republic, see: Nilay Özlü, 'Hagia Sophia and the Demise of the Sacred', *Design Philosophy Papers* 8/1 (2010): 11–24; Ceren Katipoğlu and Çağla Caner-Yüksel, 'Hagia Sophia 'Museum': A Humanist Project of the Turkish Republic', in C. Bilsel et al. (eds), *Constructing Cultural Identity, Representing Social Power* (Pisa: Plus-Pisa University Press, 2010), 287–308; and Wendy Shaw, 'Museums and Narratives of Display from the late Ottoman Empire to the Turkish Republic', *Muqarnas* 24 (2007): 253–80.

67. *Cumhuriyet*, 4 February 1932, 1 and 4; *Akşam*, 4 February 1932; *Milliyet*, 4 February 1932.

68. For the discussions on the language of worship in the late nineteenth and early twentieth centuries, see: Ali Suavi, 'Lisan ve Hattı Türkî', *Ulum* 1/2 (1868–9): 69–70; Ali Suavi, 'Lisan ve Hattı Türkî', *Ulum* 1/3 (1869–70): 123–31; Ali Suavi, 'Zamane Hutbeleri', *Ulum* 1/18 (1870–1): 1,116; Ziya Gökalp, *Türkçülüğün Esasları* (Istanbul: MEB Yayınları, 1990), 176–7; Dücane Cündioğlu, *Bir Siyasi Proje Olarak Türkçe İbadet* (Istanbul: Kitabevi, 1999), 64–5; and Hidayet Aydar and Necmettin Gökkır, 'Discussions on the Language of Prayer in Turkey: A Modern Version of the Classical Debate', *Turkish Studies* 8/1 (2007): 121–36.

69. It was considered almost like a starting point for the prayers in Turkish in the provinces. For example, newspapers on the day after the Night of Power (5 February 1932) reported that in many provincial cities, such as Şebinkarahisar, İnebolu, Kırşehir, Balıkesir, Manisa and Trabzon, masses had listened to the ceremony that took place in the Hagia Sophia from radios. They also announced that in all these cities, public Qur'an recitations and prayers would be in Turkish from then on. See: *Akşam*, 5 February 1932.

70. The news also mentioned another 30,000 people who could not fit inside Hagia Sophia and filled the square in front of the building. *Cumhuriyet*, 4 February 1932.

71. The Night of Power ceremonies were held in Hagia Sophia, entirely in Turkish, on 23 January 1933 and one final time on 13 January 1934. See: *Cumhuriyet*,

24 January 1933; *Milliyet*, 14 January 1933. Newspapers reported the wide interest of the Muslim worshippers and the continued involvement of the non-Muslim viewers. However, it seems that non-Muslims were now also allowed to watch the ceremony in other imperial mosques. I have not come across any news of the Night of Power ceremonies in the newspapers of 1935 and 1936 following the conversion of Hagia Sophia into a museum. However, on 1 December 1937, a day after the Night of Power, the newspaper *Son Telgraf* gave an extensive report of the ceremonies that took place in the Sultan Ahmed, Bayezid and Fatih Mosques. According to the news, the Istanbulites had filled these mosques and non-Muslims who wanted to witness the ceremony had gone to the Sultan Ahmed Mosque.

72. M. İnanç Özekmekçi, 'Türk Sağında Ayasofya İmgesi', in İ. Ö. Kerestecioğlu and G. G. Öztan (eds), *Türk Sağı: Mitler, Fetişler, Düşman İmgeleri* (İstanbul: İletişim Yayınları, 2012), 283–306.
73. Tuğba Tanyeri Erdemir, 'Remains of the Day: Converted Anatolian Churches', in I. Jevtić and S. Yalman (eds), Spolia *Reincarnated* (Istanbul: ANAMED, 2019), 71–93.
74. For the 3-D show, see e.g. 'İstanbul'un Fethi 567. yıl - 3D Video Mapping Gösterisi 2020', 29 May 2020, YouTube video, 11:38. https://www.youtube.com/watch?v=qrXR41sZR7I (accessed 1 December 2022).
75. Danıştay, Esas No. 2016/16015, Karar No. 2020/2595 (2020).
76. For recent debates on the decision to re-convert Hagia Sophia into a mosque, see: the open letter signed on 30 June 2020, by almost 400 scholars of Byzantine and Ottoman Studies, https://medium.com/@hagiasophia/an-open-letter-about-the-status-of-hagia-sophia-bea9afd1a62f (accessed 6 May 2022); Berkley Forum, Hagia Sophia: From Museum to Mosque Series, 2020, https://berkleycenter.georgetown.edu/posts/hagia-sophia-from-museum-to-mosque (accessed 5 May 2022); Robert Ousterhout, 'The Reconversion of Hagia Sophia in Perspective', Oxford University Press blog: Academic Insights for the Thinking World, 8 September 2020, https://blog.oup.com/2020/09/the-reconversion-of-hagia-sophia-in-perspective/ (accessed 6 May 2022); Sampson M. Nathanailidis, 'The Political Risk of Converting Hagia Sophia Back into a Mosque in the Year 2020', *Global Journal of Political Science and Administration* 9 (October 2021), 34–41; Spyros A. Sofos, 'Space and the Emotional Topography of Populism in Turkey: The Case of Hagia Sophia', Cogent Social Sciences, 7/1 (2021), 1982495, https://doi.org/10.1080/23311886.2021.1982495 (accessed 5 May 2022); Shannon Steiner and Emily Neumeier, '"A Church is Never Just a Church": Hagia Sophia and the Mutability of Monuments', *Journal of the Ottoman and Turkish Studies Association* 8 (2021): 215–21; İpek Kocaömer Yosmaoğlu, 'History, Memory, and the Hagia Sophia Controversy', *Journal of the Ottoman and Turkish Studies Association* 8 (2021): 235–42; Markus Dreßler, 'The Reconversion of the Hagia Sophia: Silences and Unheard Voices', *Journal of the Ottoman and Turkish Studies Association* 8 (2021): 209–13; Edhem

Eldem, 'The Reconversion of the Hagia Sophia into a Mosque: A Historian's Perspective', *Journal of the Ottoman and Turkish Studies Association* 8 (2021): 243–60; Tuğba Tanyeri-Erdemir, 'Reconquest of Hagia Sophia', Virtual Lecture, https://vimeo.com/479868724 (accessed 5 May 2022); Özcan Hıdır, 'Ayasofya'nın Camiye Çevrilmesi Kararı ve Teo-Politik Tepkiler', 17 July 2020, https://www.aa.com.tr/tr/analiz/ayasofya-nin-camiye-cevrilmesi-karari-ve-teo-politik-tepkiler/1913722# (accessed 6 May 2022). For international press coverage of Hagia Sophia's re-conversion into a mosque, see: Bülent Öztürk, 'Presentation of the Opening of the Hagia Sophia Mosque in the Printed Media of Islamic Countries', *OPUS–Journal of Society Research* 19/46 (2022): 246–57; 'World Reacts to Turkey Reconverting Hagia Sophia into a Mosque', *Al Jazeera*, 11 July 2020, https://www.aljazeera.com/features/2020/7/11/world-reacts-to-turkey-reconverting-hagia-sophia-into-a-mosque (accessed 6 June 2022); 'Hagia Sophia: Turkey Turns Iconic Istanbul Museum into Mosque', *BBC News*, 10 July 2020, https://www.bbc.com/news/world-europe-53366307 (accessed 6 June 2022); 'Russia Church Reject Turkey's Hagia Sophia Mosque Conversion Plans', *MEMO Middle East Monitor*, 11 July 2020, https://www.middleeastmonitor.com/20200611-russia-church-reject-turkeys-hagia-sophia-mosque-conversion-plans/ (accessed 6 June 2022); Alessio Dellanna, 'Watch Back: Athens Protest as Turkey's Hagia Sophia Becomes a Mosque', *Euronews*, 24 July 2020, https://www.euronews.com/2020/07/24/church-of-greece-mourning-as-istanbul-s-6th-century-hagia-sophia-is-reconverted-into-a-mos (accessed 6 June 2022).

Chapter 9

Temple of the World's Desire: Hagia Sophia in the American Press, c. 1910–27[1]

Robert Ousterhout

At the beginning of January 1921, a special service was held in the cathedral of St John the Divine in New York City, with Orthodox and Episcopal clergy offering prayers in six languages – Hungarian, Greek, Arabic, Russian, Serbian and English – for the restoration of Hagia Sophia as a Christian sanctuary (Figures 9.1, 9.2).[2] The enormous church was filled to capacity for the service, with hundreds of would-be worshippers turned away at the doors. News reports highlighted the exotic character of

Figure 9.1 Hagia Sophia, seen from the south-west in a popular postcard view; although postmarked 1916, the photograph on which it is based must be from the third quarter of the nineteenth century. Author's collection.

Robert Ousterhout

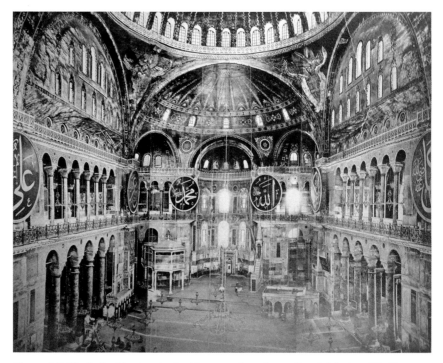

Figure 9.2 Hagia Sophia, interior looking east, from the studio of Sébah and Joailler, end of the nineteenth century, assembled from six different prints and rephotographed. Author's collection.

the gathering, noting that each of the twelve representatives of the many branches of the 'Ancient Church of the East' was 'dressed in the brilliant vestments of his church, which included scarlet, purple, pale blue, gold, dark red, and pure white robes spangled elaborately with silver'.[3] Similar services were held simultaneously in Washington, St. Louis, Detroit, Newark, Philadelphia and Chicago, all authorised by the Episcopal Church as part of its planned reconciliation with the Greek Orthodox Church.[4]

A present-day reader might rightly wonder how and why Hagia Sophia could have held a central place in the American imaginary at the end of the long nineteenth century. In an attempt to understand the popular sentiments of this fraught period, the newspapers offer many insights as to how the years of international conflict and disaster – the Balkan Wars (1912–13), the First World War (1914–18) and the Turkish War of Independence (1919–23) – could be viewed through the symbolic presence of Hagia Sophia, particularly in the United States.[5]

It was not an easy period. To the international conflicts just mentioned we should add the influenza pandemic of 1918–19. Taken individually,

each of these might be regarded as catastrophic, with enormous loss of lives, but taken together in rapid succession they signalled a major global realignment – politically, economically and socially. Even sorting out the political transformations is not an easy task: any historian of this period is aware of the delicate negotiations behind the scenes, the unpredictability of almost all the players, and divisions within the participating nations, as well as deeply-entrenched economic interests and religious sentiments, not to mention the convoluted and constantly changing political map.

Yet the general public rarely understood the complexities and nuances of the conflicts. It was much easier to encapsulate them in powerful symbol – indeed, ever since Procopius, Hagia Sophia has received a multitude of symbolic readings. Still, nowadays it is difficult to imagine such a global response to a single building; by contrast, the recent calls for the reopening of Hagia Sophia as a mosque have generally fallen on deaf ears outside of Turkey and the Greek Orthodox community.[6] How could one building become a universal symbol of Christian aspirations? It is similarly difficult today to fathom the political impact Christianity had across Europe and America throughout the long nineteenth century, particularly in the waning days of the Ottoman Empire. Deep-seated religious attitudes coloured all discussions of the 'Eastern Question' and the Greeks' *Megale Idea*. In these discussions, Hagia Sophia emerged as the Christian equivalent of the Wailing Wall: a universal symbol of lost heritage to people of faith. Viewed more positively, it represented the future aspirations for greater Greece and of the Christian world in general, as well as the political ambitions of Great Britain.[7]

In fact, such sentiments were not new in 1921 and had been expressed across Europe for decades. The American inter-denominational prayer services came as a response to the British movement known as the Anglican and Eastern Churches Association, founded in 1864 but particularly active in the years 1914–21.[8] Moreover, ever since the liberation of Greece in the 1820s, the *Megale Idea* had the reconquest of Constantinople and the restoration of Hagia Sophia as its top priorities.[9] An 1877 article in the *New York Times* began:

> How soon will the crescent over the minarets of St. Sophia be replaced by the cross, or how soon the minarets themselves will be entirely swept away, leaving the outlines of the church in their ancient condition, no seer has foretold.[10]

The same article notes the longstanding belief among the Greeks, 'not altogether discredited by the Turks', that the building would be restored to Christianity. As Ottoman control of its European territories crumbled, the

restoration of Hagia Sophia to Christianity was a strongly-held hope and widely-felt belief.

One of the correspondents whose name turns up again and again – and regularly in reference to Hagia Sophia – is William T. Ellis, a fervent Presbyterian from Swarthmore, PA, whose weekly Sunday School lessons were syndicated. As a newspaper correspondent for the *New York Herald*, he travelled widely, in Bible Lands, as well as in Russia in 1917 to observe the Bolshevik Revolution, followed by Cairo and Constantinople, and ultimately Paris for the Peace Conference.[11] As might be expected, there is little distinction in his writings between religious doctrine and reportage. On 10 December 1910, he published the International Sunday School Lesson on the Crucifixion. For him it was a quick leap from the Crucifixion, to the sign of the Cross, to the wish for a cross atop Hagia Sophia. He writes:

> The Turkish problem, which engrosses the attention of European diplomats and is intertwined with the future of Greece, Crete, Bulgaria, Servia, Montenegro, and Roumania – not to mention the nationalities under Turkish dominion – is essentially a problem of Islam versus Christianity. Greeks, Russians, Armenians and Syrians see it all typified in the cross coming back to the mosque of St. Sophia in Constantinople ... For nearly five centuries it has been in the hands of the Moslems. But the belief is strong in millions of hearts that 'the cross is coming back.' When it does, the Turkish empire will have fallen.[12]

The quotation here is from the *Topeka State Journal*, but the lesson was distributed widely. These are strange sentiments to be expressed in a Sunday School lesson, but they help us to understand how religion and politics were inextricably intertwined in this period.

Popular opinions and political realities often stood in sharp contrast, however. With the penetration of Bulgarian forces into Ottoman Thrace during the second Balkan War, anything seemed possible, and the conquest of Edirne was taken as a prelude of things to come. After the fall of Edirne (Odrin in Bulgarian) on 26 March 1913, in anticipation of a permanent occupation there was even a movement to transform the Selimiye Camii into an Orthodox Church – although this was wisely nipped in the bud by the Bulgarian Tsaritsa. The account in the notes of Bogdan Filov for 2 April 1913 is worth quoting in full:

> at our arrival in Odrin, we met the Queen, who got out of her automobile and walked with us to a certain place. She told us that a committee had been established in Sofia, whose wish had been to turn the mosque 'Sultan Selim' into a church. She of course had opposed this and expected us to support her. I think that it would be best if the architecturally significant mosques are left to

be owned by the state but available for the Turks to use them, by letting them be open for visitors.[13]

Still, many saw the Bulgarians' success in Thrace leading inevitably to the conquest of Constantinople, the liberation of Hagia Sophia and the triumph of Christianity. As Bulgarian troops advanced on Constantinople in the fall of 1912, the *New York Times* published a long article captioned 'Bulgars May Plant Cross on St. Sophia. Byzantine Edifice, where their forefathers were made Christians, goal of fighters. A tradition of a miracle. When Moslems invaded the church, a voice foretold its recapture by a regenerated nation'.[14] As with so many others, the report is much more concerned with popular sentiment than with military strategy, troop movements, or even the basic facts on the ground. About the same time, it is reported that a letter from Tsar Ferdinand of Bulgaria to Pope Pius X read, 'If God permits the Bulgarian army to enter Constantinople, I have vowed to tear the Moslem emblems from St. Sophia and restore the Basilica to the Christian religion'.[15] News reports have the Bulgarian army at the gates of Constantinople, with conquest imminent. Ferdinand was said to have prepared his regalia for a triumphal entry into the city, to be followed by mass in Hagia Sophia, envisioning himself as Emperor of a united Christian East: 'The cross is to be carried in triumph into the ancient cathedral of St. Sophia ... Afterward, it is said, Ferdinand will have himself proclaimed Emperor, under the name Simeon II.'[16] The Turks vowed resistance; another popular article was captioned: 'Turks Armed with Bombs Waiting at the Church. Czar Ferdinand threatens to attend mass in mosque at St. Sophia which Moslems will destroy before allowing'.[17] None of this came to pass; by July the Bulgarian army was in retreat, both armies decimated by a horrific outbreak of cholera. And then the First World War began.

But the allure of Hagia Sophia persisted. Russia also had long had its sights set on Constantinople and Hagia Sophia: not only were the straits of the Bosporus and the Dardanelles vital to the Russian economy, but Russia also owed its Christian heritage to Constantinople and specifically to the impression Hagia Sophia had made on its medieval ambassadors. As part of the secret negotiations to divide the Ottoman Empire held in London in March 1915, the Triple Entente promised Constantinople and the Dardanelles to Russia – that is, following the expected victory in the Gallipoli Campaign (February 1915–January 1916).[18] A pamphlet of a lecture given by Prince Trubetskoy, 'Saint Sophia: Russia's Hope and Calling', published in translation in 1916, makes Russia's interest in Hagia Sophia abundantly clear.[19] Beyond economics and politics,

Trubetskoy emphasised that 'the very ego, spiritually, of Russia' was bound to Constantinople.[20] Of course, the Gallipoli Campaign turned out very differently from expected, and by 1917 the Bolsheviks were in control in Russia. France and England subsequently denied they had ever made such an agreement.

Following the end of the war, as the Peace Conference was meeting in Versailles, ardent philhellenes across England formed the St Sophia Redemption Committee. Its manifesto was published by the Rev. John A. Douglas in February 1919.[21] Reading it today, he sounds like a crackpot, naive at best, but the redemption movement had been instigated and supported by major political figures of the day, including nine Members of Parliament. Douglas writes:

> if, for no selfish ends and regardless of the cost, she [England] now proceeds to set the Cross again upon the dome of the great church, she will kindle a beacon of peace and of progress which will change the face of the earth and the ways of men.[22]

While naively optimistic, the tone of the group was decidedly pro-Greek and anti-Turkish, pro-Christian and anti-Muslim. For many, the hope of the Peace Conference was to drive the Turk out of Europe once and for all.

In Great Britain, the pro-Greek movement was championed by David Lloyd George. Prime Minister from 1916 until 1922, Lloyd George was an ardent philhellene and involved himself enthusiastically in Greek politics, making promises and assurances right and left, while encouraging the Greek invasion of Asia Minor. Indeed, so involved was he that the subsequent Catastrophe, which culminated in the burning of Smyrna and the Çanak Crisis in September 1922, proved to be his political undoing, after which Great Britain stepped back from international meddling.[23] With the involvement of the United States in the First World War and the Versailles Peace Conference, President Woodrow Wilson had sought a greater American involvement in world affairs, but following his debilitating stroke in October 1919, the United States reverted to an isolationist position. Indeed, the Allied powers had hoped that the Americans would agree to take charge of the straits, but this did not happen.

The political considerations were not simply Christian vs Muslim, although they were often reduced to that simplistic dichotomy in the popular press. One report of 1912, for example, is entitled 'Sancta Sophia May Echo Again Christian Music. Great Mosque of Constantinople Held by Followers of False Prophet for More Than Four Centuries Will Return to Followers of Nazarene If Balkan Allies Enter Gates of City Long Held by Turks'. If the sentiments were not obvious enough, the header to the

Hagia Sophia in the American Press

Figure 9.3 Hagia Sophia, as illustrated in a newspaper article of 1912, with caption included (*Los Angeles Times*, 1 December 1912).

article reads, 'Christians vs. Moslems' (Figure 9.3).[24] But if Hagia Sophia were to become Christian, which denomination would control it? Even with the almost-successful Bulgarian offensive, many assumed that the Greek Orthodox would gain control, and that Tsar Ferdinand would 'adopt the Greek form of Christianity'.[25] At the same time, many quickly realised there would be difficulties. In March 1915, the *Pittsburgh Gazette Times* reported, 'Famous Church May Lead to Trouble. Custody of St. Sophia Likely to Raise Strange Questions When Constantinople Falls. Many Faiths Want It'.[26] 'After all these years', it continued,

St. Sophia will again become a Christian church, perhaps a cathedral. But the question is: What religious body will own it? What services will be maintained in it? If it is a cathedral once more, what church will it be a cathedral of? Whose bishop will have his official seat in it?[27]

Church of England? Roman Catholic? Russian? Greek Orthodox? Reports offered various opinions. In the same month, the *New York Times* reported:

> Concerning St. Sophia, the same [anonymous] missionary reports say it is to become, if Constantinople fall, a cathedral of the Russian Church. It is declared on all hands that the famous mosque will not be permitted to remain in the hands of the Moslems.[28]

The question of who should inherit Hagia Sophia continued to surface after the end of the War, particularly during the Allied occupation of Constantinople. Nevertheless, the universal assumption was that it would be converted. An article of May 1919 was captioned 'Turk Very Much Discouraged Over War/Lost His Dogs, Mosques Not Well Attended and All Is Wrong/Will Lose St. Sophia'.[29] The article adds:

> The faithful Turk does not visit the great mosque of St. Sophia as frequently as he used to, for he considers it a foregone conclusion that St. Sophia will become a Christian church as it was in the fifth and sixth centuries. Christian architects already have visited the mosque and are making their plans for the transformation.

This story was repeated multiple times in newspapers across the United States.

In April 1919 William T. Ellis proudly announced in the *Washington Post*: 'War Frees Religion/Greeks May Ask Pope to Lead Services in St. Sophia'.[30] With the expectation that the Ecumenical Patriarchate would gain control of Hagia Sophia, combined with the expectation that the Metropolitan of Athens, Meletios, would ascend the patriarchal throne (as he did, briefly, 1921–3), everything seemed possible. Meletios had travelled widely and had visited the United States, where he was impressed by the collaboration of the various Protestant denominations, proposing something more universal, and as a symbol of his ecumenical vision he would invite

> all the divisions of the Greek Orthodox Church, Russian, Roumanian, Servian, Syrian, Bulgarian &c., but also the Bishop of Rome ... the various Eastern churches and all the Protestant Churches of Christendom, declaring the Bishop of Rome would be invited to preside over this most momentous event in the history of modern Christendom.[31]

Although this seems to be a bit of a Christian ecumenical pipe dream, it was widely reported, and it was ultimately one of the stepping stones that led to the formation of the World Council of Churches. On the subject of Hagia Sophia, however, there was not consensus. The Vatican muddied the waters, stepping into the fray with its own claim: 'The Holy See maintains that [St Sophia] must be returned to the Catholics as it was built for the Catholic faith, and the Catholics possessed it when Mahomed II. conquered Constantinople.'[32]

In Great Britain, Lloyd George and the St Sophia redemption movement hit a snag, as adversaries pointed to the fact that the largest group of the world's Muslims actually lived within the British Empire (mostly South Asia) and would not take kindly to the conversion of Hagia Sophia. As early as 1919, news reports began to express the uncertainty of the British position. Would Lloyd George actually 'give' Hagia Sophia to the Muslims? Had the British formed a secret pact with the Turks?[33]

By 1920, the Turks had become suspicious of Christian interests in Hagia Sophia, keeping the building closely guarded and demanding passports from those who entered, turning away Greeks and Armenians, while threatening to dynamite the mosque if the Greeks were to take Constantinople. An article in the *Tampa Tribune* notes the frequent visits to Hagia Sophia by Russians, but concludes that 'the Turks do not love the Russians. Neither do they hate them. No Christian is loved by a Moslem, but the power of the Turks to hate is exhausted on the Greeks and Armenians.'[34]

So much in the news was Hagia Sophia that the most popular movie of 1920 was *The Virgin of Stamboul*, a blockbuster, swashbuckling Orientalist silent film that starred the alluring Patricia Dean as a peasant girl, who witnesses a murder inside Hagia Sophia and is ultimately rescued by an American soldier of fortune. A 'masterpiece' with a budget of $500,000, the film set attendance records in many American cities.[35] To promote the film, the production company had a 'sheik' from Constantinople and his Arabo-Turkish entourage check into the Majestic Hotel in New York, all in full costume, including a eunuch to guard the door. The troupe was allegedly in pursuit of a missing girl, affianced to the sheik's brother, who had run off with an American marine. A reward was offered, but the ruse was quickly uncovered. In fact, former Ambassador Henry Morgenthau blew their cover, calling the so-called Sheik Ben Mohamed a 'fake' and a 'blasted liar'.[36] Both the alleged sheik and the film were woefully short on ethnic and geographical accuracy, conflating Turk and Arab, Istanbul and the Arabian Desert, but no matter. The film was nonetheless a hit.

By January 1921, an old prophecy had resurfaced. The *Washington Evening Star* reported:

> All Greece and Turkey are aroused with superstitious awe, awaiting the fulfillment of an old prophesy ... If a ruler named Constantine should occupy the Greek throne with a consort named Sophia, then Constantinople will fall to Greece again and the crescent on the Hagia Sophia ... will be replaced by the cross.[37]

And the fair-haired Constantine would crown himself Emperor of the East beneath the dome of Hagia Sophia:

> The prophesy is so old that its origin is lost in tradition, but it is known to all Turks and Greeks ... The crux of the situation comes in the fact that with the return of Constantine to the throne of Greece, he brings a wife named Sophia.

The names, of course, 'were not a matter of coincidence, but were given them as aspirations of the Greek nation'.[38] At the same time, a highly respected Greek prophet from Ioannina, Papa Johannes (formerly a priest in Philadelphia), predicted that Constantine would enter Constantinople before November – a prophecy taken seriously enough to be reported in the *New York Times*.[39] But, the *papas* concluded, 'at the moment of Constantine's triumph, something terrible will befall him'. Although not superstitious, the king apparently attached some credence to the prophecy, commenting, 'Let me once enter Constantinople with my army and I do not care what happens to me afterward.'

By April, Constantine was threatening to march on Constantinople unless England and France came to the aid of the Greek forces in Asia Minor.[40] In one of the most curious events of the Greek campaign, in June 1922 the commander in charge, Gen. Georgios Hadjianestis, began redeploying troops from Asia Minor to Thrace, apparently to be ready to march on occupied Constantinople.[41] Whether this was a viable threat or simply a bluff is still unclear, but the stand-off with Allied forces came to an end with an order from Athens on 2 August to pull back. By September, Smyrna was in flames, and the *Megale Idea* died an unhappy death – as did the Hagia Sophia redemption movement. Hadjianestis and his cohort were put to the firing squad; King Constantine died in exile shortly thereafter in Palermo, without entering Constantinople, and without attending mass at Hagia Sophia.

After 1922, the discussions about the religious fate of Hagia Sophia cease, and there is virtually no mention of the controversies over the building's function in the reports of the Treaty of Lausanne in July 1923, as the Kemalist regime gained control of the city. After that time, the news

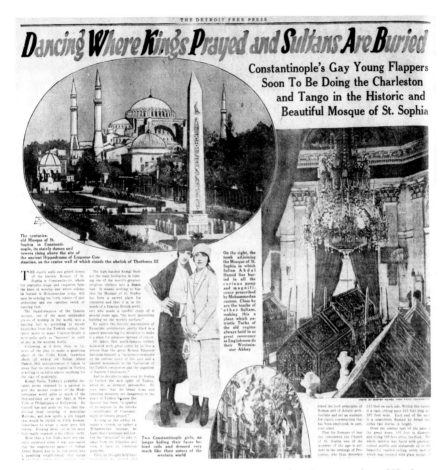

Figure 9.4 Popular newspaper feature from 1927 concerning the conversion of Hagia Sophia into a dancehall (*Detroit Free Press*, 23 January 1927).

was more sober about plans to restore the building, both Turkish-initiated and international. The move to secularism by the Kemalist regime is also reflected in a bizarre series of reports, beginning in 1926, about the proposed secularisation of the building. Newspaper items claim (without foundation) that Mustafa Kemal planned to transform the building into a dance hall, a temple to jazz. One widely-circulated full-page spread was headlined: 'Dancing Where Kings Prayed and Sultans Are Buried/ Constantinople's Gay Young Flappers Soon To Be Doing the Charleston and Tango in the Historic and Beautiful Mosque of St. Sophia' (Figure 9.4).[42] The rumoured transformation is seen as 'the latest move to make Constantinople a metropolis quite as "modern" in spirit as any in the Western world'; alternative versions of this 'fake news' report have it

that Mustafa Kemal would transform the building into a motion picture palace, a restaurant or an amusement arcade. It is actually amazing how widespread these reports were. It is also worth noting that, in the same year, Turkish authorities attempted to outlaw the Charleston, not on religious grounds, but as a matter of safety, as dancers were suffering physical injury in record numbers.[43]

* * *

In this chapter, I have investigated the various intersections of politics, religion and popular sentiment at the end of the long nineteenth century as they converge around Hagia Sophia in the American press. It is fascinating how quickly they fade after the Treaty of Lausanne. We are left with the question: how much did popular Western sentiment contribute to the decision to convert the building into a museum? In fact, this idea had been mooted as early as 1919. When the Turkish government was taking the idea of conversion seriously, a British political agent in Constantinople, Thomas Hohler, had proposed an alternative: that Hagia Sophia be turned into an architectural monument, thus removing it from religiously-focused debate.[44] Indeed, through the decades preceding the conversion to a museum, the newspaper reports of its 'restoration' had been as much about its physical repair and the promise of uncovering Byzantine mosaics as they had been about its proposed Christianisation. For example, as early as 1912, there are expressed concerns for the stability of the dome; the Turks had engaged Luigi Marangoni, the *proto* of San Marco in Venice, to prepare an account of necessary repairs.[45] In expectation of the Christianisation of the mosque, the mosaics – still covered – were lauded in 1919 on the basis of the Fossati documentation.[46] At the same time, reports have the building ready to collapse structurally, blaming Ottoman negligence: 'So writes Sterling Heilig, and He Says Famous Building May Not Last Until Americans Can Rescue It – Turks Have Known the Facts Since 1849, But Refused to Make Repairs'.[47] The American Institute of Architects proposed to aid the restoration in 1926.[48] The following year, the new Turkish government is reported to have undertaken a restoration programme.[49]

On 24 November 1934, the same day on which Mustafa Kemal was proclaimed Atatürk, the Turkish Council of Ministers decreed that the building should be a museum:

> Due to its historic significance, the conversion of Ayasofya Mosque, a unique architectural monument of art, located in Istanbul, into a museum will please

the entire Eastern world; and its conversion to a museum will cause humanity to gain a new institution of knowledge.[50]

We may never know the chain of events that ultimately led Mustafa Kemal to this decision. Similarly, we may never know how exactly Thomas Whittemore and his Byzantine Institute of America gained permission to conserve the mosaics. Both gentlemen were adept at re-inventing themselves, and Whittemore preferred his life to be shrouded in mystery.[51] Still, both momentous decisions were decades in the making, as press reports indicate. Nevertheless, by the early 1930s, newspapers had for the most part abandoned the high-minded rhetoric of infidels and atrocities, and those poor beleaguered Christians.[52] Through it all, as Robert Nelson has so eloquently argued in his book, Hagia Sophia had become a monument – isolated, taken out of the everyday life of the city around it – and subsequent accounts focus on its artistic merit and not its complex religious heritage.[53]

The fascinating period under discussion here ended with the death of empires, the decline of grand colonialist ventures, the waning of Christianity as a political force, and a greater international awareness across the West. The autocratic Ottoman Empire, long mired in its own troubled past, was replaced by a modern and *modernist* republic, keen to take its place on the world stage. For all of these global transformations, the secularisation of Hagia Sophia seems a symbolically appropriate finale with which to bring down the curtain on the long nineteenth century.

Notes

1. My title is obviously a reference to Philip Mansel's important book, *Constantinople: City of the World's Desire, 1453–1924* (London: John Murray, 1995); but it owes much more to the foundational work *Hagia Sophia, 1850–1950: Holy Wisdom Modern Monument* (Chicago: University of Chicago Press, 2004) by Robert S. Nelson, whose continuing inspiration and decades of friendship I gratefully acknowledge.
2. 'Pray in 6 Tongues at Union Service', *New York Times*, 3 January 1921, 15.
3. Ibid.
4. 'Episcopalians to Join in Service with Greeks', *Philadelphia Enquirer*, 1 January 1921, 12; 'Says Episcopal Church is Medium for Merger', *Philadelphia Enquirer*, 3 January 1921, 3; 'Churches Take Steps to Unite', *Detroit Free Press*, 3 January 1921, 3.
5. As many of the footnotes will indicate, I have consulted a variety of newspapers of the last decades of the nineteenth and first decades of the twentieth century, primarily through the website www.newspapers.com. While I have

cited a single paper for each story mentioned here, most appeared in a variety of papers across the country, often word for word, without citation.
6. Robert G. Ousterhout, 'From Hagia Sophia to Ayasofya: Architecture and the Persistence of Memory', *İstanbul Araştırmaları Yıllığı* 2 (2013): 91–8. [Editors' Note: This chapter was originally written before the Turkish high court ruling in summer 2020 that led to the official conversion of Hagia Sophia into a mosque. Shortly after this event, the author published the following remarks: Robert G. Ousterhout, 'The Reconversion of Hagia Sophia in Perspective', Oxford University Press blog: Academic Insights for the Thinking World, 8 September 2020, https://blog.oup.com/2020/09/the-reconversion-of-hagia-sophia-in-perspective/ (accessed 6 May 2022).]
7. Erik Goldstein, 'Holy Wisdom and British Foreign Policy', *Byzantine and Modern Greek Studies* 15 (1991): 105–28.
8. *The Anglican and Eastern Churches: A Historical Record, 1914–21* (London: Society for Promoting Christian Knowledge, 1921).
9. For background on this period, see, *inter alia*: Arnold J. Toynbee, *The Western Question in Greece and Turkey: A Study in the Contact of Civilizations* (Boston: Houghton Mifflin, 1922); and more recently Michael Llewellyn-Smith, *Ionian Vision: Greece in Asia Minor, 1919–1922* (London: Lane, 1973, 2nd edn London: Hurst, 1998); and Michael M. Finefrock, 'Atatürk, Lloyd George, and the Megali Idea', *Journal of Modern History* 52 (1980): D1047–66.
10. 'A Great Domed Church', *New York Times*, 20 August 1877, 2.
11. See the obituary in: *Swarthmorean*, 19 August 1950, http://www.swarthmorean.com/photos/dr-william-t-ellis/ (accessed 1 December 2022).
12. W. T. Ellis, 'At the Sign of the World's War. The International Sunday School Lesson for December 11 Is "The Crucifixion". Matt. 27: 15–50', *Topeka State Journal*, 10 December 1910, 13.
13. Filov was an archaeologist and art historian, later Prime Minister of Bulgaria. See: Ivo Hadjimishev et al., *The Gipson Archive: Dr. Bogdan Filov – Photographs and a Description of His Research Mission in 1912–1913* (Sofia: Zhanet-45, 2009), 10; discussed in Ousterhout, 'From Hagia Sophia to Ayasofya'.
14. 'Bulgars May Plant Cross on St. Sophia', *New York Times*, 12 November 1912, 3.
15. 'Vows to Replace Cross on St. Sofia Mosque', *Oregon Daily Journal*, 3 November 1912, 14.
16. 'Fall of Capital Matter of Hours; Bulgarians Advance', *New York Evening World*, 9 November 1912, 2.
17. 'Turks Armed with Bombs Waiting at the Church. Czar Ferdinand Threatens to Attend Mass in Mosque at St. Sophia which Moslems Will Destroy before Allowing', *Keokuk Sunday Gate City*, 10 November 1912, 1.
18. 'Agreement between France, Russia, Great Britain and Italy, Signed at London, April 26, 1915', *UK Parliamentary Papers*, Cmd. 671, Misc. no. 7,

1920. The text of the treaty is available online at: https://en.wikisource.org/wiki/Treaty_of_London_(1915) (accessed 1 December 2022).
19. E. N. Trubetskoy, *Saint Sophia: Russia's Hope & Calling, A Lecture by Professor Prince Eugene Nicolayevich Trubetskoy*, trans. Lucy Alexeiev (London: Faith Press, 1916).
20. Ibid., 7.
21. J. A. Douglas, *The Redemption of S. Sophia* (London: Faith Press, 1919); see also *Anglican and Eastern Churches*, 56–8; Goldstein, 'Holy Wisdom'; for popular reporting, see e.g. 'Mosque of St. Sophia A Symbol of Redemption', *Louisville Courier-Journal*, 15 March 1919, 4.
22. Douglas, *Redemption*, 11.
23. For further on this, see Smith, *Ionian Vision*; and Finefrock, 'Atatürk, Lloyd George, and the Megali Idea'.
24. M. D. Taylor, 'Sancta Sophia May Echo Again Christian Music', *Los Angeles Times*, 1 December 1912, 125.
25. 'Fall of Capital Matter of Hours; Bulgarians Advance', *New York Evening World*, 9 November 1912, 2.
26. 'Famous Church May Lead to Trouble', *Pittsburgh Gazette Times*, 14 March 1915, 4.
27. Ibid.
28. 'A New Palestine If the Allies Win', *New York Times*, 22 March 1915, 3; see also 'Mosque of St Sophia to Become Russian Church Cathedral', *Washington Evening Star*, 20 March 1915, 19.
29. 'Turk Very Much Discouraged Over War', *Pittsburgh Post-Gazette*, 15 May 1919, 20.
30. William T. Ellis, 'War Frees Religion', *Washington Post*, 8 April 1919, 4.
31. William T. Ellis, 'Christian Creeds Invited by Greeks to First Service in Mosque', *Atlanta Constitution*, 27 April 1919, 3.
32. 'The Future of St. Sophia. Vatican's Claim', *Manchester Guardian*, 8 January 1920, 14.
33. William T. Ellis, 'Turkey to Protect British from Rebels', *New York Daily Herald*, 21 January 1920, 12.
34. 'Turks Threaten to Dynamite Mosque', *Tampa Sunday Tribune*, 19 September 1920, 47.
35. See e.g. 'Notes of the Movies', *Topeka State Journal*, 21 July 1920, 6.
36. 'Universal Puts Stunt Over', *Motion Picture News*, 27 March 1920, 2,920; 'Morgenthau Passes Lie to "Sheik Ben Mohamed"', *New York Tribune*, 8 March 1920, 20.
37. 'An Old Prophesy May Be Fulfilled in Turk Capital', *Washington Evening Star*, 1 January 1921, 9.
38. The legend was widely reported as early as 1913, even as Bulgarian forces were moving towards Constantinople: see e.g. 'Constantine's Son Will Rule Constantinople', *St. Louis Post-Dispatch*, 6 April 1913, 59.

39. 'Seeks New Triumph for Constantine. Greek Priest Predicts His Entry into Constantinople Before November', *New York Times*, 8 January 1921, 7.
40. 'Greek King Threatens to Take Turk Capital. Warns England and France That Unless They Aid in Asia Minor He Will Occupy It', *Baltimore Sun*, 16 April 1921, 1.
41. Llewellyn-Smith, *Ionian Vision*, esp. 266–83.
42. For example, 'Dancing Where Kings Prayed and Sultans Are Buried', *Philadelphia Inquirer*, 23 January 1927, 118 (widely reported throughout December 1926 and January 1927).
43. Charles King, *Midnight at the Pera Palace: The Birth of Modern Istanbul* (New York: Norton, 2014), 142.
44. Goldstein, 'Holy Wisdom', 59; see also Abe Attrep, '"A State of Wretchedness and Impotence": A British View of Istanbul and Turkey, 1919', *International Journal of Middle East Studies* 9 (1978): 1–9; Nelson, *Hagia Sophia*, 121–4.
45. 'Nations Join in Project. Byzantine Dome of St. Sophia's in Constantinople Is To Be Saved from Destruction', *Bisbee (Arizona) Daily Review*, 28 June 1912, 5.
46. W. Littlefield, 'Art Glories of Saint Sophia. Sealed Beauties of Famous Mosque at Constantinople May Be Revealed When Sultan's Capital Passes into Other Hands', *New York Times Magazine*, 22 June 1919, 79.
47. S. Heilig, 'St. Sophia Ready to Collapse Structurally', *Washington Evening Star*, 19 October 1919, 74; see also S. Heilig, 'St. Sophia Totters While Nations Discuss Question of Restoration', *New York Herald*, 19 October 1919, 89.
48. 'American Institute of Architects Plan Restoration of St. Sophia's', *St. Louis Post-Dispatch* 29 November 1926, 17.
49. 'Restoring Mosque of St. Sophia Is Kemalists' Order', *Minneapolis Star*, 8 October 1927, 21.
50. See the excellent account of this in: Nelson, *Hagia Sophia*, esp. 155–86; a more general account appears in King, *Midnight at the Pera Palace*, 267–86.
51. Holger A. Klein, 'The Elusive Mr. Whittemore: The Early Years, 1871–1916', in Holger A. Klein, Robert G. Ousterhout and Brigitte Pitarakis (eds), *The Kariye Camii Reconsidered* (Istanbul: İstanbul Araştırmaları Enstitüsü, 2011), 465–80.
52. See, for example, R. Halliburton, 'New Use for an Ancient Church. Santa Sophia at Istanbul, in Service 1,400 years, to Become a Museum', *Baltimore Sun*, 17 February 1934, 76–7.
53. Nelson, *Hagia Sophia*, passim.

Index

Note: page numbers in *italics* refer to figures; n after page number refers to note; the Hagia Sophia in Thessaloniki is indexed as Hagia Sophia, Thessaloniki; entries with Hagia Sophia without a location always refer to the Hagia Sophia in Istanbul

Abdul Medjid *see* Abdülmecid I
Abdülaziz, 247
Abdülfettah Efendi, 115–16
Abdülhamid II, 139, 247–8, 250, 259n36
Abdülmecid I (Abdul Medjid)
 attendance of Night of Power prayers, 247
 calligraphy of, 102, *103*, 106, *107*
 commissioned restorations of Hagia Sophia, 10, 13, 16, 99, 133, 197, 250
 mosaics of the Hagia Sophia, 19, 133, 217, 221
 as patron of (Christian) art, 201, 205–7, 221, 226
 as protector of Islam, 99, 205, 250–1
 reforms under, 15–16
 tuğra (sultanic monogram), 18–19, *18*, 115, 117, *206*, 207
abide (memorial), 5–6
ablution fountain (*şadırvan*), 66, 67–9, *68*
ablution fountain (*şadırvan*) of the Hagia Sophia, *31*, *32*, *43*, 67, 69
 Baroque aspects of, 47–8
 brass gratings, 69, *70*
 commissioned by Mahmud I, 27, 31, 41, 68, 84, 88
 muqarnas capitals, 41, 69
 outer dome with finial, 71, *72*

Qasida al-Burda on entablature, 16, 66–7, 71–4, *73*, 84–8
 song in praise of, 46
acanthus scroll motif, *40*, 40, 49, *51*, 51, 69, 178, *179*
adhan (call to prayer), 253–4
Ahmed III
 architectural works of, 37–8, 67, *68*
 dethronement of, 33, 84
 Hagia Sophia's royal prayer loge, 38
 Qasida al-Burda, 83, 86
 territorial losses, 49
 tuğra as decorative heraldic emblem, 40
 'Tulip Era', 37
Alaaddin Ali (Damad), 78
Alschuler, Alfred, 170, 186–7
alterity, 210, 215, 234–5
al-Amâsî, Muyhiddin, 82
antiquarianism, Ottoman, 149–50
Antoniades, Eugène Michael, 128, 139–40, 142–3
 Έκφρασις της Αγίας Σοφίας (Description of Hagia Sophia), 11, 139
al-Aqsa Mosque, Jerusalem, 87
Aristokles, Theodores, 129, 132
Armenians, 8, 48, 268, 273
Atatürk, Mustafa Kemal, 12, 18–19, 275–7
Athenaeum, 221, 223

Index

Aya Sofia, Constantinople, as Recently Restored by Order of H. M. the Sultan Abdul-Medjid (Fossati) *see* Fossati album
Ayasofya, Thessaloniki *see* Hagia Sophia, Thessaloniki
Ayasofya-yı Kebir *mahalle* (neighbourhood), Istanbul, 3–5
Ayvansarayî, Hafız Hüseyin, *The Garden of the Mosques* (*Hadikat el-Cevami*), 106
al-Ayyub Tomb, Istanbul, 66, 85

Balkans Wars, 162–3, 266, 268, 270
Baltacı Mehmed Paşa, Grand Vizier, 74
Baltacızâde Mustafa Paşa, calligrapher, 74
barbarism, 204, 227
Baroque, Ottoman
 Hagia Sophia *ʿimāret*, 41–6, 47, 50, 53
 Hagia Sophia Library, 40–1, 44
 Laleli Mosque, Istanbul, 52
 link with Byzantine traditions, 50–3
 Mahmud I's renovation of the Hagia Sophia, 16, 27, 47–50
 Nuruosmaniye Mosque, Istanbul, 48–9, 51–2, 68, 109–10, *111*
 renovation of Süleymaniye Mosque, Istanbul, 115
 start of, 46, 48, 64n79
 state-sponsored strategy, 46–7, 49
Bartlett, William, 198, *211*, 212, 213
Başçavuş Mosque, Yozgat, 111–12, *112*, *113*
Beaumont, Adalbert de, 203–5, 210, 216, 218–19, 225
Belgrade
 reconquest of, 33, 46, 49
 Treaty of, 34
Bihzad, miniature painter, 45
biography
 memoir (*tezkere*), 3
 object, 2–6, 107
Blackall, Clarence, 184
Bonneval, Claude Alexandre, Comte de (Humbaracı Ahmed Pasha), 52–3
BRF (Byzantine Research Fund), 151, 155, 161

Bukhara, 16, 66
 lodges in Istanbul, 85, 88
al-Būṣīrī, Iman Sharafaddin, *Qasida al-Burda* ('Poem of the Mantle')
 concept of *jihad al-nafs* (one's greater struggle with oneself), 75
 decoration of Masjid an-Nabawi (Prophet's Mosque), Medina, 83, 86
 decoration of Privy Chambers Topkapı Sarayı, Istanbul, 83
 decoration of Prophet's Tomb (the Sacred Chamber), Medina, 86
 decoration of *şadırvan* of Hagia Sophia, 66–7, 71–4, *73*, 84–5, 86, 87–8
 decoration of Topkapı Sarayı Harem, Istanbul, 83–4
 inscribed on lock of Fatima's house, Medina, 86
 manuscript in Bibliothèque nationale, Paris, 78–82, *81*
 manuscript in Süleymaniye Library, Istanbul, 75–7, *77*
 manuscripts in Walters Art Museum, Baltimore, 78, *79*, *80*
 manuscripts of, 67, 75–83
 Ottoman appreciation of, 84–8
 Sufi worship, 86, 88
 veneration of the Prophet, 74–5, 84, 86
Byzantine Institute of America, 10, 12, 277
Byzantine Research Fund (BRF), 151, 155, 161
Byzantios, Skarlatos, 128, 133
 Constantinople: A Topographical, Archaeological, and Historical Description, 133–9, 142
 harmonises Byzantine and Ottoman traditions, 142–3
 interest in folklore, 133–4, 136–40, 142–3

Cabi Ömer Efendi, 240
calligrapher
 Abdülfettah Efendi, 115
 Abdülmecid (Sultan), 102, *103*, 106, *107*
 Baltacızâde Mustafa Paşa, 74
 court, 101
 Habib Allah ibn Dust Muhammad al-Khwarizmi, 78

Index

Kazasker Mustafa İzzet Efendi, 101–6, *103*, 111, 114, 117, 121n18, 122n26, 142
Mir ʿImad al-Hasani, 45
Moralı Beşir Agha, 47
Muhyiddin al-Amâsî and relatives, 82
Mustafa Rakim, 112
Teknecizade İbrahim Efendi, 104, 109, 117
capitals
 basket, 50
 Corinthianising, 41, 50, *51*, 62n66, 64n79
 late antique (Byzantine), 50, *51*, *180*
 modified Ionic, 178, *179*
 muqarnas (stalactite), 39, 41, 51, 69
Carnoy, Henry and Nicolaïdès, Jean, *Folklore of Constantinople*, 140–2, 143
catacombs of St John the Baptist, Thessaloniki, 158, *159*, *160*
Chamber of the Holy Mantle (*Hırka-i Saadet*), Istanbul, 83–4, 259n36
Constantine, King, 127, 274
Constantine and Justinian mosaic *see* Virgin and Child mosaic
Constantinople
 Allied occupation of, 272
 Christian aspiration to reconquest, 127, 267–9, 271–4
 European travellers in the nineteenth century, 244–5, 252
 folk song of the capture of, 125–7, 135
 Frankish capture of, 9, 126
 hadith foretelling Muslim capture of, 10
 Islamic character of, 250
 Mehmed II's conquest of, 9, 12, 18, 52, 100, 241, 254, *255*
 Russian claims over, 249–50, 269–70
costume album, 207, 214–15, 217
Cram and Ferguson, Boston, 185
Crimean War, 135, 247
Crusades, 9, 135, 204

Dallaway, James, 130–2
Darülfünun (also *Dâr'ül-fünûn*; The University), Istanbul, 198, 199, 205, 228n2

dervishes, 66, 85–6, 214–15, 218
Diegesis ('The Story of Hagia Sophia'), 8, 9, 134, 136, 139, 142
Diehl, Charles, 148, *149*, 161
diplomats
 al-Būṣīrī's *Qasida al-Burda* and, 16, 66–7, 74, 83
 Hagia Sophia and European, 130, 149, 268
 oil-on-canvas paintings in residences of, 112
Dome of the Rock, Jerusalem, 114
dome of Hagia Sophia, *177*
 collapses, 7–9
 model for Ottoman mosques, 177–8
 model for synagogues, 176–9, 182, *183*, 190
 mosaics, 7, 120n11, 132
Dostoyevsky, Fyodor, *Diary of a Writer*, 249–50
Durkheim, Emile, 127–8

Edinburgh Review, 117–18, 221, 222, 223
Edirne (Odrin), 14, 37, 84, 268
Ellis, William T., 268, 272–3
empiricism
 of Antoniades, Michael, 139, 143
 of Byzantios, Skarlatos, 133–9, 143
 of Patriarch Konstantios, 129–32, *131*, 142
endowment
 deeds (*vakfiye*; *waqfiyya*), 8, 31–3, 54n6, 54n9, 55n16, 57n31
 pious (*vakıf*; *waqf*), 19, 33, 106, 150, 153, 157–8
Ephorate of Antiquities in Thessaloniki, 163
Erbaş, Ali, 20
eser (historical building), 5–6
Essen synagogue, Germany, 169–70, 171
Evliya Çelebi, *Seyahatnâme* ('Book of Travels'), 135–6, 139, 143, 256n9
Eyüb district, Istanbul, 85, 87, 95n57

faience tiles, 31, 39
Farohar, the ancient, 134, 136
Fatih Mosque (Mosque of Mehmed II), Istanbul, 39, 46, 64n79, 77, 106, 253, 263n71

Index

Fauriel, Claude, 125–8, 135, 139, 141, 142
Ferdinand of Bulgaria, Tsar, 269, 271–2
firman, 130, 235n59, 240, 244–5, 248
folk song on capture of Constantinople, 125–7, 135
Folklore of Constantinople (Carnoy and Nicolaïdès), 140–42, 143
Fornari, painter (Antonio), 214, 234n56
Fossati brothers (Gaspare and Giuseppe)
 commemorative column to Tanzimat reforms, 227
 Darülfünun (The University), Istanbul, 205, 228n2, 229n11
 Russian embassy, Constantinople, 228n2, 250
 State Archives, Istanbul, 228n2
 Ottoman Neoclassicism, 50
 see also Fossati album; Fossati restorations
Fossati album (*Aya Sofia, Constantinople, as Recently Restored by Order of H. M. the Sultan Abdul-Medjid*)
 emphasising Hagia Sophia's multiple temporalities, 11, 210–22
 emphasising Hagia Sophia's Muslim character, 241, 251–2
 French text by Adalbert de Beaumont, 203, 205, 216
 frontispiece, 205–7, *206*
 imperial self-representation, 199, 205, 214–15, 219–22, 224–8
 lithograph of Grand Vizer Place (plate 7), 219–22, *220–1*
 lithograph of Main Entrance (plate 1), *208–9*
 lithograph of New Imperial Loge (plate 9), 215–17, *216*
 lithograph of Upper Galleries (plates 10, 11), *212–14*, 213–14, 219–22, 241–2, *243*
 lithograph of view from lower north gallery, 241, *242*
 lithograph of view from north aisle (plate 5), 217–19, *218*, *224*
 neighourhood of 'Ayasofya-yı Kebir' (plates 21, 25), 3, *4*, *5*, *32*
 reconciliation of tradition and reform, 217–19, 225–8
 reviews of, 221–4, 226

Fossati restorations
 commemorating, 3, 18
 (uncovering and re-)covering of mosaics, 12, 19, 132, 202, 250
 European press on, 154, 199–205, 227
 inauguration ceremony, 204–5, 207, 251
 installation of calligraphic roundels, 16, 99, 100, 101, 104, 117, 250
 as metonym for Tanzimat reforms, 199, 201–5, 224–7
 Ottoman state's investment and stewardship of, 14, 15, 117, 201, 226–7
 stripes painted on stucco cladding, 178
 in Swainson and Lethaby, *The Church of 'Sancta Sophia'* monograph, 223–4
 tuğra of Sultan Abdülmecid, 115
fountains
 ablution (*şadırvan*), 66, 67–9, *68*
 at Tophane, Istanbul, 37, 68
 Byzantine holy wells, 66, 88
 commissioned by Ahmed III, 67–8, *68*
 Fossati's design of Tanzimat monument, 239n103
 Holy Well (*Phiale*) at Hagia Sophia, 88
 Ottoman Baroque, 15, 46, 67–8, 88
 public, 67–8, 219
 see also ablution fountain (*şadırvan*) of the Hagia Sophia
Franks, 9, 126, 127
Freshfield, Edwin, 155
Friendship Baptist Church, Cleveland, Ohio, 175–6, *176*

Gallipoli Campaign, 269–70
Garden of the Mosques, The (*Hadikat el-Cevami*) (Ayvansarayî), 106
Geo. B. Post & Sons, New York, 185, 186
George, Walter, 161
gift economies, 75, 83, 85
Gottlieb, Albert S., 182, 185
Grand Vizier, 47
 Baltacı Mehmed Paşa, 74
 Ferid Pasha, 139
 İbrahim Paşa, 151–2
 Mustafa Reşid Pasha (*also* Reshid; Redschid Pacha), 198, 219–22, *220*, *221*, 249

Index

Nisancı Ahmed Pasha, 46
 office of (*Sadâret*), 219, 237n75
'Grand Vizier Place', Hagia Sophia, 219, *220–1*, 237n75–6
Great Idea, the (*Megale Idea*; Greek irredentism), 125, 127–8, 142, 163, 267, 274
Greco, Charles R., 170, 171–81, *172*, 184, 185, 186–8, 190
Greek War of Independence, 126, 128, 201
Greek Kingdom
 archaeology and 'historical (territorial) rights' of, 163
 Hagia Sophia as cultural/religious heritage of, 127, 251, 267, 271–4
 Hagia Sophia as metonym for territorial ambitions of, 127–8, 135, 139, 142, 267, 274
 incorporation of Thessaloniki and part of Ottoman Macedonia in, 162–3
Greeks
 and the Great Idea (Megale Idea), 125, 127–8, 142, 163, 267, 274
 modern, 130
 Ottoman (*Rhomaioi*; *Rumlar*), 48, 128, 140, 142
grilles (*also* gratings)
 Hagia Sophia ablution fountain, 31, 41, *43*, 69–71, *70*
 Hagia Sophia Library, 28, *29*, 39, 41, 45, 51
Guastavino tile, 174, 182
Gülhane, Edict of, 198; *see also* Tanzimat

Habsburg Empire, Ottoman war with, 33–5
Hadikat el-Cevami (*The Garden of the Mosques*) (Ayvansarayî), 106
Hadjianestis, General Georgios, 274
Haghe, Louis, 205, *206*
Hagia Eirene, Istanbul, 6, 201, 226
Hagia Sophia, Thessaloniki
 Byzantine marble pulpit, 158–9
 catacombs of St John the Baptist, 158, *160*
 conversion to mosque (Makbul İbrahim Paşa Mosque), 148, 151–3
 converted back into church, 163, *164*

Edwin Freshfield's proposal for restoration, 155
1890 fire, 148, 150, 155, *156*, *157*
gateway, 161, 163
Greek restoration, 163
Marcel Le Tourneau, 148, *149*, 159, 161
mosaics, 148, 151, 159, 161
myths relating to, 153
Ottoman restoration, 148, 150, 151, 159–63
song on the capture of Constantinople, 125
visit of Sultan Mehmet V, 161, *162*
Hagios Dimitrios (Kasımiye Mosque), Thessaloniki, 151, 161
Hajj, the, 86–7, 88
Hamidiye Mosque, Istanbul, 248
Hamidiye Mosque (*also* Yeni Cami; New Mosque), Thessaloniki, 150, 158
heritage
 conceptions of, 2
 Constantinopolitan, 52
 Hagia Sophia's complex religious, 277
 Hagia Sophia as Greek Kingdom's cultural/religious, 127, 251, 267, 271–4
 Hagia Sophia as symbol of lost Christian, 251, 267–73
 Ottoman interest in restoring Byzantine, 161–2, 163, 201, 226–7
 Thessaloniki's Byzantine, 151–5
 see also World Heritage List
Herzfeld, Michael, 126, 127
Hijaz, the, 66, 74, 85, 87–8
Hırka-i Saadet (Chamber of the Holy Mantle), Istanbul, 83–4, 259n36
Hırka-i Şerif Mosque, Istanbul, 102, *103*, 110
historicism, 169–70, 223, 225
Hobsbawm, Eric, 15
Holy Well (*Phiale*), 88
Hosios Loukas, Phocis, 174–5, 188
Hubbell & Benes, 185, 186
Humbaracı Ahmed Pasha *see* Bonneval, Claude Alexandre, Comte de
Hünkar Kasrı, Istanbul, 19
hünkâr mahfili (imperial or royal loge), 38, 197, 215, *216*
Hurva synagogue, Jerusalem, 177–8, *178*

285

Index

Ibn Khaldun, 75
İbrahim Paşa, 151–2
iconostasis, 100, 104, *164*, 180, 181
identity
 Christian, 48
 Fossati album's and Hagia Sophia's, 205–7, 210–22, 225–6, 227
 Greek Macedonian, 154
 of the Hellenes, 127
 Wilhelm Salzenberg publication and Hagia Sophia's, 224–5
 symbolic, 150
Illustration, L', 204–5
imaret (mosque complex; also *külliye*), 5, 14, 27, 38–9, 105, 115, 153
 Fatih Mosque (Mosque of Mehmed II), Istanbul, 39, 46, 64n79, 77, 106, 253, 263n71
 Nuruosmaniye Mosque, Istanbul, 48–9, 51–2, 68, 109–10, *111*
imaret (public soup kitchen) of Hagia Sophia
 ballad about, 46, 57n31
 carpet museum, 33
 commissioned by Mahmud I, 10, 27, 31–3, *32*, *34*, 38, 49
 Corinthianising capitals of main gate, 50, *51*, 62n66
 entrance to dining hall and portico, 33, *35*, 39, 45
 main gateway, 33, *36*, 38, 39, 41–4, *44*, 46, 53
 Moralı Beşir Agha, calligrapher of, 47
 Ottoman Baroque, 41, 44–5, 46, 47, 50, 52
 Subhi's account of opening ceremony, 45, 47
Imperial Archaeological Museum, Istanbul, 150, 151, 154, 159, 160
inauguration ceremony
 Fossati restoration, 204–5, 207, 228n3, 234n57, 251
 ᶜ*imāret*, 45, 47
Iran, 33, 75, 82–3, 85
irredentism, Greek *see* Great Idea, the (*Megale Idea*; Greek irredentism)
İznik tiles, 107, 109, 115

Jay, Mary H., 248, *249*, 252
Jews, Sephardic, 153, 158
Journal de Constantinople, 199–202, *200*, 203, 210, 217, 227
Justinian
 construction of atrium and *Phiale* of Hagia Sophia under, 66, 88
 construction of Hagia Sophia, 5, 6–7, 12, 13, 203, 226
 mosaic of Constantine and (Virgen and Child mosaic), 7, 8, *8*, 10, 19, 133, 230n24

Ka'ba, Mecca, 86, 87, 100
Kadı Abdurrahman Pasha, 240–1
Kadızadeli reformers, 84
Kahn, Albert, 186–7, 188
Kasımiye Mosque (Hagios Dimitrios), Thessaloniki, 151, 161
al-Kawākib al-Durriyyah fī Madḥ Khayr al-Bariyyah see al-Būṣīrī, Iman Sharafaddin, *Qasida al-Burda* ('Poem of the Mantle')
Kazasker Mustafa İzzet Efendi, 101–6, *103*, 111, 114, 117, 121n18, 122n26, 142
Kemal, Mustafa *see* Atatürk, Mustafa Kemal
Khidr
 and the Drunkard, 141–2, 143
 imprints of his arms in Hagia Sophia, 140
Kılıç Ali Pasha Mosque, Istanbul, 106, *107*
Konstantios I, Patriarch, 128–9
 critique of Byzantine hyperbole, 129, 130, 132, 133, 142
 Konstantinias Ancient and Modern (or, *a Description of Constantinople*), 129–32, *131*, 133
 pamphlet on Hagia Sophia, 129, 132–3
 quantitative empiricism of, 129–30, *131*, 132, 134, 136, 142
Kopytoff, Igor, 2–3
külliye see imaret (mosque complex)
Kütahya ware, 31

Laleli Mosque, Istanbul, 52, 106
Lausanne, Treaty of, 274, 276

286

Index

Layard, Austen Henry, 134, 136, *138*
Laylat al-Qadr see Night of Power
Le Tourneau, Marcel, 148, *149*, 159, 161
Lehman & Schmitt, Cleveland, 186
levha (framed panel)
 emergence of, 100, 109–16
 cami takımı ('mosque set'), 111
 Hagia Sophia, 17th century, 109, 111, 114
 murabba ('square'; also *satranç*, 'chessboard') technique, 102–4
 see also roundels, calligraphic
library of Fatih Mosque (Mosque of Mehmed II), Istanbul, 39, 64n79, 77
library of the Hagia Sophia
 ballad of, 45–6
 Baroque motifs, 40–1, *40*, 44, 47, 48
 commissioned by Mahmud I, 10, 27–8, *28*, 34, 77
 grilles (*also* gratings), 28, *29*, 39, 41, 45, 51
 inscription in kiosk, 35–6, 38, 41
 kiosk, 28, *30*, 35, 40–1, *40*, *42*
 muqarnas capitals, *29*, 39, 41, 51
 reading room, 28, *29*, 40
 Subhi's account of, 37, 45
 tiles, *29*, *30*, 31, 39, 40, 45
 tuğra, *29*, 40, *42*, 51
library of Nuruosmaniye Mosque, Istanbul, 39, 49, 78
Lloyd George, David, 270, 273
lodges in Istanbul, 85–6, 88
loge, imperial (or royal) prayer (*hünkâr mahfili*), 38, 197, 215, *216*
longue durée perspective, 107, 226

Macedonia, Ottoman, 149, 154, 162
madrasa, 38, 49, 75
Mahmud I, 1
 al-Būṣīrī, *Qasida al-Burda* and, 74, 75, 77–8, 84, 88
 commissioned library at Fati Mosque, Istanbul, 39–40, 77
 Hagia Sophia building campaigns, 10, 27–33, *28*–*32*, *34*, 38–9, 68
 library at Topkapı Sarayı, Istanbul, 77
 Nuruosmaniye Mosque, Istanbul, 39, 48, 68, 78
 and Ottoman Baroque, 16, 27, *35*, 39–6, 40, 44, 47–50, 53
 patron of the arts, 37–8, 52–3
 Tophane fountain, Istanbul, 37, 68
 war with Habsburg and Russian empire, 33–7, 46–7, 48
Mahmud II, 101, 240, 245
 reforms, 15, 217, 218, 236n68
 tuğra of Mahmud II, 44, *44*, 58n45, 124n51
manuscript
 with ballads about Hagia Sophia (anonymous), 45–6
 copying by calligraphers who stayed in lodges, 85–6
 Diegesis, library of Topkapı Sarayı, Istanbul, 9
 illustrated Persian, 136
 Ottoman *Qasida al-Burda*, 82
 paintings of Hajj ritual, 88
 Qasida al-Burda in Süleymaniye Library, Istanbul, 75–7, *76*–*7*
 Qasida al-Burda, 67, 75–83
 Qasida al-Burda in Bibliothèque nationale, Paris, 78–82, *81*
 Qasida al-Burda in Walters Art Museum, Baltimore, 78, *79*, *80*
 of *Siyer-i Nebi* ('Life of the Prophet'), 136, *137*
Masjid an-Nabawi Mosque (*also* Prophet's Mosque), Medina, 83, 86
mausolea, southern corner Hagia Sophia, 10, 38
McCormick Jr, Richard Cunningham, 243–4
Mecca, 85, 86, 87, 100, *137*, 218, 234n56
Medina, 83, 85, 86, 87, *137*, 234n56
Megale Idea (the Great Idea; Greek irredentism), 125, 127–8, 142, 163, 267, 274
Mehmed II, the Conqueror
 conquest of Constantinople, 9, 18, 52
 conversion of Hagia Sophia into mosque, 9–10, 38, 86, 204, 241
 Hagia Sophia and myths of, 140
 Hagia Sophia's *vakiye*, 18, 19, 20
 madrasa established by, 38
 Mosque of (Fatih Mosque), Istanbul, 39, 106
 tuğra of, 18

Index

Mehmed III mausoleum, Istanbul, 10
Mehmed IV, 83–4
Mehmed V, 161, 162, *162*
Mehmed Emin, 69, 71, *73*, 90n9
Meletios, Metropolitan of Athens, 272
Melling, Antoine-Ignace, 207
memoir, biographical (*tezkere*), 3
mihrab
 area and minbar Hagia Sophia, 10, 20, 100, 121n18, 122n26
 area Hagia Sophia, Thessaloniki, 152, *152*, 163, *164*
 area Süleymaniye Mosque, Istanbul, 115–17, *116*
 area Ulu Camii (Great Mosque) of Adana, 107, *108*
Mimar Sinan, 14, 105
minarets
 Hagia Sophia, 10, 12, 19, *32*, 38, 205, 267
 Hagia Sophia, Thessaloniki, 152, 155, 163
 Selimiye Mosque, Edirne, 14
modernity, 12, 14–16, 158, 204
modernism, 169–70
monument, historical, 6, 11, 127, 201–3, 224–6, 230n19
Moralı Beşir Agha, 47
mosaics
 documented and re-covered, Fossati restorations, 19, 99, 119, 132, 197, 222, 225, 251
 Hagia Sophia's figural, 7, 10, 13, 38, 99, 132, 197, 217
 Hagia Sophia's naos and dome, 7, 120n11, 132
 Hagia Sophia, Thessaloniki, 148, 151, 152, *152*, 159, 161
 Hagia Sophia, uncovered in 1930s, 12, 276–7
 gold, 18, 114, 115, 120n11
 Qur'an verses in Dome of the Rock, Jerusalem, 114
 seraphim (*also* angels), 10, 19, 119, 128, 134–9, 142
 Sultan Abdülmecid and uncovered, 19, 124n52, 201–4, 217, 221–2
 tuğra of Sultan Abdülmecid, 18, 115, 117

Virgin and Child (*also* of Constantine and Justinian), 7, 8, *8*, 10, 19, 133, 230n24
Wade Memorial Chapel in Cleveland, Ohio, 186
mosque complex *see* imaret
motifs, decorative
 acanthus scroll, 40–1, 49, 51, 69, 178
 Ahmed III 'Tulip Era', 37
 arabesque, 40
 Baroque, 40, 48, 49, 51
 Central Asian floral and geometric, 78
 Greco-Roman, 51
 Justinian mosaics, 7
Mouradgea d'Ohsson, Ignatius, 207, 233n45
Muhammad, Prophet
 finial shaped in name of, 71, *72*
 al-Ayyub, companion and standard bearer of, 85
 al-Būṣīrī *Qasida al-Burda* and veneration of, 66, 71–5, 84
 calligraphic panels with name of, 100, *101*, 104, 120n8, 250
 Chamber of the Holy Mantle (*Hırka-i Saadet*), Istanbul, 83
 Hagia Sophia's myths about, 134, 136, 139, 140
 Night of Power, 245
 Tomb of (Sacred Chamber), Medina, 86
 Siyer-i Nebi ('Life of the Prophet'), 136, *137*
 veneration of, 84, 88
Müller, Georgina Adelaide, 245, 256n7, 257n17
muqarnas (stalactite) capitals, 39, 41, 51, 69
murabba ('square'; also *satranç*, 'chessboard') technique, 102–4
Murad III, 10, 83, 245
 Mosque of (Muradiye), Manisa, 109, *110*
Murad IV, 86
Muradiye (Sultan Murad III Mosque), Manisa, 109, *110*
Murray's Handbook for Travellers in Constantinople, 252

Index

museum
 of antiquities, Hagia Eirene (*Cebhâne*), Istanbul, 201, 226
 (Imperial) Archaeological, Istanbul, 150, 151, 154, 159, 160
 Hagia Sophia's conversion into, 1, 12–14, 16–19, 27, 99, 253–4, 276–7
Mustafa II, 84, 86
Mustafa III, 52, 91n26, 124n51
'mutability' of a monument, 19
Muyhiddin al-Amâsî, 82

naos of Hagia Sopia *see* dome of Hagia Sophia
Nerval, Gerard de, 227
Newark temple (B'nai Jeshurun), 182, *183*, 185
Nicolaïdès, Jean, 128, 140–2, 143
Night of Power (*Laylat al-Qadr*) prayer ceremonies *(kadir gecesi rüsumu)*
 Hagia Sophia, 21st-century re-invention of, 254
 Hagia Sophia, non-Muslim attendance on, 241, 245, 248, 250, 252
 Hagia Sophia, sultan's attendance on, 241, 245–7
 (Yıldız) Hamidiye Mosque, Istanbul, sultan's attendance on, 248
 Nusretiye Mosque, Istanbul, sultan's attendance on, 247–8
 used to propagate Islamic symbolism of Hagia Sophia, 248–50, 252
 used to propagate Turkification policies in Hagia Sophia, 241, 252–4, *253*
Niš, Treaty of, 34
Nogués, George, 227
Nuruosmaniye Mosque, Istanbul, 48–9, 51–2, 78, 106, 109–10, *111*
Nusretiye Mosque, Istanbul, 247–8

Odrin *see* Edirne
Osman III, 48, 78
Ottoman Baroque
 Byzantine references in, 50–3
 Hagia Sophia, 16, 27, *35*, 39–47, *44*, 49–50
 Laleli Mosque, Istanbul, 52

Nuruosmaniye Mosque, Istanbul, 48–9, 67, 109–10, *111*
 state-sponsored strategy, 46–50, 52–3
 Süleymaniye Mosque, Istanbul, 115

Papageorgiou, Petros, 154, 158, 161
Pardoe, Julia, *The Beauties of the Bosphorus*, 198, *211*, 235n59, 257–8n21
Path of Muhammad (*al-Tariqah al-Muhammadiyyah*), concept of, 84
patronage
 of architecture, arts and antiquities, 38, 88, 107, 114, 227
 of drinking fountains by Mahmud I, 37
 of Fossati album, 224
 of Hagia Sophia by Abdülmecid I, 99, 115, 119, 133, 201–7, *206*, 226
 of Hagia Sophia by Mahmud I, 37–9, 53
 of Hagia Sophia by Selim II, 38
 of mosque restoration, 105–6, 114, 115, 119, 199
 of Ottoman Baroque, 46, 48, 51, 88
 of tiled inscriptions of the *Qasida al-Burda* by Murad III, 83
periodisations, normative, 15–16
Phiale (Holy Well), 88
Pigeory, Félix, 217
pilgrimage, secondary, 66, 85, 86–7, 89n4
pilgrims
 en route to Mecca and Medina, 85, 86, 87
 visiting Hagia Sophia, 3, 16, 66, 87, 88
 visiting Istanbul, 67, 74, 85, 86
 visiting Tomb of al-Ayyub, Istanbul, 66, 87
'Poem of the Mantle' *see* al-Būṣīrī, Iman Sharafaddin, *Qasida al-Burda* ('Poem of the Mantle')
Privy Chamber (*Has Oda*), 77, 83–4, 259n36
Procopius, 6–7, 190, 236n64, 267
Prophet's Tomb (Sacred Chamber), Medina, 86

Qasida al-Burda see al-Būṣīrī, Iman Sharafaddin, *Qasida al-Burda* ('Poem of the Mantle')
qibla, 100, 109, 140

289

Index

re-conversion to mosque, 1, 17–18, 254–5
Redschid Pacha *see* Reşid Pasha, Grand Vizier Mustafa
Republic of Turkey, 252
 Hagia Sophia as metonym for territorial sovereignty, 127
 Hagia Sophia as propaganda tool for Turkification policies, 241, 252–4
Reşid Pasha, Grand Vizier Mustafa (*also* Reshid; Redschid Pacha), 198, 219–22, *220*, *221*, 249
restoration (and conservation) practices, 2, 17, 99, 149, 163; see also *tamirât* (restoration work)
Rococo, 40, 41, 45
roundels, calligraphic
 Başçavuş Mosque, Yozgat, 111, *112*, *113*
 commemorating *tamirât*, 98–107, 109, 111, 117
 Fossati restorations and installation of, 16, 98–107, *101*, 109, 111, 121n18
 in Great Mosque (Ulu Camii), Adana, 107, *108*
 in Hagia Sophia, central prayer area, 13, 98, *98*, 103, 119
 in Hırka-Şerif Mosque, Istanbul, 102, *103*, 110
 in Kılıç Ali Pasha Mosque, Istanbul, 106, *107*
 murabba ('square'; also *satranç*, 'chessboard') technique, 102–4
 names on Hagia Sophia's, 100–1, *102*, 104, 111, 120n8–9
 set of eight (*cami takımı*), 111
 see also *levha*
Russia
 claims over Istanbul, 249–50, 269–70
 Ottoman war with Habsburg Empire and (1736–9), 33–5, 37, 47
 Turko-Russian wars (1828–9; 1877–8), 158, 245, 249–50

St Peter's Basilica, Rome, 6, 130, 176
St Sophia Redemption Committee, 270, 273, 274
Salonika (Thessaloniki)
 annexation by Greece, 149, 162–3
 catacombs of St John the Baptist, 158, *160*
 fire of 1890, 148, 150, 151, 155, *156*, *157*, 161
 Hagios Dimitrios (Kasımiye Mosque), 151, 161
 Hamidiye Mosque (*also* Yeni Cami; New Mosque), 150, 158
 Islamisation of, 151–3
 Ottoman urban reforms, 149, 150, 155–7
 Sephardic Jews, 153
 song on the capture of, 125
 visit of Sultan Mehmed V, 161, *162*
 see also Hagia Sophia (Ayasofya), Thessaloniki
Salzenberg, Wilhelm, *Early Christian Monuments of Constantinople*, 11, 11, 222–5, *223*, 238n89
San Stefanos (today Yeşilköy), 249, 250
satranç ('chessboard, also *murabba* 'square') technique, 102–4
school(s)
 Hagia Sophia primary school, 10, 27, *31*, 31, 39, 49, 41
 Hagia Sophia, Thessaloniki, 153
 in late 19th century Thessaloniki, 157–8
 madrasa established by Mehmed II, 38
secularisation, 12, 16–17, 19, 170, 217–19, 275–7
Selim I, 75–6, 250
Selim II, 10, 38
Selim III, 218
Selimiye Camii (Mosque), Edirne, 14, 268
seraphim, 10, 19, 119, 128, 132, 134–9, 142–3
Şeyh Hamdullah, 82
seyr ü temaşa ('view and contemplate'), 240, 241, 242–4, 247
Silver, Abba Hillel, 181–2, 184–5, 186–90
Sinan (*also* Mimar Sinan), 14, 105
Siyer-i Nebi ('Life of the Prophet'), 136, *137*
Smyrna, burning of, 270, 274
song
 ballad of Hagia Sophia's ablution fountain, 46

Index

ballad of Hagia Sophia Library, 45–6
balled of Hagia Sophia's ʿimāret, 46
Qasida al-Burda as devotional, 86
on the capture of Constantinople, 125–7, 128, 135
soup kitchen of Hagia Sophia see *imaret* (public soup kitchen) of Hagia Sophia
Stanwood, Richard. R, *172*, 178–9, 189–90
Subhi Mehmed Efendi, 37, 45–6, 47
Sufi, 84
 'Ayoz Sofi' or 'Ayaz Sufi', 87
 lodges, 85–6
 Naqshbandi, 85
 see also al-Būṣīrī, Iman Sharafaddin, *Qasida al-Burda* ('Poem of the Mantle')
Süleyman I, 82, 83, 115
Süleymaniye Mosque, Istanbul, 12, 244
 framed calligraphic inscriptions, 115–17, *116*, 123n40
 funerary complex for Süleyman I, 115
 galleries used as safe deposits, 243, 257n17
 interior and exterior 'cleaning', 243–4
 Library, 75, *76*, 77, *77*
 visits of non-Muslims, 244–5
Sultan Murad III Mosque (Muradiye), Manisa, 109, *110*
Swainson, Harold and Lethaby, W.R., *The Church of 'Sancta Sophia', Constantinople*, 223–4
symbolism, 47–50, 53, 128, 148, 161–2, 188, 252

Taksim (*taksīm*) waterworks project, 37
tamirât (restoration work), 105–6
 calligraphic panels commemorating, 98–107, 109, 111, 117
 tuğra commemorating, 10, 18, 114–15, 117, 124n51
Tanzimat, 198, 229n8
 commemorative monument to, 227–8
 communicating, 204–5, 207, 227
 elite, 198, 201
 Grand Vizier Mustafa Reşid Pasha (*also* Reshid; Redschid Pacha), 219–22
 Hagia Sopia as metonym for reforms of, 199

imposed uniformity of attire, 214–15
reforms, 15, 99, 198–9, 217, 221
Tekfur Sarayı tile production, 31
Teknecizade İbrahim Efendi, 104, 109, 117
Texier, Charles and Pullan, Richard, *Byzantine Architecture: Illustrated Examples of Edifices Erected in the East during the Earlies Ages of Christianity*, 154, 161
tezkere (biographical memoir), 3
Thessaloniki *see* Salonika
Tiferet Yisrael synagogue, Jerusalem, 177–8, *178*
Tifereth Israel synagogue (*also* University Circle Temple; Maltz Performing Arts Center), Cleveland, Ohio
 decoration resembles Hosios Loukas, Phocis, 174–5
 design and decoration refer to Hagia Sophia, 11, 174–9, 190
 design competition for, 185–6
 façade, *172*, 178, *179*, 188
 Greco, Charles R., 170, 171–81, *172*, 185, 186–8, 190
 Rabbi Abba Hillel Silver, 181–2, 185, 186, 187, 188–9
 scaenae frons, 180–1
tiles
 blue-and-white İznik, 107, 109, 115
 faience, 31, 39
 Hagia Sophia Library, 31, 39, 40, 45
 with inscriptions on mosque' walls, 100
 Kütahya ware, 31
 trompe-l'oeil, 111, *112*
 with verses of the *Qasida al-Burda*, 83, 88
tomb
 al-Ayyub, Istanbul, 66, 85
 Hagia Sophia, 3, 10, 38
 Prophet's (Sacred Chamber), Medina, 86
Tophane, Istanbul, 37, 68, 106, *107*, 247
Tophane Fountain, Istanbul, 37, 68
Topkapı Palace, Istanbul, 3, 31
 Ahmed III' Privy Chamber, 83
 Chamber of the Holy Mantle (*Hırka-i Saadet*), 83–4, 259n36

Index

Topkapı Palace, Istanbul (*cont.*)
fountain at entrance, 67, *68*
Harem quarters, 83, 84
library of, 9, 77
Mehmed IV's Privy Chamber, 83
Süleyman I's Privy Chamber, 83
tuğra commemorating renovation, 124n51
tourists, 2, 3
depicted on plates in Fossati album 215, 227, 241–2
guidebooks and publications for, 12, 252
interest in Hagia Sophia, 229n6, 244–5
interest in Thessaloniki, 153–4
travellers' account, 198, *211*, 242, 244, 245, 257n21
Trdat the stoneworker, 8, 12
treasury
Chamber of the Holy Mantle (*Hırka-i Saadet*), 83–4, 259n36
Hagia Sophia's circular, 33, *36*
imperial, 77, 243
trompe-l'oeil designs, 111, *112*, 115
Trubetskoy, Prince, 269–70
tuğra (sultanic monogram)
of Abdülmecid I, 10, 18, 115, 117, 207, 230n24
to commemorate renovation efforts, 10, 18, 114–15, 117, 124n51
of Mahmud I, *29*, 40, 41, *42*, 45, 51
of Mahmud II, 44, *44*, 58n45, 124n51
of Mehmed II, 18
of Mustafa III, 124n51
use as architectural ornament, 41, 114–15
'Tulip Era', 37, 41
Turkification, 241, 253–4
Turkish War of Independence, 266, 270, 272–4
Turko-Russian wars (1828–9; 1877–8), 158, 249–50, 254

ulema, 38, 99, 205, 218
Ulu Camii (Great Mosque), Adana, 107, *108*

University Circle Temple *see* Tifereth Israel synagogue

vakfiye (*waqfiyya*; endowment deed), 18, 31–3, 54n6, 54n9, 55n16, 57n31
vakıf (*waqf*; pious endowment), 19, 33, 106, 150, 153, 157–8
van Millingen, Alexander, 252
Versailles Peace Conference, 270
'view and contemplate' (*seyr ü temaşa*), 240, 241, 242–4, 247
Viollet-le-Duc, Eugène, 203, 213
Virgin and Child mosaic (*also* mosaic of Constantine and Justinian), 7, 8, *8*, 10, 19, 133, 230n24
Virgin of Stamboul, The, 273

Walker and Weeks, Cleveland, 185–6
waqf see vakıf
waqfiyya see vakfiye
war(s)
Balkan (1912–13), 162–3, 266, 268–9
Crimean, 135, 247
First World, 14, 15, 169, 181, 186, 266, 269–72
holy, 35, 36
of Independence, Greek, 126, 128, 201
of Independence, Turkish, 266, 270, 272–4
between Ottomans and Habsburg and Russian Empire (1737–39), 33–5, 37, 47
between Ottomans and Iran, 33
Second World, 163, 169, 170
Turko-Russian (1828–9; 1877–8), 158, 249–50, 254
westernisation (*Batılılaşma*), 15, 16, 47, 113–14, 204, 242–3, 275
Whittemore, Thomas, 277
World Heritage List, 12, 99

Yozgat, calligraphic roundels, 16, 111–12, *112*, *113*